Comedia
Series editor: David Morley

HIDING
IN THE
LIGHT

HIDING IN THE LIGHT

ON IMAGES AND THINGS

Dick Hebdige

A Comedia book
published by Routledge
London and New York

A Comedia book
First published in 1988 by
Routledge
11 New Fetter Lane, London EC4P 4EE
29 West 35th Street, New York NY 10001

Cover design by Andy Dark, Graphics International

Printed in Great Britain by Richard Clay Ltd, Bungay, Suffolk
Typeset by Photosetting, 6 Foundry House, Stars Lane, Yeovil, Somerset

British Library Cataloguing in Publication Data
Hebdige, Dick
 Hiding in the Light: on images and things.
 1. Modernism (Aesthetics) 2. Postmodernism
 3. Civilization, Occidental
 I. Title
 306 BH301.M54
ISBN 0 415 00736 4
 0 415 00737 2

Library of Congress Cataloguing in Publication Data
Hebdige, Dick.
 Hiding in the light.
 (A Comedia book)
 1. Popular culture – History – 20th century. 2. Great
 Britain – Popular culture – History – 20th century
 I. Title
 CB430.H4 1987 941.082 87-14162

ISBN 0 415 00736 4
 0 415 00737 2

Contents

To Generalise is to be an Idiot. To Particularise is the Alone Distinction of Merit. General Knowledges are those Knowledges that Idiots possess.

(*William Blake*)

What it is is what it is.

(*James Brown*)

Acknowledgements

Many people have helped in the writing of this book. I would like especially to thank the editors of *Block* for the stimulating exchange of ideas, for providing an accessible introduction to debates in art and design history and for encouraging me to venture into a new field of enquiry. I would also like to thank the editors of *Ten.8* for opening up a space in which it became possible to try out new kinds of writing about imagery and new ways of combining words and photographs. I am grateful to the staff and students of two other institutions – the Center for 20th Century Studies at the University of Wisconsin, Milwaukee, and the Communications Department at McGill University, Montreal – for inviting me to speak, for introducing me to approaches and traditions with which I was entirely unfamiliar, and for asking useful questions which I couldn't answer at the time but which served as catalysts for later work.

Thanks particularly to Kathy Woodward and Herb Blau at Milwaukee for their hospitality and for providing me with an opportunity to rethink earlier work from a different angle and, ultimately, to acknowledge and confront its limitations.

In the two weeks I spent at McGill in January, 1986, only the weather was cold – staff and students on the graduate program in communications took care to make me feel at home and discussion was always lively and engaged.

Without the benefit of that dialogue and the opportunity to think my way in lectures and seminars through current debates on cultural studies and postmodernism, the last section of this book would not have been written. I would like especially to thank Irene Bellertz for inviting me and Dorothy Carruthers, Peter Wollheim, Marika Finlay and Bruce Ferguson for giving me so much time, help and support during my stay in Montreal.

While on the subject of friends in distant places, I would also like to thank Kirsten Drötner, Stuart and Liz Ewen, Ien Ang, Anne McNeill, Ido Weijers, Johann Meyer, Sam Rosenberg, Iain Chambers, Marty Allor, Beth Seaton, Philip Corrigan, Debra Riley, Chris Parr, Reebee Garafalo, Vyenka Garms-Homolova, Lidia Curti, Ina Bauhuis and Larry Grossberg for making visits to other institutions both enjoyable and productive occasions. In each case I learned far more than I ever taught. Thanks too to Greg Hollingshead for his comments on the first draft. Of those closer to home, I would especially like to thank Jessica Pickard for her clarity and insight, her sense of words. The combination of passion, judgement, grace and nerve which she brings to bear on any project to which she is attached is rare and precious and it touches the text and shapes the trajectory of the arguments in ways which are too subtle and private to be properly acknowledged here. I am grateful to Mike Karslake, president of the Lambretta Preservation Society, for making his Lambretta archive available to me, for his time and for the expert knowledge of design matters that he brought to our discussions for the "Object as Image" piece. Thanks, too, to Dave at Comedia for having the nerve to go for it and Andy Dark again for his excellent design work. Finally, I would like to thank John Woodman for his prescience and quiet insight and Peter Osborne for his wit, his company and conversation.

Pete bears no responsibility for the garbled echoes of his own words which may have found their way on to the pages which follow.

Introduction

According to some contemporary theorists of literature we are living in an age when books as we traditionally conceive them are no longer possible. The word "book" implies a degree of coherence and organisation which is neither appropriate nor desirable in a world where the individual voice has been decentred, disinherited, stripped of its imaginary resonances. The shining that seemed in an earlier epoch to surround and sanctify the gush of human utterance in written form melts away as the voice and the book dissolve into a plethora of half-completed "texts", voices, incommensurable "positions". Between the two moments – a world of difference. This book was put together – as most books no doubt are and always have been – on the cusp of those two moments. There was no single point of origin, no prior revelation of a theme, an idea of the book conceived, planned out, then realised. Most of the writing had already happened before a book was on the cards. Many of the articles published here were written during the past five years for different journals, magazines, readerships. It was only in retrospect that the sequence from one essay, one set of concerns to the next, seemed to take on meaningful shape and direction. And yet such a pattern does, I hope, emerge unforced. Certain questions concerning on the one hand the relationship between consumption, culture and design, between "Pop", popular culture and postmodernism and on the other the "crisis" of "radical" critique and the limitations of "general [academic] knowledges" are returned to at regular intervals. And by the last page, it seems – though I didn't always know it as I was writing – that a journey has been undertaken through the territory of images and things (hence the subtitle) – a journey from subculture through postmodernism and out the "other side" – a journey which begins with early nineteenth-century costermonger culture in the slums of Henry Mayhew's London and which ends in the American mid-West at "noon

plus one" taking a ride down the road to nowhere. This book is a record of that itinerary. If it holds together as a book, then it does so, perhaps, in the same snatched kind of way as the discontinuous jottings in a traveller's diary come together as you read them. If it has any consistency at all, then it is the uneven consistency of writing on the run.

The book is divided into four sections. Section One – *Young lives* – contains two essays. The first, which gives this book its title, was based loosely on a paper given at the Center for 20th Century Studies at the University of Wisconsin, Milwaukee, in 1983. The version reprinted here was first published in the same year in *Ten.8*, a journal devoted to the theory and history of photography. *Hiding in the Light* tracks two stereotypical images of adolescence: youth-as-trouble and youth-as-fun back to their respective sources – the former in the nineteenth-century literature of "social exploration", social policy documents and early documentary photographs and the latter in post-war market research, marketing and advertising imagery. This crude genealogy is intended to put current concern over the "youth problem" in an historical perspective and the article ends with the suggestion that the outrageous displays which some (photogenic) sections of youth engage in in Britain today can be seen as a response to the exploitative, supervisory and voyeuristic attention which has been lavished upon them by a variety of interested parties since the early industrial revolution. By way of conclusion, I suggest that spectacular youth cultures convert the fact of being under surveillance into the pleasure of being watched. The second article, *Mistaken Identities*, is about the deaths of Nancy Spungen and Sid Vicious, formerly of the Sex Pistols (now, significantly enough, the subject of a "major new film" by Alex Cox [*Sid and Nancy*, 1986]). The essay is based on a short piece written in 1981 for the arts magazine, *ZG*, and is included here to mark the passing not only of Sid and Nancy but also of the "moment" of the punk "subculture" and the model of subcultural "negation" and "resistance" which informed an earlier phase in my own work. The lesson I draw from this triple obituary is that theoretical models are as tied to their own times as the human bodies that produce them. The idea of subculture-as-negation grew up alongside punk, remained inextricably linked to it and died when it died ... *Young lives* is my attempt at a farewell to youth studies.

Section Two, *Taste, Nation and Popular Culture*, consists of three research articles on design history and popular culture written for the art and design theory journal, *Block*, between 1981 and 1983. In *Towards a Cartography of Taste* (also available in B. Waites et al. (eds.), *Popular Culture Past and Present*, Croom-Helm and the Open University, 1981), I attempt to map out the various responses to imported American goods – especially popular music and streamlined products – during the period 1935–1962. In *Object as Image: the Italian Scooter Cycle*, I present a case-

8

study of one commodity – the Italian motor scooter – and pursue it from the design stage through production via marketing and advertising into use both here and in Italy in the 1950s and 1960s. Taken together these two articles offer a socio-cultural critique of the allegedly "neutral" category of taste – a critique which is intended to puncture the mystique of "official" judgements of popular commodity preferences.

A hidden agenda subsists beneath these legitimated definitions of cultural and aesthetic value concerning questions of national and racial identity and "heritage". The singularity of British culture is felt to be increasingly threatened in the post-war period by the conditions under which consumption values and popular culture are disseminated. For critics pledged to defend "authentic" British values, mass-produced commodities aimed at specific target groups begin to function as symbols of decadence. They are seen to pose a threat to native traditions of rugged self-reliance, self-discipline and the muscular puritanism of the stereotyped (male) workforce, thereby leading to a "softening up" and "feminisation" of the national stock. Paternalist attempts to frame, contain and limit the flow of imported goods and to determine their meanings and uses are, however, doomed to failure and both Americanised and Italianate taste formations become rapidly established. Far from leading to the homogenisation of British culture, these appropriations of commodities are used during the period by specific groups to mark out aspirational differences in the social domain through the invocation of an exotic elsewhere – an "America" of open roads and affluence, a cool and sophisticated "continental Europe".

In the third article, *In poor taste: notes on Pop*, I pursue these themes onto the terrain of fine art and fashion. A similar dialectic is seen to dictate the appeal of American iconography for a new generation of post-war British artists anxious to dissociate themselves from the austerity both of Clement Greenberg's definition of modernism and the drab visual environment of Britain in the early 1950s. Not only do the members of the Independent Group admit the illicit, "glossy" imagery of American popular culture into the "pure" realm of the arts, they also desert what the American cultural critic, Fredric Jameson, has called the "depth model" so central to critical modernism and marxism. I suggest that instead of deploring or dismantling the ideology of consumerism, Pop artists like Paolozzi and Hamilton and later Blake, Jones, Boshier, Philips and the rest, line up alongside the general public and are content merely to relay their fascination with icons, images, mass-produced objects back to the viewer. I conclude that part of Pop's initial impact and radical value derived from its celebration of the accessible, the immediate, the "superficial" rather than the difficult, the invisible, the "profound" which formed the criteria for assessing the radicalism of modernist gestures in the arts.

Section Three, *Living on the Line*, comprises two essays on the contemporary inheritors of the British Pop tradition: the Biff cartoon team and *The Face* magazine. In *Making do with the nonetheless*, which is based on a lecture I gave in March, 1986, at Exeter College of Art and Design, I look at "the whacky world of Biff" cartoons, try to isolate the ideal reader and to describe the postmodernist, image saturated "structure of feeling" they appear to embody. In *The Bottom Line on Planet One*, which was first published in *Ten.8* magazine in 1985, I square up to the influential style manual *The Face*, reflect upon its appropriateness for the 1980s and use an exhibition of photographs celebrating its first five years of publication as a pretext for teasing out some themes and issues raised in theoretical discussions of postmodernism. The article is an "about face" in another sense too, insofar as I took the opportunity in the original article to indicate a change of heart in relation to the putative importance of "style" in life, politics and art and to dissociate myself from the overall fetishisation of style which, together with incessant Royal Weddings, armed conflicts over remote Atlantic islands, support by default for the most disgraceful regime in the world (South Africa) and the despotic prohibition of long-established trade union practices seems set to characterise this place they call "great britain" in the 1980s. The analogy between intellectual "options" and a "war of the worlds", by the way, should not be taken too seriously. We rarely choose the positions we find ourselves occupying and intellectual work has very little to do with war in any directly lived sense - at least in the areas I write about. These articles are maps of an imaginary terrritory, not plots of real estate, and if I've learned little else from postmodernism, I have at least learned that military metaphors are only metaphors and that we should always reserve the right to change our minds. In the end no one can really choose to live all the time on what I call in this article, "Planets One" or "Two". Instead we are continually - all of us - being shuttled back and forth between them...

The final section, *Postmodernism and "the Other Side"* falls into two parts. *Staking out the Posts* offers an historical and interpretative overview of postmodernism and postmodernity. It was written for an issue of the *Journal of Communications Inquiry* (summer, 1986) in response to an interview with Stuart Hall published in the same issue, in which he opened up a debate between marxism, British cultural studies and post-structuralism/postmodernism. The second part consists of four "post-scripts" written specifically for this book, in which I seek to explore in what I hope is a constructive spirit, the territory staked out by the various Posts: postmodernism, poststructuralism, post-industrialism, post-marxism. Far from being extraneous afterthoughts, these post-scripts represent attempts to confront in as direct and forthright a fashion as I could manage, what I take to be the really central issues and

questions which lurk unexplicated and unacknowledged elsewhere in this book. It is in these post-scripts that I try to discard once and for all the "refusals" of an earlier moment and to move beyond the limitations of both subcultural analysis and what Adorno called "negative dialectics" in order to explore the genuinely life-enhancing and positive dimensions opened up in recent debates around this term "post-modernism". In these closing pages I try at last to come down to earth, to renounce the grand postures of the totalising intellectual – the mastermind, the idiotic subject of Blake's "General Knowledges" — and to speak instead in a smaller voice as a finite, gendered being bounded by particular horizons, perspectives, experiences, knowledge.

One of the central strands that runs throughout this book concerns the relations we are all forced to contract – some of us despite our best intentions – with the quintessentially *modern* category – the nation-state. My reluctance to acknowledge my own "englishness" is inscribed in the sources which I cite. Many of the theoretical and critical reference points which provide the primary orientations in this book are French. Some are American. A few are Italian and German. Very few are identifiably British. Like so many arts and social science graduates educated in the late 1960s and 1970s, I have tried to escape the English tradition, to find my own "elsewhere", to stage-manage my own symbolic defection. But in the end, the legacy of an English education (however poorly assimilated, however badly understood) shows through. The debates encountered in these pages, after all, have a far longer history, a more ancient provenance, than we sometimes care to admit. Many of the questions raised here about language, meaning and the "real" were raised long ago at the very root of the Northern European intellectual tradition in what now tends to be regarded as the "absurd" dispute between the medieval scholastics – the nominalists and the realists. The issue – signs or things – was not decided then and it is unlikely to be satisfactorily resolved in the future. In the meantime, the old mistakes are repeated (many of them, no doubt, are repeated in the pages which follow). But it was an Englishman, William Occam, who – with an aplomb later inflated into a national characteristic – steered a middle course between the two extremes – finding a third way between the absurd propositions that either the only things that are real are universal or that the real is absolutely up for grabs, that only signs exist. "Occam's razor" shaved the big questions down to a manageable size by establishing the principle that "entities must not be unneces-sarily multiplied". For Occam, the real was always individual, never universal and science could only proceed through the investigation of the real likenesses between individual things. The foundations of English empiricism were laid here at the crossroads in this Janus-like attention to detail and structure. It demanded, on the one hand, that

sense of awe engendered by the incandescence of the particular, the reverence for the irreducibility of the thing-in-itself and on the other, a faith in the power of correspondence, a faith in the endurance, the relative stability over time, of that which *is*. Instead of reasoning from universal premises taken on trust from authority, we are left after Occam, after Bacon, Hume, Locke and Berkeley, to generalise from what we know and see. There is always a ground to return to – the ground of observation, experience, reasoned intuition. In the end, I seem to have stumbled down a path that runs parallel to the one that Occam took (though mine doesn't run in a straight line, is full of holes, is crazy-paved – it owes more to William Blake and the English romantics than it does to the masters of the British empirical tradition). That path is the path of the always neither-nor. In the end, I come out neither "for" nominalism nor realism, neither "for" semiotics nor phenomenology, neither "for" postmodernism nor culturalism nor (even) cultural studies – at least for that truncated amalgam of textbook "tendencies" and "traditions" which some people are currently purveying as "cultural studies".

If I have a preference at all, then, it is that obdurate English preference for the particular, for the thing itself. That's why I have devoted so many pages to a thing as "unimportant", as undeniably there, as factual, as solid and as serviceable as an Italian motor scooter. Such an excess of attention to what many would regard as an insignificant object may invite the old saw about sledgehammers and walnuts. My only hope is that, in this case, the walnut proves so tough, so recalcitrant, that it shatters the sledgehammer.

Of course, none of this means that I escape the terms of the debates which shape and frame the arguments put forward in this book. I have to steer a course across the same muddy, bounded country as everybody else. That country is composed of the times and the terms in which we live: the (con)fusion of sign and sense, events and structures, chance, dreams, conflicting interests, desires, discourses, intentions. In the end I try to walk the flickering line between images and things but not, I'd like to think, just any old images, any old things – choosing rather those images which burn for me, those things that I think really matter.

One last crossing of the Channel may establish where I stand at the end of the journey documented in this book. Michel Foucault once described the debate between academic "structuralists" and "anti-structuralists" as a circus occupied by mummers, tumblers, clowns and fools.[1] While I tend to agree with him I have to acknowledge that however much I try to leave the ring, the smell of the sawdust and the sharper reek of bullshit always pulls me back. This book closes with the image of the fool, the laughing man. In the end I mummer with the rest of them.

12

A note on the photographs and reproductions

The images reproduced in this book should not be regarded as an afterthought or supplement designed passively to "illustrate" the arguments put forward in the text. Their very form and presence serve to pose from the margins one of the central questions – (signs or things?) – that binds the book together. For as Barthes and Bazin put it, the ontological status of the photograph is always equivocal.[2] Photographs are substantial shadows. Simultaneously material and immaterial, they are at once signs and objects, documents of actual events, images of absent things, and real things in themselves. They embody a paradox: they are substantive echoes – echoes of the first order. For all photographs are, on the one hand, quotations from an irrecoverable text (the world of yesterday, of the hour before last, of the second before this one) and on the other they are ghostly emanations from the real (what Barthes once called the *spectrum* of the photograph – light radiating from an object captured on light sensitive emulsion through a combination of chemical and mechanical means[3]).

The photographs included here are – irrespective of the quality of the reproductions – haunting images. (They are, at least, for me.) They haunt and dog the serious intentions which drive the arguments along. Like a dream-track, they run alongside the text as a series of suggestions and associations. They are triggered by the words not bound to them. Sometimes the links between images and arguments may seem tenuous but I hope that however they're connected, those connections are always dynamic, to use Mikhail Bakhtin's term, "dialogic" in nature. There is, then, something of a surrealist intention behind the combination of image and text which forms the mode through which this journey is narrated. The French film critic, André Bazin, was aware of photography's surrealistic potential. He eulogised the "objective" nature of the camera but his eulogies were always founded in the recognition that the photograph can be at the same time, in the same instance, judicious and irreverent: the photographic image serves a dual function, revealing that which is and acting in the same arrested moment as a mischievous and necessary foil to our presumptions. For Bazin the mystery and the joy of photography consisted in its ability simultaneously to disclose reality and to puncture our pretensions to *know* exactly *what* it is that's been disclosed:

> "The photograph as such and the object in itself share a common being, after the fashion of a fingerprint. Wherefore, photography actually contributes something to the order of natural creation instead of providing a substitute for it. The surrealists had an inkling of this when they looked to the photographic plate to provide them with their monstrosities

and for this reason: the surrealists do not consider their aesthetic purpose and the mechanical effect of the image on our imaginations as things apart. For them, the logical distinction between what is imaginary and what is real tends to disappear. Every image is to be seen as an object and every object as an image. Hence photography ranks high in the order of surrealist creativity because it produces an image that is a reality of nature, an hallucination that is also a fact."[4]

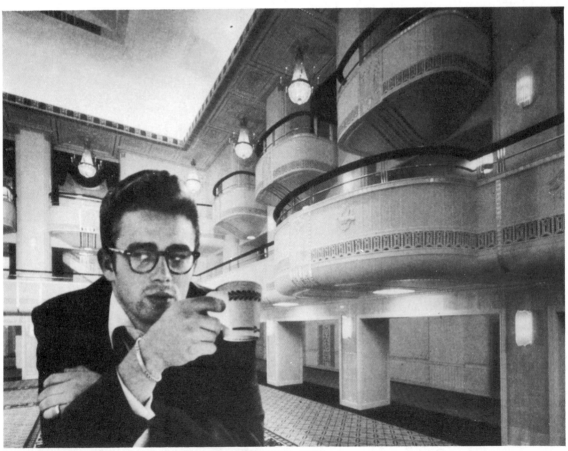

James Dean was not here: photomontage (Shoot That Tiger, 1987)

SECTION ONE:
YOUNG LIVES

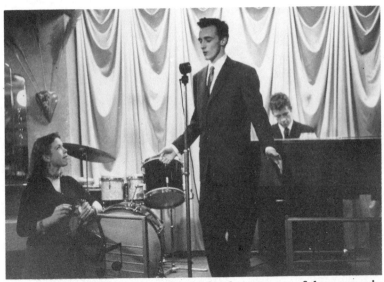

Showing off in public is a natural outlet for the arrogance of the young spiv. Immaculately dressed, he seeks admiration from girls (original caption)

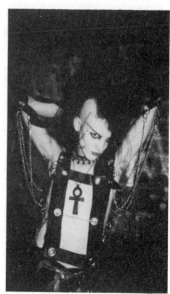

Chapter 1

Hiding in the Light: Youth Surveillance and Display

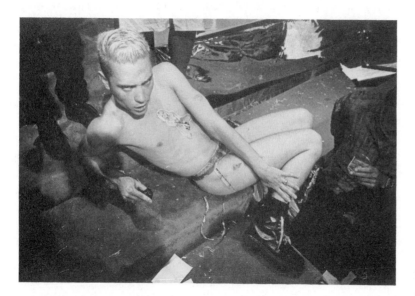

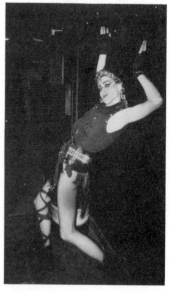

I shall begin with a proposition – one that is so commonplace that its significance is often overlooked – that in our society, youth is present only when its presence is a problem, or is regarded as a problem. More precisely, the category "youth" gets mobilised in official documentary discourse, in concerned or outraged editorials and features, or in the supposedly disinterested tracts emanating from the social sciences at those times when young people make their presence felt by going "out of

17

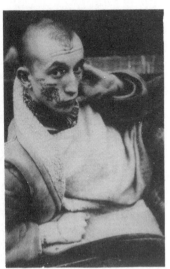

striking poses ...

bounds", by resisting through rituals, dressing strangely, striking bizarre attitudes, breaking rules, breaking bottles, windows, heads, issuing rhetorical challenges to the law.

When young people do these things, when they adopt these strategies, they get talked about, taken seriously, their grievances are acted upon. They get arrested, harassed, admonished, disciplined, incarcerated, applauded, vilified, emulated, listened to. They get defended by social workers and other concerned philanthropists. They get explained by sociologists, social psychologists, by pundits of every political complexion. In other words, there is a logic to transgression.

When disaffected adolescents from the inner city, more particularly when disaffected, inner city *unemployed* adolescents resort to symbolic and actual violence, they are playing with the only power at their disposal: the power to discomfit. The power, that is, to pose – to pose a threat. Far from abandoning good sense, they are acting in accordance with a logic which is manifest – that as a condition of their entry into the adult domain, the field of public debate, the place where real things really happen, they must first challenge the symbolic order which guarantees their subordination by nominating them "children", "youngsters", "young folk", "kids".

To take one of the more sensational examples: when youths in the inner cities rioted in July, 1981, they were visited by senior police officials, journalists, the prime minister and Michael Heseltine. They got noticed. Their portraits appeared in the *Daily Mail* and *Camerawork*, *The People* and *Ten.8*. They became visible. The machinery of social reaction was set in motion and this reaction had varied, even contradictory effects. For those youths who got arrested and arraigned before the courts, the riots meant fines or imprisonment, criminalisation, the confirmation, possibly, of a criminal career. More generally, the riots triggered off debates concerning the nature of policing in the 1980s, the problem of youth unemployment, the erosion of parental discipline, the implications for Britain's most depressed communities of government cuts in welfare, housing, education. Money was suddenly found for limited job creation and youth opportunity schemes. Community policing programmes were floated and assessed. Attention was drawn to the damage caused by Thatcherite intransigence. At the same time, the riots served to harden the law and order lobby's opposition to the principle of "no go areas", and were cited in parliamentary debates to justify the drift into coercion: the introduction of the "short sharp shock centres", water cannon, tear gas, battle dress, the transplantation of the full technology of crowd control from Northern Ireland to the mainland.

All these conflicting possibilities were licensed by what happened that July, by the riots, the reports and the syndicated photographs of

18

riots: bleak studies of shattered glass, burning buildings and violent confrontation. Those photographs recall a familiar iconography, the iconography of the American city-in-crisis, and were filtered through the negative mythology surrounding the American metropolis where the city functions as a symbol of the "modern malaise". For the last ten years, since the mugging panic of the early 1970s, the predatory instincts of this imaginary city, its pathology, have been concentrated in a single image: "The image of the mugger erupting out of the urban dark in a violent and wholly unexpected attack".[1]

In July, 1981, that iconography was extended. Behind the headlines, the parliamentary debates and independent enquiries, lurked the familiar spectre of the solitary black mugger only now he (and almost invariably it is a "he") had been collectivised. A new collective subject was proposed – the "mass mugger" – the unruly, resentful and delinquent black mob.

That's just one example. But the issues raised by the media representation of the riots – issues concerning the marginalisation and scapegoating of black youth, the sources and uses of stereotypical images of the "youth problem" – are so self-evidently serious that they sometimes threaten to obscure the significance of other forms of cultural resistance amongst youth. Pictures of punks and mods and skinheads, for instance, are commonly regarded, even amongst many documentary practitioners, as unproblematic, or as distractions from the real issues: visually interesting but ideologically suspect. The subcultures them-selves are dismissed on the grounds that they are sexist/racist/brutalised/narcissistic/commodified/incorporated: "commercial" not "political".

I want to question that puritanical distinction between youth in its "commercial" and "political" guises, in its "compromised" and "pure" forms, the distinction, that is, between the youth market and the youth problem, between youth-as-fun and youth-as-trouble – an opposition which I hope to show has been codified into two quite different styles of photography. I want to challenge that distinction between "pleasure" and "politics", between "advertisements" and "documentaries" and to pose instead another concept: the politics of pleasure. This will entail tracing back in a rather schematic way, the historical development of youth as a loaded category not only within photography but also within certain branches of journalism and the social sciences.

... **posing threats**

Youth and the silent crowd

The definition of the potentially delinquent juvenile crowd as a particular urban problem can be traced back in Britain at least to the beginnings of the Sunday School movement – an attempt on the part of

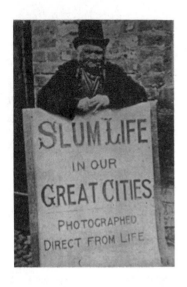

the church to extend its moderating influence downwards in terms both of social class and biological age.[2] Haphazard urbanisation, child factory labour and the physical and cultural separation of the classes into two separate "nations" were together held responsible for creating a new social problem: the unsupervised, heathen working-class juvenile who appears in contemporary novels, journalism and early parliamentary reports as a symptom of the industrial city, which is itself typically presented in this literature as a "monstrous" and "unnatural" place.

One image recurs: the silent crowd, anonymous, unknowable, a stream of atomised individuals intent on minding their own business. One of the major threats which the urban crowd seems to have posed for literate bourgeois observers lay in the perception that the masses were illegible as well as ungovernable.[3] Indeed, the two threats, the crowd's opacity and its potential for disorder, were inextricably connected.

Children and adolescents were regarded as a particular problem. During the mid-nineteenth century when intrepid social explorers began to venture into the "unknown continents", the "jungles" and the "Africas" – this was the phraseology used at the time – of Manchester and the slums of East London, special attention was drawn to the wretched mental and physical condition of the young "nomads" and "street urchins". The most celebrated "sighting" of a working-class youth subculture in this period occurs in Henry Mayhew's *London Labour and the London Poor* (1851), in a section devoted to the quasi-criminal costermongers.

The costers were street traders who made a precarious living selling perishable goods from barrows.[4] The young coster boys were distinguished by their elaborate style of dress – beaver-skin hats, long jackets with moleskin collars, vivid patterned waistcoats, flared trousers, boots decorated with hand-stitched heart and flower motifs, a red "kingsman" kerchief knotted at the throat. This style was known in the coster idiom as looking "flash" or "stunning flash".

The costers were also marked off from neighbouring groups by a developed argot – backwards slang and rhyming slang. In coster-speak, beer was "reeb", the word "police" was carved up and truncated into "escop", later "copper", finally "cop". The newly formed police force (introduced by Sir Robert Peel in 1840) was resented because its supervision of public space in the working-class ghettoes was already jeopardising the survival not only of the costers' culture but of their very livelihoods. Charged with the mission of imposing uniform standards of order throughout the metropolis, irrespective of local circumstances, the police were actively disrupting the casual street economy upon which the costers depended.

The mass of detailed observations of urban street life assembled and collated by social explorers like Mayhew eventually formed the

documentary basis for legislative action, for the formation of charitable bodies and the mobilisation of public opinion through newspaper articles on the plight of what were called the "wandering tribes" of London. In these ways, the social explorers helped to direct the growing moral impetus towards the education, reform and "civilisation" of the working-class masses – an impetus which was itself underwritten by a generalised concern with the problems involved in disciplining and monitoring the shifting urban population.

The Victorian classification of working-class youth into "respectable" and "criminal" classes, the "deserving" and "undeserving" poor, the "delinquent" and "perishing juveniles", eventually led to the construction of separate educational and punitive institutions. The Ragged Schools were open to all street urchins. The Industrial Schools were designed to inculcate the virtues of factory time-discipline and orderly behaviour and to give young people an opportunity of learning a useful trade. The Reformatories were reserved for the hardened young criminals who would previously have been committed to adult prisons. The progression is a clear one: from reportage to intervention. The traces left by a "gathering of the facts", motivated as far as the fact gatherers themselves were concerned by Christian compassion, are real enough.

Photography played its part in this process. The fact that photographic records of Ragged School pupils have survived is important. It indicates a new departure: the systematic monitoring by means of photographic plates and daguerreotypes of potential juvenile offenders. As John Tagg has ably demonstrated,[5] the scientific administration of the urban setting required for its functioning a mass of evidence, statistics, documentation – details about the most intimate aspects of individual lives. It required a supportive, efficient bureaucracy.

The camera supplanted earlier systems of classification employed by the police to identify known criminals and record the distinctive features of new ones. By drawing representation closer to reality, photography seemed to make the dream of complete surveillance realisable. Inscribed in photography and photographic practice from its very inception, there were these official documentary uses, this potential for surveillance, by no means neutral, representing, rather, a particular point of view, particular interests, embodying a desire and a will to know the alien-in-our-midst, the Other, the victim and the culprit.

The technology was adaptable. It translated to new contexts of control. It served the needs of a charitable institution like Doctor Barnardo's Home for Working and Destitute Lads as efficiently, as competently as it served the police. Meanwhile, as the middle-class market for photographic anthologies began to open up in the latter part

21

of the nineteenth century, the "urchin" and the "ragamuffin" were prominently featured as "quaint", low-life types in books like Thomson's *Street Life in London* (1876) and the anonymous collection, *Slum Life in Our Great Cities* (1890).[6]

Us and Them: Us as concerned and voyeuristic subjects, Them as objects of our pity, fear and fascination.

The power relations inscribed in documentary practice from the outset persist in photographs of contemporary victims, contemporary culprits:

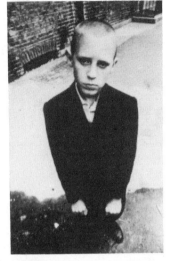

the skinhead as object of Our compassion

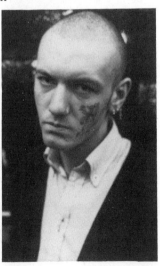

the skinhead as object of Our fear

22

These mugshots, as carefully cropped as the heads of the skins themselves

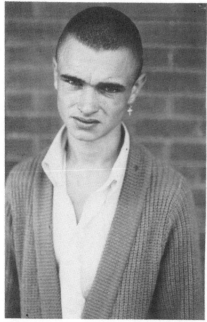

fix crime on a pin for Us: the skinhead as victim

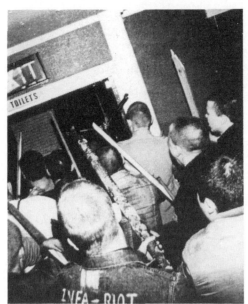

the skinhead as culprit

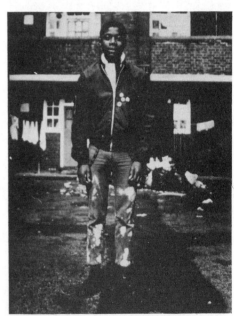

the skinhead returned to its natural habitat: the urban ghetto

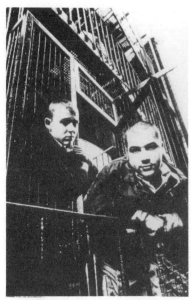

the bleak fluorescent underpass, the council estate

These are Our unkown continents, Our jungles, Our Africas. These are
the people We wouldn't dare to stare at in the street. These, it is implied
in the cryptic presentation, the brutally direct address to camera, are
the real signs of Our times.

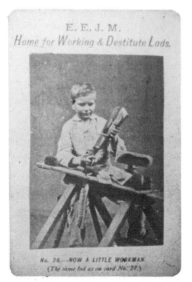
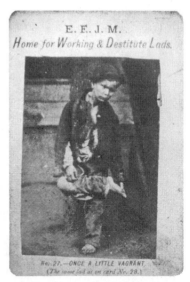

The Mythology of Redemption 1: A before and after ad from Dr Barnado – The scowling waif transformed through education into a little model worker.

The Mythology of Redemption 2: Same story, different institution

A view from the boys

If we turn from documentary photography to the construction of youth within sociology, a similar pattern, a similar set of relations, is disclosed. The category "youth" emerges in sociology in its present form most clearly around the late 1920s and the responsibility for that construction is generally attributed to the American tradition of ethnographic research, particularly to the work produced by the Chicago school of Social Ecology.

Robert Park and his colleagues at the University of Chicago were concerned with developing a broadly-based theory of the social ecology of city life. The high incidence of juvenile crime in inner-city areas and the significance of group bonding in distinctive juvenile gangs was explained by these writers through organic metaphors – the metaphors of social pathology, urban disequilibrium, the breakdown of the organic balance of city life. This tradition is largely responsible for establishing the equation, by now a familiar one in the sociology of youth, between adolescence as a social and psychological problem of particular intensity and the juvenile offender as the victim of material, cultural, psychological or moral deprivation. These two enduring images – the more general one of youth as a painful transitional period, the more particular one of violent youth, of the delinquent as the product of a deprived urban environment, are fixed within sociology largely through the work of the Chicago school and of those American researchers who, throughout the 1950s and 1960s, continued to publish "appreciative" studies of marginal groups based on the Chicago model.

It is this tradition which produces or secures the frames of reference which then get fixed on to the study of youth in general and which define what is going to be deemed significant and worth studying in the area – the link between deprivation and juvenile crime, an interest in the distinctive forms of juvenile youth culture, the gang, the deviant subculture. Youth becomes the boys, the wild boys, the male working-class adolescent out for blood and giggles: youth-as-trouble, youth-in-trouble.

Girls have till quite recently been relegated to a position of secondary interest, within both sociological accounts of subculture and photographic studies of urban youth. The masculinist bias is still there in the subcultures themselves. Subject to stricter parental controls than the boys, pinioned between the twin stigmas of being labelled "frigid" or a "slag", girls in subculture, especially working-class subculture, have traditionally been either silenced or made over in the image of the boys as replicas ...

.... as accessories.[7]

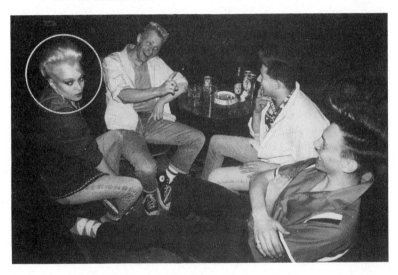

That "tradition" has been broken, at the very least reshaped, in punk and post-punk, where girls have begun playing with themselves in public:
parodying the conventional iconography of fallen womanhood – the vamp, the tart, the slut, the waif, the sadistic *maitresse*, the victim-in-bondage.

These girls interrupt the image-flow. They play back images of women as icons, women as the Furies of classical mythology. They make the s-m matrix strange. They skirt round the voyeurism issue, flirt with masculine curiosity but refuse to submit to the masterful gaze.

28

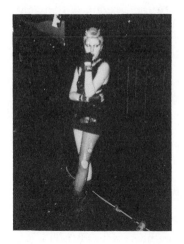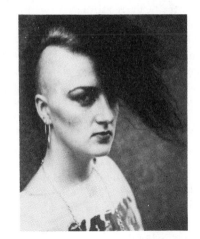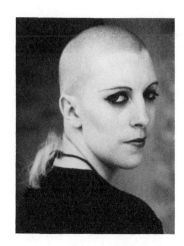

These girls turn being looked at

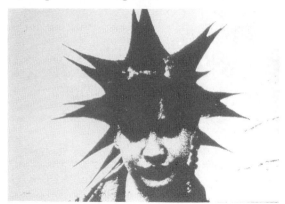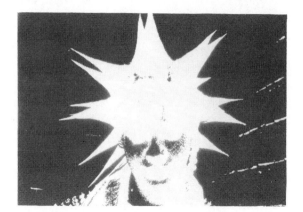

into an aggressive act.

The consuming image: youth as fun

By the 1950s, relative affluence brought the other face of British youth into focus: youth at its leisure: exotic, strange, youth-as-fun. The term "teenager", invented in America is imported into Britain and applied by popular weekly journals like the *Picture Post* to those cultures of the "submerged tenth" of working-class youth whose consumption rituals, musical tastes and commodity preferences are most clearly conditioned by American influences.

The word "teenager" establishes a permanent wedge between childhood and adulthood. The wedge means money. The invention of

29

the teenager is intimately bound up with the creation of the youth market. Eventually a new range of commodities and commercial leisure facilities are provided to absorb the surplus cash which for the first time working-class youth is calculated to have at its disposal to spend on itself and to provide a space within which youth can construct its own immaculate identities untouched by the soiled and compromised imaginaries of the parent culture. Eventually, the cult inspired boutiques, record shops, dance halls, discotheques, television programmes, magazines, the "Hit Parade".

The new images are superimposed on the old images: youth as trouble, youth as fun. During the 1950s, the distinction between "respectable" and "criminal" classes was transmuted into the distinction between "conformist" and "nonconformist" youth, the workers and the workshy, "decent lads" and "inverts", "patriots" and "narcissists". The new youth cultures based around consumption were regarded by the arbiters of taste and the defenders of the "British way of life", by taste-making institutions like the BBC and the British design establishment as pernicious, hybrid, unwholesome, "Americanised".

When the first rock 'n roll film, *Blackboard Jungle*, was shown at a cinema in South London in 1956, Britain witnessed its first rock riot. The predictions were fulfilled: teenaged sexuality dissolved into blood lust. Seats were slashed. Teddy boys and girls jived in the aisles. Those expelled from the cinema vented their rage on a tea-stall situated on the pavement outside. Cups and saucers were thrown about. It was a very English riot. It represented a new convergence: trouble-as-fun, fun-as-trouble.

The two image clusters, the bleak portraits of juvenile offenders and the exuberant cameos of teenage life reverberate, alternate and sometimes they get crossed. By the mid-1960s, youth culture has become largely a matter of commodity selection, of emphatically stated taste preferences. Image serves for the members of the groups themselves as a means of marking boundaries, of articulating identity and difference. The regulation of body posture, styles and looks becomes anxious and obsessive. There is even a distinctive mod way of standing. According to one "face":

> "Feet had to be right. If you put your hands in your pocket, you never pulled the jacket up so it was wrinkled. You'd have the top button done up and the jacket would be pulled back behind the arm so that you didn't ruin the line. You'd only ever put one hand in your pocket if you were wearing a jacket..."[8]

1964: a new departure. Troublesome youth, fun-loving youth are here reduced to youth-as-image. Denzil, the *Sunday Times* top mod, addresses us from the cover with the look of 1964. The Coca Cola sign in the

youth as trouble

30

background consecrates the image as fine art through its references to Warhol, New York Pop and the 'cool' style of photography.

The circle has now been fully described: fractions of youth now aspire to the flatness and the stillness of a photograph. They are completed only through the admiring glances of a stranger.

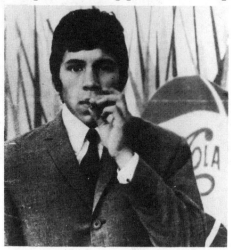

The swear word made flesh: 'youth culture' as sign-system centres on the body – on appearance, posture, dress. If teenagers possess little else, they at least own their own bodies. If power can be exercised nowhere else, it can at least be exercised here.

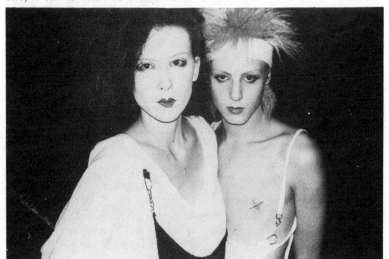

youth as fun

The body can be decorated, and enhanced like a cherished object.

31

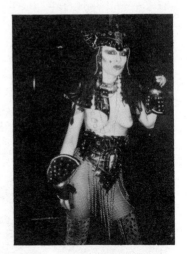

It can be cut up and cooked like a piece of meat. Self mutilation is just the darker side of narcissism. The body becomes the base-line, the place where the buck stops. To wear a mohican or to have your face tattooed, is to burn most of your bridges. In the current economic climate, when employers can afford to pick and choose, such gestures are a public disavowal of the will to queue for work,

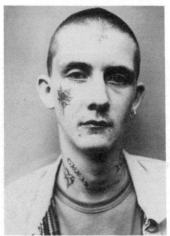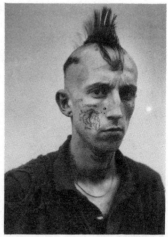

throwing your self away before They do it for you. One of the brighter signs I saw when interviewing skins in London's Petticoat Lane in 1981 was the scabs – traces of former tattoos for the National Front, or the British Movement removed as the skins 'pass through' the Nazi phase. A change of heart is a serious, surgical business when you wear it bleeding like a wet rose on the outside of your body . . .

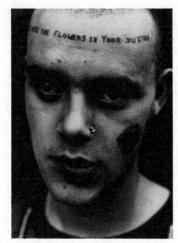

We are the flowers in your dustbin.

A riot of colour

A recent edition of the *Observer Colour Magazine* shows the persistence of familiar strands. Those strands have now been converted into two antagonistic systems. The magazine contains two articles on separate aspects of the youth question. The first deals with community policing in Handsworth. The subject matter is serious, political. It deals with black youth and the police. Real issues are foregrounded. Real problems rendered formidable by the temporal proximity of the riots in July. The photographs are in black and white. They are steeped in the ideology of the documentary photograph, the photograph as evidence, austere, cold, objective. These are real pictures of the real thing. Paradoxically, the black and white system signals that this is real. It is the system for photographers to proclaim their intention to have their work and the issues it raises taken seriously. Black and white has become the real system, the system of high contrast, the colours of confrontation.

The next article in the magazine deals with Adam of Adam and the Ants. This is white youth in the leisure mode, relaxed, at home in an attractive, designed environment. The photographs are in colour. The colour system signifies escape, fantasy, a revelling in things. Paradoxically, its relation to the real is less direct. It doesn't claim to strip things down, to reveal the truth. It is content to luxuriate on the surface of things. It advertises. (Adam's face in colour advertises the magazine.)

It reflects, it doesn't probe. The two systems are mutually exclusive, the two approaches they embody are incompatible. Youth at play, youth in the consumption mode is incompatible with youth out of work, youth in an ugly mood.

And yet. In the month of the riots, the *Sunday Times* ran an article providing a kind of consumer guide to the various rioting contingents. The categorisation was elaborate: rastas, punks, 2-Tone youths, mohawks. Each description was illustrated by an artist's impression of the relevant type – an identikit for the breakfasting voyeur.

And yet. A rumour circulated in the press and television that the looting was being directed and co-ordinated by white youths on scooters equipped with CB radios. And if these stories are regarded as conflation pure and simple, as part of the media conspiracy to trivialise and depoliticise the disturbances, it should also be remembered that political activists who attempted to intervene at Toxteth, to take control, to elevate the outbreaks to the status of "political confrontations", had, for their own safety, to be escorted from the scene by community workers and the police. They were not wanted. They were not needed.

And yet. A comprehensive, chronological record of the major incidents of the summer of 1981, appearing in the journal of the Commission for Racial Equality *New Community*,[9] listed alongside the New Cross march and the Brixton riots, the seaside rampages of mods, skinheads, punks and rockers. Sandwiched between the riots of 10 July in Southall, Dalston, Clapham and Handsworth and the police raid on the Front Line on the 15 July, we read of a "multiracial mob" of skinheads, Asians and West Indians in Leicester wrecking cars and throwing petrol bombs at the police; of a crowd of black and white youths storming through the centre of Huddersfield. As August drew to a close, so too did the riots. The Notting Hill Carnival passed almost entirely without incident despite earlier predictions of violence and sabotage. But over the same weekend disturbances occurred at Brighton where a crowd of 300 mods stoned the police and passing cars and threw petrol bombs.

And yet. The typical precipitators of clashes between blacks and the police have not been heavy handed policing of demonstrations and marches but invasions of symbolic space, raids on blues, shebeens, clubs and cafés, the perceived violation of communal space, of spaces for consumption.

A fragmented picture emerges, one which fails to correspond with the neat separations perpetuated within the official discourses of responsible commentary, concerned reportage and social scientific analysis. "Politics" and "pleasure", crime and resistance, transgression and carnival are meshed and confounded.

Neither affirmation nor refusal

"Whatever They say I am, that's what I'm not".
(Albert Finney as Arthur Seaton speaking to his reflection in the mirror as he dresses up for a Saturday night out in the film, Saturday Night and Sunday Morning*)*

"Maybe the target nowadays is not to discover what we are but to refuse what we are. We have to imagine and build up what we could be to get rid of this kind of political 'double bind' which is the simultaneous individualization and totalization of modern power structures.... We have to promote new forms of subjectivity through the refusal of this kind of individuality which has been imposed on us for several centuries."
(Michel Foucault, The Subject and Power*)*

The politics of youth culture is a politics of metaphor: it deals in the currency of signs and is, thus, always ambiguous. For the subcultural *milieu* has been constructed underneath the authorised discourses, in the face of the multiple disciplines of the family, the school and the workplace. Subculture forms up in the space between surveillance and the evasion of surveillance, it translates the fact of being under scrutiny into the pleasure of being watched. It is a hiding in the light.

The "subcultural response" is neither simply affirmation nor refusal, neither "commercial exploitation" nor "genuine revolt". It is neither simply resistance against some external order nor straightforward conformity with the parent culture. It is both a declaration of independence, of otherness, of alien intent, a refusal of anonymity, of subordinate status. It is an *in*subordination. And at the same time it is also a confirmation of the fact of powerlessness, a celebration of impotence. Subcultures are both a play for attention and a refusal, once attention has been granted, to be read according to the Book.

Since the 1950s, the "politics of youth" in this country has been played out, first and foremost as spectacle: as the "politics" of photogenic confrontations, of consumption and "life style". That politics has now entered a new phase. In the current recession, the imaginary coherence of subculture seems about to dissolve under the pressure of material constraints.

During the July '81 riots, in the decimated inner cities, black and white youths turned to crime and open conflict with the police. After Toxteth and Brixton, the politics of consumption, at least for unemployed youth, seems to be converging on a single point of tension, a simple opposition: desire and the absence of means, a brick and a shop window. The targets for the rioters and looters were in their way

35

predictable enough – not the town halls, the labour exchanges, the schools and factories. Not, at least not often, the police stations but rather the video and hi fi shops, the boutiques and the record stores. The right to work subsumed in the right to consume. For a week or two in 1981 in city centres throughout England, the shopping precinct, that sign of misplaced 1960s optimism, took on the grim aspect of the medieval City State, an embattled community of goods under siege. The rows of boarded up shop fronts, reminiscent of the blitz and science fiction television series, marked a line of defence in a new price war: the end of window dressing as an art form.

Chapter 2

Mistaken Identities: Why John Paul Ritchie Didn't Do It His Way

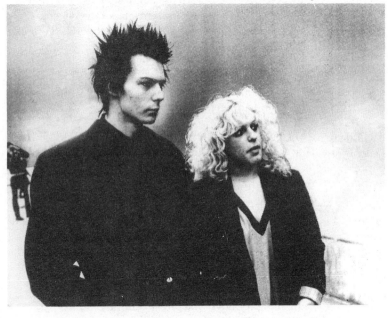

And now the end is nigh,
I come to face the final curtain...

I did what I had to do
And may I say not in a shy way,
And more, much more than this,
I did it my way.

Something's wrong

Sid Vicious calling room service on discovering Nancy Spungen's body. Reported in the Evening News *(13 October, 1978). Subsequently denied.*

On 12 October, 1978, Nancy Spungen bled to death propped up against a bathroom wall in a hotel called the Chelsea in Manhattan. "The blonde-haired beauty"[1] ... "clad in a black-laced bra and panties" ... was found ... "crumpled under the ... sink" ... "lying in a pool of blood" ... "with a knife sticking out of her stomach" ... "A trail of blood led to the bath of Room 100 from the untidy bedroom" ... where her lover ... "PUNK ROCK STAR" ... Sid Vicious, who had ... "gained much attention by grinding broken glass into his chest" ... "had slept on oblivious to ... her plight" ... "under the influence of a depressant drug called Tuinal."

"It took four policemen to hold the struggling Vicious as he was taken off to a police station" ... where the ... "21 year old Londoner was charged in his real name of John Paul Ritchie with first degree murder. Police said he had been provided with a lawyer."

"It was to be only a matter of months before" ... "THE BOY FROM A BROKEN HOME IN LONDON'S EAST END" ... "a violent, swearing drug addict only his mother could love" ... "was himself lying dead ... "in a seedy hotel room" ... from an overdose of heroin ... "supplied by his mother Mrs Anne Beverley".

How else were these events to be recounted but in the language of the tabloids – in cliché and hyperbole? After all, it had happened like that. There was no need for editorial comment. The facts told their own story, spoke for themselves as clearly as any parable of Christ's, holding out the moral – bloody like the head of John the Baptist on a plate. This was the ballad of Sid and Nancy: a cautionary tale for intemperate youth:

> For naughty boys who swear and break
> All boundaries and try to make
> Pain out of pleasure, pleasure from pain
> Look on Sidney; think again.

It would be difficult to imagine a more fitting end for a boy who seemed intent on singlehandedly living out the Decline of the West, a boy who, like Durand in de Sade's *Juliette* was so set "against nature" that he seemed, at times, to embody "the ecological crisis in person".[2] And Nancy's doomed career had passed through a set of parallel archetypes which were no less potent or exemplary. From "poor little rich girl" to

"punk queen" to "half-clad corpse", the fate of Nancy Spungen held a lesson for all recalcitrant daughters. The lesson was, don't.

However, the emblematic quality of the affair can itself be opened up and made strange . . .

The chain of events which led from death to death could scarcely be distinguished from the sensational mode in which it was dragged before the British public. It submitted to the logic of disclosure unfolding episode by episode in four distinct parts: Spungen murdered; Vicious arrested; Vicious charged with assault while out on bail; Vicious dead. The "fates" of two chaotic individuals unravelling in time could thus appear to take on order and significance. This was punk's grisly strip show in which each incident served to peel away another layer of illusion to reveal – at last – the "TRUTH BEHIND PUNK ROCK", what all non-punks had feared, that underneath the outrage there lurked *real* violence, *real* perversion, a *real* threat of death. Because the fact of two young deaths was undeniable. When confronted with the stark option of getting hurt or getting bored; feeling pain or feeling nothing whatsoever, Sid and Nancy had always chosen pain because they knew for once (perhaps and only then) – they were *alive* when they were bleeding.

Yet

at the same time, the saga of Sid and Nancy came to us through a long detour composed of literary and journalistic archetypes. This was scandal with a capital "S" in the classic mould of *True Detective* magazine or Kenneth Anger's *Hollywood Babylon*. It was filtered through the terminal projections of William Burroughs and Hubert Selby Jr, through 1950s "B" movies, through the narcissistic angst of a host of rock-stars-on-junk from Frankie Lymon to Johnny Thunders, through documentary images of New York as the epitome of the City in Crisis, even, finally, through the retrospective destiny of punk itself as a movement which began with "No Future". Paradoxically, this "real life tragedy" had no reference point outside myth and fiction. The events themselves occurred in quotes. Moving inexorably on to their dramatic conclusions, they obeyed the laws of narrative and inevitably, given the status of the protagonists, they remained, first and foremost, events within representation. Almost immediately, as soon as the news broke, T-shirts bearing the caption SID LIVES or with screenprinted headlines proclaiming his death were being churned out. (I saw one of these T-shirts in the window of a Wolverhampton joke shop sandwiched between the horror masks and the black-face soap . . .)

through it all, Vicious and Spungen had been complicit in the process of symbolisation – a negative process which was eventually to turn them into icons, which had already transformed New York, at least for us in Britain, from a real city into "that dangerous, sad city of the imagination... which is the modern world".[3] Why else did they go there?

Compelled irresistibly by the dictates of an image they'd in part constructed but in larger part had had constructed for them, they were in a sense victims of their own drive to coherence, in bondage to a fantasy of absolutes in a world where they simply don't exist.

The rest is "his story": the saga ran its course. The principal boy, a cipher in someone else's psychodrama (Act One opened in a shop called SEX) is overtaken by a destiny as ineluctable, as overblown, as desperate as that impelling Bizet's *Carmen*, Goethe's *Werther*, Corman's *"Mad Dog" Coll*. Bound into a dark and ominous configuration of places, people, happenings, he gets dragged down to his death like Ahab strapped to the flank of the Great White Whale by the ropes of his own harpoons (Sid's white whale was smack and the white canvas screen on which he got himself projected). When Vicious, the poor man's libertine, goes under in the Hell Game he stays under:

> "The structure of his own invented reality hardens around him
> and imprisons him. The passions he thought would free him
> from the cage of being become the very bars of the cage that
> traps him; he himself cannot escape the theatrical decor he has
> created around himself... During the Hell Game the libertine
> is himself as much in hell as his victims..."[4]

In cities all along the disintegrating line of the western front, Sid Vicious walks again in the lurching gait of the Vicious clones (they learn Sid's sailor's roll from old Sex Pistols videos). The black nest of hair, the pallor, the chains, the hol(e)y drainpipe jeans, the motheaten leather jacket slung across the ectomorphic frame (SID LIVES picked out in studs or white paint on the back): these are the runes of the replicants, designed to bring him back. "Sid Vicious" had always been a phantom – an idea in search of a body – and now the heavy boots, and the thicksoled creepers of the Vicious clones are the only ballast left to stop the ghost from being blown away for good.

Nancy Spungen's obituary in the *Evening News* ran to just six lines:

> "Nancy's father is head of a paper firm in Philadelphia. She
> had bleached blonde hair in a frizzy style, used heavy eye
> make-up and often dressed in punk style black leathers."[5]

There is a sense in which Nancy "herself" never really existed. She is at last reduced officially to the status of pure sign within a patriarchal network of significance which defines her, on the one hand, as the daughter of a rich and powerful man and, on the other, as the ruined object of our gaze. She is the cat which curiosity killed. Fixed on the point of her boyfriend's knife, she is now a literally lifeless thing: a set of cosmetic appearances (some hair, "heavy eye make-up", "black leathers").

When the police arrived and Sid Vicious stepped out looking dazed into a world of flashing lights and questions, he was charged "in his real name".

I don't think John Paul Ritchie did it his way.

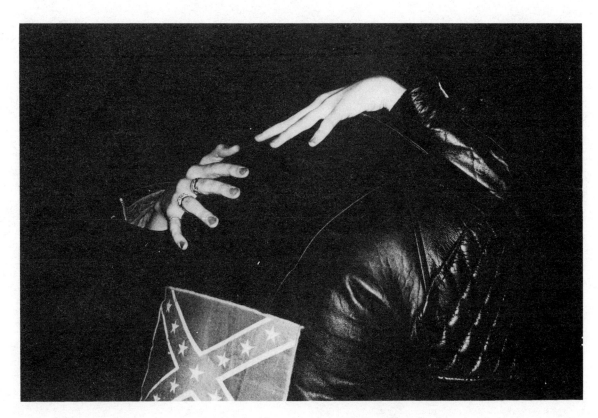

SECTION TWO:

TASTE, NATION AND POPULAR CULTURE

Chapter 3

Towards a Cartography of Taste 1935—1962

"To an ever greater degree the work of art reproduced becomes the work of art designed for reproducibility. From a photographic negative, for example, one can make any number of prints; to ask for the 'authentic' print makes no sense. But the instant the criterion of authenticity ceases to be applicable to artistic production, the total function of art is reversed. Instead of being based on ritual, it begins to be based on another practice – politics."

Walter Benjamin, The Work of Art in the Age of
Mechanical Reproduction

In Evelyn Waugh's trilogy, *The Sword of Honour* (1955) there is a minor character called Trimmer. Trimmer. The name is a synecdoche: the short, clipped vowels sum up the man exactly. He is meticulously neat: he has a clipped moustache, wears tightly waisted suits and two-tone shoes. He has worked as a hairdresser (trimmer) on a Transatlantic liner but through a certain native cunning by skilfully using his knowledge of the forms (he reads fashion magazines and studies accents), he has managed to insinuate himself into the officer class. Once there he takes his place alongside the protagonist, Guy Crouchback, the sole surviving male in an old English Catholic family of impeccable lineage (there are connections with Italy, with the most antique of antique traditions). Crouchback, with his fine sense of honour and decorum, represents a doomed elite. And when the awful Trimmer sleeps with Crouchback's estranged wife Virginia, whom he meets one night in a cocktail bar in Glasgow, the inference is clear: here is a hopeless future, a post-War future in which we are destined to witness the inevitable supercession of the old order by the new – the replacement of the divinely authorised caste-system by the "democratic sham", of a noble but effete aristocracy by modern man who is quite clearly a vapid impostor.

Trimmer bears not the remotest relation to a "true" officer and gentleman. His aspirations are offensively transparent, he is a little too chameleon-like: when on leave in Scotland he dons a kilt, calls himself Major McTavish and pins a "pair of major's crowns on his shoulders (he... changed them for his lieutenant's stars in the train lavatory)."[1] Trimmer is far too slick and amenable to be properly convincing. His hair is too perfect; his accent a little off-key; his manner a little too contrived. His tie is too carefully chosen. His suits fit just too well.

For Waugh what is at stake here in the drama of Trimmer's impertinence is the sanctity of the established social order – its inalienable right to perpetuity. At a time when the structure of inequality underlying that order had been laid bare by the Depression years, when the sheer *visibility* of the gulf between rich and poor was beginning to seem unacceptable or at the very least embarrassing to all but the most intransigent reactionaries, Waugh sets himself in retrospect in the teeth of history; defends the indefensible by resurrecting the most archaic, inegalitarian criteria – the rule book of the snob. For Waugh, the Trimmers may inherit the post-War world but because they lack the "backbone", the "calibre" of the people they replace. They will squander the inheritance...

In this paper I want to consider some of the changes in British social and cultural life during the period 1935–62, to refer these changes back to the emergences of new patterns of consumption and new technological developments, particularly to the qualitative transformations which automation was seen to have effected and to examine some of the

conflicting interpretations of these changes offered in contemporary accounts.

What we call "popular culture" – e.g. a set of generally available artefacts: films, records, clothes, TV programmes, modes of transport, etc. – did not emerge in its recognisably contemporary form until the post-War period when new consumer products were designed and manufactured for new consumer markets. Paradoxically, in many of the debates about the impact and significance of popular culture, these profound social and economic transformations have been mediated through aesthetic concepts like "quality" and "taste". These words are passionately contested. Different ideologies, different discourses – we could cite at random here the "sociological", the "art historical", the "literary critical", as well as the discourses of marketing and industrial design cut across these words at different angles producing different meanings at different moments. Underneath the discussion of an issue like "discrimination", complex moral, social, even economic, options and strategies are more or less openly examined and the issue of taste – of where to draw the line between good and bad, high and low, the ugly and the beautiful, the ephemeral and the substantial – emerges at certain points as a quite explicitly political one.

From the 1930s to the 1960s, the debates about popular culture and popular taste tended to revolve, often obsessively, around two key terms: "Americanisation" and the "levelling down process". We shall see how a number of cultural critics and commentators working out of quite different traditions equated the expanded productive potential opened up by the automation of manufacturing processes with the erosion of fundamental "British" or "European" values and attitudes and further associated this "levelling down" of moral and aesthetic standards with the arrival in Britain of consumer goods which were either imported from America or designed and manufactured "on American lines". I shall open by mapping out the connections between certain varieties of cultural conservatism focusing on the "spectre of Americanisation" and indicating some of the ways in which the ideologically weighted separation of the "serious" from the "popular" was undertaken. I shall then analyse the formation of those connotational codes which framed the reception given by certain key elites to imported streamlined products and popular American music. Finally, I shall attempt to assess how far the fears concerning the impending "Americanisation" and "homogenisation" of British society were borne out by empirical work in the sociological and market research fields. This paper deals, then, with some of the controversies surrounding the emergence from 1935–62 of the new cultural forms and patterns of consumption.

The full complexity of the relations between such a heavily loaded series of debates and the larger set of historical transformations to which,

however indirectly, they refer can hardly be adequately treated in a paper of this length. But by pursuing a limited number of themes and images across a fairly wide range of discourses it may be possible to reconstruct at least some of that complexity. Such an approach must by definition be eclectic and based on intuitive and what, at times, will seem arbitrary criteria. It may also require the reiteration of histories which are already familiar to the reader. Another review of the streamlining debate, for instance, may seem redundant to a design historian and yet I hope that by placing that debate against parallel developments in other disciplines it may be possible to modify the received wisdoms through which a phenomenon like streamlining is conventionally understood. It is perhaps only in this way by outlining the connections and breaks between groups of separate but interlocking statements that we can begin to imagine the particular dimensions of a language which is now largely lost to us and to appreciate not only the historical conditions under which that language was originally constructed, but also the social conflicts and shifts in power which were registered inside it and which ultimately led to its dispersal and decline. Moreover, it is only through such a process that we can begin, albeit tentatively, to specify the conditions under which a project as elusive and forbidding as a "cartography of taste" might be developed.

Waugh and the war of position

As the example from *Officers and Gentlemen* indicates, the work of Evelyn Waugh is relevant to this project in so far as it both symptomatises and parodies the complicity between definitions of "good taste", class origin and social and political position. For this novelist, the aesthetic boundaries were coterminous with the cultural and moral boundaries and these ran along the same lines which separated the social categories of class. The preservation of the natural order depended for Waugh upon the continual patrolling of these boundaries by a vigilant, incorruptible soldier like himself. In this context, Waugh's depiction of Trimmer as literal detritus – dirt for Mary Douglas is "matter out of place"[2] – is peculiarly telling. Although Waugh was distanced from the British upper classes both by his background and his misanthropic disposition, perhaps because both these factors qualified him more clearly for the role of court jester than palace spokesman, his savage revelations can serve as an illuminating counterpoint to the more guarded statements of his peers.

Like all militant reactionaries, Waugh delineates a previously submerged set of values, preferences and assumptions by attempting to exculpate them at the moment when those values and the interests they

embody are in crisis, on the point of disintegration. In fact, the growing belligerence of Waugh's prose from 1945, the year in which *Brideshead Revisited* was published, onwards dramatically signals the extent to which the cultural consensus had shifted against him during these years, transforming the language of power and control, moving away not only from the kind of caricatured elitism that Waugh himself represented but also – and more gradually – from the "gentler" patrician and paternalist ideologies which had found favour during the inter-War period. David Cardiff has demonstrated how these shifts had already registered at the BBC by the late 1930s in the evolution of characteristic styles of presentation in radio talks, in the demarcation of the boundary between the "serious" and the "popular" and in the debates about who should speak for the "common man", in what voice, how often and in support of whose interests.[3] The spectacular trajectory of Waugh's later career in which he posed as the obstinate and unrepentant defender of privilege throws into stark relief the ground on which discussions concerning "high" and "low" culture, "popular" and "classical" values were initially conducted in the years immediately after 1945. The iconoclasm which motivated Waugh's choice of persona here can only be fully appreciated when it is placed against the emergent orthodoxies of progress, moderation and reform.

Of course, in 1945 the Attlee Government had been lifted to power on a wave of left-wing populism and had succeeded in inaugurating the welfare and nationalisation programmes which made possible the transition to the corporate post-War state. With the institutionalisation in the pledge to full employment and the provision of secondary schooling of the rights to work and to free education, the quasi-feudal structures on which Waugh's vision of British society rested were if not entirely swept away then at least seriously disfigured. A social anachronism, Waugh's only possible role was the one to which, finally, he was most temperamentally suited – that of *Anastasias contra mundum* – a kind of cultural Canute, and this eventually led him to codify the rituals of exclusion through which the power of an already superseded *ancien régime* had been perpetuated.

During the mid-1950s he helped to specify some of the key signifiers of "breeding" in an exchange with Nancy Mitford over "U" and "Non U" (he corrected her on points of detail[4]). The cartography of taste here took on an aggressively reactionary flavour. The codification of the system of U and non-U was designed to clarify and redefine boundaries rendered opaque by post-War "affluence". It was meant to deter would-be climbers by exposing their charades through the identification of speech mannerisms so habitual and diverse that under normal circumstances they could not be adequately monitored, still less adjusted. The sheer density of signifiers, themselves inextricably bound

into modes of perception, expectation and belief, to the irrefragable facts of "social background" militated against the aspirations of even the most versatile pretender. Though ostensibly ambivalent, U and non-U (particularly Waugh's pungent contribution) testified to the persistence of class differences. The survival of the particular configuration of power and value which Waugh chose to defend could by no means be permanently assured and elsewhere he succumbed to a different set of certainties. In his last book, *The Ordeal of Gilbert Pinfold* (1957), written some nine years before his death, we find locked away in the usual labyrinth of irony, his keenest fear: that together affluence and universal education will fulfil the promise or rather the threat of democracy by removing the fact of difference which alone confers value:

> "... His strongest tastes were negative. He abhorred plastics, Picasso, sun-bathing and jazz – everything in fact that happened in his own life-time. The tiny kindling of charity which came to him through his religion sufficed only to temper his disgust and change it to boredom... He wished no one ill, but he looked at the world *sub specie aeternitatis* and he found it flat as a map; except when, rather often, personal arrogance intruded. Then he would come tumbling from his exalted point of observation. Shocked by a bad bottle of wine, an impertinent stranger or a fault in syntax..."[5]

Waugh's list is revealing: *plastic* (i.e., festival of Britain/"inauthentic" mass culture); *Picasso* (Continental modern art/subversive high culture); *sun-bathing* (increased leisure/national inertia/a "soft" obsession with cosmetics/"immoralism, naturism... non-conformism"),[6] and *jazz* (American negro/subversive "low" culture). Together, Waugh suggests, these items and the shifts in taste and value which they embody form part of that process whereby the contours of achievement produced by a tradition based on privilege, have been progressively planed down until the world for Waugh seems as "flat as a map".

This provides a starting point. For Waugh merely stood in the vanguard of a widespread backlash against the confident post-War rhetoric of reconstruction and equal opportunity – a backlash which spread across the entire field of cultural criticism during the 1950s.

Hoggart and Orwell: a negative consensus

The critical space in which this reaction took place had already been opened up by the literary tradition of dissent and polemic which Raymond Williams describes in *Culture and Society* (1958). Though different political perspectives coexist within that tradition, the

"levelling down process" associated with "mass culture" provided a radical populist like Orwell, a self-confessed elitist such as T. S. Eliot and a social democrat like Hoggart with common cause for concern.

Cultural if not political conservatism drew together writers who were prepared to take opposing sides on issues which at the time were more openly contentious (e.g., the role of education in the state). Though there was never any agreement as to what exactly should be preserved from the pre-War world, there was never any doubt amongst these writers that clearly *something* should. Whereas Eliot and Leavis were pledged to defend the immutable values of minority culture against the vulgar inroads of the popular arts, to defend in Arnold's terms "culture" against "anarchy", Orwell and Hoggart were interested in preserving the "texture" of working-class life against the bland allure of post-War affluence – television, high wages and consumerism. The blanket hostility with which the former set of writers greeted the advent of mass culture requires little explanation or critique. It has become part of the "commonsense" of cultural studies.

However, the more complex and ambivalent resistance to cultural innovation offered by Hoggart and Orwell is frequently bracketed off in the face of the more lasting and positive contributions both writers have made. (Orwell, in this particular context, tends to be remembered for *Road to Wigan Pier* [1937], Hoggart for his portrayal of the pre-War working-class community in the early chapters of *The Uses of Literacy* [1958]). In fact both writers castigate the emerging "consumer culture" on roughly the same grounds. They both equate the classless tone of the glossy advertisements with the erosion paradoxically of personality and choice.

Both Orwell and Hoggart use the image of the holiday camp as a paradigm for working-class life after the War. Orwell imagines a modern design for Coleridge's *Kubla Khan* consisting of air-conditioned caverns turned into a series of tea-grottoes in the Moorish, Caucasian and Hawaiian styles. The sacred river would be dammed up to make an artificially warmed bathing pool, and playing in the background there would be the constant pulse of muzak "to prevent the onset of that dreaded thing – thought".[7]

In the same way, to achieve the same effects, Hoggart sets one of his parodies of the cheap romantic fiction of the 1950s in a place called the Kosy Holiday Kamp complete with "three dance halls, two sun-bathing parades and lots of milk bars"[8] in which the imaginary female narrator "drools" over a "hunk of luscious manhood" who combines the dubious appeal of "Marlon Brando and Humph. Bogart".[9] Strangely enough, then, despite the ideological gulf(s) which separate these two writers from a man like Evelyn Waugh, there are common themes and images linking what they all wrote on developments in the

THE 100-MILLION-DOLLAR LOOK!

So big, so new, so smart... so easy to buy!

CHRYSLER AMERICA'S MOST SMARTLY DIFFERENT CAR

field of popular culture in the post-War years. Where Waugh saw a decline and fall, a flattening out of social and aesthetic criteria, Hoggart and Orwell see the substitution of an "authentic", "vigorous" working-class community by the idea of a community; the replacement of "real" values by what Hoggart at his most evocative calls a "shiny barbarism" . . . "the ceaseless exploitation of a hollow brightness" . . . "a spiritual dry-rot" . . . a "Candy Floss World".[10]

Though they spoke from quite different positions, these three writers share a language which is historically determined and determining. They are loosely linked in this particular context through a largely unspoken because largely unconscious (Waugh for reasons I have indicated is the exception here) *consensus* of taste even if that consensus is organised around a list of negatives – i.e., round those things that they do *not* like.

The spectre of Americanisation

Increasingly, as the 1950s wore on, this negative consensus uniting cultural critics of all persuasions began to settle around a single term; Americanisation. References to the pernicious influence of American popular culture began to appear whenever the "levelling down" process was discussed and the concept of "Americanisation" was swiftly and effortlessly absorbed into the existing vocabulary of the "Culture and Society" debate. Many of the Fritz Lang-like fantasies of an inhuman, fully automated society which lurk behind so much of this writing drew their urgency and power from the ubiquitous spectre of "Americanisation". Although during the Cold War the *prospect* of Soviet territorial ambitions could provoke similar indignation and dread, American *cultural* imperialism demanded a more immediate interpretative response. Whenever anything remotely "American" was sighted, it tended to be read at least by those working in the context of education or professional cultural criticism as the beginning of the end whether the imagined apocalypse took the form of Huxley's *Brave New World*, Fyvel's "subtopia", Spengler's "megalopolis" or, at a more mundane level, Richard Hoggart's Kosy Holiday Kamp where we will all float together, "A great composite . . . of the unexceptional ordinary folk: minnows in a heated pool."[11] America was seen by many of these writers as the prime mover in this terrifying process, as *the* homogenising agent and from the 1930s onwards the United States (and its productive processes and scale of consumption) began to serve as the image of industrial barbarism; a country with no past and therefore no real culture, a country ruled by competition, profit and the drive to acquire. It was soon used as a paradigm for the future threatening every

advanced industrial democracy in the western world.

Unfavourable depictions of the "American way of life" and the American way of business such as these were of course hardly novel (see for example Matthew Arnold on American anti-intellectualism and "philistinism" or T. S. Eliot's poem *Burbank with a Baedeker; Bleistein with a Cigar*) but during the War and immediately afterwards these depictions broke more decisively into the arena of public, explicitly *populist* discourse and were circulated in a wider number of printed and broadcast contexts. This wider "official" resistance to American influence can only be understood in the light of particular historical developments – the American military presence in Britain from the early 1940s onwards and Britain's increasing dependence on American economic and military aid. The first *direct* experience of American popular culture for most "ordinary" Britons occurred during the War through informal contact with American servicemen stationed on British bases. It is difficult to estimate the impact of this dramatic encounter though reactions seem to have been ambivalent: curiosity, envy and resentment are blended in those popular representations of American soldiers which stressed their "affluence" and their relaxed and "casual manner" (and by inference their "easy morals").

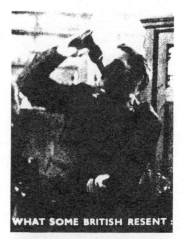

WHAT SOME BRITISH RESENT :

Despite the fact that a good deal of frequently illegal commerce did take place between American troops and the civilian population – perhaps indeed because of it – the American GI began (surreptitiously at first) to be presented in the press as a "folk devil", as the enemy at home – a subversive and unsettling influence. It was not only German propaganda dropped behind British lines which played upon the fears and resentments of British soldiers separated from their girlfriends and wives. British journals and newspapers often resorted to similar tactics.

The American serviceman with his dollars and chewing gum, listening to jazz on the A.F.N., buying favours with candy, stockings, cigarettes and beer became a familiar stereotype – one which was easily assimilated into existing mythologies – superimposed on the stock image of the American tourist in Europe. One US chaplain writing home described the typical GI:

> "There he stands in his bulging clothes... lonely, a bit wistful,
> seeing little, understanding less – the Conqueror with a
> chocolate bar in one pocket and a package of cigarettes in the
> other... The chocolate bar and the cigarettes are about all that
> he, the Conqueror has to give the conquered..."[12]

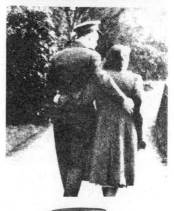

After the War, this covert hostility persisted and was exacerbated by new factors: by Britain's declining status as a world power, the disintegration of the British Empire coupled with the simultaneous rise in America's international prestige and the first indications of American

imperial ambitions. In addition, the War Debt and the continuing reliance on the American military presence in Europe provided a dual focus for popular resentment.

In magazine articles and newspaper reports, Britain's austerity was frequently contrasted against the booming American economy and the strong dollar. In July, 1948, to celebrate the launching of the Queen Elizabeth the *Picture Post* carried a report of a transatlantic crossing entitled prophetically "The American Invasion" which displayed a thinly veiled contempt for the new "disposable" culture:

> "Deck-sweepers are filling buckets with five inch cigar butts and quarter-smoked cigarettes, unconsidered debris from the land of not-yet-too-much-plenty."[13]

This was followed by an image which was guaranteed to grate with a *Picture Post* readership still subject in 1948 to the rigours of strict rationing:

> "In the forward bar two loose-shouldered young men apparently limited to six words an hour, four of which are 'Steward' are spending a morning-long dice-session just for the hell of it."[14]

These themes were elaborated in further articles which appeared throughout the late 1940s and early 1950s (see, for instance, *The Truth about GI Town* (21 May, 1949), in which "GI boredom" is explained through the absence in the North of England of "juke boxes, television, soda fountains and drive-in cinemas"; see also *London's American Colony* (30 June, 1951) which includes photographs of "ostentatious" Americans playing dice in an illegal London gambling club).

American music and the British media

The articulation of these historically localised dissatisfactions in a journal as determinedly "popular" as the *Picture Post* must have helped to condition the reception given to American cultural imports during the period by the official arbiters of good taste – by the BBC and the literary and artistic establishments. But a chilly reception was already guaranteed by the varieties of cultural conservatism prevalent in official quarters. According to archive research now in progress, BBC policy statements throughout the late 1940s and early 1950s lay down detailed guidelines as to how much American material should be presented and in what context. The content and quality of American comedy shows was apparently subjected to particularly intense scrutiny and ideally the image of America received by the British public was to be filtered

through the paternalistic framings of professional commentators like Alastair Cooke. At a time when a tremendous upsurge of popular radicalism, a popular demand for change coincided with severe material shortages, BBC personnel – programmers and policy makers alike – appear to have been perfectly aware of the "damaging" indeed potentially subversive impact which American cultural artefacts (particularly popular music: swing, crooning and jazz) could have on public "morale". By 1956, when the "threat" of left-wing populism was hardly a significant political factor, and memories of austerity were beginning to recede, these practices had become firmly sedimented and institutionalised.

Despite the relaxation in the tone and style of BBC broadcasting allegedly effected by the advent of commercial television in 1954, rock 'n roll was deliberately ignored and resisted by the BBC radio networks. British balladeers and cabaret-style singers were systematically favoured and in 1956, the year when Elvis Presley's *Heartbreak Hotel* was released, not one single rock 'n roll record was featured in the annual review of popular songs. A similar pattern of more or less explicit censorship has been observed by Iain Chambers in the music press where throughout the 1950s notions of "quality" and "taste" were consistently opposed to the "commercial" blandishments of *ersatz* rock 'n roll. (*Melody Maker* resisted readers' requests to run a weekly "top ten" until 1956.[15]) The following was, apparently, a typical response:

> "Come the day of judgement, there are a number of things for which the American music industry, followed (as always) panting and starry-eyed by our own will find itself answerable for to St. Peter. It wouldn't surprise me if near the top of the list is 'Rock-and-Roll'... Viewed as a social phenomenon, the current craze for Rock-and-Roll material is one of the most terrifying things to have happened to popular music... The Rock-and-Roll technique, instrumentally and vocally, is the antithesis of all that jazz has been striving for over the years – in other words, good taste and musical integrity."
>
> *(Melody Maker)*

Historical "authenticity" and/or stylistic sophistication served as the criteria for distinguishing the acceptable forms (i.e. the "natural" blues, folk and Trad; sophisticated swing, balladeering, etc.) from the unacceptable (i.e., rock, rhythm and blues). As Chambers remarks, "What in hindsight appear to be the most arbitrary distinctions were at the time fiercely patrolled aesthetic parameters"[16] and the passion with which those distinctions were defended and maintained indicate once more the extent to which the values they embodied were felt to be at risk in this case from the "monotony of incoherence"[17] which early rock 'n

roll was seen to represent. When the broadcasting authorities eventually capitulated to popular demand, the music was subject to the same elaborate monitoring and framing procedures laid down in the early post-War years. *6.5 Special*, *Thank Your Lucky Stars* and *Juke Box Jury* on television, *Saturday Club* and *Easy Beat* on radio were all hosted by already-established "professional" presenters (e.g., Pete Murray, David Jacobs). *Juke Box Jury* was in fact a study in mediation: new musical product was processed through a panel of "well-known show business personalities" who submitted it to a brief barrage of witty, frequently barbed but always self-consciously lighthearted commentary. Jack Goode's *Oh Boy!* was the only programme in which the more delinquent connotations of the music were permitted to creep through unremarked (and this, perhaps significantly, appeared on the commercial channel).

Milk bar horrors and the threat of youth

The gate keeping and policing functions undertaken as a matter of course by the BBC were, as we have seen, assumed with equal seriousness elsewhere in the broader currents of cultural and aesthetic criticism. By the early 1950s, the very mention of the word "America" could summon up a cluster of negative associations. It could be used to contaminate other words and concepts by sheer proximity as in "Americanised sex", "the false values of the American film", etc.[18] Once more an example from the *Picture Post* indicates just how far the Americanisation thesis had infiltrated the more "respectable" reaches of popular journalism. In an article entitled *The Best and Worst of Britain* (19 December, 1953), Edward Hulton, the editor, describes the emergence of a new race of "machine minders and comic-strip readers".[19] He quotes a welfare officer who compares a group of factory girls who "put pieces of paper into slots for eight hours a day" to "chickens pecking corn" and when asked about religion confesses:

> "They prefer Victor Mature to God because they can understand Victor – and he relieves the monotony of their lives; as far as they know, God doesn't."[20]

Hulton concludes with references to the "Growth in juvenile crime", talks ominously about young "thugs...who revel in attacking old men and women, and hitting people when they are down" and the article ends with this solemn warning:

> "We are on the brink of that horrible feature of American life where, in many a shady district, thugs go round from shop to shop demanding the payment of 'protection money' or else..."[21]

Here, the way in which images of crime, disaffected youth, urban crisis and spiritual drift are anchored together around "popular" American commodities (Victor Mature, comic strips) suggests a more completely structured response than those we have so far encountered – a fixing of a chain of associations (between youth, the future, America and crime) which has since become thoroughly sedimented in British common sense. As we have seen, such typifications emerge only slowly; meanings coalesce around particular configurations of attitudes, values and events and are gradually naturalised as they circulate in different contexts. By isolating two distinct moments in the formation of this structure – one from Hoggart, one from Orwell – the process of naturalisation can itself be arrested and examined.

ANALYSED BY A PSYCHIATRIST

In Hoggart's description of the "juke box boys" (1958), the associations which had begun to congregate around the term "Americanisation" are organised to the point where they are about to be translated into fully-fledged connotational codes. Hoggart describes a group of young men "aged between fifteen and twenty, with drape-suits, picture ties and an American slouch" who spend their evenings listening to "nickleodeons"[22] in the "harshly lit milk bars". The snack bars are associated with an unprecedented spiritual and aesthetic breakdown and the depressing picture is completed by what Hoggart calls the "hollow cosmos" effect of early rock 'n roll. Summing up, Hoggart attributes the decline to some received notion of America:

"Many of the customers – their clothes, their hair-styles, their facial expressions all indicate – are living to a large extent in a myth-world compounded of a few simple elements which they take to be those of American life".[23]

Hoggart closes on a note which establishes once and for all the links between a number of emotive images and ideas: the equation between America and mass culture, between Americanisation and homogenisation, between America's present and Britain's future. At the end of this section on the juke box, Hoggart writes:

"The hedonistic but passive barbarian who rides in a fifty horse power bus for threepence to see a five million dollar film for one and eight is not simply a social oddity; he is a portent."[24]

The impression created is one of monstrous disproportion (threepence, 5 million dollars, one and eight), dislocation ("hollow cosmos", "myth world") and disharmony (rock 'n roll) and together these images form a menacing amalgam which collapses the threat of "mindless", "violent" youth into the larger threat of the future (bland and alien).

To trace the origins of these connotational codes back a little further we need only turn to George Orwell's *Coming Up for Air* (1939) in which

the same "artificial", "alienated" environment is made to serve in exactly the same way as a metaphor for moral and aesthetic entropy. George Bowling, the disillusioned middle-aged narrator, suspecting that something has gone badly wrong with Britain, returns to the village in which he was born (now a sprawling industrial estate) to find his suspicions confirmed – indeed realised and reified – in the emergence of the flashy new milk bars:

> "There's a kind of atmosphere about these places that gets me down. Everything slick and shiny and stream-lined: mirrors, enamel and chromium plate whichever direction you look in. Everything spent on the decorations and nothing on the food. No real food at all. Just lists of stuff with American names, sort of phantom stuff that you can't taste and can hardly believe in the existence of".[25]

In both Hoggart and Orwell, the words "soft" and "streamlined" are virtually synonymous and streamlined products made out of "shiny" "modern" materials are frequently used by these writers as a kind of shorthand for all manner of imagined decadence. Once they had been defined as signs of the perfidious "American influence" the very invocation of such commodities in a piece of journalism or cultural criticism could be used to stand in for any combination of the following ideological themes: the rebellion of youth, the "feminisation" of British culture, the collapse of authority, the loss of Empire, the breakdown of the family, the growth in crime, the decline in attendance at places of worship, etc., though none of these are necessarily present in the example from Orwell. In this way the very mention of a word like "streamlined" at a particular historical moment could be used to mobilise a whole set of ideologically charged connotations from a number of different sources. To appreciate the complexity of this process we have to consider the way in which the word "streamlining" itself came to be applied to industrial products by those working within the professional design *milieu* and to try to tease out some of the meanings encoded into streamlined artefacts at the design and production stages. In this way it becomes possible to turn at last to those discourses in which the issues of quality and taste were overtly confronted and discussed.

The streamlining controversy

(1) The blasphemy of "jazz forms"

References to "streamlining" first began appearing on a regular basis within American design discourse in the 1930s (though Harold van

Doren cites the submission as early as 1867 of a patent for a "streamlined train"). To begin with the smooth cigar shapes to which the word "streamlining" referred were associated exclusively with aviation technology where it was argued that they served a specific function – facilitating speed, maximising air flow, etc. However, these visual motifs were by the early 1930s being carried over into American car design. (The 1934 Chrysler Airflow, for instance, was modelled on Douglas aircraft designs.) Streamlining soon constituted in this new context a popular, "eye catching vocabulary"[26] – one which clashed with the purist architecturally based idioms of classical European modernism. The ideals of modernism in this particular field were most clearly embodied in the angular designs by Walter Gropius for the German Adler Company. (For example, the 1930 Adler Cabriolet is often quoted in books on design theory as the apotheosis of "tasteful" car design.)

By the end of the decade streamlining was beginning to be applied to commodities totally outside the transport field in which it had found its initial rationale. Edgar Kauffman's example of a scotch-tape dispenser "naively echoing" tailplane "fairing" is probably, thanks paradoxically to Reyner Banham,[27] the most "notorious" instance of the "improper" usage of aviation motifs. By 1940 Harold van Doren could write:

> "Streamlining has taken the modern world by storm. We live in a maelstrom of streamlined trains, refrigerators and furnaces; streamlined bathing beauties, soda crackers and facial massages..."[28]

The ensuing controversy surrounding these allegedly "improper" applications of streamlining lasted for more than two decades and constitutes perhaps the most famous, and certainly one of the most protracted and comprehensively documented debates to have occurred in professional design circles. It still remains in effect the decisive, determining "moment" in the formation of much current academic discourse on design (e.g., formalism/anti-formalism; aesthetic/commercial; "good" design/"popular" design). Its interest for us lies in the fact that it acted as the medium through which the hegemony of the modern school (le Corbusier, the Bauhaus, etc.) which had shaped much of the critical theory of industrial design since its inception as a professional discipline in the early 1920s was challenged and eventually broken (we are now, for instance, or so the rubric goes, living in the "post modernist age"). By exploring the controversy within design over the streamlining issue it may be possible to determine how the ideologically charged distinctions between the "serious" and the "popular" between "good" and "bad" taste came to be articulated in a particular discursive field between the years 1935–55, to examine how far they paralleled similar distinctions produced in other areas at more

59

or less the same time and to relate these developments back to changes in the modes of industrial production, distribution and consumption.

The response of the European design establishment to the indiscriminate streamlining of imported American products was immediate and uniformly hostile. A streamlined refrigerator was interpreted as an act of provocation in direct defiance of the most fundamental principle of "good design" – that "form follows function". Such an object was plainly blasphemous: a hymn to excess. It was "decorative", "decadent" and its offensiveness as far as the European design authorities were concerned hinged on its arbitrariness. The intrusion of an expressive design vocabulary which bore no *intrinsic* relation to the commodities it shaped was plainly subversive. It introduced the possibility of an *intertextuality* of industrial design – of the unrestricted passage of signifiers across the surfaces of a whole range of unrelated products without any reference whatsoever to "essential" qualities such as "function" and this ran absolutely counter to the prevailing "modern" orthodoxy. (The fact that so much Modern Movement rhetoric was based on an equally arbitrary analogy with architectural idioms was hardly considered. Moreover, an alternative "European" style of streamlining which had its roots in Italian futurism was apparently permissible so long as it remained "tasteful" and restrained. Once again we encounter the entrenchment and preservation of what in hindsight appear to be peculiarly untenable distinctions.)

The differences between dominant European and American conceptions of the place of "good taste" in product design stemmed from the different infrastructural links which had been established on the two continents between manufacturing industry, design practice and design theory. American design had been firmly placed on a commercial free-lance footing and was studio and consultancy-based. The most prominent figures in the American design field – van Doren, Bel Geddes, Loewy, Dreyfuss and Teague – ran their own design agencies and while they all subscribed to ideal notions of "form", "harmony" and "proportion", the market continued to exert a major determining influence on both their theory and practice.[29] In Europe, on the other hand, national bodies had been set up at least in Britain and Germany to promulgate the principles of "good design" but, in Britain, there were few integral links with industry, and when design teams were eventually formed they tended to be permanently attached to a single company or corporation. This separation of theory and practice had direct consequences on the formation of the dominant European design aesthetic. (In America the very notion of privileging "aesthetic" principles over considerations of market demand and "popular" taste tended to be regarded as an expensive indulgence.)

lessons in good form

illustrations (above and opposite page) from Herbert Read's *Art and Industry* **extolling the virtues of Modern Movement design: Form follows Function. Good Form = Order = Reason**

60

In Britain the Design for Industries Association (DIA) which had been established in 1915 and was modelled on the Deutscher Werkbund, pursued a policy rooted in the ideals of William Morris and the Arts and Crafts Movement. DIA statements had a strongly paternalistic flavour (see, for instance, early issues of *Design for Today*) which reflected how far it was institutionally and ideologically identified with government rather than industrial interests. Its influence on British design was minimal and by the late 1930s the DIA was under siege from an evangelical group of Modern Movement proponents led by Nikolaus Pevsner and John Bertram. Both wrote influential books – Pevsner's *Pioneers of Modern Design*; Bertram's *Design* – which were published eventually as Pelican Specials and which soon found favour and support amongst the dominant taste-making elites. Stephen Bayley has indicated that by the late 1930s, institutions like London Transport and the BBC, mainly through the *Listener*, were actively promoting the principles of modern design. The austere, patrician values of the Continental Modern Movement were perfectly compatible with the definitions of "good taste" which were then becoming prevalent in broadcasting circles. The writings of Pevsner and Bertram were full of references to "progress" and "quality", to the "challenge" of technological change and the need for cultural continuity. Moderation in aesthetics was combined with a commitment to social democracy in a way which fitted in with the more liberal ethos of control which was emerging during this period.[30] (For a similar, roughly contemporaneous development in a different field, see for instance John Grierson's essays on documentary, in which the film-maker eulogises the "power" of industry and the "dignity" of work reconciling a paternalist interest in "ordinary" life with the demand to produce "good", affirmative and accessible work.[31]) The serious and responsible tone in which questions of popular taste and popular culture were discussed within the Modern Movement closely paralleled the new, more democratic accent – the "accent on change" – which the BBC sought to adopt in the late 1930s, and significantly, Bertram's book was based on a series of radio talks entitled *Design in Everyday Things* which he presented in 1937.

This is not to say, of course, that in other countries, other contexts, the aesthetic principles of the Modern Movement were necessarily identified with moderate social democratic ideologies. John Heskett, for example, has demonstrated how, in Germany, design forms and concepts normally associated with the Bauhaus and with the Weimar Republic were used just as fully and successfully as German folk and craft forms by the Nazis.[32] Even Pevsner recognised that there was no *intrinsic* relation between "well-made" forms and those programmes for social change which he personally supported:

Offices and printing works of the "Turun Sanomat" newspaper, Åbo, Finland. Architect: Alvar Aalto. Photo: P. Morton Shand.

'rational' rectilinear solutions

61

"In Germany the post-War Labour Government fostered the modern style... In Italy modern architecture and modern design enjoy the special furtherance of the government as being an expression of Fascism.

In Russia the same style was, after some years of state approval, given up as an outcome of latter-day bourgeoisie, and a decidedly conventional and therefore probably more popular style was launched. The reaction of art to changes within our civilisation thus remains indeterminate..."[33]

What is, however, clear is that the manner in which modernist principles were predominantly interpreted in Britain by people like Pevsner, the kind of intervention which the early British popularisers of modernism imagined they were making (Pevsner, for instance, refers in the same sentence to the "levelling up of class contrasts... the raising of standards of design"[34]) fitted in exactly with the more liberal and progressive ideologies which were then just beginning to find favour among certain key elites (e.g., the BBC).

Both Bertram's and Pevsner's writings contain lengthy polemics against the philistinism of British industry, the vulgarity of popular taste and British reticence in the face of the "new" and "well-formed". Bertram's book is perhaps more purely "Continental" in tone: attacks on domestic kitsch ("The sewing machine... decorated with gold transfers of ornament borrowed from Gothic altar-pieces"... the "bijou-baronial" and "Tudoristic" bungalow, etc.[35]) alternate with clusters of adjectival positives: "practical, honest, cheap, lasting and beautiful".[36]

The excesses of American streamlining were then hardly likely to be welcomed by this new design oligarchy, and when Pevsner accuses "modernism in its jazz forms"... of spoiling the market... "for more serious modern work"[37] one suspects he is referring specifically to American imports or American-influenced designs (the words "jazz" and "American" are virtually interchangeable in this kind of writing throughout the 1920s and 1930s). The disjunction between British and American traditions – the different relationships with industrial practice and the State formed by the respective design elites – provides some explanation for the emergence of discursive polarities between what was defined as "commercial" and "responsible" work and for the development of quite different criteria in America and Europe for judging what constitutes "good" design. But in order to obtain a more adequate account of these differences and to appreciate their wider historical importance, we have to go beneath and beyond the terms in which the debate was originally conducted and to consider changes both in the production process and in the scale of consumption.

The emergence of streamlining from 1930 to the late 1950s as *the* popular style – "popular" in the sense of being simultaneously "commercially successful" and "democratic", "anti-purist", "running counter to the classical", etc., can be explained by reference to two major developments: the refinement of pressed steel technology and the creation of new consumer markets. The development of pressing and stamping techniques (whereby sections of a product could be stamped out whole and subsequently welded together) can be seen as an integral part of that process of accelerated automation and rationalisation through which in the years immediately before and after the War, financial and technological resources became concentrated into progressively larger and more efficient units. In other words, it was just one of the many technological innovations which enabled monopoly capital to become consolidated in the period.

In this context, the movement away from fabricated, geometric forms to pressed or stamped ones, from what van Doren calls "rectilinear" to "curvilinear" forms[38] signalled a more general shift within industrial production towards a greater output of a more limited range of items for a larger domestic market at a lower unit cost. The fact that stamping technology made it easier to produce curved forms, that in Banham's words it "works most efficiently with broad, smooth envelope shapes",[39] meant that this innovation and the increased rationalisation of the production process which went with it could literally *declare itself in form*, could advertise through its very newness those quantitative and qualitative breaks that had been made in the production process, in the scale of production and in the size of the potential market to which "streamlined" products were to be directed.

This is not to return to some crude technological determinism. Commercial pressures remained paramount here. The range of design options available continued to be structured by market as well as productive forces. Designers continued to provide appealing and commercially viable designs which at the same time were intended to maximise the potential for formal and stylistic change opened up by the new technology. And as the American designer Raymond Loewy put it in 1945, ultimately the only streamline aesthetic which was likely to impress the directors and the shareholders continued "to consist of a beautiful sales curve shooting upwards".[40] But the potential for stylistic experimentation opened up by a new technological "advance" such as stamping could be cashed in in the market place precisely through the deliberate exaggeration of stylistic *difference*, through the extent to which the new products could be clearly marked off by their very "newness" and "uniqueness" – in this case by their "curvilinear"

qualities – from those already available. It was largely through the vocabulary of style and form, then, that adaptations in the technical apparatus were mediated to the new mass of consumers.

Advertisements for streamlined products appealed directly to popular conceptions of an irresistible scientific progress and frequently drew their inspiration from contemporary science fiction and science fiction genres – for instance, from those popular magazines of the 1930s which presented utopian futures "based half on fact and half on prophecy".[41] Streamlining became synonymous with the "shape of the future", with a romantic exultation in the power of the new and its vocabulary simultaneously influenced and was influenced by what Robin Spencer has called the "popular imaginative concept of tomorrow's world".[42] The significance and appeal of this concept, as Spencer points out, "has nothing to do with established art forms".[43] The futurist manifestos and the popular imagery of progress shared only "the bright innocence of technological aesthetics"[44] but that aesthetic and the meanings constructed round it were transformed as they passed across from high to low, from the lofty assertions of an artistic avant garde to the context of consumption and use – the domain of the popular.

The innocent enthusiasm for technological progress was not confined solely to the reception end of design aesthetics in America. Even a respected designer such as Henry Dreyfuss whose works always followed months of sober market research, could succumb just as uncritically as his public to the attraction of crystal-ball gazing. Sometimes, inevitably, these predictions were a little off the mark:

Cadillac presents the greatest advancements it has ever achieved in motor car styling and engineering!

> "In less than half a century it will be AD 2000. Who can say what life will be like then? One can only speculate knowing that for all the incredible scientific progress of the last fifty years, limitless vistas lie ahead... Mail will probably be dispatched across the country by guided rockets..."[45]

Increasingly, American product design became the art of imaginative projection as the pressures to overcome the law of the declining rate of profit necessitated the constant stimulation of demand through the production of ever "newer", more fancifully and "futuristically" styled commodities. In turn, the competition between manufacturers determined to make an impression on an increasingly heterogeneous market grew more intense as consumers became more status-conscious and more responsive to visual criteria. As John Heskett has indicated (here in the context of German manufacturing industry "after the American model") "... the work of designers became predominantly oriented towards the creation of artificial and superficial differences between products";[46] these intensified market pressures led to a new

64

direction in product design which was subsequently dubbed "consumer engineering".[47]

(3) From borax to pop

The production spiral was most marked in the American car industry. By the 1950s the policy of "planned obsolescence" which was admitted, indeed openly paraded in Detroit, as a positive factor both in design and "consumer-satisfaction" led to what can only be described as the "creation" of some of the most outlandish and, as it turned out, provocative examples of "dream" styled artefacts to have yet rolled off a production line. (The 1953 Cadillac El Camino was in fact advertised as everybody's "Dream Car".)

Harley J. Earl, head of General Motors styling department, was responsible for many of the more outrageously somnambulent designs. His most controversial innovation involved the transposition in 1949 of the Lockheed Lightning tailfin to the rear bumpers of the Cadillac range – a move which he justified by claiming that it conferred "visible prestige" on the car owner. In the furore which these "unwarranted" and "ostentatious" features caused in European design circles, many of the themes of the original streamlining debate of the 1930s were recapitulated but, with the shift in the post-War years from a production to a consumer economy, the issue of impending "American-isation" was far more clearly foregrounded:

> "Streamlining is the jazz of the drawing board – the analogy is close, both are US phenomena, both are "popular" in their appeal, both are far removed from their characteristic sources – negro music and aero-dynamics and finally both are highly commercialised and use the star-system".[48]

British and "classical" American designers united to protest the arrival of General Motors' "short-term, low-rent chromium utopia".[49]

The term "borax", which had been coined in the American furniture industry to denote "obviously heavy forms and elaborate ornament",[50] was taken over by the dissenters and used to refer to the kind of terminal styling represented by Detroit. (There was even an adjective – "borageous".) And as Reyner Banham has pointed out, the very presence of such terms in journals as clearly devoted to Modern Movement principles as *The Architectural Review*, implies a simple Cold War logic: "borax is bad . . . elegant is good, stylised is bad, functional is good".[51] Indeed, the introduction of tailfins which were subsequently described as the "Vietnam of product design"[52] was even (apparently) blamed for "the fact that America lagged behind Russia in the space-race". Whilst the Russians had been developing 'Sputnik' . . . the

Americans had been debauching themselves with tailfins."[53]

Nonetheless by this time (as Banham's confidently satirical voice here indicates) the opposition was growing in strength and articulacy: the modernist consensus was being attacked from within (Banham was a former student of Pevsner). The New York Journal *Industrial Design* began to carry arch and generally appreciative reviews of new Detroit product and there were attempts on the part of certain sections of the New York intelligentsia as early as 1951 to have Earl's creations reassessed as art in inverted commas (e.g., the Hollow Rolling Sculpture exhibition at the Museum of Modern Art). In London the emergence of a similarly ironic sensibility – a sensibility which was eventually to produce both Pop Art and Tom Wolfe's New Journalism – was signalled in the formation of the Independent Group and the mounting in 1956 at the Whitechapel Art Gallery of the *This is Tomorrow* exhibition which revelled in the despised iconography of the new popular culture.

Once again these discursive shifts and breaks within the art and design world(s) reproduced transformations in the intersecting spheres of cultural criticism and popular journalism and these were in turn written out of and against the prevailing ideologies of "Americanisation", the "levelling-down process", "cultural decline" and "consumer affluence". And to trace the connections one stage further (and one stage back), all these shifts occurred out of or in response to changes in the composition of the market and the forces of production. The "borax" controversy which extended and accentuated the resistance on the part of dominant European elites to American streamlined products helped to crystallise with exceptional lucidity within the confined space of a professional discipline the issues which were felt to be at stake; the significance of form in everyday life, the need for a "responsible" interpretation of popular demand, the place of public taste in design practice. The Cadillac of the 1950s merely acted as a catalyst for a clash of values and interests which had been building up since the development in America in the first two decades of the twentieth century of mass production technology. It represented the concretisation in form of conflicts between different definitions of legitimacy and taste. It was an object which *invited* strong reactions.

Towards the streamlined workforce

In America, of course, the Cadillac was, as the El Camino advertisements acknowledged, the embodiment in chrome of the American Dream. Throughout the 1950s and 1960s it represented the aspirations precisely of the "disadvantaged American",[54] and it was the blatant expression of these aspirations in their raw state – untouched by

the paternalistic mediations of European "good taste" – which had proved so divisive. This was, of course, what made the Cadillac so "vulgar". It was the levelling down process in-car-nate. It was the tangible elimination of value and distinction (in the twin senses of "difference" and "distinguishing excellence") achieved paradoxically through the "pretentious" claims made on its behalf to "social status". (This was the car for the "upwardly mobile".) This was the culmination of the whole pernicious process. Here, in the 1950 Cadillac it was quite evident that the "hallmarks of distinction" had been at last replaced by the fetish of stylistic variation.

Nor was this interpretation confined solely to conservative cultural critics though the imagined erosion of class differences which affluence was supposed to have produced was subject to a different inflection on the Left. Marcuse, who in *One Dimensional Man* (1964) describes what amounts to a "streamlined" workforce, cites the example of "the negro who owns a cadillac" along with "the typist who is as attractively made up as the daughter of her employer" (sic)[55] to demonstrate the extent to which subordinate groups have been assimilated and won over by "passive consumerism" to dominant modes of thought and action.

The work of Marcuse – the European marxist in California – is of particular interest here because it represents a conscious attempt to draw together strands and themes elaborated in the context of a number of different discourses – sociological, aesthetic, literary, and psycho-analytical – and to bring these to bear directly on the question of the "transubstantiation of labour power"[56] supposedly effected by the automation of the work process. Marcuse takes the suggestion put forward by, amongst others, Vance Packard and Charles Walker that the tendency to rationalise and standardise the production process together with the rise in wages associated with it leads to "the strengthening of the position of management, and increasing impotence and resignation on the part of the workers".[57] Interestingly enough, he uses the example of the "Americanised Caltex refineries at Ambes France" to illustrate Serge Mallet's notion of "voluntary integration":[58] the factory as the microcosm of an enclosed consumer society – a society which works like an efficient, unstoppable machine (cf. *Metropolis* and incidentally Foucault's panopticon).

The image of a class of "privatised", affluent workers locked into a closed circuit of production and consumption, "watching the same TV programmes and visiting the same resort places"[59] as their employers, struggling only to purchase the products of their own alienated labour informs much of the critical sociological discourse of the 1950s and 1960s. And as Crichter has pointed out, here referring to Goldthorpe and Lockwood's classic study of Luton car workers, *The Affluent Worker in the Class Structure* (1968), the evidence of these changes , in this case:

"changes in economic circumstances (increased incomes and access to consumer goods with consequent changes in life styles); changes in the technology and management of work (the decline of manual labour the new 'technician' roles involving greater teamwork and integration into the goals of management); changes in the ecology of cities (increased owner-occupation, suburbanisation and the redevelopment of the inner city)".[60]

tends to be assumed rather than assessed. The authors merely concern themselves with discovering "whether, in those situations where most of these 'new' factors are most apparent, they have the effects attributed to them".[61]

The evidence of change

The evidence which *can* be assembled here is, in fact, conflicting, fragmentary and flawed. Many of the available statistics on consumption after the War, for instance, emanate from the new consumer-oriented industries of market research and advertising, and while these can be extremely useful in delineating general trends, the evidence they provide is sometimes questionable (see below).

Of course there *were* real changes in patterns of consumption from 1935 to 1962. Quite apart from a steady rise in the availability of a wider range of consumer goods throughout the period, there was a particularly dramatic transformation in the scale of working-class expenditure on leisure in terms both of time and money. For example, Paul Wild has traced the development of new forms of consumption – principally the spread of cinemas and dance halls – in one provincial town, Rochdale, from 1900 to 1940. During these years leisure provision became increasingly centralised (e.g., by 1929 British Gaumont owned 300 cinemas up and down the country, by 1945 the Rank group had opened a further 500 and owned the Ealing and Shepherds Bush studios[62]) and American and American-influenced products began to dominate the "popular" market. Wild characterises the following broad trends: the growth of recreation oligopolies (e.g., Rank and after the War, EMI), the removal of leisure provision from popular control, a tendency towards greater specialisation in what had previously been communal or class-based rituals, and a swing on the part of a working-class audience dominated by a less gruelling work schedule and "increasingly lured into a world of novelty and the appearance of glamour towards American style entertainments".[63] But as yet very little work has been done on how working-class people themselves

perceived these developments, how they *used* the new facilities, and to what extent they really were (as Wild implies in the phrase "lured into") deradicalised by the inter-War restructuring of popular leisure.

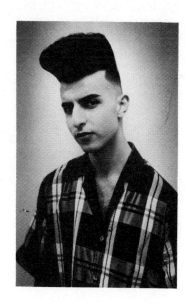

After the War, changes in patterns of specifically *teenage* consumption attracted a perhaps inordinate amount of attention. One market researcher, Mark Abrams in *The Teenage Consumer* (1959) – together with Colin MacInnes in books like *Absolute Beginners* – was largely responsible for constructing the influential paradigm of the hedonistic, working-class teenager prepared to spend a large proportion of his or her income (which Abrams calculated to have risen to twice its pre-War value) on leisure. But subsequent research carried out by sociologists (e.g., Smith's Bury sample (1966)) threw many of these assertions into question (Smith found that some forty per cent of the eighteen-year-olds he interviewed spent less than seventy-five pence per week on clothes, drink, and going out, etc.)[64]

Nonetheless, the "myth of affluence" and the accompanying ideologies of "classlessness" and "incorporation" representing, as they did, attempts to provide coherent explanations for changes in the phenomenal forms of working-class life and the formation in particular of the new "popular culture" ran directly parallel to the "Americanisation" thesis: the assumed eradication of traditional differences remained largely intact. Abrams, for instance, claimed that:

> "Under conditions of general prosperity the social study of
> society in class terms is less and less illuminating. And its place
> is taken by differences related to age".[65]

However, there was a good deal of confusion here. Abrams went on to insist that by 1959:

> "... not far short of ninety per cent of all teenage spending is
> conditioned by working-class taste and value".[66]

Most of the more dramatic developments as far as adolescent consumption was concerned – e.g., increased provision of leisure facilities (discotheques, boutiques, Wimpey bars, Ten Pin Bowling Alleys, etc.) and magazines (*Fab*, *19*, etc.) aimed at a specifically teenage market did not fully emerge until the early to mid-1960s. But even here amongst the young, consumption rituals, far from being classless continued to take place within a culture sharply divided precisely round the class-related questions of quality and taste. In 1971 the National Board of Prices and Incomes reported that the distribution of earnings remained more or less the same as in 1886: material hardship may have diminished but relative deprivation still persisted. Before 1962, teenage consumption, where it wasn't organised through church youth clubs, voluntary associations (and involuntary ones – National

Service continued until 1958) tended to be a largely subterranean affair occurring, at least for working-class males in the interstices of the parent culture, on the street corners, in arcades, cafés and dance halls. And the most conspicuous evidence of change – the emergence in the early 1950s of flamboyant sub-cultures like the teddy boys – of groups whose tastes were most clearly conditioned by exposure to American imports, to American popular music and American films (the style according to Barnes[67] was strongly influenced by Hollywood gangster and Western stereotypes), served to accentuate rather than annul class differences. The teds, after all, were drawn more or less exclusively from the "submerged tenth" of lower working-class youth.[68]

According to one survey conducted by the *Picture Post* at the Tottenham Mecca ballroom in 1954, a teddy boy's wages could range from as little as £4.17.6d per week (an apprentice) to as much as £12 (a skilled cabinet-maker) whilst the made-to-measure drape suit which was compulsory wear (described by Fyvel as a "theatrical outfit . . . un-English . . . simply weird"[69]) cost £17.00–£20.00, a "good poplin shirt" £2.00 and a pair of "beetlecrusher" shoes £3.00.[70] In other words, becoming a teddy boy was not something which could be undertaken lightly. Far from being a casual response to "easy money" the extravagant sartorial display of the ted required careful financial planning and was remarkably self-conscious – a going against the grain, as it were, of a life which in all other respects was, in all likelihood, relatively cheerless and poorly rewarded.

But these groups were hardly representative. They served for most contemporary observers of the scene as the "dark vanguard"[71] and were perceived as traitors on the shore of the imagined sea of comics, quiffs and bubble gum which threatened to overwhelm the singularity of British culture unless "something" (rarely specified) was done. The piece from Hoggart on the "juke box boys" gives some indication of how these forms of cultural "desertion" could be read as "the most advanced point of social change"[72] – the shape of things to come.

Beyond the shock of the new

It is now possible to reassess the broader political and cultural implications of the debates on taste, American cultural influence and the "quality of life" which took up so much critical space from the 1930s to the 1960s. Discourses evolved in a wide variety of relatively autonomous professional contexts are linked together paradigmatically through recurrent ideological themes, images and issues. Specifically we have seen how a number of ideologically charged connotational codes could be invoked and set in motion by the mere mention of a word like

"America" or "jazz" or "streamlining". Groups and individuals as apparently unrelated as the British Modern Design establishment, BBC staff members, *Picture Post* and music paper journalists, critical sociologists, "independent" cultural critics like Orwell and Hoggart, a Frankfurt-trained marxist like Marcuse, even an obsessive isolationist like Evelyn Waugh, all had access to these codes. Together they form a language of value which is historically particular. With the appearance of imported popular phenomena like "streamlining" and "jazz" this language – not only the terms themselves: "excellence", "quality", "distinction" and so on – but the structure of expectations and assumptions which lay behind them – the desirability of cultural continuity, and social stability, the existence of moral and aesthetic absolutes – was thrown into crisis.

The challenge represented by shifts in the organisation of market and productive forces was registered at the level of form in the appearance of new recorded musical genres (rock 'n roll, r & b, etc.) and a new order of commodities differentiated from each other by superficial stylistic features. Just as the Afro-American musical language emerged from a quite different cultural tradition to the classical European one, obeyed a different set of rules, moved to a different time and placed a far greater emphasis on the role of rhythm, participation and improvisation, so the new economy based on the progressive automation and depersonalisation of the production process and the transformed patterns of consumption it engendered disrupted and displaced the old critical language. This new economy – an economy of consumption, of the signifier, of endless replacement, supercession, drift and play – in turn engendered a new language of dissent. Those terms which had been negatively defined by the established cultural elites were inverted and made to carry oppositional meanings as they were appropriated (in the way that Marcuse had recommended) by the (counter-cultural) advocates of change and converted into positive values – hedonism, pleasure, purposelessness, disposability, etc. However, this displacement of one language, of one set of discourses by another set did not occur simply or solely through the mysterious "dispersal" of epistemological categories and "regimes of truth" but by the irruption into a historically particular realm of meaning through the agency of *real* objects, a new range of material commodities – of another message, written, so to speak, in a quite different "language". This message spoke another set of transformations, and emanated from a zone which is, "in the last instance" more decisive and determining than language – the sphere precisely of production. As the opening quotation from Walter Benjamin suggests, there is a more grounded explanation for the way in which that "message" was received, and for the conflicting definitions of "good taste" with which this chapter deals...

We have seen how streamlining constituted the explicit declaration in form of technological innovations (e.g., stamping and pressing techniques) which have made the production of an increasingly standardised and uniform range of commodities possible. Streamlining came to be used as a metaphor for industrial barbarism, stylistic incontinence and excess. The proliferation of "jazz forms" was cited by European cultural commentators to connote simultaneously: "popular taste", the "look of the future" and "Americanness" – all of which were negatively defined. On the other hand, for designers and advertisers of streamlined products and for the "public at large" the vocabulary of streamlining was used to signal a positive improvement in the quality of life which in turn entailed a massive expansion in the productive base and in the scale of conspicuous consumption. Quality and quantity were indistinguishable here – the clash over issues of taste was inextricably linked to conflicting definitions of material progress, and the rhetoric of modernism with its references to "beautiful machines" and "well-made objects" served only to obscure the extent to which mass production technology under "free market" conditions *necessarily* entailed the transformation and displacement of traditional aesthetic criteria and established social distinctions. It was the simultaneous articulation of the fact of *accessibility* and *reproducibility* (a million streamlined Chevrolets, a million streamlined radios) which finally proved disturbing to so many cultural critics. A run of different commodities rendered indistinguishable through the identical lines which enfolded them represented in Banham's words, "a chromium horde bearing down on you"[73] for a group of European intellectuals educated in a tradition which placed (and still continues to place) – value on the "authentic", the "unique" or at the very least the "honest" and the "functional". It was Walter Benjamin who foresaw most clearly the transformation of aesthetic criteria which mass production would eventually necessitate:

> "the technique of reproduction detaches the reproduced object from the dimension of tradition... by overcoming the uniqueness of every reality".[74]

Writing in the same spirit at more or less the same time, Gramsci produced a remarkably cogent critique of the response of the Italian intellectual bourgeoisie to the first tentative signs of "Americanism". He predicted that the introduction into Italy of American-style mass production technology ("Fordism") would lead to the intensification of economic exploitation and eventually to the more effective penetration of the State into every aspect of private and public life – to a subtler, more developed ideological and "moral coercion" of the masses. But he refused to deplore the changes in the phenomenal forms which

inevitably accompanied such structural adaptations. He pinpointed the source of the resistance to American cultural influence precisely:

> "In Europe it is the passive residues that resist Americanism (they represent 'quality') because they have the instinctive feeling that the new forms of production and work would sweep them away implacably".[75]

In the image of a streamlined car, in the snatch of "hot" jazz or "ersatz" rock 'n roll blaring from a streamlined speaker cabinet, the cultural conservatives of 1935 or 1965, irrespective of their overt political affiliations were right to perceive what Benjamin described as "the destructive, cathartic aspect, that is, the liquidation of the traditional value of the cultural heritage".[76] They were right to perceive that what was at stake was a future – their future.

Conclusion

It would, finally, be misleading to end a discussion of some of the conceptions of "popular taste" which prevailed from 1935–62 without making at least some reference to the alternative definitions of America and American influence which were circulating at the time or attempting to assess the actual extent of American cultural penetration during this period.

As we have already seen, where changes in taste and patterns of consumption did occur, they tended to be associated with changes in the composition of the market (i.e., the "intrusion" into the sphere of "conspicuous consumption" of the working class and the young), and these changes in turn were linked to objects and environments either imported from America or styled on American models (e.g., film, popular music, streamlined artefacts, milk bars, hair styles and clothes). There can be no doubt that America, particularly in the post-War period began to exert considerable cultural and economic influence on European culture though those statistics which are readily available tend to fall outside the period covered by this paper (e.g., in 1973 it was estimated that fifty per cent of the world's screen time was taken up with American films, and that American-made programmes accounted for more than twenty per cent of total television transmission time in Western Europe; that twenty to twenty-five per cent of British manufacturing output was American controlled and that eight of the leading advertising agencies were owned by American companies[77]).

But there is little evidence to suggest that the eradication of social and cultural differences imputed to these developments by a generation of cultural critics has taken place at least in the form they predicted. For

instance, the sheer plethora of youth cultural options currently available (e.g., the rockabillies, heavy metal enthusiasts, ted revivalists, etc.) most of which are refracted however indirectly through a "mythical America" seems to suggest that the early fears about the homogenising influence of American culture were unfounded. Rather, American popular culture – Hollywood films, advertising images, packaging, clothes and music – offers a rich iconography, a set of symbols, objects and artefacts which can be assembled and re-assembled by different groups in a literally limitless number of combinations. And the meaning of each selection is transformed as individual objects – jeans, rock records, Tony Curtis hair styles, bobby socks, etc. – are taken out of their original historical and cultural contexts and juxtaposed against other signs from other sources. From this perspective, the style of the teddy boys can be interpreted less as the dull reflex of a group of what Hoggart called "tamed and directionless helots"[78] to a predigested set of norms and values than as an *attribution* of meaning, as an attempt at imposition and control, as a symbolic act of self-removal – a step away from a society which could offer little more than the knowledge that "the fix is in and all that work does is to keep you afloat at the place you were born into".[79]

In the same way, positive images of America did persist throughout the period though these were generally constructed and sustained underneath and in spite of the "official" authorised discourses of school and state. Of course, even in 1935 there existed a positive mythology of the "New World" – perhaps a remnant of much earlier, romantic myths in which America and Americans were depicted as young, innocent, dynamic and vigorous. In the early 1960s the Kennedy brothers were portrayed as personifying these qualities. For instance Christopher Booker, in his study of post-War Britain, *The Neophiliacs*, has described how the vocabulary and imagery of the Kennedy era were imported into Britain and used to bolster up the myths of "Swinging London" and Harold Wilson's "dynamic" leadership.[80] But until the 1960s the romantic affirmation of American culture tended to be left to such unashamedly "popular" weeklies as *Titbits* and to the undergrowth of literature – the novelettes, comics and Hollywood ephemera – which were aimed at a predominantly working-class market. And by 1960, this market – at least significant sections of it, particularly amongst the young – had swung again – away from the exuberant vocabularies of streamlining and rock. In 1962, Len Deighton's *Ipcress File* appeared. It contained the following passages:

"... I walked down Charlotte Street towards Soho. It was that sort of January morning that has enough sunshine to point up the dirt without raising the temperature. I was probably

74

seeking excuses to delay; I bought two packets of Gauloises, sank a quick grappa with Mario and Franco at the Terraza, bought a *Statesman*, some Normandy butter and garlic sausage... In spite of my dawdling I was still in Lederer's Continental coffee house by 12.55... Jay had seen me of course. He'd priced my coat and measured the pink-haired girl in the flick of an eyelid. I knew that he'd paid sixty guineas for each of his suits except the flannel one, which by some quirk of tailor's reasoning cost fifty-eight and a half... (Later in a strip club)... Finally he went to the Gents excusing himself with one of the less imaginative vulgarisms. A cigarette girl clad in a handful of black sequins tried to sell me a souvenir programme. I'd seen better print jobs on a winkle bag, but then it was only costing twelve and six, and it was made in England.... 'I'll have a packet of Gauloises' I said...".[81]

What is so remarkable here – unsurprising perhaps in a genre which as Amis pointed out is so unremittingly brand and status-symbol conscious as the British spy novel of the 1960s – is the defection of a man like Harry Palmer not to Russia – still less to America – but to Italy ("Mario", "Franco", "grappa"), to the Continent ("garlic sausage", "Normandy butter", all those "Gauloises"). It is perhaps the final irony that when it did occur the most startling and spectacular revolution in British "popular" taste in the early 1960s involved the domestication not of the brash and "vulgar" hinterland of American design but of the subtle "cool" Continental style which had for so many decades impressed the British champions of the Modern Movement. Fyvel writing in 1961 had recorded the switch from the teddy boy style (betraying in the process a set of preferences which should require little explanation):

"Step by step, through various deviations, the clothes and haircuts grew less eccentric and extreme, until at the end of the 1950s they had become unified in the rather attractive 'Italian style', which had become normal walking-out wear for the working-class boy; and by 1960 this had blended with 'conservative cool' or just very ordinary but well-cut clothes".[82]

It was not to be long before the first "ordinary" (i.e., working class) disciples of the Modern Style in their Italian suits on their Italian motor scooters, moving to black American modern jazz and black American soul were swarming over Soho. And Harry Palmer with his proletarian origins, his eye for detail (*his* world is hardly as "flat as a map"), his refined and discriminating tastes (a sixty-guinea suit – a fifty-eight and a half guinea suit) and his confident appropriation of Italy (Guy Crouchback's sacred Italy!) is a fictional extension of mod just as

Trimmer – the thoroughly contemporary master of appearances bore attenuated traces of the 1950s spiv. What is more, the "spy masters", Burgess and Maclean (followed later by Philby) – motivated, or so the story goes, by a profound contempt and loathing for America, for American cultural, economic and military imperialism, for the "Americanisation" of the globe had flown the roost leaving men like Palmer to take care of things. Needless to say, Gilbert Pinfold would have been appalled.

Chapter 4

Object as Image:
the Italian Scooter Cycle

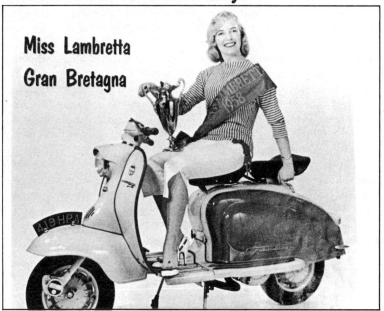

Miss Lambretta
Gran Bretagna

"One of the difficulties of sociological discourse lies in the fact that like all discourse, it unfolds in strictly linear fashion whereas, to escape over-simplification and one-sidedness one needs to be able to recall at every point the whole network of relationships found there."

(Pierre Bourdieu, La Distinction, *1979)*

Nowhere do we encounter "networks of relationships" more familiar and "material" yet more elusive and contradictory than those in which material objects themselves are placed and have meaning(s). If linearity

77

is an effect of all discourse then the world of things seems especially resistant to coherent exegesis. And one of the central paradoxes facing those who write about product design must be that the more "material" the object - the more finite its historical and visual appearance - the more prodigious the things that can be said about it, the more varied the analyses, descriptions and histories that can be brought to bear upon it.

In a sense, each essay in Roland Barthes' *Mythologies* is an equation which depends for its impact on the initial recognition of this perverse formula and Barthes handles the paradox with a relish which alternates between the comic and the macabre ("What I claim is to live to the full the contradiction of my time, which may well make sarcasm the condition of truth"[1]). In "The New Citroen", Barthes describes how the "tangible" is made to intersect with the "ethereal", the "material" with the "spiritual" through the convention of the annual motor show where the industry's new product is miraculously "unveiled" before the public. He refers the mystique of the object: the dual mystery of its appearance - its magical lines, its "classical" body and the unanswerable riddle (unanswerable at least for Barthes, the aesthete) of how it came to be made in the first place - to religious myths and archetypes. Here a set of contemporary wonders - the transubstantiation of labour power into things, the domestication of the "miracle" in use - is intimated by Barthes through the manipulation of a single pun: the Citroen DS19 (short for "diffusion Special") is pronounced *"Déesee"* (Goddess) in French.

The essay is, then, a kind of trial by catachresis. It might be argued that that is precisely Barthes' "method"; that Barthes would have been the first to insist on the validity of constructing an analysis on the strength of a single word - on what it evokes and makes possible for the mythologist. Indeed, for Barthes it is only through "displacements" of this kind that writing is exalted into Literature:

> "... for the text is the very outcropping of speech, and it is within speech that speech must be fought, led astray - not by the message of which it is the instrument, but by the play of words of which it is the theatre... The forces of freedom which are in literature depend not on the writer's civil person, nor on his political commitment... nor do they even depend on the doctrinal content of his work, but rather on the labour of displacement he brings to bear upon the language..."[2]

To be Barthesian, writing is the only practice in which the writer has a "presence" in which, about which he or she is qualified to speak:

> "The paradox is that the raw material, having become in some ways its own end, literature is basically a tautological

activity... the *ecrivain* is one who absorbs the why of the world radically into a how to write..."[3]

And for Barthes, that writing which would claim to deal with representation, with myth and the "doxa" must satisfy certain conditions. It must be self-returning and sensitive to the plurality of verbal signs. It must be capable of "sarcasm". A pun is therefore valued insofar as it opens up and undermines the strictures of a "natural" (i.e., "bourgeois") speech. So Barthes renders the Citroen back into its "real" premythical components. He recreates it using purely linguistic materials. Barthes' "New Citroen" is powered on a figure of speech. Nonetheless the subversive rationale of this replacement is not necessarily visible to everyone who picks up a copy of *Mythologies*. Like the DS revolving slowly on its dais, the argument is simply "exhibited", turned by a mechanism which remains hidden from the wondering eyes of the reader (even, in all likelihood, from the eyes of the reader who appreciates the pun):

> "It is obvious that the new Citroen has fallen from the sky inasmuch as it appears at first sight as a superlative object. We must not forget that an object is the best messenger of a world above that of nature: one can easily see in an object a perfection and an absence of origin, a closure and a brilliance – a transformation of life into matter... and in a word a silence which belongs to fairy tales."[4]

If writing is regarded as a "narcissistic activity"[5] as Barthes would have it, then the gross illusion that language is transparent (what has recently been dubbed the "realist fallacy") is certainly avoided. But the "new" position has its own attendant fantasies: when language becomes a mirror for the narcissist, other illusions are, of course, possible. We could say that what is "misrecognised" in (this kind of) language is the depth of perception (the depth of the reflection). To put it another way, what is "misrecognised" is the illusory "materiality" of language itself.

For Barthes, the real can only be inserted into language as a "silence" – "a silence which belongs to fairy tales". But instead of the "silence" of the object, we might like to stress its solidity, its materiality, the simple fact of its "being there". And it might be more accurate to say that the problem of representing the material world remains paramount in Barthes and is depicted in that form – i.e., as the relationship of speech to silence – because that problem is itself material: Barthes was, after all, a litterateur. Had he been an engineer or a travelling sales rep. who yearned to own a car capable of impressing potential clients ("actualising (perhaps)... the very essence of petit-bourgeois advancement"[6]), then the "problem" would have been differently

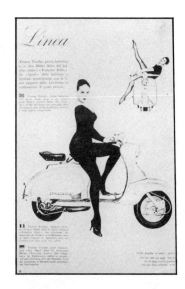

79

conceived and differently presented. And if he had shared the interest in mechanics and "progress" (mechanics as a metaphor for progress) which no doubt informed the ecstatic response of many of the supplicants who filed past the Citroen stand in 1955 and wanted, themselves, to possess the Goddess, then, no doubt, we too would have been confronted with a different object, a different alienation. For, far from being silent, the number of voices which speak through and for "dumb things" are legion. The enigma of the object resides for us less in its "silence", its imagined essence than in the babble which proliferates around it.

Three "moments"

> "The variability of significance rather than the persistence of qualities should be at the forefront of analysis..."
> *(Fran Hannah* and *Tim Putnam,* Taking Stock in Design History, *Block 3)*

How then can we hope to provide a comprehensive and unified account of all the multiple values and meanings which accumulate around a single object over time, the different symbolic and instrumental functions it can serve for different groups of users separated by geographical, temporal and cultural location? The problem Bourdieu outlines and Barthes embodies in *Mythologies* has already been acknowledged: there is a tendency amongst those who aspire towards a "materialist" conception of design to question the adequacy of the object as the basic unit of analysis and to substitute instead design practice as a more satisfactory point of entry. But this shift in emphasis and the quest for epistemological rigour which motivates it carries its own price. For in the case of design history, there can be no subject without objects. All design practice has as its ultimate ideal and actual destination a tangible result, a real set of objects. Indeed, in design the thing itself is the ideal.

How then is it possible to talk simultaneously about objects and the practices which shape them, determine or delimit their uses, their meanings and their values without losing sight of the larger networks of relationships into which those objects and practices are inserted? The task becomes still more daunting if we acknowledge first that there can be no absolute symmetry between the "moments" of design/production and consumption/use and, further, that advertising stands between these two instances - a separate moment of mediation: marketing, promotion, the construction of images and markets, the conditioning of public response. It is tempting when writing about design either to run

80

these three moments together or to give undue prominence to one of them so that production, mediation or consumption becomes the "determining instance" which dictates the meaning of the object in every other context. In either case, the result is more or less the same – a delicately (un)balanced sequence of relationships is reduced to a brutal set of aphorisms, e.g., masses consume what is produced in mass (where production is regarded as determining); desire is a function of the advertising image (where mediation is regarded as the determining instance); people remain human and "authentic", untouched by the appeal of either images or objects (where consumption or the refusal of consumption is seen as determining). Clearly none of these models is sufficient in itself though each may seem appropriate in particular circumstances when applied to particular objects. It would be preferable to find a way of holding all three instances together so that we can consider the transformations effected on the object as it passes between them. But we are still left with the problem of constructing a language in which that passage can be adequately represented.

If we abandon those solutions to the problem which limit the production of significance to the immanent logic of the object itself – as an internal organisation of elements or as a latent essence – if, in other words, we abandon the formalist option and if we also discard the no less abstract language of pure function: "uses", "gratifications" and so on, then the criteria for excluding and organising information become increasingly uncertain. We are in a field without fences left with an intractable mass: "cultural significance".

To reconstruct the full "cultural significance" of the DS Citroen we would have to do more than merely "demystify" its reception in the marketplace at the point where, as Barthes would have it, the Goddess is "mediatised" from "the heaven of Metropolis" and brought within the range of some people's pockets and everybody else's aspirations. If we were to produce a comprehensive analysis we would have to take into account the kinds of significance generated as the object passes through a maze of independent but interlocking frames – drawing back at every point to consider the structures in which each individual frame is housed.

We could trace the passage of the Citroen, then, from its inception/conception through the various preparatory stages: market research, motivational research, design – engineering, styling (division of labour within the design team; relationship of team to management infrastructure), modifications in conception at design stages, constraints of available technological resources on DS design, adaptation of existing Citroen plant to accommodate the new product, production of prototypes and models; production (labour relations, labour processes), exhibitions and launch of new product, press conferences, press releases

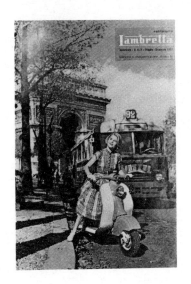

and handouts, reviews in trade press, advertising campaign (target group), distribution of finished product: retail arrangements, distribution of foreign licences, provision of servicing facilities, price, sales figures (consumer profile of target group), formation and composition of the Citroen user groups, etc., etc. Finally we would have to place the DS alongside other cars available in 1955 in order to assess its difference from equivalent products – the extent of its stylistic and technical "advances" or departures, its potential for "prestige", etc.

The "cultural significance" of the Citroen DS 19 might be defined as the sum total of all the choices and fixings made at each stage in the passage of the object from conception, production and mediation to mass-circulation, sale and use. Nor do the connotations accumulate in an orderly progression from factory to consumer. In the production of significance, time is reversible and each stage in the sequence (production-mediation-consumption) can predominate at different times in determining meaning.

For instance, to take a more topical example, the meaning of the Mini Metro is overdetermined by the uncertainty surrounding its production and the reputation for "bloodymindedness" of the British Leyland workforce – a reputation constructed through Press and television coverage of industrial disputes. This in turn enables the Metro to function contradictorily in the news media both as a symbol of "Britain's hope" and as a symptom of the "British disease" (where production hold-ups and technical faults are cited as evidence of Britain's decline as an industrial power which, to complete the circle, is "explained" by reference to the "problem" of the British workforce). The entire history of British Leyland labour relations is reified in the Mini Metro's public image. The advertising campaign mobilises that history (the memory of strikes hovers just behind the copy just as in the Hovis television ads the memory of the Depression looms out of the conjunction of sound and image – the melancholy strains of a northern brass band, the black and white image of "noble" cloth-capped workers). The Mini Metro advertising campaign overlays two forms of patriotic optimism – that Britain can make it, that British Leyland can go on making it (and supplying the spares) across the more generalised faith in the future which purchasing a new car normally implies. The potential purchaser is invited to make all three investments simultaneously – in the future of Britain, in the future of British Leyland, and in his or her own personal future. And newspaper reports make it clear that whenever a dispute threatens production of the Metro, then all three investments are endangered. In this way every reader's stake (as a taxpayer) in the British Leyland Motor Company is realised in the image of the Metro (the car for little people), in the image of the Metro in jeopardy and a number of parallel interpellations become possible:

"you" the reader/taxpayer/consumer/car-owner/Briton/patriot/ non-striker. The place of the Mini Metro in the present scheme of things is thus defined by a double address in time – back to British Leyland's past and forward towards a dream of trouble-free consumption, a purified economy and a disciplined, docile working class . . .

That, of course, does not exhaust the "meaning" of the Mini Metro for all time or for all people. It is merely an attempt to isolate some of the themes which already in 1981 have begun to congregate around what we might term the "official" fixing of the Mini Metro image – a fixing which brings us back to Barthes and myths and second-order significations. And the degree to which that reading of the Metro image proves convincing and even intelligible depends on the reader's prior knowledge of and place within a nexus of political issues and cultural codes which are historically particular and lie quite outside the scope of the list I compiled in relation to the 1955 Citroen. We come back, then, to the original problem: not one object but many objects at different "moments" (the moments, for instance, of design, assembly and use), at different (real and mythical) times (in different conjunctures in relation to imagined pasts and futures) seen from different perspectives for different purposes. How can all these different times, purposes and perspectives be reconciled so that they can be depicted? One solution might be to turn from the object to the text in order to find a more fragmentary mode of representation in which the object can be brought back "into touch" with that larger, less tangible and less coherent "network of relationships" which alone can give it order and significance . . .

The rest of this paper consists of a "dossier" on one particular genre of commodities: the Italian motor scooter. The sequence of the narrative corresponds loosely to the progression of the object from design/produc- tion through mediation into use though there is a good deal of cross- referencing between different "moments". Theoretical models have been introduced to frame the material and the narrative has been interrupted at certain points so that sections dealing with larger economic and social developments can be inserted. It is hoped that by presenting the "history of the motor scooter" in this way, some indication of the extent of the variability in its significance can be given as "echoes" and "rhymes" build up within the text. The text itself is "variable" because there is no one "voice" speaking through it. The same or similar information may be relayed through a different "voice" in a different section, i.e., its significance may vary according to its placement. In the same way, for the same reason, any "echoes" which do accumulate cannot be closed off, summed up, reduced to a "silence" or amplified into a thunderous conclusion.

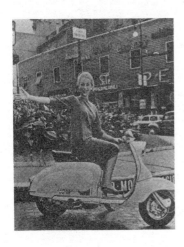

What follows is premissed on the assumption – itself hardly novel – that the facts do not speak for themselves. They are already "spoken for" ...

The scooter as sexed object: early days

The first motor scooters were manufactured in Europe in the years immediately after the First World War (though there are recorded examples of machines called "scooters" being sold even earlier than this in the United States). From the outset, the word "scooter" denoted a small, two-wheeled vehicle with a flat, open platform and an engine mounted over the rear wheel. The scooter was further characterised by its low engine capacity: the Autoglider (1921) had a two-and-a-half hp engine. Together these features distinguished the scooter from other categories of two-wheeled transport and marked it off especially from its more powerful, more "primitive" (i.e., of earlier origin, more "functional" and "aggressive") antecedent: the motor cycle. The demarcation between motorcycle and motorscooter coincided with and reproduced the boundary between the masculine and the feminine.

The earliest scooters were designed to meet the imagined needs of the female motor cyclist. For instance, it was possible for women to stand while driving the Scootamotor (1920) thus preserving decorum and the line of their long skirts. (How could the designer have predicted the flattening out of the female silhouette in the women's fashions of the 1920s? How could he have foreseen the vogue for trousers, breeches and strictly tailored suits which, as Lisa Tickner suggests, were to provide such provocative metaphors for the emancipation of women?[7]) Long before the mass production of Italian Vespas and Lambrettas began to threaten the supremacy of the British motorcycle industry in the 1950s and 1960s, the scooter was interpreted as an alien intrusion – a threat to the masculine culture of the road. It was seen as an absurd omen of a much more general process: the feminisation of the public domain (women over thirty were enfranchised in 1918 and one year later the Sex Disqualification Removal Act was passed giving women access to the professions). The machine's lowly status and its vulnerability to ridicule were further reinforced by its visible resemblance to a child's toy scooter. The Zutoped, for instance, was modelled directly on the original toy. Despite modifications in design over the years, the overall conception and placement of the scooter – its projected market, its general sh ts public image – remained fixed in the formula – motor cycles:scooters as men:women and children.

Scooters were permanently wedded to motorcyles in a relation of inferiority and dependence:

"The scooter is a device that we refuse to grace with the description of motorcycle and which, therefore, has no place in this work".

(*Richard Hough*, A History of the World's Motorcycles
Allen & Unwin, 1973)

The gender of machinery

"The operative value of the system of naming and classifying commonly called the totemic drives derives from their formal character: they are codes suitable for conveying messages which can be transposed into other codes and for expressing messages received by means of different codes in terms of their own system... totemism, or what is referred to as such, corresponds to certain modalities arbitrarily isolated from a formal system, the function of which is to guarantee the controvertibility of ideas between different levels of social reality..."

(*Claude Levi-Strauss*, The Savage Mind*)*

If we start the scooter cycle by following the lead established in 1962 by Levi-Strauss we do not approach isolated phenomena as the imaginary bearers of substance and meaning but are driven to focus instead on how those phenomena are arranged conceptually and semantically; on what signifying power they possess as elements or functions within codes which are themselves organised into symbolic systems. For the structuralist,

"the term totemism covers relations, posed ideologically between two series, one *natural* the other *cultural*... [where] the natural series comprises on the one hand *categories*, on the other *particulars*; the cultural series comprises *groups* and *persons*".

(*Levi-Strauss*, Totemism *(1962))*.

In "primitive" societies, elements from the natural world – flora and fauna – are made to perform these totemic functions. Through the principles of metaphor and metonymy, they guarantee the controvertibility of formal codes into moral, aesthetic and ideological categories. Machines on the other hand, are for Roland Barthes, "superlative object(s)" invested with a super-natural aura ("We must not forget that an object is the best messenger of a world above that of nature..."). They are brought down to earth ("mediatised") by being made to function as differential elements – as markers of identity and difference – organised into meaningful relations through their location

His.

May we recommend our System 7 to your ears. We think its features speak for itself.
HA-3400 35 watt super-linear amplifier; FT-3400 tuner with MW, LW and FM stereo; D-35s cassette deck with Dolby NR and metal tape facility; HT-40s turntable, direct drive with "Unitorque" motor.

And hers.

May we recommend our System 7 to your eyes. It has a beautiful simulated teak cabinet and a smoked glass door.
Put it in your living room and it's just like part of the furniture.
So you can have all the hi-fi specifications on the left—but it looks right.

mechanical sexism
His = engineering
Hers = styling

within cultural/ideological codes. The first marker of identity is sexual difference. The sexing of the object is the first move in its descent from "the heaven of *Metropolis*" to its "proper" place in the existing (ie mortal and imperfect) order of things. In advanced industrial societies, the transposition of gender characteristics onto inanimate objects is peculiarly marked. Typically the qualities and status ascribed to the gender of the "ideal" user are transferred on to the object itself. Paul Willis's study of a Birmingham motorcycle gang provides an interesting example of this kind of "anthropomorphisation":

> "The motor cycle boys accepted the motor bike and allowed it to reverberate right through into the world of human concourse. The lack of the helmet allowed long hair to blow freely back in the wind, and this, with the studded and ornamented jackets, and the aggressive style of riding, gave the motorbike boys a fearsome look which amplified the wildness, noise, surprise and intimidation of the motorbike. The motorbikes themselves were modified to accentuate these features. The high cattlehorn handlebars, the chromium-plated mudguards gave the bikes an exaggerated look of fierce power."[8]

This is merely an extreme localised instance of a much more widespread assumption that equates motorcycles with masculinity, machismo with what Barthes has called the "bestiary of power".[9] Once it has been sexed, the machine functions as a material sign of (realises) imagined gender differences: mechanical sexism.

Advertisements adjudicate in the settling of gender differences. Sometimes the object is split, janus-like, into its two opposed aspects: his and hers. His: functional, scientific, useful. Hers: decorative, aesthetic, gratifying. The distinction corresponds to the separation of design functions: his/engineering; hers/styling. Relations of dominance/subordination inscribed in the sexual division of labour are transposed so that engineering is perceived as superordinate and necessary (masculine/productive), styling as secondary and gratuitous (feminine/non-productive).

These transpositions can colour critical perception of the broadest social and economic developments. For instance, the transition from a production (puritan) economy to a consumer (pagan) one is often condensed in books on economic history into a single image: the image of General Motors' growing ascendancy from the mid-1920s onwards over the Ford Motor Company. The success of General Motors is represented as the triumph of sophisticated marketing strategies (obsolescence of desirability – the annual model; massive advertising; "consumer financing" (the "trade in", hire purchase); exotic styling)

over Ford's more sober approach ("honest" competition in terms of quality and price). Styling is seen as the key to the popularity of General Motors' products: whereas Ford's Model T design remained virtually the same for decades but became relatively cheaper to purchase and produce, G.M. designers introduced ostentatious styling features to distinguish between markets on status grounds. The development of the modern advertising industry is frequently associated either with the increased spending power of the female consumer or with the growing influence which women are felt to exert over household expenditure. Vance Packard, writing in the late 1950s quotes the chairman of Allied Stores Corporation to "illustrate" women's progressive colonisation of the consumption sphere:

> "It is our job to make women unhappy with what they have. We must make them so unhappy that their husbands can find no happiness or peace in their excessive savings..."[10]

The "spread of consumerism" is understood by reference to woman's essential gullibility and improvidence. Packard's triple invective against *The Wastemakers* (1960) – the Detroit motor industry; *The Status-Seekers* (1959) – the new breed of consumer; and *The Hidden Persuaders* (1957) – saturation and "subliminal" advertising – is carried along on a series of analogies between the decline of the "real" solid/masculine/ functional aspects of American industrial design which symbolise the pioneer spirit, and the complementary rise of the "fantastic"/feminine/ decorative elements which symbolise consumer decadence. The fact that terms taken from women's fashion are beginning to infiltrate the language of automobile design is cited as evidence of a more general decline in standards: a car parts dealer from Illinois is quoted as describing a car as a "woman's fashion item" and Packard claims that in professional design argot, product styling is now referred to as the "millinery aspect" and designing a new car shell is called "putting a dress on a model".[11] The sinister nature of these developments is inferred through the connection between General Motors' success and the investment in styling which is itself indicative of the "feminisation" or "emasculation" of American society. Throughout the book, indeed throughout much of the critical writing on product design produced in the 1950s, a certain type of car, a certain type of styling functions totemically to duplicate category distinctions which are collectively predicated on the denial or dismissal of the "female" and the "feminine". Misogynist values are thus relayed mechanically through the medium of objects and attitudes towards objects. The marking out of sexual difference moves along a chain which is constantly slipping: man/woman: work/pleasure: production/consumption: function/form, for example:

> "... women have escaped the sphere of production only to be absorbed the more entirely by the sphere of consumption, to be captivated by the immediacy of the commodity world no less than men are transfixed by the immediacy of profit..."[12]

This characterisation of the "masculine" and "feminine" domains and the priorities it encapsulates have been institutionalised in education in the distinction between "hard" and "soft" subjects: engineering is installed in universities as a scientific discipline (and seems relatively protected from the cuts?) fashion/fashion history is doubly subordinate – it is only an "applied art" – and is eminently dispensable.

The patriarchal inflection cuts across the entire field of academic discourse. It is this implicit bias which, at a deep level, orders the marxian distinction between "phenomenal forms" and "real relations". It is no coincidence that Althusser, in his parody of "vulgar marxism", should refer to the "economic base" as "His Imperial Majesty":

> "... when the Time comes, (the superstructures) as his pure phenomena... scatter before His Majesty the Economy as he strides along the royal road of the Dialectic..."[13]

Hairdrier: motorcyclists' slang for an Italian scooter

The 1946 Vespa

Scooter
"A machine of less than 250cc engine capacity with body work giving considerable weather protection and having a smart, clean appearance" *(J. Simmonds:* Design no 94. *1957)*

In 1946 and 1947, two new Italian scooters appeared which eclipsed all previous models in terms of sales and served to fix the design concept of the contemporary scooter – the Vespa (Wasp) appeared first and was designed by Corriando D'Ascanio for Piaggio, formerly Piaggio Air, the company which during the War had produced Italy's only heavy bomber, the P108 B. (It was not particularly successful. Mussolini's son, Bruno, was killed piloting an early test flight.)

In 1943, the works at Pontedera were completely destroyed by Allied bombing and a new factory was built with facilities geared towards peace-time production. (Piaggio later diversified into machine tools.) The scooter was originally conceived as a small-scale project which was intended to make maximum usage of available plant, materials and design expertise and to fill a gap in the market, supplying the demand on the part of consumers deprived during the War years of visually attractive, inexpensive luxury goods, for a cheap, stylish form of transport capable of negotiating Italy's war-damaged roads.

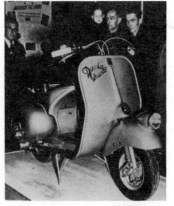

1946 Vespa

D'Ascanio, who had previously specialised in helicopter design, incorporated aeroplane motifs into the original Vespa. The air-cooled engine and stressed skin framework were commonplace enough in aircraft design but their application to two-wheeled transport was regarded as a major innovation. Equally novel was the idea of mounting the wheels on stub-axles rather than between forks. This made them easier to detach – and thus easier to repair – than motorcycle wheels. D'Ascanio was said to have adapted the idea from the mountings used on aeroplane landing gear though stub-axles were, of course, a standard feature of car design. But the spot-welded, sheet-metal frame represented the most noticeable departure from the conventional idea of the motorcycle. The two-stroke engine was concealed behind re-movable metal cowlings and the platform frame, which was attached to the central spine, extended upwards almost to the handlebars, providing foot support and protection from the weather. Speed was hardly a consideration: the 98cc engine (subsequently 130cc) had a top speed of only 35mph but the low fuel consumption (approximately 120mpg) and the ease with which the gear and clutch controls could be mastered, acted as compensatory incentives. (D'Ascanio had sub-stituted handlebar controls for the foot pedals favoured by the motorcycle industry.) The two-stroke engine which was mounted over the rear wheel was chosen for its simplicity and, without complicated valve gear or pump lubrication, driving was reduced to a basic set of operations which could be assimilated quickly even by people with no prior motorcycling experience.

The design, then, made concessions to the rider's comfort, convenience and vanity (the enveloping of machine parts meant that the scooterist was not obliged to wear specialist protective clothing). In addition, the Vespa made a considerable visual impact. It was streamlined and self-consciously "contemporary". There was a formal harmony and a fluency of line which was completely alien to the rugged functionalism of traditional motorcycle designs.

The Vespa was launched at the 1946 Turin show and was an immediate commercial success though reactions in the motorcycle trade were varied. While the novel styling was on the whole regarded favourably, at least in design circles, attention was drawn to basic engineering faults (the suspension was considered too "soft" and the sparking was sometimes erratic), and the scooter was criticised on the grounds of general safety (it was unstable at speed, and the eight-inch wheels were considered too small to give adequate road grip, especially in wet or slippery conditions). Piaggio, for their part, argued that these criteria were simply not appropriate: the machine was designed as a small, "gadabout" vehicle suitable for travelling short distances at low speeds. In other words, the Vespa was to be presented to the public not

as a poor relation of the motorcycle but as the principal term in a new transport category, as a machine in its own right with its own singular qualities, its own attractions and its own public.

D'Ascanio's Vespa established the pattern for all subsequent scooter designs and its general shape changed little over the years (the headlamp was later moved from the mudguard to the handlebars but this was the only major styling alteration). It combined three innovations – the stub-axles, open frame, and enclosed engine – which were reproduced over the next twenty years by manufacturers in France, Germany and Britain so that, by 1966, one journalist could state authoritatively that "there is hardly a scooter built today which does not incorporate two out of these three distinctive features".[14] This fixing of the design concept was made possible through the phenomenal sales (by 1960, 1,000,000 Vespas had been sold, and after a slack period in the late 1960s, the oil crisis led to a market revival and in 1980 Piaggio were reported to be producing 450,000 scooters a year (see *Guardian*, 21 February, 1981)). Domination of the market led to domination of the image: the field was secured so effectively that by the mid-1960s the words "Vespa" and "scooter" were interchangeable in some European languages. (Traffic signs in Paris still stipulate the times when "Vespas" can be parked.)

The 1947 Lambretta

In design history, the monopoly exerted by the Vespa design over definitions of the scooter has tended to obscure the fact that Piaggio were not the only engineering company in Italy to recognise the emergence of the new "mood" and market. When the Vespa was entered for the 1946 Milan show, it appeared alongside a range of new lightweight motorcycles and mopeds and no fewer than seventeen auxiliary motors for powering pedal-cycles (see Hough, *The History of the Motor Cycle*). Moreover, the car industry was just as concerned to make inroads into the revitalised working-class and teenaged markets. By 1953, the Vespa was competing against a peculiarly Continental hybrid: the Isetta three-wheeler, the first of the "bubble cars". D'Ascanio was, then, merely the victor in the race to find a metaphor for the *ricostruzione*, to develop a "popular" commodity capable of translating the more inchoate desire for mobility and change – a desire associated with the re-establishment of parliamentary democracy and given a material boost in the form of Marshall Aid – into a single object, a single image.

In 1947, another scooter appeared which in its basic concept, scale and price, bore a close resemblance to the Piaggio prototype – the Lambretta produced by Innocenti of Milan. For almost twenty-five years, until Innocenti's scooter section was bought outright by the

Undressed Lambretta

Indian Government in the early 1970s, the Lambretta range offered the most serious threat to Piaggio's lead in terms of international sales and trade recognition. By 1950, Piaggio and Innocenti had between them opened up a completely new market for cheap motorised transport. Early advertising campaigns were directed at two emergent consumer groups – teenagers and women – neither of which had been considered worthwhile targets for this class of goods before the War. A new machine had been created and inscribed in its design was another new "invention": the ideal scooterist – young, socially mobile, conscious of his or her appearance. The scooter was defined by one sympathetic journalist as "a comfortable, nicely designed little vehicle for people who do not care too much about the mechanical side of things".[15]

As the two companies competed for the same markets, the design of Lambretta and Vespa scooters drew closer together until, by the late 1960s, they were, in styling if not in performance and engineering detail, virtually identical. However, there were marked differences between the Lambretta model A and the D'Ascanio Vespa. Once again, the Lambretta design was a feat of *bricolage* – the material resources: expertise, plant and production processes – of the two component firms (Innocenti SpA which specialised in steel tube manufacture had amalgamated after the War with the Trussi coachbuilding concern) were adapted and diverted into scooter production. The model A chassis was based on a double steel tube structure (similar to the one used on the earlier British Corgi); the front wheel was carried on a fork, the rear wheel on a stub-axle and, as with the Vespa, there was a footboard for the rider. But the Lambretta differed from the Vespa in that it had a larger (125cc) engine and a pillion seat for passengers; on the model A there were footpedal changes for the gears and the clutch, the legshields were shorter and narrower and, most significantly, at least most conspicuously, the engines of the early models were open. Though for safety reasons, the gear and clutch controls were subsequently transferred to the handlebars, the Lambretta engine remained fully exposed until 1951 when the C and CL models were introduced. On the C model, the double tube chassis was replaced by a single tube frame and the prospective buyer was confronted with a choice between two different machines: the "dressed" (CL) or the "undressed" (C) scooter. Demand for the "dressed" model (which also offered superior weather protection with broader, higher legshields based on the D'Ascanio design) was so great that Innocenti were soon forced to withdraw open Lambrettas from production. Inevitably, the addition of the sleek, protective side panels drew the Lambretta closer to its rival. A pattern of parallel growth emerged: the production of a new model by Innocenti would force a similar design response from Piaggio and vice versa. By 1953, both companies were offering 125 and 150cc models. During the

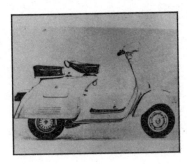

mid- and late-1950s, two factors: the demand for sturdier, high performance scooters suitable for long-distance touring and the appearance of powerful German machines – the Heinkel, the Bella, the TWN Contessa – led to adjustments in the engine and wheel sizes of both Vespa and Lambretta models: Piaggio introduced the four-speed GS (*Gran Sport*) and SS (*Super Sport*), Innocenti countered with the Lambretta 175cc TV series.

But throughout, the basic scooter "silhouette" remained more or less unchanged: the word "scooter" became synonymous with a streamlined shape and legshields. By the end of the 1950s, most of the successful designs for scooters in the popular 125-150cc ranges – the Italian Iso Milano, the French Moby, the German NSU Prima – made clear visual references to the Piaggio original. When British motorcycle manufacturers finally, and with considerable reluctance (see section entitled "The reception in Britain"), capitulated to local demand and began producing their own (resolutely unsuccessful) scooters, they tended to turn to Italian models, even, occasionally, to Italian designers (e.g., Vincent Piatti designed a scooter for Cyclemaster in the mid-1950s). The extent to which Continental scooters had penetrated the international motorcycle market was to lead (for a brief period) to an inversion of the traditional hierarchy. Motorcycle designers began adopting the "effeminate" practice of enclosing the machine parts. With the Ariel Leader the engine at last slipped out of sight...

The production of consumers

This convergence of form in the designs for machines in related categories is not in itself remarkable. After all, design innovations are meant to set trends. However, the encasement of mechanical parts in metal or plastic "envelopes" – a development associated historically with the emergence of streamlining – signalled more than just a change in the look of things. It marked a general shift in production processes, in the scale and rate of capital accumulation, in the relationship between commodity production and the market. The drift towards a more systematic "packaging" of objects, itself linked to the growth of the consultancies, coincided with a much broader development – the rise of the giant corporations – the modern conglomerates and multi-nationals – with the concentration of power and resources into larger and larger units, a movement which in turn had required a fundamental reorganisation of social and cultural life: the translation of masses into markets.

The economist Paul Sweezey has outlined some of the changes associated with the development of monopoly capitalism in the post-War period: the automation of the work process; increased specialisa-

tion and diversification (spreading of risk over a wider product range); expansion of the white-collar sector; control of distribution networks; market sharing between corporations; price fixing (the self-imposed limitation of growth in productive capacity to keep prices pegged at an "acceptable" level); imperialism (exploitation of Third World resources, domination of Third World markets); the displacement of competition from the field of price to the field of sales promotion; increased expenditure on research, design and "market preparation". All these developments were motivated by need: "the profound need of the modern corporation to dominate and control all the conditions and variables which affect its viability".[16]

It is in this context that the massive expansion of the advertising and marketing industries during the period can be most clearly understood. Given the huge costs involved in producing a new line of goods, if crippling losses were to be avoided, the consumer had to be as carefully primed as the materials used in the manufacturing process. The expedient was, on the face of it, quite simple: the element of risk was to be eliminated through the preparation and control of the market. It was not just the careful monitoring of current market trends that could help to guarantee profits. What was required was a more structured supervision of consumer demands according to the principles of what was later called "want formation".[17] In other words, corporate viability was seen to rely increasingly upon the regulation of desire.

It was during this period that design became consolidated as a "scientific" practice with its own distinctive functions and objectives. From now on, the shape and look of things were to play an important part in aligning two potentially divergent interests: production for profit, and consumption for pleasure. The investment on a previously unimagined scale in the visual aspects of design from the 1930s onwards indicated a new set of priorities on the part of manufacturers and marked another stage in a more general (and more gradual) process: the intercession of the image between the consumer and the act of consumption.

These developments were, of course, already well advanced by the time Piaggio's Vespa appeared on the scene. In America there was a thriving, highly-organised advertising industry by the mid-1920s and advertising personnel were already formulating policy on the basis of sociological and psychological research (according to Stuart Ewen, the work of the early symbolic interactionists which placed the emphasis squarely on the social construction of personal identity was particularly influential[18]). The elaborate cynicism and self-consciously shark-like image of the post-War advertising executive were already fully in evidence by the end of the decade. The following passage appeared in 1930 in *Printer's Ink*, the advertising trade journal:

"... advertising helps to keep the masses dissatisfied with their mode of life, discontented with the ugly things around them. Satisfied customers are not as profitable as discontented ones".[19]

And by 1958, the equivalence between the amounts of money spent on the construction of products and the production of consumers had become so systematised that J. K. Galbraith could present it to his readers as an economic law:

"A broad empirical relationship exists between what is spent on the production of consumer goods and what is spent in synthesizing the desires for that production. The path for an expansion of output must be paved by a suitable expansion in advertising budget."[20]

With the pressure on designers to provide "product identity" and "corporate image", a further refinement became possible: a single commodity could be used to promote a range of visually compatible objects produced by different divisions of the same corporation. An Olivetti typewriter or an IBM computer was an advertisement for itself and the company which produced it. The form functioned tautologically: it was a trademark in three dimensions. It "looked its best" in a "totally designed environment".

Developments such as these brought the practical aims of product and graphic design into a close proximity and this tendency to merge design functions became even more pronounced as multidisciplinary approaches – ergonomics and "management science" – emerged to displace the notion of designer "intuition" (see *The Practical Idealists*, J. P. A. Blake, Lund Humphries, 1969). By the end of the 1950s, the language of contemporary design, peppered with analogies from cybernetics and systems theory, was beginning to reflect the preoccupations with teamwork, integration and total planning which were to provide the dominant themes of the 1960s design boom. The dream of achieving a perfect symmetry between collective desires and corporate designs seemed at last on the point of fruition. An exaggerated formalism took root. The object itself would mediate between the needs of capital and the will of the masses: the consumer would be made over in the image of the object. In an article called "The Persuasive Image", which appeared in *Design* magazine in 1960, Richard Hamilton wrote:

The Persuasive Image: integrated design

"... the media... the publicists who not only understand public motivations but who play a large part in directing the public response to imagery... should be the designer's closest allies, perhaps more important in the team than researchers or sales managers. Ad man, copy writer and feature editor need to be

working together with the designer at the initiation of a programme instead of as a separated group with the task of finding the market for a completed product. The time lag can be used to design a consumer to the product and he can be 'manufactured' during the production span. Then producers should not feel inhibited, need not be disturbed by doubts about the reception their products may have by an audience they do not trust, the consumer can come from the same drawing board..."[21]

Mediation

Both Innocenti and Piaggio invested in aggressive advertising campaigns supervised by their own publicity departments. By the early 1950s, both companies were publishing their own magazines (in three or four European languages) and had formed their own scooter clubs with massive national, later international memberships. Through these clubs they organised mass rallies and festivals. They mounted exhibitions, sponsored (sometimes in conjunction with Via Secura, the Italian Road Safety Organisation) tours, trials, races, hill climbs, competitions. Against those interests which sought to discredit the scooter's performance, Innocenti and Piaggio set out to display its versatility and range, its resilience, its androgynous qualities ("feminine" and sleek but also able to climb mountains, cross continents...)

More than this, by controlling the structures within which the scooter was to be perceived and used, they were attempting to penetrate the realm of the "popular". The duty of manufacturers to the market was to extend far beyond the mere maintenance of production standards, the meeting of delivery dates. Now they were to preside over the creation of new forms of social identity, and leisure, a new consumer relation to the "look of things". The tests and trials, the spectacles, displays and exhibitions, the social clubs and magazines were part of a more general will – linked, as we have seen, to the expansion of productive forces – to superimpose the image of the factory on the world.

The four sections which follow deal with public representations of the scooter. Most of the detail is drawn from material put out by Innocenti during the 1950s and 1960s – promotional films, advertisements, copies of *Lambretta Notizario*, etc. This simply reflects the availability of sources – Piaggio's campaigns were no less intensive and incorporated similar themes.

The way in which the material itself has been organised is not entirely arbitrary: the narrative is ordered according to the dictates of an economic principle: the circulation of the Image precedes the selling of the Thing. Before looking at what the scooter came to mean in use, it is necessary to consider how it was made to appear before the market...

"The Age of the Product ended after World War 2 with industrial design's search to disperse, miniaturise and demater-ialise consumer goods".

(Ann Ferebee, A History of Design from the Victorian Era, *1970)*

Innocenti's decision to launch the ("dressed") CL and ("undressed") C Lambrettas simultaneously in 1951 determined once and for all the direction in which consumer preferences were moving in the transport field. It amounted to an unofficial referendum on the issues of styling and taste and the results were unequivocal: the scooter-buying public voted overwhelmingly for convenience, looks, an enclosed engine. The success of the CL merely confirmed the growing trend in product design towards "sheathing" – defined by one design historian as the encasement of "complex electronic parts in boxes that are as unobtrusive and easy to operate as possible".[22]

All these themes were foregrounded in the advertising campaigns and marketing strategies employed by Innocenti and Piaggio. Scooters were presented to the public as clean, "social appliances"[23] which imposed few constraints on the rider. Design features were cited to reinforce these claims: the panels enclosing scooter engines were easy to remove and the engines themselves were spread out horizontally to facilitate cleaning and the replacement of spares. The stub-axles made it simpler to remove the wheels and by the 1960s most scooters were designed to accommodate a spare. Elegance and comfort were selected as particularly strong selling points: the Lambretta was marketed in Britain as the "sports car on two wheels" and a variety of accessories – windscreens, panniers, bumpers, clocks, even radios and glove compartments were available to lend substance to the luxurious image. Innocenti's promotion policies tended to centre directly on the notion of convenience: an international network of service stations manned by trained mechanics was set up to cater for the needs of a new class of scooterists who were presumed to have little interest in even the most routine maintenance (though the stereotype of the "effeminate", "impractical" scooterist was resisted by the scooter clubs which encouraged their members to acquire rudimentary mechanical skills, to carry tool boxes, etc.). The concept of "trouble free scootering" was taken even further in Spain. At the height of the Continental touring craze in the late 1950s, Innocenti introduced a special mobile rescue unit called the Blue Angels to cope with Lambretta breakdowns and consumer complaints.

All these support structures can be regarded as extensions of the original design project: to produce a new category of machines, a new

type of consumer. The provision of a comprehensive after-sales service can be referred back ultimately to the one basic element which distinguished the D'Ascanio Vespa from its competitors – the disappearance of the engine behind a sleek metal cowling. The sheathing of machine parts placed the user in a new relation to the object – one which was more remote and less physical – a relationship of ease. As such it formed part of what Barthes described in 1957 as the general "sublimation of the utensil which we also find in the design of contemporary household equipment"[24] – a sublimation effected through the enveloping skin which served to accentuate the boundary between the human and the technical, the aesthetic and the practical, between knowledge and use. The metal skin or clothing added another relay to the circuit linking images to objects. It was another step towards an ideal prospect – the dematerialisation of the object; the conversion of consumption into life style.

The advertisement below incorporates many of the themes explored in the last two sections:

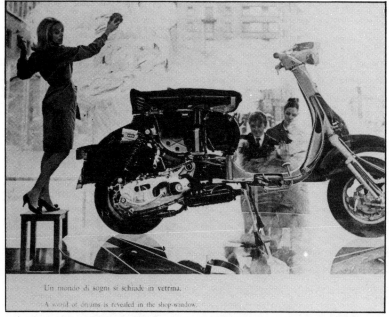

Un mondo di sogni si schiude in vetrina.

A world of dreams is revealed in the shop-window.

A machine, suspended on a circle of glass, is seen through a shop window. The voyeuristic relation is now a familiar one, familiar through the investment made by commerce in the Image, through the reiteration in similar advertisements of the same visual structure. (This is an early example of the genre. It is almost quaint. Almost innocent. The conventions have yet to be refined, obscured.) We look at them

97

looking. We circle round from "her" to "him" to "her", from the "girl" to the "boy" to the "mother" (that, surely, is implied). We have all come by now to recognise the indirect address: desire by proxy. We are all now visionary consumers. Placed through the geometry of looks in a precise relation to the dream machine – a revelation in mechanical parts, we gaze with them from "outside" at "her", the object of desire – the scooter/girl poised on their adjacent pedestals. The girl's posture is classical. It is Diana, naked, surprised in the wood: the heel slightly lifted, the mouth slightly open (provocative, ashamed). The model is "undressed". But a pane of glass intercedes between "her" and the boy. Its function is to mediate. This, at least, is made perfectly clear because the cleaning fluid masks it, makes it visible, opaque. The boy's hands, pressed against the glass, mark it as a barrier. Our glance is directed round a circle of glass, through the girl, through the glass, through the boy and his "mother", through a reflection of a scooter on a circle of glass. All looks are turned at last towards the centre of the image where the engine stands exposed – a still point at the centre of reflection. This is the place where we can all meet – "her" and "her" and "him" and "her" and you and I – the place where we can come into contact at a distance. A place where we can find contentment (where we can find the "content" of the "message"). The transference from "her" to "her", from the object-girl to the fetishised object – has taken place. At last – the object that was lost is found . . .

The mechanism which motivates our gaze is as naked as the machine which motivates the ad. The devices are laid bare: the caption reads: "A world of dreams is revealed in the shop-window". A historical transition is arrested in the composition of a single image: the dematerialisation of the object, the emergence of what Henri Lefebvre has called the "Display Myth":

"Consuming of displays, displays of consuming, consuming of displays of consuming, consuming of signs, signs of consuming"[25]

Fashion and the feminine

> *Sound:* 'The air hostess can become the pilot herself . . .'
> *image:* air hostess sprints across runway from plane to Lambretta;
> *sound:* '. . . and there's plenty of room on that pillion for a friend!'
> *image:* man in pilot's uniform leaps on behind her

(Sequence from Travel Far, Travel Wide, *promotional film, Innocenti for G.B., 1954)*

When Innocenti first began exporting Lambrettas to New York in the early 1960s (a time when, according to Vance Packard, the New York *cognoscenti* were turning from Detroit to Europe for their cars seeking that "Continental, squared off boxy look"[26]) scooters were displayed (and sometimes sold) not in car or motorcycle showrooms but in exclusive "ladies" fashion shops. They were thought to be a good thing to dress a window with, regarded less as a means of transport than as chic metal accessories, as jewellery on wheels.

Fashion items appeared regularly in issues of *Lambretta Notizario* (e.g., "one is all-too-frequently tormented by the sight of badly trousered women on motor scooters [sic] ... Hats? Any hat – provided it is practical and above all else – elegant.") A series of advertisements in the same magazine showed young women seated on scooters in a variety of contexts: the captions ran "On a Pic-nic", "Shopping", "In the Country", "By the Sea", "In the Busy City", etc. A reciprocal effect is achieved through the elision scooter/girl: the scooter's versatility is used to advertise the freedom enjoyed by "modern" young Italian women and vice versa (i.e., look at all the places "she" can visit, all the things "she" can do). These two creations – the new Italian woman (an image fixed and disseminated internationally by the post-War Italian film industry through stars like Anna Magnani, Silvano Mangano and Sophia Loren) and the new Italian scooter are run together completely in an article which appeared in the British weekly magazine, *Picture Post* entitled "A New Race of Girls" (5 September, 1954). The two inventions – "untamed, unmanicured, proud, passionate, bitter Italian beauties" – and the "clean, sporting Vespa scooter" are together alleged to have "given Italians the same sort of 'lift' that the creation of the Comet gave the British". The article is illustrated by a photograph of Gina Lollabrigida on a Vespa.

The scooter is singled out (along with "beauty competitions and films") as a catalyst in the "emancipation" of the new Italian woman ("the motor scooter gave her new horizons" ...) And it is held directly responsible for successive changes in Italian women's fashion since the War:

"The pocket handkerchief fashion which swept the women's world in 1949 was devised to keep a pillion girl's hair tidy at speed. The following winter, the headkerchief was developed by the Florentine designer, Emilio Pucci, into a woollen headscarf. Next year, the blown hair problem was solved by the urchin cut. The narrowing of the new look skirt was dictated in order to prevent it getting tangled up with the wheels. The slipper shoe was created for footplate comfort. The turtle neck sweater and the neckerchief were designed against draughts down the neck ... "[27]

The final sentence reads:

"By such means as this was the Italian girl's appearance transformed, and her emancipation consummated."

Tourism and the international context

"The entire world becomes a setting for the fulfilment of publicity's promise of the good life. The world smiles at us. It offers itself to us. And because everywhere is imagined as offering itself to us, everywhere is more or less the same"
(John Berger, Ways of Seeing *,1972)*

By 1951, Vespas were being manufactured under licence in Germany, France and Britain. Innocenti had a factory at Serveta in Spain and the motorcycle company NSU held the licence for Lambrettas in Germany until 1955. As the domestic market reached saturation point (by 1956 there were 600,000 two- and three-wheelers in Italy), Innocenti and Piaggio directed their attention towards Europe and the Third World. (Ironically enough, when Innocenti were forced to sell their scooter operation in 1972 (according to business history sources because of industrial disputes), it was taken over by Scooters India, a state-funded project based in Lucknow which still produces the "classic" Lambretta models of the 1960s.) By 1977, Vespa were exporting 289,000 scooters a year to 110 countries.

These new horizons were inevitably translated into advertising imagery. During the late 1950s, Innocenti ran a series of posters entitled "The Whole World in Lambretta", which showed scooters posed against Buddhist temples or busy London streets. The caption beneath a photograph depicting a group of Ghanaian scooterists in "folk costume" invoked the then fashionable notion of youth/style-as-a-universal: "Wearing a continental suit or a native dress does not change young people's taste for scooters." It was through strategies such as these that Innocenti and Piaggio could appropriate new markets and convert them into visual capital. One promotion ploy exemplifies the process clearly:

In 1962, Innocenti mounted a "world wide photographs" competition. Entrants were instructed to submit "holiday style" snaps of Lambrettas in "representative" national settings:

"For example: a street in Las Vegas with the signboards of the famous gambling houses, a picture of a Lambretta amidst the intense traffic of a street of a great metropolis like London, New York, Paris, etc., or against a background of forests, exotic

countries, natives in their traditional costumes, wild animals, monuments, and antique vestiges [sic] etc...."

Other conditions were stipulated: the Lambrettas should dominate the frame, be "well centred . . . if possible taken in close up". The "boys and girls" photographed on or directly adjacent to the scooter should be "young and sports looking" (sic). All photographs and negatives were to be retained "in INNOCENTI files as documentation" and could be used in any future "advertising exploit considered by INNOCENTI suitable for its purposes".

The competition rules lay out in a precise, accessible form, the criteria which shaped Innocenti advertising policy. The scooter was to be loosely located within a range of connotations – youth, tourism, sport – which were so open-ended that they could be mobilised literally anywhere in the world. In this way, it was possible to reconcile the different practical and symbolic functions which the scooter was likely to serve for different national markets. Ultimately Innocenti ads recognise only one collectivity: the "international brotherhood" of "boys and girls": they interpellate the world.

A film produced for Innocenti in 1954 *(Travel Far, Travel Wide)* equates "freedom" with physical mobility, with the freedom to "go where you please". Made against a background of sponsored global marathons and long-distance rallies (one, organised by Innocenti in 1962 went from Trieste to Istanbul), the film was designed to promote the touring potential of the larger "sporting" scooters. The closing image shows a group of young scooterists approaching a frontier. The voice-over reads:

"A frontier. And on the other side, a completely different way of life. But whatever country you go to in the world today, you'll find Lambrettas and Lambretta service stations".

This is the paradigm of tourism (everywhere is anywhere, everywhere is different) but here it is especially contradictory. On the one hand, the need for "national markets" and the impetus to travel demand that national characteristics, "different ways of life" be accentuated. On the other hand, trouble-free touring (complete with every modern convenience) and the construction of homogenous "modern" markets require the suppression of national differences and traditional cultures. "Youth" and "progress" mediate between these two demands: it is natural for youth to be different, it is the destiny of science to generate change. The scooter serves as the material bridge between different generations, different cultures, different epochs, between contradictory desires. It is a sign of progress. It is for the "young or young at heart". It

is a passport to the future. Freedom in space becomes freedom in time: "with a Lambretta you're part of the changing scene".[28]

The image of the factory

This image of the Innocenti works in Milan appeared as a logo on many of the early Lambretta ads. The image of the factory itself is the final mediation – the moment of production recalled at point of sale. The photograph, taken from an aeroplane, reduces an entire industrial complex to the status of a diagram (the reduction is a display of power in itself). We are left with an abstract "modern" pattern signifying progress, technology, resources: an echo of the image of the scooter.

The idealisation of production and production processes and the related image of the factory-as-microcosm are not of course confined to Innocenti's publicity campaigns. The same motifs can be found in the tradition which led to the development of Italian corporatism under Mussolini and to the "progressivism" of Giovanni Agnelli, head of Fiat during the period immediately after World War I. They lay behind Adriano Olivetti's attempts to establish "factory communities" and worker welfare schemes after World War II; they provided the moral and aesthetic basis for Olivetti's concept of "integrated design". And the images themselves derived originally from Marinetti, Sant'Elia and the futurists...

Factory

as

logo

A promotion film called *We carry on*, made in 1966 soon after Innocenti's death, clearly draws on this native tradition. (The film won first prize in the non-fiction class at Cannes in 1967. The pressure to enter an impressive ("artistic") product must have been intensified after 1961 when Piaggio won the same award.)

... The slow aeriel surveillance of the huge Innocenti plant which opens the film suddenly cuts to the production area. The camera work is determinedly "modern" and avant garde. A scooter is assembled before our eyes. As it moves along the line each stage in its construction is dramatised through the use of expressionist lighting, jump cuts and skewed camera angles. On the sound-track, harsh *musique concrete* further reinforces the image of inhuman automation and industrial power. The voice-over alternates between the sober recital of statistical facts (... "the production line is one mile long and one-third of a mile wide...") and "poetic" descriptions of technical processes. The style of the latter is "futurist baroque": – "The factory is a hothouse in which the flowers are pieces of machinery... the electro-magnetic test bed is the altar of destruction on which will be sacrificed the body of a Lambretta"... At one point, there is a montage sequence which recalls the earlier "World in Lambretta" series but the rapid juxtaposition of shots – a scooter parked near an oasis, in a city street, on a Mediterranean beach – marks

102

the conjunction of scooter and landscape as "bizarre". The contrasts are deliberately violent. (Surrealism in the service of industry: the film seems to have helped determine the stylistic conventions and the "strangeness" of many present-day (prestige) advertising films, e.g., the Benson and Hedges's "desert" series.) After an elegaic tribute to Innocenti (the camera circling respectfully round a plinth mounted with a bust of "our founder") the film ends with another aeriel shot as the camera sweeps across the workers' swimming pool and tennis courts to rest, at last, above the enormous central tower/panopticon. There is a slow final scan along the ranks of completed scooters waiting for dispatch on the factory forecourt... "machines which carry one name and one name only – a name which dominates the whole world". The soundtrack is dominated by the wail of a siren on top of the tower "calling his [i.e., Innocenti's] people to work.... He is gone but we shall carry on... "

The power

The scooter in use

The final sections are designed to explore some of the "cultural meanings" which became attached to the scooter as it was used in Britain.

of

The reception in Britain

a) The motorcycle industry

> "Look, here's a beauty for you. She buys a scooter for a hundred and forty pounds and then she wants to know where the spark comes from"
> > *(Motorcycle dealer, quoted in Jan Stevens,* Scootering, *1966)*

> "Imports of foreign motorcycles and scooters into Great Britain for the first six months of 1954 – 3,318; for the first six months of 1956 – 21,125;"
> > *(Figures from J. Symonds, "Where are the British Scooters",*
> > Design *no. 94, 1957)*

reproduction

The first Italian scooters appeared in Britain in the early 1950s. Innocenti and Piaggio opted for different distribution strategies. Piaggio granted a manufacturing licence to the Bristol-based Douglas Motorcycle Company in 1951 and, in the same year, P. J. Agg and Son were registered as the Lambretta Concessionaires importing Innocenti's scooters from the Continent. Sales and marketing were also handled differently by the two companies. Innocenti advertising tended to be

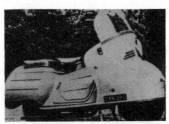

**The Maicolette
(The Dustbin)**

pitched more directly at the image-conscious youth market and by 1960 the Agg concessionaires had established a nationwide network of over 1,000 service stations and, for the first time in Europe, had secured a market lead for Innocenti over Piaggio.

By the mid-1950s the Italian scooter was beginning to represent a threat to the British motorcycle industry which until World War II had dominated the international market. Demand for the traditionally heavy, high performance machines which British manufacturers produced had been declining steadily since 1945. Within ten years, the trend had become pronounced: at the 1955 Earl's Court Motor Cycle Show, three motorcycles were on a display competing against fifty new scooters.

British manufacturers were eventually forced into scooter production though the transition from heavy, utilitarian vehicles to light, "visually attractive" ones was never satisfactorily accomplished. (The BSA Dandy, for instance, had narrow legshields and footboard, and there was none of what Stephen Bayley has described as the "beautiful clothing"[29] of the Vespa or Lambretta.) However, the initial response was one of scorn and dismissal. All the criticisms levelled by the Italian motorcycle industry in the 1940s were revived. Scooters were defined as "streamlined" and "effete". The original sales line – that this was a form of transport which (even) women could handle – was turned against itself. Scooters were not only physically unsafe, they were morally suspect. They were unmanly. They ran counter to the ethos of hard work, self-sufficiency and amateur mechanics upon which the success of the British motorcycle industry and the prevailing definitions of masculinity – the "preferred readings" of manhood – were based.

These objections, formed at least partly in response to commercial pressure, percolated down throughout the motorcycle producer, retail and user cultures. Motorcycle shops, many of them owned by former TT veterans, refused to stock the "gimmicky" new machines, to finance service facilities, or to employ mechanics. The reluctance to legitimate scooters and scooterists lingered on within the motorcycling fraternity. The scooter remained, for "committed" motorcyclists, a sexed (and inferior) object. As recently as 1979, an article appeared in *Motorcycle Sport* which invoked all the old categories and prejudices. The article, entitled "Is the Scooter making a comeback?" consists of an apparently neutral assessment of scooter performance. The writer endorses only the more powerful machines. The German Maicolette (known in the early 1960s as the "dustbin" amongst those British scooterists with Italianate tastes) is praised for "its beefy two-stroke engine. It could romp along at a confident 70mph holding the road like a motorcycle . . . it went like a rocket."[30] The author concludes by extracting the "essence" of "motorcycling sport" – its complexity, "depth", power, its solitary

nature – and contrasting these qualities against the "superficial", "social" "fun" of scootering: "Naturally", the gender of the ideal motorcyclist is beyond question.

> "... motorcycling is a much more complex sport than scootering... the enjoyment springs from the pure isolation aboard a fast solo when the rider, for a brief spell, is beyond authority and is in control of his own destiny. Motorcycling is fun of a multi-dimensional variety. Scootering is pleasure of the more superficial sort."[31]

b) Design

> "Somewhere on the lower slopes of clique acceptance was the popular Italian craze which dominated British taste in the later 1950s and which found expression in the vogue for products like motor scooters... Olivetti typewriters... Espresso coffee machines..."
>
> *(Stephen Bayley,* In Good Shape, *1979)*

Those "superficial" qualities which were interpreted negatively by the motorcycling industry – the social aspects and the look of the scooter – were regarded as positive assets by those working in the design field, at least by those young enough to appreciate the beauty of a mass-produced but "well-shaped" machine. The emergent Modern consensus in design which was to become dominant during the 1960s closed more or less unanimously around the Italian scooter and held it up to British industrialists as an example of what a good design should look like. As an everyday artefact invested with some standards of style and utility but which still managed to satisfy all the key criteria: elegance, serviceability, popularity and visual discretion – the scooter fulfilled all the modern ideals.

At least that was the opinion circulated amongst the "select band of glossy monthly magazines" which, as Banham puts it, decides "who shall see what"[32] in the design world. Indeed, the first article in the inaugural issue of one of the most influential of the post-War journals was entirely devoted to the "Italian look". Writing in *Design* (January, 1949), F. K. Henrion compiled a list of tasteful artefacts which "have together transformed the appearance" of Italian city life. He singled out cars, furniture, ceramics and a Gio Ponti coffee machine. But the Vespa scooter – "a virtual institution" was especially commended:

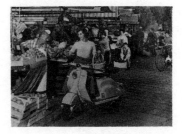

> "... the most important of all new Italian design phenomena is without doubt the Vespa. This miniature motorcycle, streamlined and extremely pleasant to look at, has become an important factor in Italian village and town life".[33]

Henrion drew attention to the scooter's flexibility in use and its capacity for bridging markets:

> "... you see businessmen with briefcases, commercial travellers with boxes of samples on the vast floorspace. In the evenings, you see young couples ... at weekends, mother, child and father on picnics. You see these machines parked side by side in front of Ministries and it is surprising how many people afford them at a price equivalent to £80".[34]

Finally he placed the significance of the Vespa in the context of an overall "Italian style", as part of the "second Italian renaissance":

> "I seemed to sense a similarity of aesthetic values amongst different products – a similarity which, seen from a distance of many years, might be called the style of the mid 20th Century".[35]

Throughout the 1950s and early 1960s, Italy tended to epitomise for young, trendsetting British designers, everything that was chic and modern and "acceptable", particularly in automobile and (through magazines like *Domus*) interior design. The cult of the individual designer-as-genius – as a modern Renaissance man blending mathematical skills and artistic flair – seems to have grown up largely round a few Italian names – Ponti, Ghia, Pininfarina, Nizzoli, etc. Sometimes the "superiority" of the Italian design is "explained" through its relationship to fine art (e.g., futurism). Ann Ferebee, for instance, compares streamlined Italian products to Boccioni's *Unique Forms of Continuity in Space* and praises "sheathed" Italian transport for its "sculptural elegance".[36] And always the "refinement ... and purity ... of line" – in this case of Pininfarina's 1947 Cisitalia Coupe – is valorised because it sets "alternative standards against the baroque styles [then] emerging in America".[37] All these qualities and effects have been attributed at different times to the Italian scooter. It has become installed in the mythology of good Italian taste. It has now become an "object lesson": it is the only entry for 1946 in Stephen Bayley's *In Good Shape* – it stands in for its time.

A clash, then, between two "official" versions of the scooter, between two divergent interests. A "clash of opinion" between, on the one hand, a declining heavy engineering industry with a vested interest in preserving the market as it stands, with a fixed conception of both product and market, with material resources geared towards the reproduction of that market, the production of a particular design genre, with a set of established cultural values to mobilise in its defence; on the other, a design industry on the point of boom, with a vested interest in transforming the market, in aestheticising products and

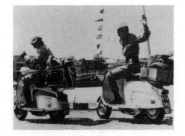

"educating" consumers, with material resources geared toward the production of a new commodity – Image – with an emergent set of cultural values (a new formation of desire) to articulate and bring to fruition. The Italian origins of the scooter function differentially within the two systems. In the first, "Italianness" defines the scooter as "foreign competition" and doubles its effeminacy (Italy: the home of "male narcissism"). In the second, it defines the scooter as "the look of the future" and doubles its value as a well-designed object (Italy: the home of "good taste").

The object splits. And is re-assembled in use...

The scooter clubs

By the mid-1950s, there were British branches of the Lambretta and Vespa user clubs, co-ordinated from separate offices in Central London and sponsored by the Douglas Company and the Agg Concessionaires. Both provided monthly magazines (*Vespa News*, *Lambretta Leader*, later *Jet-Set*). While these organisations were clearly modelled on the lines of the Italian clubs and served a promotional and public relations function, they tended to be less rigidly centralised and local branches, run by amateur enthusiasts, were allowed to organise their own affairs. Moreover, some of the larger branches had their own names – the "Bromley Innocents", the "Vagabonds", the "Mitcham Goons" – their own pennants, badges and colours and, in their informal character, and strong regional affiliations, they bore some resemblance to the pre-War cycling clubs. In the 1950s and early '60s the mass rallies and organised scooter runs were a major attraction for club members. As many as 3,000 scooterists would converge on Brighton and Southend for the National Lambretta Club's annual rally where, at the service marquee, set, according to one enthusiast, amidst "banners and flags, bunting and a Carnival atmosphere... your Lambretta would be repaired and serviced entirely free of charge".[38] During the evenings, there would be barbecues, fancy dress competitions and dances ("... this was the day of Rock and Roll... Marty Wilde, Tommy Steele, Adam Faith... ").[39] One of the socially cohesive elements at these events, at least for many of the younger club members, was a shared prediliction for Italy and "Italianate" culture. The clubs organised "Italy in Britain" weeks to foster the connection. At the Lambretta Concessionaires' headquarters in Wimbledon, an espresso coffee machine dispensed "free frothy coffee" for club members who brought their machines in to be serviced.[40] One of the records played at the Southend rally dances in the early 1960s was an Italian hit entitled the *Lambretta Twist*...

As more scooters came on to the market (by 1963, there were twenty-two different firms selling scooters in Britain), the emphasis shifted on to

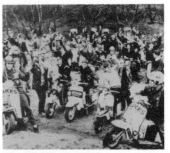

The Epping rakes: scootering Run

107

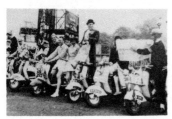

Scooter rally:
Alexandra Palace

the competitive events, which tended to be dismissed by the motorcycling contingent as "rally-type stuff of an endurance nature".[41] It seems likely that the British scooter clubs were particularly receptive to the idea of competition because it offered a means of counteracting the stigma (of "effeminacy" and "shallowness") which had been attached to the sport in its earlier "social" phase. Innocenti developed the 200cc Lambretta specifically to meet the demands of the Isle of Man Scooter Rally which, by the late 1950s, had become the most important event of its kind in Europe. Quite apart from the racing and the track events, there were scooter expeditions to the Arctic circle, non-stop runs from London to Milan, ascents of Snowdon on a scooter with a side-car: feats of lone heroism which were intended to display the toughness and stamina of both rider and machine. Some of these gestures had a positively epic quality: one scooterist crossed the English Channel using a Vespa to operate paddles fitted to floats.[42] Club scootering became more muscular, scooter runs longer, trials more arduous. Scooter Tours, an extension of the Lambretta Club of Great Britain, provided couriers to lead "snakes" of up to forty scooters to Switzerland, Austria and Germany.

As the demand for scooters began to level out (i.e., around 1959) the pressure to win races and break records grew more intense. "Friendly competition" sometimes gave way to open rivalry and these tensions tended to filter down from the works teams to the ordinary badge-wearing members. The younger, more ardent club supporters began marking out their loyalties in dress. The "blue boys", for instance, wore sharply cut suits in royal blue – the Lambretta club colour. These rivalries were underscored by the distribution policies of the two firms: dealers were licensed to sell only Vespas or Lambrettas.

Nonetheless, competitiveness never totally dislodged the frame which had been imposed upon the sport at its inception: the "social aspects" with their attendant connotations of health, open air and cheerful cameraderie. This ideal was reflected in the actual composition of the clubs themselves. Subscriptions were not restricted to a single class or age group (though it seems plausible that there was a bias towards relatively young people (i.e. sixteen to thirty-five) from "respectable" working-class and lower middle-class backgrounds). Female scooterists figured as prominently as the men, at least on the non-competitive circuit...

Piaggio and Innocenti publicity departments regarded the inclusion of a Vespa or Lambretta in a feature film as a major advertising coup. Film directors were solicited to promote the firms' products. Stars were photographed on set (sometimes in period costume) seated on the latest scooter model.

muscular scootering

In the early 1960s, two films appeared both of which were, in a sense, made around the Italian scooter (and Cliff Richard): *Wonderful Life* (which featured the Vespa) and *Summer Holiday* (which co-starred the Lambretta). These films articulate precisely the ideal of the "fun-loving" collective which hovers over the literature, the rallies and the "socials" of the early scooter clubs, and they recapitulate many of the themes encountered in the scooter ads: "tourism", "youth", "freedom" and "fashion". All these categories were brought together in the image of Cliff Richard and a group of "zany", "up-to-date" but good-hearted youngsters off on their scooters in search of a continental coast-line, a holiday romance . . .

The Mods

During the mid-1960s, Italian scooters became wedded, at least as far as the British press and television were concerned, to the image of the mods (and rockers) – to the image of "riotous assembly" at the coastal resorts of Southern England. (The marriage has yet to be dissolved: a feature made in 1979 for the television programme *About Anglia* on the Lambretta Preservation Society (a "respectable" offshoot of the old scooter clubs) began, as a matter of course, with documentary footage of the clashes in 1964 at Margate and Brighton.) The words "social scootering" had formerly summoned up the image of orderly mass rallies. Now it was suddenly linked to a more sinister collective: an army of youth, ostensibly conformist – barely distinguishable as individuals from each other or the crowd – and yet capable of concerted acts of vandalism. The mods and the scooter clubs, the "Battle of Brighton", 1964, and the Brighton runs of the 1950s, were connected and yet mutually opposed. They shared the same space like the recto and verso of a piece of paper. After the "social aspects", the "anti-social"; after *Summer Holiday, My Generation* . . .

The "dressed" image

> "Everyone was trying to look like a photograph, as smooth and as flat as a page in a magazine . . . Everyone wanted to catch the light . . . "
>
> *(Joan Buck,* Whatever Happened to the British Model?, *Harpers & Queen, 1980)*

" . . . and even here in this Soho, the headquarters of the adult mafia you could everywhere see the signs of the un-silent teenage revolution. The disc shops with those lovely sleeves set in their windows . . . and the kids inside them purchasing

guitars or spending fortunes on the songs of the Top Twenty.
The shirt-stores and bra-stores with cine-star photos in the
window, selling all the exclusive teenage drag... The hair-style
salons... The cosmetic shops... Scooters and bubble-cars
driven madly down the roads by kids, who, a few years ago
were pushing toy ones on the pavement... Life is the best film
for sure, if you can see it as a film... "
(Colin Macinnes, Absolute Beginners, *1959)*

The first wave of modernist youth emerged in or around London in the
late 1950s. Most commentators agree on certain basic themes: that Mod
was predominantly working class, male-dominated and centred on an
obsessive clothes-consciousness which involved a fascination with
American and Continental styles. The endorsement of Continental
products was particularly marked.

The Dean in Colin MacInnes's *Absolute Beginners* (1959) is a
"typical" (i.e., ideal) early modernist:

"College-boy smooth crop hair with burned-in parting, neat
white Italian rounded-collared shirt, short Roman jacket very
tailored (two little vents, three buttons) no turn-up narrow
trousers with seventeen-inch bottoms absolute maximum,
pointed toe shoes, and a white mac folded by his side...".[43]

His (unnamed) girl friend is described in similar detail:

"... short hem lines, seamless stockings, pointed toe high-
heeled stiletto shoes, crepe nylon rattling petticoat, short blazer
jacket, hair done up into the elfin style. Face pale-corpse colour
with a dash of mauve, plenty of mascara...".[44]

But here the absence of precise calibration (no twos or threes or
seventeens) pinpoints her position within the signifying systems of both
the novel and the subculture itself. In the same way, though her style is
rooted in the Italian connection, derived in all likelihood from the "new
race of [Italian] girls," this isn't stated. The Dean, on the other hand, is
defined through a geography of dress. He is English by birth, Italian by
choice.

According to sociological and marketing sources, Mod was largely a
matter of commodity selection.[45] It was through commodity choices
that mods marked themselves out as mods, using goods as "weapons of
exclusion"[46] to avoid contamination from the other alien worlds of
teenaged taste that orbited round their own (the teds, beats and later
the rockers).

Mods exploited the expressive potential within commodity choice to
its logical conclusion. Their "furious consumption programme" –

clothes, clubs, records, hair styles, petrol and drinamyl pills – has been described as "a grotesque parody of the aspirations of [their] parents" – the people who lived in the new towns or on the new housing estates, the post-War working and lower-middle-class...[47] The mods converted themselves into objects, they "chose" (in order) to make themselves into mods, attempting to impose systematic control over the narrow domain which was "theirs", and within which they saw their "real" selves invested – the domain of leisure and appearance, of dress and posture. The transference of desire ("... their parents'... aspirations...") on to dress is familiar enough. Here the process is auto-erotic: the self, "its self" becomes the fetish.

When the Italian scooter was first chosen by the mods as an identity-marker (around 1958–9 according to eye witness accounts[48]), it was lifted into a larger unity of taste – an image made up out of sartorial and musical preferences – which in turn was used to signal to others "in the know" a refinement, a distance from the rest – a certain way of seeing the world. Value was conferred upon the scooter by the simple act of selection. The transformation in the value of the object had to be publicly marked:

> "There was a correct way of riding. You stuck your feet out at an angle of forty-five degrees and the guy on the pillion seat held his hands behind his back and leant back..."[49]

proto-mod: contestant
in best-dressed
scooter competition
(early '50s)

Sometimes the object was physically transformed. According to Richard Barnes,[50] Eddie Grimstead, who owned two scooter shops in London during the mid-1960s, specialised in customising scooters for the mods. The machines were resprayed (Lambretta later adopted some of Grimstead's colour schemes) and fitted with accessories: foxtails, pennants, mascots, chromium, horns, extra lights and mirrors, whip aerials, fur trim, and leopard-skin seats. Such features extended the original design concept organically.

Although the scooter imposed no constraints on the rider's dress (this, after all, was what had originally made the scooter "suit-able" for the fashion-conscious mods), a style became fixed around the vehicle – a uniform of olive green (parka) anoraks, levi jeans and hush puppies. Sometimes French berets were worn to stress the affiliation with the Continent and to further distinguish the "scooter boys" from the rockers whose own ensemble of leather jackets, flying boots and cowboy hats signalled an alternative defection to America, an immersion in the myth of the frontier.

The innovative drive within Mod, the compulsion to create ever newer, more distinctive looks was eventually to lead to another customising trend, one which, once again, seems to contradict the logic of the scooter's appeal. As the banks of lights and lamps began to

multiply, a reaction set in amongst the hard core of stylists – scooters were stripped: side panels, front mudguards, sometimes even the footboards, were removed and the remaining body-work painted in muted colours with a matt finish.[51] These were the last, irreverent transformations. By this time Mod had surfaced as a set of newspaper photographs and Bank Holiday headlines. Fixed in the public gaze, Mod turned, finally, against itself. After baroque, minimalism: the image of the scooter was deconstructed, the object "re-materialised" . . .

The aestheticisation of everyday life

> "It'll be a great day when cutlery and furniture swing like the Supremes."
>
> *(Michael Wolff writing in the* SIA Journal, *in 1964)*

However, Mod's significance (and influence) stretched beyond the confines of the subcultural milieu. It was largely through Mod that the demand for more "sophisticated" and autonomous forms of teenaged leisure was expressed. And provision expanded accordingly. By 1964, the coffee bars, "Shirt-stores and bra-stores" of MacInnes's *Absolute Beginners* had given way to discotheques and boutiques. There was now a Mod television programme, *Ready, Steady, Go* (opening sequence: Mod on scooter at traffic lights/voice-over: "The Weekend Starts Here . . ."). There was a thriving teenaged fashion industry in London based on Carnaby Street and the Kings Road. There were bowling alleys, Wimpey bars and no less than six weekly magazines aimed directly at the Mod market.[52]

At a more general level, Mod highlighted the emergence of a new consumer sensibility, what Raymond Williams might call a "structure of feeling", a more discriminating "consumer awareness". It was, after all, during the late 1950s when the term "modernist" first came into use, that the Coldstream Council recommended the expansion of Design within Higher Education, that Design Departments were set up in all the major art schools, that royal patronage was formally extended to industrial design,[53] that the Design Centre itself opened in the Haymarket, that magazines like *Which?*, *Shopper's Guide*, *Home* and *House Beautiful* began publicising the ideas of "consumer satisfaction" and "tasteful home improvement". And it was in 1964 when "mod" became a household word, that Terence Conran opened the first of the Habitat shops which, according to the advertising copy, offered "a pre-selected shopping programme . . . instant good taste . . . for switched on people".[54]

The mirrors and the chromium of the "classic" Mod scooter reflected not only the group aspirations of the mods but a whole

historical Imaginary, the Imaginary of affluence. The perfection of surfaces within Mod was part of the general "aestheticisation" of everyday life achieved through the intervention of the Image, through the conflation of the "public" and the "personal", consumption and display. In 1966, a Wolverhampton reader of a national newspaper felt concerned enough about a "decorating problem" to write in for advice:

> "I have painted walls and woodwork white and covered the floors with Olive Sullivan's 'Bachelor's Button' carpet in burnt oak orange chestnut. Upholstery is Donald Bros unbleached linen mullein cloth. Curtains are orange and in a bright Sekers fabric and I am relying upon pictures, books, cushions, and rug for bright contrasting accessories. I have found a winner in London Transport's poster 'Greenwich Observatory' which I think looks marvellous against the white walls."[55]

The separation of a room into its parts (each part labelled, placed), of a suit into its "features" (each button counted, sited on a map) spring from a common impulse. Together they delineate a new disposition. The reader's room in Wolverhampton, the Dean's suit in Soho – both are "integrated structures", designed environments. Both are held in high regard. They are subjected to the same anxious and discriminating gaze. This is the other side of affluence: a rapacious specularity: the coming of the greedy I.

Brighton revisited revisited

In 1964, on the stately promenades of the South Coast resorts, a battle was enacted between two groups of adolescents representing different tastes and tendencies. The seaside riots provided a spectacle which was circulated as an "event" first as news, later, as history (the film *Quadrophenia* appeared in 1979). The spectacle "just happened" to be watched ("... one local paper carried a photo of a man amongst a crowd of boys swinging deck-chairs holding his child above his head to get a better view... "[56]).

According to a survey conducted at Margate, the mods tended to come from London, were from lower-middle- or upper-working-class backgrounds and worked in skilled or semi-skilled trades or in the service industries. (Jimmy, the hero of *Quadrophenia*, is presented as a typical mod, he works as an office boy in a London advertising agency....) The rockers were more likely to do manual jobs and to live locally.[57] Most observers agree that mods far out-numbered rockers at the coast. When interviewed, the mods used the words "dirty" and "ignorant" to typify the rockers. The rockers referred to the mods as "pansy" and "soft".

The clash of opinion between design and motorcycling interests, between service and productive sectors, "adaptive" and "outmoded" elements was translated at Brighton and Margate into images of actual violence. The rocker/mod polarity cannot be so neatly transposed into options on gender (i.e., sexist/counter-sexist). Apparently, girls occupied equally subordinate positions within both subcultures. Male mods sometimes referred to girlfriends as "pillion fodder". There were proportionately fewer girls driving scooters within the mod subculture than outside it in the "respectable" scootering community...

The Mod revival

> "The scooter fanatic of eighteen to twenty really doesn't know what it is about. It isn't impossible to be Mod [in 1980], they just go about it the wrong way – a scooter was a means of transport. You didn't worship it... "
>
> *(Original Mod quoted in* Observer Magazine, *1979)*

The disappearance of the service stations, the recession, small Japanese motorcycles, compulsory crash helmets, Scooters India, the Red Brigades: the original "network of relations" transformed over time, and with it the object, and the relationship of the user to the object.

The scooter is "undressed": all new mods are amateur mechanics. The shortage of spare parts and the collapse of the support structure of garages mean that more scooterists are forced to service and maintain their own machines.

Conclusion

In the *Evening Standard* (24 February, 1977), a Mr Derek Taylor, "one of these new fashionable middle-management people", explained why he had sold his car and bought a secondhand Lambretta:

> "... with road tax at £4 a year, insurance £12 and petrol consumption of nearly 100mpg, I reckon I'm on to a good buy... I still enjoy my comfort and want to get to work in a clean and presentable condition... "

Fashion remains a significant vector but its significance resides in the fact that it can be turned in on itself: "... fashion takes a back-seat, but the practical scooter man has all the accessories on board (monsoon-proof mac... RAF long johns)..." (ibid.)

The fashion paradigm is punctured by the practical scooter-man. The fuel crisis and the plight of the *Evening Standard*'s "neglected" middle-management have redefined the object (some traces linger... "comfort

... clean ... presentable''). The image falls off into irony.

On the London Underground, a new poster advertising the "more attractive angular look"[58] of the "New Line" P range Vespa takes its place alongside the Suzuki and the Mini Metro ads, the images of Adonis briefs, the Elliott twins and the "This Insults Women" stickers. The Italian scooter cycle kicks off again in slightly higher gear ...

Late 50s: Italianicity

Chapter 5

In Poor Taste: Notes on Pop

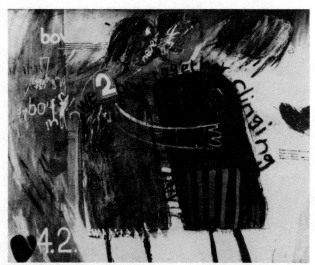

David Hockney, We Two Boys Together Clinging

"Pop was meant as a cultural break, signifying the firing squad without mercy or reprieve, for the kind of people who believed in Loeb classics, holidays in Tuscany, drawings by Augustus John, signed pieces of French furniture, leading articles in the *Daily Telegraph* and very good clothes that lasted forever...
(Reyner Banham)

One thing I dislike more than being taken too lightly is being taken too seriously. *(Billy Wilder)*

David Hockney painted *We Two Boys Together Clinging* in 1959. It exhibits many of the qualities characteristic of Hockney's later work – a self-consciously deployed pictorial naivete which is contradicted by the accomplished and painterly manner in which that naivete is com-

116

municated... hence subverted... and there is the reference to homosexual love: two boys and a black heart in the left-hand corner. There is nothing particularly "pop" about it. It comes as some surprise, then, to learn the apparent source of inspiration. For, like the earlier Hockney painting, *Doll Boy* – a reference to the record [*Got Myself*] *a walking, talking Living Doll* – this painting was originally suggested, according to the artist's own account, by a chance association with Cliff Richard...

According to the catalogue *Pop Art in England*, produced in 1976 for the York City Gallery and translated somewhat awkwardly from the original German, Hockney was partly inspired by a line from a Walt Whitman poem. But what clinched the painting (and its title) was a newspaper headline which had caught Hockney's eye. It read "Two Boys Cling To Cliff All Night":

> "... at first glance, Hockney had thought that this meant Cliff Richard, to whom at that time he felt himself very strongly drawn; but it actually referred to a cliff.[1]

The apparently chance association with what was then regarded in fine art circles as the netherworld of popular music and the laconic, deadpan manner in which Hockney "explains" the reference and the painting are pure pop. The canvas has been polluted not by the homosexual allusions – homoerotic art was, even in the 1950s, within limits permissible – as old as ancient Greece, as old, at least, as the Yellow Book. But the incorporation of ersatz motifs drawn from commercial pop culture represented a new turn of the screw in the art of *épater les bourgeois*.

Pop art and pop art critics were drenched in the rhetoric of the most despised forms of popular culture. They used the most soiled and damaged currency. This is how Richard Smith, writing in the Royal College's house journal, *Ark*, in 1960, described David Hockney's "curtain of fantasy":

> "[It is] as essential as Bardot's towel. Hockney's range may be narrow as the lapels on his jacket but within his terms, he has made a highly successful, personalised statement...[2]

The logic of this analogy is immaterial. What matters is the style of the review, the references to fashion, to the forbidden ephemera, to the details and the dress. That is what counts together with the implication secreted within it, that the traditional hierarchical ranking of art and design – a ranking established during the Renaissance – moving down in descending order of merit, importance and spiritual value from fine art through graphics to the decorative arts has been overthrown and cast aside. And with this, another implication – that the disruption of

established formal values signals the collapse not only of aesthetic boundaries but of the principle of exclusivity – of social segregation – which those boundaries are erected to maintain: the return (yet again) of the repressed: art's sacred vessel seized by a gang of low-born pirates. This implication is echoed four years later by Jonathan Miller writing in the *New Statesman*:

> "There is now a curious cultural community, breathlessly *à la* Mod where Lord Snowdon and the other desperadoes of the grainy layout jostle with commercial art-school Mersey stars, window dressers and Carnaby Street pants-peddlers. Style is the thing here – Taste 64 – a cool line and the witty insolence of youth."[3]

A similar convergence of previously segregated social types occurs in New York at around the same time. A bright, brittle ambience was created in the lofts and galleries of Manhattan in which fashion, fine art, photography and film provided a platform for a new kind of cultural entrepreneur: the artist-as-star.

Warhol pictured here is indistinguishable from his mannequins. His studio is indistinguishable from a film set; flesh indistinguishable from plastic; fine art from fashion. This could *be* a fashion photograph.

The rise of pop art in New York was associated with the emergence of a *nouveaux riches* art market – socially ambitious, upwardly mobile, epitomised by Tom Wolfe in the person of Robert C. Scull, former cab-driver turned executive and pop art collector. Scull, the man who bought Jasper Johns' beer cans from Leo Castelli in 1965 and who was the subject of one of Wolfe's cruellest and most telling cameos, an essay which originally appeared in *New York* magazine under the title "Upward with the Arts".

Bob Scull, the man whose motto was "Enjoy. Enjoy", the man who walked into a Savile Row tailor's when on a trip to London and ordered, in the face of frosty Anglo Saxon opposition, a sports jacket in traditional riding pink. Tom Wolfe describes the first fitting a week later:

> "... they bring out the riding pink, with the body of the coat cut and basted up and one arm basted on, the usual first fitting, and they put it on him – and Scull notices a funny thing. Everything has stopped in the shop. There, in the dimness of the woodwork and bolt racks, the other men are looking up towards him, and in the back, from behind the curtains, around door edges, from behind tiers of cloth, are all these eyes, staring.
>
> Scull motions back toward all the eyes and asks his man, 'Hey, what are they doing?'

The man leans forward and says, very softly and very sincerely, 'They're rooting for you, sir.'
Enjoy! Enjoy!"[4]

Robert C. Scull, seated here at the family table with his wife Spike in front of a new Rosenquist - dinner served by the family maid. The photograph, by Ken Heyman, is another cruel lampoon. The room could be an "environment" from a Duane Hanson exhibition - the figures modelled in wax or plaster. The title of the piece would be (in capitals of course) EAT, subtitle in lower case: enjoy! enjoy!

And yet, Sidney Tillim writing in *Art Forum* in 1965 could say:

"The pop art audience, as arrogant and *arriviste* as much of it is, is involved with art in a way that I think no American art public has been involved before. It is concerned less with art, with quality than with the release of a spirit that has been repressed by its subservience to an idea of culture essentially foreign to its audience. The pop audience is tired of being educated, tired of merely *good* art."[5]

Pop art clearly forms part of that quest for an American vernacular in which European pictorial conventions are seen to re-present, however obliquely, a rigid and alien social structure, a hierarchy of taste, which is essentially European, where "taste" functions as a marker between the social classes, where "good taste" is inscribed above a door which is reserved for "Members Only".

Mark Twain had stood outside that door a hundred years earlier when, in 1867, he boarded the ship *Quaker City* for the very first American package tour of Europe. In Italy, as the first of Scott Fitzgerald's "fantastic neanderthals", he *suffered* the ruins, the art works and the gondoliers and when he returned home he wrote:

"I never felt so fervently thankful, so soothed, so tranquil, so filled with blessed peace as I did yesterday when I learned that Michelangelo was dead."[6]

In pop - in the figure of Bob C. Scull - Mark Twain and America finally had their revenge on Europe.

This is undoubtedly familiar territory: part of pop's copious folk lore.

However, that a "serious" discussion of pop, should be introduced via anecdote and trite analogy is appropriate because I shall be arguing that pop's contribution to "cultural politics" lies precisely in the manner in which it is served to problematise those two terms, "culture" and "politics", by abandoning the tone (of solemnity, of "seriousness") in which any "radical" proposal in bourgeois art and art criticism -

avant garde or otherwise – is conventionally presented. The brief glances above at London and New York pop in the 1960s encapsulate the themes I want to touch on here:

(i) what might be described as pop's deictic function – the way in which it can be used to point up the complicity between aesthetic taste, and economic and symbolic power.

(ii) Pop as an inspired move in the culture game, the object of which is to fix the shifting line between "sensation" and "spirit", "low" and "high", "art" and "non-art" – categories which Bourdieu has shown to be coterminous.

(iii) Pop art as a strategy in another "taste war" (the same war, in fact, fought along a different front) between the Old and New Worlds, between an America which, as Leslie Fiedler puts it, "has had to be invented as well as discovered"[7] and a Europe with its long literary and aesthetic traditions, its complex codings of class and status – between, that is, two continents and a history, between two symbolic blocs: "Europe" and "America".

(iv) Finally, less grandly but no less seriously, pop as a discourse on fashion, consumption and fine art; pop as a discourse on what Lawrence Alloway called in 1959, "the drama of possessions":[8] pop as a new suit of clothes: a sports jacket in riding pink with narrow lapels.

The emphasis will fall mainly on British pop though comparisons will be drawn wherever these are relevant with the work of American pop artists and the critical reception pop art received in the States.

A detailed exposition of the full history of British pop is neither necessary nor possible here. Suffice it to say that it's generally agreed that the development of British pop art falls into three approximate phases. The first is associated with the work of the Independent Group at the ICA and spans the years 1952–5. This is generally understood as the period of pop's underground gestation during which the members of the group and, most especially, Eduardo Paolozzi and Richard Hamilton developed many of the obsessional motifs and represen-tational techniques which were later to surface to such sensational effect, though in a slightly different form, within the Royal College of Art during the second and third phases. The second phase is usually dated from 1957–9 and is associated with the early work of Peter Blake and Richard Smith.

The third stage during which British pop is seen to emerge as a distinct, more or less coherent movement (though it is often conceded that pop was, in fact, never much more than an ad hoc grouping

together of Young Contemporaries) is generally held to incorporate at least some of the early work of Derek Boshier, Patrick Caulfield, David Hockney, Allen Jones, Ronald Kitaj and Peter Philips. It was during this phase that pop attracted an enormous amount of publicity, thanks partly to the exposure afforded by the annual Young Contemporaries' exhibitions and by the Ken Russell television documentary *Pop Goes the Easel* which was broadcast in 1962 and which helped to establish the stereotype of the young, iconoclastic and highly-sexed male pop artist whose "lifestyle", to use another 1960s keyword, was conspicuously in the Swinging London mode. The programme also helped to fix pop art in the public imagination as the corollary in the visual arts of the British beat and fashion booms which were beginning to gather a similar momentum at about the same time.

By the mid-1960s, the word "pop", like its sister words "mod", "beat" and "permissive" had become so thoroughly devalued by over-usage that it tended to serve as a kind of loose, linguistic genuflexion made ritualistically by members of the press towards work which was vaguely contemporary in tone and/or figurative in manner, which leant heavily towards the primary end of the colour range and which could be linked – however tenuously – to the "swinging" *milieu*.

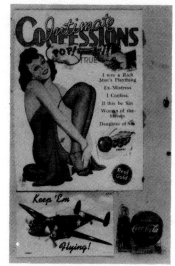

I was a rich man's plaything (*E. Paolozzi*)

Pop and the critics

"The one thing everyone hated was commercial art; apparently they didn't hate that enough either."

(Roy Lichtenstein)

I shall return later to a more detailed examination of the first and third phases but before proceeding further, it is perhaps necessary to stop and ask why, given the mountain of literature devoted to the subject (pop, as Hugh Adams points out, always made good copy), should we attempt yet another appraisal of pop art's significance. I would give two principal reasons.

First, pop art in Britain has become so thoroughly absorbed into the language of commercial art and packaging – dictating, for instance, the peculiarly ironic tone of so much "quality" British advertising – that we are in danger of losing sight of the radical nature of its original proposal: that popular culture and mass-produced imagery are worthy of consideration *in their own right* and, in addition, *almost incidentally* provide a rich iconographical resource to be tapped by those working within the fine arts. It is easy to forget, for instance, that when it first appeared in this country in the 1950s, pop presented itself and was widely construed, in critical circles as a form of symbolic aggression and that it fell into an

121

awkward, unexplored space somewhere between fine art and graphics, between, that is – to use the critical oppositions of the time – on the one hand, fine art: the validated, the creative, the pure and, on the other, graphics: the despicable, the commercial, the compromised. The assumed incompatibility of art and commerce is clearly registered in some of the protests which greeted pop's emergence. For instance, in an article entitled "Anti-Sensibility Painting" which appeared in *Art Forum* in 1963, Ivan Karp wrote:

> "The formulations of the commercial artist are deeply antagonistic to the fine arts. In his manipulation of significant form, the tricky commercial conventions accrue. These conventions are a despoliation of inspired invention..."[9]

During the late 1950s and early 1960s the arts field was still being scanned continuously by self-appointed defenders of "good taste", determined to "maintain standards". Points of potential "cross over" and "break down" were particularly susceptible to this kind of monitoring. Trespassers could be prosecuted. When Janey Ironside, using William Morris wallpaper blocks, transferred the bold designs to her textiles in 1960, the William Morris society lodged a complaint with the Royal College authorities.[10] As the prolonged austerity of the 1940s and early 1950s gave way to a period of relative affluence, the official taste-making bodies sought new ways to extend their paternalistic influence over popular tastes. The BBC, presumably in an attempt to arrest the cultural decline with which commercial television was commonly equated amongst the BBC hierarchy, set out to educate the new consumers. According to John McHale:

> "[there was] a calculated co-operation between the BBC and the Council for Industrial Design... Around mid-1956, a fire was written into the script of *The Grove Family* television series – so that the 'family' could refurnish their 'home' through the Design Centre."[11]

Pop challenged the legitimacy of validated distinctions between the arts and the lingering authority of pre-War taste formations. The "lessons" inscribed in pop's chosen objects – Americana, "slick graphics", pop music, etc. – matched BBC didacticism point for point and turned it upside down. Where the BBC counselled discrimination and sobriety, pop recommended excess and aspiration.

Clearly the emergence of the new visual sensibility that found its expression in pop is linked to the shift in the social composition of art schools during the 1950s. It is often claimed that pop embodied the aspirations of a new generation of art students – many from working-class or lower-middle-class backgrounds, the first beneficiaries in the

122

immediate post-War period of servicemen's grants and the 1944 Butler Education Act. Pop, in Reyner Banham's words, represented "the revenge of the elementary schoolboys". Also (and this is no coincidence) it augured the revenge of graphics on fine art. Pop was just the first, most visible sign of the move within art education after the War, away from the craft-based disciplines towards a more direct engagement with professional design and the needs of industry. (The Coldstream Council submitted its recommendations for the expansion of design within art education in 1957.) The break with tradition was first signalled by a symbolic defection on the part of some British artists, architects and art students to the forbidden, glossy continent of American graphic and product design. Banham, writing in 1969, described that defection:

> "... it is important to realise how salutary a corrective to the sloppy provincialism of most London art ten years ago, American design could be. The gusto and professionalism of widescreen movies or Detroit car styling was a constant reproach to the Mooreish yokelry of British sculpture, or the affected Piperish gloom of British painting. To anyone with a scrap of sensibility or an eye to technique, the average Playtex or Maidenform ad in *American Vogue* was an instant deflater of most artists then in Arts Council vogue."[12]

It is, then, easy to overlook that when pop first appeared, it was both orphan and bastard and was, in the very early days, stigmatised accordingly. The fact that it was subsequently adopted, redeemed, lifted up and transformed – rather in the manner of Dickens' protagonist in the last chapters of *Oliver Twist* – lost aristocratic lineage suddenly revealed, vast fortunes suddenly inherited – the fact that this miraculous redemption did occur is, in this context, neither here nor there.

The second reason I would give for attempting some kind of reappraisal of pop is that it tends to fare so badly, or at least indifferently, within the existing canons of art history, is so consistently rejected, disapproved of or condoned with strong reservations, that one begins to wonder what else is at stake here. Pop tends to be reified within art history as a particular moment, a distinct school of painting, sculpture and print-making which falls within a discrete historical period, i.e., roughly from 1953 to 1969, and is defined simply as that-which-was-exhibited-as-pop.

Alternatively, pop is interpreted as a kind of internal putsch, as a reaction occurring more or less exclusively within the confines of the art world. From this viewpoint, pop is regarded as a more or less conscious move on the part of a group of ambitious young Turks, intent on displacing an older group of already established Academy painters and

sculptors – in Britain, Henry Moore, Stanley Spencer, Graham Sutherland et al.; in the US, Jackson Pollock and the abstract expressionists. Here pop is conceived of as a struggle conducted at the point where the Art Game meets the Generation Game. Or – and this is a slight variation – pop is seen as a term in a more general dialectic of pictorial styles – a dialectic which, in the late 1950s, clearly dictated a move away from what was already there: abstraction and "kitchen sink realism": the work of John Bratby, Jack Smith, Edward Middleditch, etc. As Robert Indiana put it in 1963,

"Pop is everything art hasn't been for the last two decades."[13]

There is some truth in both these interpretations. As Bourdieu points out, in order to create value and recognition in the art world, one must first create a *difference*. This, after all, provides the economic logic which governs most areas of cultural production. It is this logic which generates both change and small change within the art world, which creates the *value* (in both senses) of the art object and which also determines the literally outrageous form of so much avant garde practice.

However, neither of these definitions permits an analysis of the extraordinary effectivity of pop as a visual idiom *outside* fine art; the sheer variety of poster and print making – which pop helped to get consecrated as fine art. In other words, both definitions inhibit an investigation of pop's wider cultural currency. I would argue that the significance of pop lies elsewhere, beyond the scope of traditional art history, in the way in which it posed questions about the relationship between culture in its classical-conservative sense – culture as, in Matthew Arnold's words, "the best that has been thought and said in the world" – and culture in its anthropological sense: culture as the distinctive patterns, rituals and expressive forms which together constitute the "whole way of life" of a community or social group.

We should remember, for instance, that the word "pop" was originally coined by Lawrence Alloway and was used to refer not to the collages, prints and later paintings produced by Hamilton and Paolozzi, but rather to the raw material for both these artists' work – the ads, comics, posters, packages, etc. – the scraps and traces of Americana which had been smuggled into the country by GIs, enterprising stationers and John McHale – scraps and traces which spoke of another more affluent, more attractive popular culture which had, in the early 1950s, yet to be properly established in Great Britain. The term "pop", then, is itself riddled with ambiguity. It stands poised somewhere between the IGs' present and some imagined future, between their artistic aspirations and their experience of cultural deprivation in Britain in the early 1950s. And the early work of Paolozzi and the IG's

presentations and exhibitions – *Parallels of Life and Art* (1953), *Objects and Collages* (1954) and *This is Tomorrow* (1956) were motivated by a common pledge not only to produce a new kind of visual environment but also to analyse critically the fabric of everyday life and mass-produced imagery.

It should also be recalled that the tone of the early IG meetings at the ICA was self-consciously pitched towards a consideration of science and engineering rather than art, that cybernetics, Detroit car styling and helicopter design figured amongst the early topics for discussion at those meetings, that Paolozzi professed a marked preference for science museums over art galleries, that he later wrote about the origins of pop that "there were other valid considerations about art beside the aesthetic ones, basically sociological, anthropological".[14] It should be remembered, too, that as early as 1959 Alloway was arguing for the development of a sociologically inflected, "audience-orientated model for understanding mass art"[15] – the beginnings of a reception-aesthetic which would seek to account for the variable significance of objects and images as they circulated in different consumer markets. In other words, pop formed up at the interface between the analysis of "popular culture" and the production of "art", on the turning point between those two opposing definitions of culture: culture as a standard of excellence, culture as a descriptive category. The questions pop art poses simply cannot be answered within the narrowly art historical framework which most of the critical research on pop art seems to inhabit.

Here, we are beginning to touch on what I hinted at earlier: that there are larger issues at stake in the silences and antipathies which surround pop in critical and art historical discourse. For there is a third position on pop, a position which we find uniting critics who would normally find little common ground in terms either of ideology or aesthetics – critics as dissimilar as, on the one hand, Clement Greenberg and John Canaday, the conservative reviewer on the *New York Times* at the height of US pop, and, on the other, Peter Fuller and Hugh Adams, author of the comparatively recent retrospective, *Art in the Sixties*.

This unlikely consensus is formed around the shared perception that whatever else pop art was or wasn't, it certainly wasn't *serious* enough. What rendered pop suspect for both radicals and traditionalists was its instant commercial success in the art market – i.e., in relative terms, its popularity – and these suspicions have been reinforced by the ease with which pop art techniques have been incorporated into the persuasive strategies deployed by the advertising industry.

Canaday dubbed pop "a commercial hype" which resolved the crisis facing American art critics and dealers during the late 1950s when the market was inundated with mundane examples of abstract

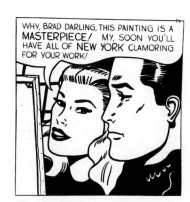

Masterpiece (*R. Lichtenstein*)

125

expressionism. In this situation, the appearance of pop was "equivalent to the discovery of a critical Klondike".[16] Irving Sandler, writing in the *New York Post* in 1962, suggested that pop was receiving an inordinate amount of unjustified exposure in what he called the "slick magazines" because it served to authorise and render respectable the advertising ethos which informs the "commercial end" of the publishing business.[17] Amongst the radical camp, pop tends to be condemned for its complicity in the art game because of its unquestioning commitment to the gallery system and the bourgeois notion of the art object. Peter Fuller throws doubts on the achievements of pop artists because "they failed to transcend the prevalent illusions of the late 1950s and the early 1960s, the ideology of the affluent society."[18] Hugh Adams has argued that "any compelling ideas" communicated in pop were

> " ... so filtered by exploitative structures that they were diluted and debased to the point where ...[they tended to degenerate into]... mere mindless pop image peddlings."[19]

Little big painting
(*R. Lichtenstein*):
**flattening the
painterly mark**

Similar objections to pop's immoral flirtation with the worlds of commerce and fashion have been voiced by Lynda Morris – the pejorative tone of her article announced in its title, *What made the 60's art so successful, so shallow?*[20]

All these critics seem to concur in the opinion that pop art was a temporary aberration from the proper concerns of responsible artists, a silly, wrong-headed or empty-headed, essentially callow or immoral digression from the serious business of making serious statements – the business which these critics imply should preoccupy committed artists of whatever persuasion – academics, formalists, propagandists and populists alike. Against this I shall argue that that dismissive critical response merely reproduces unaltered the ideological distinction between, on the one hand, the "serious", the "artistic", the "political" and, on the other, the "ephemeral", the "commercial", the "pleasurable" – a set of distinctions which pop art itself exposed as being, at the very least, open to question, distinctions which pop practice set out to erode. I shall argue that pop's significance resides in the ways in which it demonstrated, illuminated, lit up in neon, the loaded arbitrariness of those parallel distinctions, lit up in neon the hidden economy which serves to valorise certain objects, certain forms of expression, certain voices to the exclusion of other objects, other forms, other voices, by bestowing upon them the mantle of Art.

I shall attempt to do this by isolating two moments in the development of British pop – in terms of my original chronology, the first and final phases – in order to invoke some of the themes and meanings which collected around it during the mid-1950s and the mid to late 1960s. The manner in which these two moments will be

considered could be most accurately described as "invocation". This term is used to alert the reader to the fact that what follows is neither a simple chronological account of "what happened", nor an overview in the conventional sense. I hope that the kind of flexibility and arbitrary detail which a word like "invocation" licenses will enable me to locate pop within a broad cultural context, and will permit me

(i) to propose some general connections between American and British pop, connections which would be suppressed if a more sober presentation of the "facts" were attempted,

(ii) to isolate the "taste problematic" which operates around pop and the critical responses to it, and

(iii) to summon up like a medium at a seance, a medium in a message parlour, some of the peculiar connotative power which collected round the phrases "pop art" and "pop artist" during the 1950s and 1960s.

Invocation one: *This is Tomorrow*

It is difficult to recapture the austere visual and cultural context within which, or rather against which, British pop first emerged in the early 1950s. The documents and recollections which have filtered down from IG meetings stress the sheer lack of visual stimulation which afflicted every aspect of daily life in Britain at the time. The paucity of visual material merely underlined the shortage of goods. Rationing was not fully lifted till 1954. Packaging was virtually non-existent.

Against this were counterposed the exotic hyperboles of American design.

It's a psychological fact pleasure helps your disposition (*E. Paolozzi*)

These images and objects function in Paolozzi's scrap books as signs of freedom asserted against the economic and cultural constraints, as dreams, implicitly subversive "readymade metaphors".[21]

I have argued elsewhere in this book[22] that these signifiers were widely interpreted within the critical discourses of art and design and the broader streams of concerned, "responsible" commentary as harbingers of cultural decadence and the feminisation of native traditions of discipline and self-denial.

One example will suffice here. In an article which appeared in *Design* in 1955,[23] John Blake surveyed examples of contemporary product design for traces of American influence contrasting the "restraint and delicacy" of the tasteful European Mercedes air vent with the "heavy over realistic" transposition of aircraft motifs to the air vent of the 1957 Pontiac. This curiously arbitrary logic – a perverted relic of the old modernist axiom that form should follow function – leads the author to conclude that the Italian-designed Lincoln Mercury is preferable to the vulgar and bulbous forms of the US Cadillac on the grounds that the former presents a more "honest", more complete transplantation of aeroplane motifs.

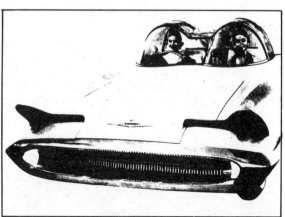

"vulgar ... bulbous" "honest"

These hysterical constructions of America as "enemy" were eventually to produce an "America" which could function for British pop artists in the 1950s (as the unconscious had for the surrealists in the 1930s and 1940s) as a repressed, potentially fertile realm invoked against the grain. Early pop imagery drew its transgressive power from the friction generated in the clash between "official" and "unofficial" taste formations – a productive clash of opposing forces. The dialectic which gave pop its power and meaning and which defined its difference can be presented through a series of juxtapositions:

Negative/official: Richard Hoggart intended to clinch his denunciation of cheap gangster fiction through the following analogy:

> "The authors are usually American or pseudo-American, after the manner of the American shirt-shops in the Charing Cross Road."[24]

Positive/transgressive: Richard Hamilton, resorting to the cool mode, played back the language of the US menswear ads.

Towards a definitive statement on the coming trends in men's wear and accessories (*R. Hamilton*)

Negative/official: Hoggart railed against the influence of Hollywood films on the "juke box boys".

> "They waggle one shoulder," he wrote, "as desperately as Humphrey Bogart... across the tubular chairs."[25]

Interior II (*R. Hamilton*)

Positive/transgressive: Alloway wrote approvingly in 1959 of the American cinema's

> "lessons in style [of clothes, of bearing]... Films dealing with American home-life, such as the brilliant women's films from Universal-International, are, in a similar way, lessons in the acquisition of objects, models for luxury, diagrams of bedroom arrangement."[26]

Negative/official: Hoggart wrote that "working people are exchanging their birthright for a mass of pin-ups".[27]

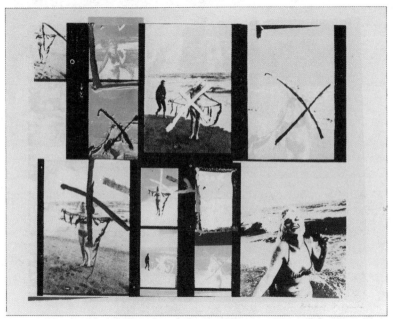

My Marilyn (*R. Hamilton*)

Positive/transgressive: Hamilton 'takes' Monroe's picture(s): publicity stills passed or censored by the star are reworked in a collage to produce a *poignant* deconstruction of mass produced glamour.

Pop art drew its power, then, from underneath the authorised discourses of "good" taste and "good" design. Pop artists dressed up, like the teddy boys, in the anxieties of the period. They converted their youth and their appropriation of "America" into future-threat.

"*This is Tomorrow*", they said. This is Our Tomorrow.

130

**Hommage à Chrysler
Corps** (*R. Hamilton*)

The *content* of tomorrow counted. The fact that Hamilton's *Hommage à Chrysler Corp.* used four different pictorial conventions to depict the shine on chromium was less important than the fact that the chromium on a Chrysler got depicted at all.

The *form* of Tomorrow counted: the blasphemy of reproduction. Screenprints, cut ups, photographs from magazines, epidiascopes: the promiscuity of collage which pointedly suggested that the craft-based tradition of the artist as sole point of creation was being superseded by the techniques of mass production and mass reproduction, that, just as the national identity was about to drown in the welter of imported, popular culture, so British painting was about to sink beneath a flood of anonymous, mass-produced images.

This is Tomorrow, they said.
This is Our Tomorrow.

By reconstructing the field of opposing forces, groups, tendencies and taste formations on which early British pop was posited, one can begin to see the points at which its breaks and transgressions became meaningful and, in a strictly limited sense, "progressive". This kind of mapping indicates, if nothing else, the provisional, historically located nature of any radical proposal within art. Such radicalism is conditional and contingent upon a number of historical givens – the availability or non-availability, the appropriateness or inappropriateness of different kinds of oppositional discourse. Criticisms of the aggressive fetishisation and sexualisation of women in pop art, at least during this period, or those blanket dismissals of pop which take as their starting point the extent of American cultural and economic penetration of Britain's leisure industries in the 1950s, tend to ignore these contingent factors. Similar objections might be raised to the accusation that early pop failed to "transcend... the ideology of affluence". The fixation of early pop artists like Hamilton on consumer goods and synthetic materials ("...the interplay of fleshy plastic and smooth, fleshier metal")[28] and his "search for what is epic in everyday objects and everyday attitudes"[29] may now seem (dis)ingenuous and improbable, but seem less so when considered against the background of the real changes in consumption patterns which lay behind the rhetoric of the "new Golden Age". After all, the 1950s did see a dramatic, unprecedented rise in living standards in Britain. No doubt the increases in spending power and rates of acquisition were not evenly distributed across all social classes (the "invisible poor" remained invisible, deprivation persisted in relative terms), but the general improvement in material conditions was real enough.

As Christopher Booker puts it:

"Between 1956 and the end of 1959 the country's hire purchase debt rose faster and by a greater amount overall, than at any other time before or since... Deep Freeze had arrived and TV Instant Dinners and Fish Fingers and Fabulous pink Camay. And with so many bright new packages on the shelves, so many new gadgets to be bought, so much new magic in the dreary air of industrial Britain, there was a feeling of modernity and adventure that would never be won so easily again. For never again would so many English families be buying their first car, installing their first refrigerator, taking their first continental holiday. Never again could such ubiquitous novelty be found as in that dawn of the age of affluence."[30]

132

After the Depression and austerity, for artists to refuse to respond positively to such transformations (overstated as they may be here by Booker) could seem more like sour grapes than a transcendence of prevailing ideology.

Invocation Two: *Goodbye Baby and Amen*

The third phase of pop requires a different style of invocation; less clearly focused on a precise time span, even less restricted to the work of individual artists as befits the moment of pop's dispersal into the wider cultural streams... a lightening up of tone for the salad days of pop. I shall begin at the very end of the 1960s.

In 1969, David Bailey and Peter Evans produced a book of photographs called *Goodbye Baby and Amen* as a kind of affectionate farewell to a "scene", a moment, a social *milieu* which since 1965 – thanks to *Time* magazine – had been described in the press as "Swinging London". The book contains some 160 black and white Bailey portraits of what Peter Evans calls in his introduction,

> "the original cast of characters, the stars and near stars, the bit players, the winners and the terrible losers, the dead, who between them got the show on the King's Road."[31]

Amongst the faces of actors, stage and film directors, rock musicians, fashion designers, photographers and models, we find – and it's appropriate – Jim Dine, David Hockney, Peter Blake, Andy Warhol. The pop artists are keywords in Bailey's litany, his hymn to "no deposit, non-returnable disposable fame",[32] the theme which provides the book with a rationale and guaranteed sales of at least 160 copies. The artists' faces fit. In fact, the only face which looks out of place here belongs to Daniel Cohn-Bendit, Danny the Red, student activist and spokesman for the Continental student movement of 1968.

Michael Caine (*D. Bailey*)

David Hockney (*D. Bailey*)

John Stephen (*D. Bailey*)

133

Cohn-Bendit (*D. Bailey*)

Bailey does not try to hide the fact that Cohn-Bendit is only distantly related to the others. The print, of course, isn't meant to look as if it's taken from real life.

Brigitte Bardot (*D. Bailey*)

134

Just as Bardot in the book is blurred and soft-focus like a wet dream, like a film still, like a fan's poster, to indicate her status as myth, as Sex Goddess, so the television image epitomises the distance which separates the world of current affairs – the real world where real things really happen – from the world of Swinging London. Danny the Red, refugee from the front pages, at sea amongst the centre spreads and gossip column figures is presented here as second-hand news, perhaps a little threatening, coming near the centre of the book, a stone inside the candyfloss.

This is a picture of a picture, an image at one remove. And our attention is drawn to the lines which mediate yet constitute the television image for us as intentionally, as emphatically as in a Lichtenstein painting, our attention is drawn to the Ben Day dots which compose the cartoon image.

Girl in Mirror
(*R. Lichtenstein*)

In both pictures, that is what is drawn: our attention. In both cases, that is what is depicted: our status as spectators, our relation to the image. Our attention, in both instances, is directed to the mediations, to use a term from video, the "generations", degenerations which mark off the television image or the comic stereotype from any referent in the real. The Bailey photograph and the Lichtenstein painting teach the same lesson: that the message is the material of which the message is composed is the medium in which it is transmitted. In other words, the McLuhanite tautology. The message in a Lichtenstein painting or a Warhol print or the Bailey photograph is that in this art, as in "mass art", to use Paul Barker's words, "the art lies on the surface."[33] "It's secret depth," to use his words again, "is that it has no secret depth".[34] In Warhol's words, "There's nothing behind it". James Brown, the black American soul singer, another 1960s icon, like Warhol a master of

banal repetition, makes the same point on a track entitled *E.S.P.* where, against an insistent rhythmic backing, Brown repeats the phrase:

"IT IS WHAT IT IS"[35]

again and again until voice and backing become indistinguishable and Brown can declaim on the nature of rhythm in rhythm . . . reminding us that that which is obvious matters, that the surfaces matter, that the surface *is* matter.

I quote James Brown here not just because he is an "authentic" spokesman for the popular arts, not just because like Lichtenstein, Barker, Bailey, Warhol, he refuses to comply with the perennial art or music critic's request to talk "in depth", to explicate, to "get to the heart of the matter". I quote him because if pop art teaches us nothing else, it teaches us the art of facetious quotation, of quotation out of context. After all, pop art was initally provocative precisely because it quoted "matter out of place".

That is why *Goodbye Baby and Amen* is so redolent of pop. You can read it by simply looking at the cover, the package in which it appears.

A girl – apparently naked – pouts out at the camera, her arms resting on a coffin which opens to reveal a bunch of plastic-looking orchids done up with scarlet ribbon. The ribbon is rude, both a joke and a fetish. It stands for the "forbidden triangle". It's "scarlet ribbon for her hair". And, what is more germane in this context, it refers to another photograph. The pose of the girl on the cover of *Goodbye Baby and Amen* recalls the famous shot of Christine Keeler, taken after the Profumo scandal by Lewis Morley for the *Daily Mirror* in 1964.

Christine Keeler, stripped and shameless, poised to "topple the establishment". This photograph marks the birth of the "Swinging '60s" as decisively, as graphically as Bailey's cover commemorates their death. In other words, it is a facetious quotation and, like the book it encloses, entirely self-parodic, just as the tombstone cover is a self-conscious play on the schlocky tabloid themes of sex and death which characterises the high camp end of pop.

Excellence, distinction, uniqueness – the three prerequisites for entry to the fine art canon – wiped out, flattened down to an undifferentiated sequence of images which reproduces the "flow" of television. The great frame of life reduced to the flat dimensions of a comic strip frame, a television screen, a swinging, swingeing social scene.

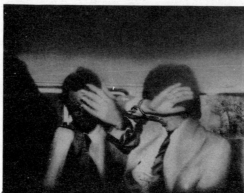

Swingeing London '67 (*R. Hamilton*)

The pulse of life to sex and death: life rendered in its crudest, crassest terms.

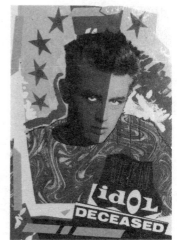

Teen idol deceased (T. Cooper)

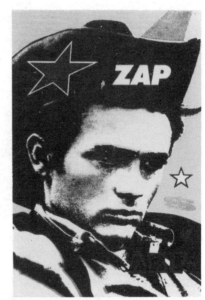

The rhythm here to sex and death,

to soup and death.

138

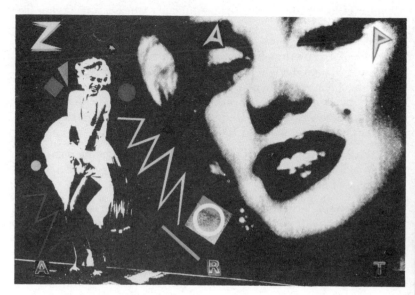

All human life is here: homogenised, runs past

your eyes like Andy Warhol's cow wallpaper which is a metaphor like most of what Warhol produced in the 1960s for the banal process of duplication – the mass reproduction of environments, of rooms, of images, of screen prints. The duplication, that is, of objects to be bought and sold, the production of commodities; production of fine art.

Production of commodities: film stars, artists, designers, art historians, sociologists of art work together in adjacent fields to produce value: to produce objects, paintings, books, perspectives, retrospectives.

As Paul Bergin noted in 1967:

> "Elizabeth Taylor is a commercial property, as commercial as
> a can of Campbell's soup... albeit turned out by a different
> type of machine... [36]

Fab-u-lous face
(*B. Gudynas*)

The organising principle of this image, of *Goodbye Baby and Amen*, of the whole pop sensibility is, of course, KITSCH, the self-conscious manipulation by those working within fine art or exposed to fine art values of those "vulgar" themes and "low" representational forms which are defined by traditionalists as being "in poor taste"...

Conclusion

> "[Kitsch is]... vicarious experience and faked sensations...
> the epitome of all that is spurious in the life of our time".
> *(Clement Greenberg)*

This brings us back, finally, to the objections levelled within art criticism against pop. For those criticisms, like Greenberg's famous denunciation of kitsch, often revolve around pop's ambivalence towards its raw material, its parasitic relation to the genuinely popular arts. Pop, it is frequently suggested, was indulgent and decadent because it refused to adopt a morally consistent and responsible line on the commercially structured popular culture which it invades, plunders and helps to perpetuate. Its ambiguity is culpable because pop exploits its own contradictions instead of seeking to resolve them. It is morally reprehensible because it allows itself to be contained by the diminished possibilities that capitalism makes available. Clearly, for British pop artists in the late 1960s, "Americanised" pictorial forms had come to stand – as "Americanised" science fiction had for post-dadaist intellectuals in the 1930s and 1950s – as a cage full of codes and little else. But whereas, in former modernist appropriations of popular culture, the coded nature of these fictional worlds could serve (as it did in Boris Vian's thrillers or Godard's *Alphaville*)[37] as an analogy for a constricted and alienated experience, in pop art and kitsch, the pull towards

140

metaphor is arrested, the metaphors – where they exist at all – tend to be distractions: jokey asides. A vicarious and attenuated relation to "authentic" experience is taken for granted, even welcomed for the possibilities it opens up for play, disguise, conceit. To use Paolozzi's words,

> "the unreality of the image generated by entirely mechanical means" is commensurate with the "new reality with which we have lived for half a century but which has yet to make serious inroads on the established reality of art."[38]

Pop, then, refuses to deploy that potential for transcendence that Marcuse claimed characterises the Great (European) Tradition. It refuses to abandon the ground of irony, to desert surface and style.

However, it is precisely here, on the reflective surfaces of pop that I would argue its potentially critical and iconoclastic force can be located. For the "politics" of pop reside in the fact that it committed the cardinal sin in art by puncturing what Bourdieu calls the "high seriousness" upon which bourgeois art depends and through which it asserts its difference from the "debased" and "ephemeral" forms of "low" and "non"-art. (Even Dada had its "statements", its slogans...) Pop's "politics" reside in the fact that it was witty, decorative and had visible effects on the look of things, on the looking at things; in the way it opened up the range of critical and creative responses to popular culture available to those who possess a modicum of cultural capital. Its "politics" reside in the fact that, in its minimal transformations of the object, it worked to reduce or to problematise the distance which Bourdieu defines as being necessary for the maintenance of the "pure aesthetic gaze", the remote gaze, the pose of contemplation on the object rather than absorption in the object: that pure gaze which unites all elitist taste formations:

> "... the theory of pure taste has its basis in a social relation: the antithesis between culture and corporeal pleasure (or nature if you will) and is rooted in the opposition between a cultivated bourgeoisie and the people..."[39]

Pop did not break down that opposition, far from it, but it did manage to smudge the line more effectively than most other modern art movements. For whereas pure taste identifies itself in the active "refusal of the vulgar, the popular, and the purely sensual",[40] pop reaches out to close those gaps in order to produce not "politics" opposed to "pleasure" but rather something new: a politics of pleasure.

This is perhaps what guarantees pop's continued exile from those places where the serious critical business of analysing both art and popular culture is conducted.

It is significant, for instance, that the references to Pop Art in the recently launched Open University course, *Popular Culture*, are confined solely to the covers ... the cover, more precisely, of the final volume in the series. Presumably, Paolozzi, Hamilton, Banham and the rest were just not serious enough. And yet an embryonic study of popular culture focusing on the conflict between popular aspirations and entrenched interests (taste makers) and proposing a model of cultural consumption which stresses class and regional differences was already being developed – albeit somewhat intuitively – by Alloway, Hamilton, McHale and the Smithsons during the mid to late 1950s. For instance, as early as 1959, Alloway was arguing against the mass society thesis (which still haunted cultural studies proper – Hoggart et al.):

> "We speak for convenience about a mass audience but it is a fiction. The audience today is numerically dense but highly diversified ... Fear of the Amorphous Audience is fed by the word 'mass'. In fact, audiences are specialised by age, sex, hobby, occupation, mobility, contacts, etc. Although the interests of different audiences may not be rankable in the curriculum of the traditional educationalist, they nevertheless reflect and influence the diversification which goes with increased industrialisation."[41]

In the same article, Alloway quotes a reader's reaction to a science fiction magazine cover from the early 1950s:

> "I'm sure Freud could have found much to comment, and write on, about it. Its symbolism, intentionally or not, is that of man, the victor; woman, the slave. Man the active, woman subjective; possessive man, submissive woman! ... What are the views of other readers on this? Especially in relation with Luros' backdrop of destroyed cities and vanquished man?"[42]

Alloway merely quotes this in order to suggest that there are possibilities for a "private and personal deep interpretation" of the mass media beyond a purely sociological consideration of their functions. What is perhaps interesting for us (and so often repressed) is that a rudimentary home-grown semiotic – one poised to "demystify" "representations" of "gendered subjects" appears to be developing here in the correspondence columns of *Science Fiction Quarterly* in 1953 without any assistance from French academics (Barthes' *Mythologies* remained untranslated until 1972).

However, that hardly matters because the true legacy of pop is not located in painting or purely academic analysis at all, but rather in graphics, fashion and popular music, in cultural and subcultural production ...

142

For instance, the Sex Pistols' career, managed with a spectacular Warhol-like flair by Malcolm McLaren, another 1960s Art School product, offered precisely the same kind of parodic, mock serious commentary on rock as a business that Pop Art in the 1960s provided on the Art Game.

The principle of facetious quotation has been applied to subcultural fashion to produce what Vivienne Westwood used to call "confrontation dressing", collage dressing, genre dressing: the sartorial insignia of that elite which Peter York calls "Them"...

Facetious quotation applied to music has produced the art of musical pastiche, word salad, aural cut ups, the art of sound quotation: the new musical genres, rap, dub, electronic "soundscape" and "constructed sound"...

The final destination of pop art, pop imagery and pop representational techniques lies not inside the gallery but rather in that return to the original material, that turning back towards the source which characterised so much of pop art's output in its "classic" phases. Its final destination lies, then, in the generation, regeneration not of Art with a capital 'A' but of popular culture with a small "pc"...

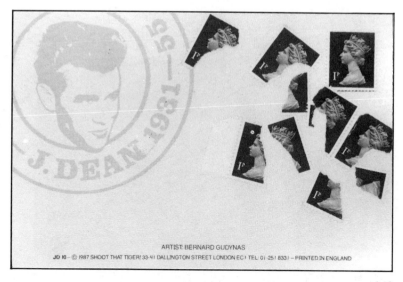

ARTIST: BERNARD GUDYNAS
JD 10 – © 1987 SHOOT THAT TIGER! 33-41 DALLINGTON STREET LONDON EC1 TEL: 01-251 8331 – PRINTED IN ENGLAND

SECTION THREE:

LIVING ON
THE LINE

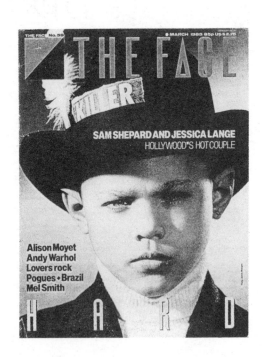

Chapter 6

Making do with the "Nonetheless": In the Whacky World of Biff

"The second degree is a . . . way of life . . . There is an erotic, an aesthetic of the second degree. We can even become maniacs of the second degree; reject denotation, spontaneity, platitude, innocent repetition, tolerate only languages which testify, however frivolously, to a power of dislocation: parody, amphibology, surreptitious quotation. *(Roland Barthes)*

147

Biff are two graphic artists, Mick Kidd and Chris Garratt, who formed a partnership in 1980. Kidd and Garratt produce cartoons in a heavily ironic style – an instantly identifiable pastiche of visual banalities and conversational clichés. Examples of their work are available in the form of postcards, T-shirts, badges, posters, mugs and books (*The Essential Biff* [1982]; *The Rainy Day Biff* [1983]; *Desert Island Biff* [1985], all published by Corgi). In addition, there are weekly strips in *City Limits* ("In Town Tonight") and the *Guardian* ("Weekend Biff").

This is a Biff cartoon. In ten years time or so when the original illustration goes on sale at Sotheby's, it will, perhaps, appear in the catalogue as a typical example of the Biff *oeuvre*: a self-conscious play with the graphic and representational styles and codes of the 1950s and 1960s, a sensitivity to the fine distinctions between taste groups, an amused and fascinated sensitivity especially to the social mores and aesthetic preferences of people like ourselves who know a bit about art history, modernism, the media, theories of representation. The catalogue might draw the reader's attention to the extent to which the Biff artists working in the mid to late 1980s could assume that a significant section of the readership of a national British newspaper like the *Guardian* would also share that knowledge, those references and interests, would share or at least recognise and smile at jokes which are, after all, appealing to what Roland Barthes once called a sensibility of "the second degree", a sensibility attuned to artifice. The catalogue entry might end by pointing out that the inclusion of such cartoons in such a newspaper in 1986 marked a shift in taste on the part of the Centre-Liberal-Left professionals who tend to read the *Guardian* away from what Posy Simmons represents in her comic strip: the feminist satire of an identifiable, *grounded* cultural *milieu* (the middle-class world of the Weber family and their friends) towards what Biff represent: the

self-conscious parody of a completely *ungrounded*, mediated set of inter-locking image-saturated cultures – the shift, in other words, from somewhere to anywhere, from satire to pastiche, from feminism to what Jean Baudrillard has called the "fascination of the code" – from feminism to ungendered fascination, a shift from the language, however lightly used, of "cultural politics" and "intervention" (the language of the 1970s) to the language of postmodernism and play (the language of the 1980s). It is less important to establish where that shift comes from – from the whim of an individual editor or as a response to readership polls – than it is to acknowledge the fact that a major British newspaper now apparently proceeds in the assumption that there is considerable market tolerance at least amongst its own readership for depictions of life in the second degree.

Of course, it would be futile to suggest any clear-cut opposition between the 1970s and 1980s, between Posy Simmons-politics and Biff-postmodernism. Such neat partitions have little to do with the way in which history works. There are always continuities across decades, moments, epochs, movements (it's been said more than once that the 1960s seen in mythical terms as the golden age of counter culture and "alternative lifestyles" didn't really take off until the 1970s). In Biff the political is there as a set of issues, themes, contents to be addressed. It's just differently inflected, differently encoded – encoded in such a way, in fact, that the code itself becomes the message.

A more explicit strand of political satire emerges from time to time. For example, one recent edition of *Weekend Biff* consisted of a strip entitled *Art in the Age of Mass Unemployment* – itself an ironic quotation/mutation of the title of Walter Benjamin's famous essay, "Art in the age of Mechanical Reproduction". The first frame depicted someone having a bath whilst a radio is tuned to a newscaster announcing a speed up in the merger of art and commerce which forms the central plank in Thatcherite arts policy. The voice reports that a government spokesperson has dismissed opposition claims that he was:

> "flogging off the National Heritage – the crates leaving the Tate – he went on to reassure the House – were not in fact Turners but used yoghurt cartons and eggboxes en route from the canteen to inner-city playgrounds..."

In the rest of the strip, the Biff cartoonists imagine an Arts Job Centre offering vacancies for someone to sing opera down the phone for British Telecom. A noticeboard is hung with ads: Composer wanted at Tescos, Cubist wanted for Police Photofit Dept, Director of Farce required at Sellafield Nuclear Power Station.

Art criticism in the Age of Biff is something quite different, something quite new. Perhaps, along with all the other posts to which

people are currently tying their critical or post-critical colours: post Marxism, post feminism, post industrialism, post structuralism, post modernism, one last post is called for – one last stake to be driven Dracula-style through the heart of the serious pundit, to lay to rest the ghost of the hollow-eyed, earnest critic once and for all – post-Biffism. Art criticism in the age of mass unemployment, in the age of the Ghetty museum and the Saatchi & Saatchi collection. Art criticism in the age of the *après* avant garde, in the age of the domesticated formal code when making strange is normal, a marker, if anything, of advertising rather than fine art (and after Warhol and Benson and Hedges the line between the two is difficult to draw). Art criticism in the age of the designer label when the new no longer seems shocking, when it just looks brand (name) new. Art criticism in the age when the pure aesthetic gaze associated at least since the eighteenth century and Kant with an educated minority seems about to converge with popular tastes in the dreamscapes of television ads and music videos, where the purity of the text succumbs to the promiscuity of the intertext, where the pleasure comes not from some imaginary encounter with "real life" – what is often assumed to be the mark of simple, untutored popular tastes – but from listing the quotations, noticing the joins between texts. Art criticism in the age when semiotics originally endowed (or so some of its proponents used to claim) with a corrosive (or at the very least) revelatory edge, threatens to become little more than signs and meanings for young consumers. In the post-Biff age, advertisers read Roland Barthes. In the post-Biff age, Hollywood reads *Screen*.

words taken from 'julie christie' by stephen a j duffy

photographic theory taken from image music text by roland brown.

For example, two advertisements for Harrods' Way In clothes boutique appeared in 1986 on the back covers of *I-D* and *The Face*. The style of these ads was a pastiche of mid-1960s "modern" graphics. There were nudging references to Op Art: the black and white high contrast

tonal-dropout images, the self-consciously dated foregrounding of bold, black 1960s type. The Way In – as the name suggests – opened up in the late 1960s but rather than play down the dated, "swinging '60s" connotations of their client's name, the agency who handle the Harrods account have decided to camp it up, to cash in on the look. As the "new" becomes discarded as an outmoded category and the invention of the new is abandoned as an anachronistic presumption, the past becomes a repertoire of retrievable signifiers and style itself is defined as a reworking of the antecedent. Just as the Grey agency working for Brylcreem decided (apparently with some success[1]) to re-run re-edited versions of 1960s television commercials with an unobtrusively updated soundtrack, so these Way In ads invoke an only slightly skewed sense of the recent past. The putative appeal of both Brylcreem and the Way In ads is based on retro-chic – the paradox of the old-fashioned, smart young modern look. In the twenty years or so that separate the image and its echo, social and moral values may have changed along with the political mood, school-leavers' expectations, prospects, aspirations but the look, the haircuts, the tailored profiles remain constant – transmitted down the line of the video generations as constant and invariable as a prayer or incantation.

However, in order to mark the product as up-market, the advertisers have contrived to signal to the sign-conscious constituency towards which these ads are targeted, that the advertisers know that times have changed by using obscure quotations from esoteric texts. (After all, this is 1980s narrowcasting: advertisers nowadays address a tightly defined "demographic" – a specific segment of the market not the "classless" teen mass implied in 1960s ads.) From *The Face*, a caption beneath the silhouette of someone sitting on a chair reads: "you are tired of provincial boutique Sundays, you want the mythical New York and the Champs Elysée". A credit in fine print informs us that these words are taken from *Julie Christie* by Stephen Duffy. Not the real Julie Christie: icon to a generation of iconoclasts, the archetype of the British "dolly bird" in the 1960s, of the politically committed socialist campaigner and anti-nuke protestor in the 1970s and 1980s, but rather something *called* "Julie Christie": Julie Christie in inverted commas.

The authenticity of the quote from the *I-D* ad is, if anything, even more uncertain. It is framed within a frame. In a two-page spread, below a heading "Double Identity", a photo graphic of an eye and a fingerprint, we read the following words:

> "The type of consciousness the photograph involves is indeed truly unprecedented, since it establishes not a consciousness of the being-there of the thing (which any [copy] could provoke) [sic] but an awareness of its having been there."

151

This quotation is attributed to "Roland Brown" although it seems likely that Roland Barthes is intended here (the quote is from "The Rhetoric of the Image"). Alternatively (and this would be appropriate) it may be that the quote is being attributed to a fictional blend of Barthes and James Brown, Godfathers respectively of the Sign and Soul Music. Such a condensation of black funk and Parisian intellectual chic would represent the perfect dream amalgam of the two elements that dominate the international high gloss style purveyed by *I-D* and *The Face*: sex and text, somatic rhythm and Continental theory – the point where the Sorbonne meets the South Bronx.

What these ads represent is the coming out of the second degree in a world where we are invited to live our whole lives inside someone else's borrowed frames, in a world which becomes bounded by the body where the body becomes first and foremost an attractive setting for the eyes – something to be looked at and looked after. The social collective, the larger collective interest, the social body, the body politic, can no longer be either dressed or addressed within this discourse as it dissolves, this larger body, into a series of narrowly defined markets, "targets", "consumption", "taste" and "status" groups. Biff take the second degree right out of the closet. They take us on a shameless, guilt-free romp through the whacky world of signs.

In marketing terms, I must be a typical Biff person. I've sent Biff cards in the past and received the same cards back from different people. Two cards in particular arrive through my letter box with a regularity which I'm beginning to find a bit alarming. In one a woman and a man embrace beneath the title *Being and Nothingness (A Johnny Sartre story)*. There is a subtitle in lower case: "Great Global Statements". The man is saying "*Life* is a meaningless comma in the sentence of *time!*" while a thought bubble emerges from his head around the words "Nothing matters anymore". The woman – eyes closed in a kiss – is thinking "Jesus! What a straight." A box in the bottom left-hand corner contains the single word, "Pointlessness". In the right-hand corner, *"The End"* is written in italics in a heart-shaped frame above an arrow pointing to the man's shoulder with the word "DANDRUFF" printed next to it. In the other card, a harassed looking character in a black shirt is depicted sitting in a train compartment. The tell-tale plastic beaker and milk container on the table before him indicate that this is British Rail. An Alpine scene with snowcapped mountains is, however, visible through the window. Next to the title set out in tabloid-bold type: HELL IS MY DESTINATION, the words: "He was always travelling never arriving" provide an anchor for the scene shown underneath. The figure in the foreground – unshaven, dishevelled, lost (if his desperate expression is anything to go by) in the moody contemplation of some profound moral dilemma – is saying to himself: "Here I am, nearly

thirty and still can't decide whether to comb my hair backwards or forwards". A jagged speech bubble behind this figure contains the perennial British Rail intercom announcement:

> "Just like to remind passengers that the bar and buffet is still open for the sale of alcoholic and non-alcoholic beverages, tea, coffee, sandwiches, toasted sandwiches, hot and cold snacks and the all-day breakfast. Thankyou!"

Another speech bubble impinges on the picture space from the left with the equally familiar ticket inspector's refrain: "Sorry... your ticket's not valid on this train on Fridays".

The frequency with which I have received these particular cards in recent years (the "30" in the second card, crossed out on one occasion and "40" scribbled in instead) has forced me to reflect seriously on many things: the quality of life, heterosexual love and British Rail coffee, the fate of friendship and personal identity in the modern world, the state of my soul and my hairline... The cartoons make me laugh – not an eye-watering, falling-on-the-floor-kicking-the-legs-in-the-air, helpless laughter just a bitter-sweet defended kind of curling of the lips. After a while, they can be a bit depressing these cards (the depression compounded in some cases by the messages that get written on the back). Biff invite a certain seen-it-all-before response, a resigned, world weary pose which correspondents (myself included) tend to adopt as they try to match irony for irony.

A sort of *noirish* pall hangs over these black and white cards for me. They seem to say: we know now that we live entirely in semiosis, we live in the "theory of the lie" (Eco) where everything that exists from "identities" to "values" to "material things" can be substituted by something else. They seem to say that the myth of personal "authenticity" – dream of 1950s boho men, of Kerouac and Dean and Jackson Pollock and all the other anguished heroes – lies in pieces (and good riddance!) along with the belief in romantic love, "deep thought", "radical" art, "radical" politics, the concept of "alternative" life styles, and the boorish cult of protest. They seem to say that the idea of people as jaded as ourselves having a direct, unmediated relation to anything at all is "hopelessly naive" that we are *really* living this time round in what Lewis Mumford called "a ghost world in which everyone lives a second-hand and derivative life".[2] But underneath all this, they seem to say that *nonetheless* it's alright really, that *nonetheless* a residue remains, that there is another option in the 1980s for us (and here I mean us men). What we are offered here in Biff – what we are offered as "the nonetheless" that makes the whole thing bearable – is a raincoat-collar-up-against-the-storm-of-disenchantment style of stoicism: an anti-heroism which can survive the demise of all those masculine stereotypes – the downbeat

poses of the 1940s, the rebel poses of the 1950s, the ''zany'' poses of the 1960s, the ''self-critical'' poses of the 1970s – poses which are all nonetheless available for us to play with as and when we like.

The Biffites: those budding Humphrey Bogarts with Art & Design degrees who are willing to go unaided by religious and political convictions down these mean airwaves armed with a keen eye for detail, are going to be alert first and foremost not to the nuances of right and wrong, to the flapping of the Right and Left wings of the established political parties; they are going to be sensitive not to the Big Issues of the day, but rather to the ''pointless'' play of social and aesthetic codes. An army of ''private eyes'' is being called up in the 1980s to wander freely through the labyrinth of signs and Biff supply the draft cards. There are no cases left to solve in the whacky world of Biff, no murders to investigate beyond the ''death of the author'' (and all the evidence suggests that either He did Himself in anyway or never really existed in the first place – that the ''author'' was nothing but an alias for the text). There is no monster at the centre of the labyrinth of signs, no Minotaur (except perhaps old Roland Brown), no clues because no crimes. And when you put the cards away, what happens if it doesn't seem enough? When you want at last, just for a change, to cast off the quotation marks, when you finally decide that you don't want to live out the rest of your life in parenthesis? What happens when you turn around and see there's nothing *but* the nonetheless? What happens if you find that – after all – the nonetheless is not enough? And – what must be the $64,000 question – what do you actually *do* when you find what looks suspiciously like your own stentorian performance in a lecture on ''Popular Culture and the Biff Cartoon'' given to an audience which included Chris Garratt delivered back to you in the form of a stinging, second order parody by the hawk-eyed, hound-eared, heartless brothers Biff??!!

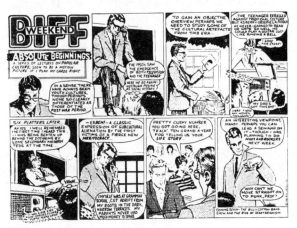

154

Chapter 7

The Bottom Line on Planet One: Squaring Up to The Face

"It was quite self indulgent. I wanted it to be monthly so that you were out of that weekly rut; on glossy paper so that it would look good; and with very few ads – at NME the awful shapes of ads often meant that you couldn't do what you wanted with the design."

(Nick Logan, publisher of The Face *interviewed in* the Observer Colour Supplement, *January, 1985)*

Last Autumn Alan Hughes, a former member of the *Ten.8* editorial board came to West Midlands College to give a talk on magazine design to students on a Visual Communications course. During his lecture, Alan asked how many of his audience read *Ten.8*. The response was muted and unenthusiastic. Alan's question prompted the following exchange:

A.H.: "What's wrong with *Ten.8* then?"

Students: "It's not like *The Face* . . . It's too political . . . It looks too heavy . . . They've got the ratio of image to text all wrong . . . I don't like the layout . . . It depresses me . . . You never see it anywhere . . . It doesn't relate to anything I know or anything I'm interested in . . . It's too left wing . . . What use is it to someone like me?"

(Approximate not verbatim transcriptions.)

Clearly, for many of the students, *The Face* was the epitome of good design. It was the primary exemplar, the Ur Text for magazine construction – the standard against which every other magazine was judged. The position it appeared to occupy in the world view of some of my students recalled – in a disconcertingly upside down kind of way – Northrop Frye's thesis on the centrality of the Bible and of Biblically derived archetypes in the West.[1] Frye argues that for the past two thousand years, the Bible has acted as what William Blake called the "Great Code of Art" in Western culture supplying artists and writers not only with a fertile body of myth and metaphor but also with the fundamental epistemological categories, the basic modes of classification and typology which structure Western thought. In the Bible, Frye sees the bones of thinking in the West – the essential framework within which a literate culture has unfolded, understood and named itself.

In the pagan, postmodern world in which some of my students live, *The Face* appears to perform a similar function. For them, *Ten.8* is the profane text – its subject matter dull, verbose and prolix; its tone earnest and teacherly; its contributors obsessed with arcane genealogies and inflated theoretical concerns. This judgement probably owes more to the conservative format; to the appearance of the typeface, the solid blocks of print in three columns, and to the lingering commitment to the strict rectangular frame than to any more substantial rapport with the content. I suspect it's not so much that they can't understand it. It's that they think they know what they are going to "learn" before they encounter it on the printed page and they calculate that the energy expended on the *style* of understanding offered in *Ten.8* in relation to the

gain made in "really useful knowledge" is just not worth the effort (or the cover price).

They are not alone in this if the circulation figures are anything to go by (*Ten.8* 1,500 – 2,500; *The Face:* 52,000 – 90,000). *The Face* has, in addition, been feted in publishing circles. In 1983, it was voted Magazine of the Year in the annual Magazine Publishing Awards, and the consistently high standard and originality of its design receive regular accolades in the professional journals. *Design and Art Direction* claimed that "from a design viewpoint [*The Face*] is probably the most influential magazine of the 1980s" whilst the *Creative Review* singled out the work of Neville Brody, who designs unique "trademark" typefaces for the magazine for special praise, suggesting that "every typographer should have a copy".

Long after the seminar with Alan was over, I found myself asking whether it was possible to trace the essential difference which I imagined dividing *Ten.8* from *The Face* back to a single determining factor. Did it reside in the form or the content, in both or neither, in the size and composition of the readership, in the style or the tone, in the mode of address, in the proportion of available space devoted to advertising, to the type of advertising, the mode of financing, the marketing or distribution or editorial policy? Did it stem from the intrinsic ties that bind the magazines to different institutions (education and the arts for *Ten.8*; the pop and fashion industries for *The Face*)? Or did it derive from some more fundamental ideological or ethical polarity between, say, the carnal pursuit of profit and the disinterested pursuit of knowledge, the private and the public sectors?

This last distinction does not stand up to too close an inspection. It is true that the two magazines emerged under different circumstances as the result of quite different initiatives. The *Ten.8* editorial group was formed in 1979, was, and still is financed by an Arts Council grant, whereas the £4,000 which was used, one year later, to launch *The Face* was raised by Nick Logan, former editor of *Smash Hits* and the *New Musical Express* from personal savings and by taking out a second mortgage on his flat. However, if it is tempting to regard *The Face* as the embodiment of entrepreneurial Thatcherite drive, it should also be remembered that in a world dominated by massive publishing oligopolies, both *Ten.8* and *The Face* remain relatively marginal and independent, are staffed by a small team of dedicated people ("The entire permanent staff of *The Face* could be comfortably fitted into the back of a London taxi" (*The Face* no. 61)) and, if press reports are to be taken at face value, both are run on what are, by mainstream publishing standards, shoe-string budgets [though, admittedly, *The Face*'s string stretches a lot further than *Ten.8*'s].

On the other hand, both magazines could be said to offer their readers quite specific forms of cultural capital: from *The Face* "street credibility," "nous", image and style tips for those operating within the highly competitive *milieux* of fashion, music and design whilst *Ten.8* offers knowledge of debates on the history, theory, politics and practice of photography and supplies educationalists with source material for teaching.

But none of this serves to close the distance between *Ten.8* and *The Face*. The chasm that divides them remains as absolute and as inaccessible to concise description as the gulf that separates one element from another. It goes right to the core of things. It has to be approached from a different angle...

War of the worlds

Imagine a galaxy containing two quite different worlds. In the first, the relations of power and knowledge are so ordered that priority and precedence are given to written and spoken language over "mere (idolatrous) imagery". A priestly caste of scribes – guardians of the great traditions of knowledge – determine the rules of rhetoric and grammar, draw the lines between disciplines, proscribe the form and content of all (legitimate) discourse and control the flow of knowledge to the people. These priests and priestesses are served by a subordinate caste of technical operatives equipped with a rudimentary training in physics and chemistry. The technicians' job consists in the engraving of images to illustrate, verify or otherwise supplement the texts produced by the scribes.

More recently, a progressive faction within the priesthood has granted a provisional autonomy to pictures and has – informally and unofficially – adjusted the working relationship between scribes and engravers. These scribes now endeavour to "situate" the images produced by the engravers within an explanatory historical or theoretical framework. But despite this modification in the rules, the same old order prevails. This world goes on turning and, as it turns, its single essence is unfolded in time. Each moment – watched, argued over and recorded by the scribes – is a point on a line that links a past which is either known or potentially knowable to a future which is eternally

Planet One: Ten 8

uncertain. Each moment is like a word in a sentence and this sentence is called history.

In the second world – a much larger planet – the hierarchical ranking of word and image has been abolished. Truth – insofar as it exists at all – is first and foremost pictured: embodied in images which have their own power and effects. Looking takes precedence over seeing ("sensing" over "knowing"). Words are pale ("speculative") facsimiles of an original reality which is directly apprehensible through image. This reality is as thin as the paper it is printed on. There is nothing underneath or behind the image and hence there is no hidden truth to be revealed.

The function of language in this second world is to supplement the image by describing the instant it embodies in order to put the image in play in the here and now – to turn it into a physical resource for other image-makers. It is not the function of language here to explain the origins of the image, its functions or effects still less its meaning(s) (which, as they are plural, are not worth talking about). In this world, the vertical axis has collapsed and the organisation of sense is horizontal (i.e., this world is a flat world). There are no scribes or priests or engravers here. Instead, knowledge is assembled and dispensed to the public by a motley gang of bricoleurs, ironists, designers, publicists, image consultants, *hommes et femmes fatales*, market researchers, pirates, adventurers, *flâneurs* and dandies.

Roles are flexible and as there are no stable systems, categories or laws beyond the doctrine of the primacy and precedence of the image, there is no higher good to be served outside the winning of the game. The name of this game which takes the place occupied in the first world by religion and politics, is the Renewal of the Now (a.k.a. Survival): i.e., the conversion of the now into the new. Because images are primary and multiple, there is, in this second world, a plurality of gods, and space and time are discontinuous so that, in a sense, neither time nor space exist: both have been dissolved into an eternal present (the present of the image). Because there is no history, there is no contradiction – just random clashes and equally random conjunctions of semantic particles (images and words).

Sense – insofar as it exists at all – resides at the level of the atom. No larger unities are possible beyond the single image, the isolated statement, the individual body, the individual "trend". But this world, too, goes on turning. It turns like a kaleidoscope: each month as the cycle is completed, a new, intensely vivid configuration of the same old elements is produced. Each month witnesses a miracle: the new becomes the now.

For the sake of argument, let's call the First World *Ten.8* and the Second, *The Face*. Imagine a war between these two worlds...

Planet Two: The Face

159

Just a magazine

When Jean-Luc Godard in his Dziga-Vertov phase coined his famous maxim "This is not a just image. This is just an image," he struck a blow for the Second World. In one brief, memorable formula, he managed to do three things:

(1) he drove a wedge into the word "good" so that you had to think twice before you said "This is a good image" when confronted by a photograph by, say, Weegee or Eugene Smith:

(2) he problematised the link between, on the one hand, an abstract commitment to ideal categories like Justice and, on the other, the "politics of representation"; and

(3) he made the future safe for *The Face*, the political, ideological and aesthetic roots of which lie as much in the 1960s, in Mod, Pop Art, the myth of the metropolis and Situationism as in Mrs Thatcher's 1980s.

The Face follows directly in Godard's footsteps. It is not a "just" magazine (in the depths of the recession, it renounces social realism, liberation theology and the moralists' mission to expose and combat social ills and promotes instead consumer aesthetics and multiple style elites). It is just a magazine which claims more or less explicitly that it is out to supersede most prevailing orthodox, "alternative", scholarly *and* common-sense constructions of the relationship between cultural politics, the image and the "popular". It's just a short step, in fact it's hardly a step at all, from Godard and 1968 to 1985 and two Second World veterans like Paul Virilio and Félix Guattari, both of whom were quoted in the Disinformation Special entitled "The End Of Politics" in the fifth anniversary issue of *The Face*:

> "Classless society, social justice – no-one believes in them any more. We're in the age of micro-narratives, the art of the fragment – "
>
> *(Paul Virilio quoted in* The Face *no. 61)*

To find artful fragments from leading Left Bank theorists like Virilio, Guattari, Meaghan Morris, Andre Gorz and Rudolf Bahro[2] jostling alongside photographic portraits of the "style-shapers of the late 1980s"; an interview with Bodymap, the clothes designers; a Robert Elms' dissection of the Soul Boys; an article by Don Macpherson on contemporary architecture; a hatchet job by Julie Burchill on Amockalyptic posturing; a profile of Morrissey, "the image-bloated clone-zone of pop" by Nick Kent; a photo-spread on how the latest

160

digital video techniques were used to identify a Japanese poisoner of supermarket goods; and a portrait of the "Sex Object of the Decade", a Transmission Electron Micrograph of stages in the growth of the AIDS virus; all this is only to be expected in a magazine which sets out to confound all expectations. *The Face* is a magazine which goes out of its way every month to blur the line between politics and parody and pastiche; the street, the stage, the screen; between purity and danger; the mainstream and the "margins": to flatten out the world.

For flatness is corrosive and infectious. Who, after all, is Paul Virilio anyway? Even the name sounds as if it belongs to a B movie actor, a member of Frankie Goes to Hollywood, a contestant in a body-building competition. I know that "he" writes books but does such a person actually exist? In the land of the gentrified cut-up, as in the place of dreams, anything imaginable can happen, anything at all. The permutations are unlimited: high/low/folk/popular culture; pop music/opera; street fashion/advertising/*haute couture*; journalism/science fiction/critical theory; advertising/critical theory/*haute couture*...

With the sudden loss of gravity, the lines that hold these terms apart waver and collapse. Such combinations are as fragile, as impermanent as the categories of which they are composed; the entire structure is a house made of cards. It's difficult to retain a faith in anything much at all when absolutely *everything* moves with the market. In the words of the old Leiber and Stoller song, recorded in the 1950s by Peggy Lee and re-recorded in the late 1970s in a New Wave version by the New York club queen, Christina:

> "Is *that* all there is? Is that *all* there is?
> If that's all there is then let's keep dancing.
> Let's break out the booze,
> Let's have a ball.
> If that's all there is."

To stare into the blank, flat *Face* is to look into a world where your actual presence is unnecessary, where nothing adds up to much *anything* any more, where you live to be alive. Because flatness is the friend of death and death is the great leveller. That's the bottom line on Planet Two.

Living in the wake of the withering signified

> "The public does not want to know what Napoleon III said to William of Prussia. It wants to know whether he wore beige or red trousers and whether he smoked a cigar."
> *(An Italian newspaper editor quoted by Pope John Paul I in D. Yallop, In God's Name, Corgi, 1985)*

From 19 April to 18 May, the Photographer's Gallery near Leicester Square in London was occupied by Second World forces. The Bill Brandt room was converted – to quote from the press handout – into a "walk-in magazine": a three-dimensional version of *The Face*.

The exhibition area was divided into five categories corresponding to the regular sections around which the magazine itself is structured: Intro, Features, Style, Expo and Disinformation. In this way it was possible to "read" *The Face* with your feet. This is entirely appropriate. Since the first issue in 1980, *The Face* has always been a totally designed environment: an integrated package of graphic, typographic and photographic (dis)information laid out in such a way as to facilitate the restless passage of what Benjamin called the "distracted gaze" of the urban consumer (of looks, objects, ideas, values). (It may be useful at this point to recall that *everything without exception* in the Second World is a commodity, a potential commodity, or has commodity-aspects).

The Face is not read so much as wandered through. It is first and foremost a text to be "cruised" as Barthes – a leading Second World spokesperson in his Tel Quel phase – used to say. The "reader" s/he is invited to wander through this environment picking up whatever s/he finds attractive, useful or appealing. (Incidentally, use-value and desire – needs and wants – are interchangeable on Planet Two. Scarcity has been banished to another, less fortunate planet called the Third World which exists on the galaxy's [southern] frontier.)

The "reader" is licensed to use whatever has been appropriated in whatever way and in whatever combination proves most useful and most satisfying. (There can be no "promiscuity" in a world without monogamy/monotheism/monadic subjects; there can be no "perversion" in a world without norms.)

Cruising was originally introduced as a post-structuralist strategy for going beyond the "puritanical" confinement of critical activity to the pursuit and taming (i.e., naming) of the ideological signified.[3] By cruising, the "reader" can take pleasure in a text without being obliged at the same time to take marriage vows and a mortgage on a house. And this separation of pleasure/use value from any pledge/commitment to "love, honour and obey" the diktats of the text constitutes the "epistemological break" which divides Planet One from Planet Two, and which sets up a field of alternating currents of attraction and repulsion between them.

The difficulties facing anyone who tries to negotiate the gap between these two intrinsically opposed models of what photography and writing on photography are and should be doing can be loosely gauged by contrasting the different positions on photography taken by a First World critic like John Berger and the Second World People of the Post (post structuralism, post modernism). For more than a decade, in his

work with Jean Mohr, Berger has been seeking to bind the photograph back to its originary context. In a series of books – *A Seventh Man, Pig Earth, Another Way of Telling, On Looking, Their Faces Brief as Photographs* – Berger has, amongst other things, attempted to place the photograph within a web of narratives which are designed to authenticate its substance (i.e., that which is depicted) in order to make the image "tell" its true story.

On the other hand, and during the same period, the disciples of the Post have been working in the opposite direction. They do not seek to recover or retrieve the truth captured in the image but rather to liberate the signifier from the constraints imposed upon it by the rationalist theology of "representation".

To recapitulate an argument which will already be familiar to many readers, this is a theology which assumes a real existing prior to signification which is accessible to analysis and transparent description by "finished", fully centred human subjects – that is by men and women sufficiently in possession of themselves to "see through" appearances to the essential truths and ideal forms "behind" those appearances. By retaining a faith in a beyond and a beneath, the members of the First World are thus seen by Second World critics to be perpetuating submission to an outmoded and disabling metaphysic.

Instead of trying to restore the image to its "authentic" context, the People of the Post have set out to undermine the validity of the distinction between, for instance, good and bad, legitimate and illegitimate, style and substance, by challenging the authority of any distinction which is not alert to its own partial and provisional status and aware, too, of its own impermanence. This, then, is the project of the Post: to replace the dominant (Platonic) regime of meaning – that is, representation – by a radical anti-system which promotes the articulation of difference as an end in itself. It is sometimes argued that this involves the multiplication of those transitory points from which a divinely underwritten authority can be eroded and questioned.

The diverse factions which gather in the Post identify the centralised source of this oppressive power variously as the Word/the Enlightenment Project/European Rationalism/the Party/the Law of the Father/the Phallus as (absent) guarantor of imaginary coherence. In other words, the project is a multi-faceted attack on the authority/authorship diad which is seen to hover like the ghost of the Father behind all First World discourse guaranteeing truth, hierarchy and the order of things.

There are, amongst Second World forces, bands of anarchists and mystics who believe that all local political objectives should be bracketed within this larger, longer term project. Born again in the demolition of the diad, they form an "impossible class"[4] refusing all law

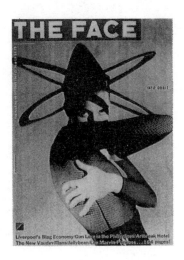

and demanding a subjectivity without guarantees.

However, the consequences of the assault on representation for *écrivains* and image makers are, on the whole, rather more mundane. First the referent (the world outside the text) disappears. Then the signified, and we are left in a world of radically "empty" signifiers. No meaning. No classes. No history. Just a ceaseless procession of simulacra.[5]

Released from the old bourgeois obligation to "speak for" truth and liberty or to "represent" the oppressed, the Third World, the "downtrodden masses" or the *marginaux* - (represent in the sense in which a Member of Parliament is supposed to "represent" her/his constituency) - we are free to serve whatever gods we choose, to celebrate artifice, to construct our selves in fiction and fantasy, to play in the blank, empty spaces of the now.

One of the most currently influential of Second World strategists, Jean Baudrillard, has gone further still, declaring that appearances can no longer be said to mask, conceal, distort or falsify reality.[6] He claims that reality is nothing more than the never knowable sum of all appearances. For Baudrillard, "reality" flickers. It will not stay still. Tossed about like Rimbaud's "drunken boat" on a heaving sea of surfaces, we cease to exist as rational *cogitos* capable of standing back and totalising on the basis of our experience.

The implication is that "we" never did exist like that anyway, that there never was a "behind" where we could stand and speculate dispassionately on the meaning of it all. Thus the 'I' is nothing more than a fictive entity, an optical illusion, a hologram hanging in the air, created at the flickering point where the laser beams of memory and desire intersect. The subject simply ceases... this is the Post Modern Condition and it takes place in the present tense. Rimbaud's *bateau ivre*, in fact, is too ecstatic and too bohemian a metaphor to encapsulate the drift into autism that the Baudrillard scene[7] entails - end of judgement, value, meaning, politics, subject-object oppositions.

A more fitting analogy for what it's like to live through the "death of the subject" might involve a comparison with the new reproductive technologies. Baudrillard's position on what life on Planet Two is like amounts to this: like the heads on a video recorder, we merely translate audio and visual signals back and forth from one terminus (the tape) to another (the screen). The information that we "handle" changes with each moment - all human life can pass across those heads - but we never own or store or "know" or "see" the material that we process. If we live in the Second World, then our lives get played out of us. Our lives get played out for us, played out in us, but never, ever *by* us. In Baudrillard's anti-system, "by" is the unspeakable preposition because it suggests that there's still time for human agency, for positive action; still some space

164

for intervention and somewhere left to intervene. But this is an inadmissable possibility in a world where politics – the art of the possible – has ceased to have meaning.

For Baudrillard, standing in the terminal, at the end of the weary European line, the music of the spheres has been replaced by the whirring of tape heads. As far as he is concerned, we are – all of us – merely stations on the endless, mindless journey of the signifier: a journey made by nobody to nowhere...

The suggestion that we are living in the wake of the withering signified may well sound like science fiction or intellectual sophistry but there are those who argue that all this is linked to actual changes in production[8] – that the flat earth thesis (what Fredric Jameson calls the "disappearance of the depth model"[9]) finds material support in the post-War shift from an industrial to a "post-industrial", "media" or "consumer" society. These terms have been coined by different writers to signal the perceived move from an industrial economy based on the production of three-dimensional goods by a proletariat that sells its labour power in the market into a new, qualitatively different era of multi-national capital, media conglomerates and computer science where the old base-superstructure division is annulled or up-ended and production in the West becomes progressively dehumanised and "etherealised" – focused round information-and-image-as-product and automation-as-productive-process.

According to some Post people, the tendency towards acceleration, and innovation, to programmed obsolescence and neophilia which Marx saw characterising societies dominated by the capitalist mode of production – where, to use his own words, "all that is solid melts into air"[10] – has been intensified under contemporary "hypercapitalism"[11] to such an extent that a kind of rapturing has occurred which has "abstracted" production to a point beyond anything Marx could have imagined possible. New commodities untouched by human hands circulate without any reference to vulgar "primary needs" in a stratosphere of pure exchange.

In such a world, so the argument goes, not only are signifiers material but a *proper* materialist (e.g., Marx himself were he alive today) would proclaim – even, some suggest, celebrate[12] – the triumph of the signifier. A materialist proper would welcome the coming of the flat, un-bourgeois world: a world without distinction and hierarchy, a society in which – although growing numbers of people are without permanent, paid employment – more and more (of not necessarily the same) people have access to the means of *re*production (television, radio, stereo, hifi, audio and videocassette recorders, cheap and easy-to-use cameras, Xerox machines if not portable "pirate" radio and television transmitters, recording facilities, synthesisers, drum machines, etc.). A

165

world where although many may be "trained" and few educated, everyone - to adapt Benjamin again - can be an amateur film, television, radio, record, fashion and photography critic.

Meanwhile, the relations of knowledge and the functions of education are transformed as models of knowledge based on linguistics and cybernetics move in to subvert the epistemological foundations of the humanities, and the university faces a crisis as it is no longer capable of transmitting the appropriate cultural capital to emergent technocratic and bureaucratic elites. The proliferation of commercial laboratories, privately-funded research bases, of data banks and information storage systems attached to multi-national companies and government agencies, amplifies this trend so that higher education can no longer be regarded - if it ever was - as the privileged site of research and the sole repository of "advanced" knowledge.[13]

At the same time, recent refinements in telematics, satellite and cable television threaten to erode national cultural and ideological boundaries as local regulations governing what can and can't be broadcast become increasingly difficult to implement. As the related strands of social and aesthetic utopianism, the notions of the Radical Political Alternative and radicalism in Art[14] are unravelled and revealed as untenable and obsolescent, advertising takes over where the avant garde left off and the picture of the Post is complete.

According to this scenario absolutely nothing - production, consumption, subjectivity, knowledge, art, the experience of space and time - is what it was even forty years ago. "Experts" equipped with narrow professional and instrumental competences replace the totalising intellectual with *his* universal categories and high moral tone. "Weak thought",[15] paradoxology and modest proposals in the arts replace the internally consistent global projections of marxism and the romantic gestures or grand (architectural) plans of modernism ("... we no longer believe in political or historical teleologies, or in the great 'actors' and 'subjects' of history - the nationstate, the proletariat, the party, the West, etc.... ".[16]) The consumer (for Alvin Toffler, the "prosumer"[17]) replaces the citizen. The pleasure-seeking *bricoleur* replaces the truth-and-justice seeking rational subject of the Enlightenment. The now replaces history. Everywhere becomes absolutely different (doctrine of the diverse v the dictatorship of the norm). Everywhere - from Abu Dhabi to Aberdeen - becomes more or less the same (first law of the level earth: lack of gravity = end of distinction *or* the whole world watches *Dallas* ergo the whole world is Dallas).

This is where *The Face* fits. This is the world where the ideal reader of *The Face* - stylepreneur, doleocrat, Buffalo Boy or Sloane - educated, street-wise but not institutionalised - is learning how to dance in the dark, how to survive, how to stay on top (on the surface) of things. After

all, in 1985 with the public sector, education, the welfare state – all the big, "safe" institutions – up against the wall, there's nothing good or clever or heroic about going under. When all is said and done, why bother to think "deeply" when you're not *paid* to think deeply?

Sur *le face*

> *Sur-face:*
> 1. The outside of a body, (any of) the limits that terminate a solid, outward aspect of material or immaterial thing, what is apprehended of something upon a casual view or consideration.
>
> 2. (geom) that which has length and breadth but no thickness. *(The Concise English Dictionary)*

A young man with a hair cut that is strongly marked as "modern" (i.e., 1940s/1950s short) is framed in a doorway surrounded by mist. He carries a battered suitcase. The collar of his coat is turned up against the cold, night air. He walks towards the camera and into a high-ceilinged building. A customs official in a Russian-style military uniform stops him, indicating that he intends searching the young man's bag. A shot-reverse-shot sequence establishes a tense, expectant mood as eyelines meet; the stylish boy confronts the older-man-in-uniform. One gaze, fearful and defiant, meets another diametrically opposed gaze which is authoritarian and sadistic. The bag is aggressively snapped open and the camera discloses its contents to the viewer: some clothes, a copy of *The Face*. The official tosses the magazine to one side in a gesture redolent of either disgust or mounting anger or a hardening of resolve. The implication is that his initial suspicions are confirmed by the discovery of this "decadent" journal.

At this, the crucial moment, the official's attention is diverted as a VIP, an older, senior official dressed in a more imposing uniform marches past between a phalanx of severe, grim-faced guards. The customs man, eyes wide with terror, jerks to attention and salutes, indicating with a slight movement of the head that the young man is dismissed. The sequence cuts to the young man, still in his coat, standing in a cramped, poorly furnished room. He opens the case, emptying the contents hurriedly onto a table or bed. The camera sweeps in as his trembling hands close around the forbidden article, the object of desire: a pair of Levi jeans.

The confrontation which provides the dramatic structure for the micro-narrative of this, the latest Levi jeans television and cinema commercial, is the familiar one between, on the one hand, freedom,

youth, beauty and the West and, on the other, the cold, old, ugly, grey and unfree East. The commercial quotes visual and thematic elements from the spy thriller genre in order to sell a multiple package: the idea of rebellious-youth-winning-through-against-all-odds; the more general myth of the young Siegfried slaying the dragon of constraint; *The Face*; Levi jeans; the image of the "self-made man" constructing himself through consumption and thereby embodying the spirit of the West. The articulation of commodity consumption, personal identity and desire which characterises life under hypercapitalism has here been universalised. There is nowhere else to go but to the shops. For in a flat world there is an end, as well, to ideology. The only meaningful political struggle left is between the individual body and the impersonal, life-denying forces of the state (whether nominally capitalist or communist).

However, this is not just another bourgeois myth that can be turned inside out and demystified (and hence deactivated) by the methods proposed by the early Roland Barthes, because the fictional scenario upon which the commercial is based has, in its turn, some foundation in fact. Rumour has it that Levi jeans go for high sums on the Russian black market and, according to issue *no. 61*, "in Moscow old copies of *The Face* are reported to change hands for upwards of £80." On a flat world, a commercial becomes a social (if not a socialist) realist text. It documents the real conditions of desire in the East and its claims to "truth" are not challenged by the fact that the copy of *The Face* used in this ad is not, in a sense, "real" either. It is, according to issue *61*, just a mock-up, a cover, a ghost of a thing, a skin concealing absent flesh. Thus, on the second world, a cover can stand in for a whole magazine (the face of *The Face* for the whole *Face*). A magazine can stand in for a pair of jeans and the whole package can stand in for the lack of a "whole way of life" which on a flat earth is unrealisable anywhere under any system (capitalist or otherwise).

But even the shadow of a shadow has a value and a price:

> "The rarest issue of *The Face* consists of only one page – a cover designed at the request of Levis for use in a new television and cinema commercial. There are only four copies in existence."
> (The Face *no. 61, May, 1985*)

Rarity guarantees collectability and generates desire which promises an eventual return on the original investment. One day, one of the three copies of the copy that we saw all those years ago on our television screens may be auctioned off at Sotheby's and end up in the V & A, the Tate or the Ghetty Collection...

Nowhere else

to go

... Do you remember John Berger speaking from the heart of the First World in the television version of *Ways of Seeing* in 1974 as he flicked through a copy of the *Sunday Times* Colour Supplement moving from portraits of starving Bangla Deshi refugees to an advertisement for Badedas bath salts? "Between these images," he said and goes on saying on film and videotapes in Complementary Studies classes up and down the country, "there is such a gap, such a fissure that we can only say that the culture that produced these images is insane." *The Face* is composed precisely on this fissure. It is the place of the nutty conjunction.

In the exhibition there is one panel of selected features from *The Face* presumably displaying the inventive layout and varied content. A photo-documentary account of a teenaged mod revivalist at a scooter rally entitled "The Resurrection of Chad" is placed alongside photographs of the Nuba of Southern Sudan above a portrait of Malcolm McLaren, inventor of the Sex Pistols, and Duck Rock, a pirate of assorted black and Third World (Burundi, Zulu, New York rap) musical sounds against an article on Japanese fashion and an interview with Andy Warhol.

More facetious (a First World critic might say "unwarranted" or "offensive") juxtapositions occur elsewhere. A photograph by Derek Ridgers of the Pentecostal Choir of the First Born Church of the Living God shot outside a church (?) in a field in hallucinatory colour is placed next to a glowering black and white portrait of Genesis P. Orridge and friend of the occult/avant garde group, Psychic TV, after they had just signed a £1,000,000 contract. The malevolent duo are posed in front of a collection of metallic dildoes alongside the original caption: "Which are the two biggest pricks in this picture?" Insolent laughter is, of course, incompatible with a high moral tone. Where either everything or

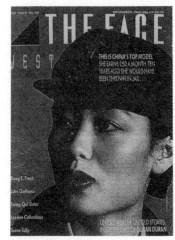

but to the shops

nothing is significant, everything threatens to become just a laugh and, as one look at television's *The Young Ones* will tell you, *that* kind of laughter is never just or kind...

On a flat world, it is difficult to build an argument or to move directly from one point to the next because surfaces can be very slippery. Glissage or sliding is the preferred mode of transport – sliding from a television commercial to the end of ideology, from the Bill Brandt Room to a Picture of the Post, from *The Face* exhibition to *The Face* itself...

All statements made inside *The Face*, though necessarily brief are never straightforward. Irony and ambiguity predominate. They frame all reported utterances whether those utterances are reported photographically or in prose. A language is thus constructed without anybody in it (to question, converse or argue with). Where opinions are expressed they occur in hyperbole so that a question is raised about how seriously they're meant to be taken. Thus the impression you gain as you glance through the magazine is that this is less an "organ of opinion" than a wardrobe full of clothes (garments, ideas, values, arbitrary preferences: i.e., signifiers).

Thus, *The Face* can sometimes be a desert full of silent bodies to be looked at, of voices without body to be listened to not heard. This is because of the terror of naming.

As the procession of subcultures, taste groups, fashions, anti-fashions, winds its way across the flat plateaux, new terms are coined to describe them: psychobillies, yuppies, casuals, scullies, Young Fogies, Sloane Rangers, the Doleocracy, the Butcheoise – and on a flat earth all terminology is fatal to the object it describes. Once "developed" as a photographic image and as a sociological and marketing concept, each group fades out of the now (i.e., ceases to exist).

The process is invariable: caption/capture/disappearance (i.e., naturalisation). ("... information is, by definition, a short-lived element. As soon as it is transmitted and shared it ceases to be information but has instead become an environmental given...".)[18] Once named, each group moves from the sublime (absolute now) to the ridiculous (the quaint, the obvious, the familiar). It becomes a special kind of joke. Every photograph an epitaph, every article an obituary. On both sides of the camera and the typewriter, irony and ambiguity act as an armour to protect the wearer (writer/photographer; person/people written about/photographed) against the corrosive effects of the will to nomination. Being named (identified; categorised) is naff; on Planet Two it is a form of living death. A terrifying sentence is imposed (terrifying for the dandy): exile from the now.

And in the words of Baudelaire who preceded Godard in the Second World as Christ preceded Mohammed; as Hegel did Marx in the First:

"The beauty of the dandy consists above all in his air of reserve, which in turn arises from his unshakable resolve not to feel any emotions".[19]

To live ironically is to live without decideable emotion; to be ambiguous is to refuse to "come out" (of the now). It is to maintain a delicate and impotent reserve...

Stretching

... The aversion to direct speech is also apparent in the tendency to visual and verbal parody. At the exhibition, Robert Mapplethorpe contributes a self-portrait in which he masquerades as a psychotic, 1950s juvenile delinquent. The staring eyes, the bulging quiff, the erect collar, the flick knife laid against the face, all suggest a mock-heroic sado-masochistic fantasy directed at him "self". Here the camera discloses no personal details as the body becomes the blank site or screen for the convocation of purely referential signs: *West Side Story*; doowop, "New York"-as-generalised-dangerous-place, the "Puerto Rican type": the banal and flattened forms of homoerotic kitsch... Annabella, singer with Bow Wow Wow sitting on the grass in the nude surrounded by the other (clothed) male members of the group glumly contemplates the camera and us in an exact reconstruction of Manet's *Déjeuner sur l'herbe*... Marilyn and Boy George stand outside the Carburton Street squat where they once lived, the mundane context and milk bottles in ironic counterpoint to their exotic, camp appearance: Hollywood and *The Mikado* come to *Coronation Street*... The high-key lighting, the braces, suits and picture ties, Duke Ellington moustaches and cigarette smoke in a black and white studio shot of Lynx are direct quotations from *film noir* and from 1930s/1940s promotional pics for black American jazz artists.

the

The past is played and replayed as an amusing range of styles, genres, signifying practices to be combined and recombined at will. The then (and the there) are subsumed in the now. The only history that exists here is the history of the signifier and that is no history at all...

... I open a copy of *The Face*. The magazine carries its own miniature simulacrum: a glossy five-page supplement commissioned by Swatch, the Swiss watch company which is aiming its product at the young, professional, style and design conscious markets. Like a Russian doll, the hollow *Face* opens to reveal a smaller, even emptier version of itself: *International Free Magazine No 2*. The black and red *Face* logo box is reproduced in the top left-hand corner with the words "Swatch o'clock" in white sans serif caps across it. The host magazine is mimicked and

face. (prints not taken from the FACE magazine)

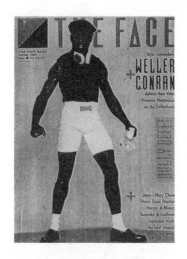

parodied by its guest. A photograph of a model wearing watch earrings – her face reduced to a cartoon with a few strokes in "wild style" with a felt tip pen – pouts out above a caption reading "Art o'clock, look chic but rare". A double page spread reveals a "hunky" man in leather posing with a bow and arrows in a wood. The captions read: "Homme Swatch. Outdoor, ton corps, ta Swatch". The "Swatch" mock-editorial "explains":

> "*Parlez vous* Swatch? To look or not to look? That is the question. *Sommaire.* Summer 85: let's go, *l'été*, come on in Swatch, *aujourd'hui la mode o'clock est entrée dans ma tête* . . . etc."

This is a parody of a parody. As the primary objection to advertising on Planet Two is aesthetic rather than ideological – a matter of the signifier and not the signified – potential advertisers can be educated to commission designs compatible with editorial preferences . . .

Advertising – the *eidos* of the marketplace – is pressed into the very pores of *The Face*. For advertisers as for *The Face*, sophists and lawyers, rhetoric is all there is: the seizure of attention, the refinement of technique, the design, promotion, marketing of product (ideas, styles; for lawyers, innocence or guilt depending on who pays). *The Face* habitually employs the rhetoric of advertising: the witty one-liner, the keyword, the aphorism, the extractable (i.e., quotable) image are favoured over more sustained, sequential modes of sense-making. Each line or image quoted in another published context acts like a corporate logo inviting us to recognise its source – the corporation – and to acknowledge the corporation's power.

The urge to compress and condense – to create an absolute homology of form and meaning which cannot be assimilated but can only be copied – is most pronounced in Neville Brody's sometimes barely legible typefaces. It is as if we were witnessing in the various trademark scripts and symbols he devises, a graphic depiction of the power shift from Europe to Japan as the phonetic alphabet takes on before our eyes a more iconic character. The occidental equivalent of Japanese or Chinese script is to be found here in *The Face* in the *semiogram*: a self-enclosed semantic unit – a word, graphic image, photograph, the layout of a page – which cannot be referred to anything outside itself. In the semiogram, *The Face* capitulates symbolically to the empire of signs, robots, computers, miniaturisation and automobiles – to Japan, which has served as the first home of flatness for a long line of Second World orientalists including Roland Barthes, Noel Birch, Chris Marker, David Bowie and, of course, the group Japan. The pages of *The Face*, like a series of masks in an occidental Noh play, act out a farce on

the decline of the British Empire. The name of this production: "[I think] I'm going Japanese"...

Renouncing the possibility of challenging the game, Baudrillard has formulated a series of what he calls "decadent" or "fatal" strategies (where decadence and fatalism are seen as positive virtues). One of these he names "hyperconformism". *The Face* is hyperconformist: more commercial than the commercial, more banal than the banal...

Behind *The Face*: the bottom line on Planet One

"Vietnam was first and foremost a war in representation"
(Jean Luc Godard)

"What are Chile, Biafra, the 'boat people', Bologna or Poland to us?" *(Jean Baudrillard,* Sur le nihilisme*)*

"*The Tatler:* the magazine for the other Boat People."
(Advertising slogan for The Tatler *accompanying an image of a group of the "beautiful rich" aboard a yacht.)*

Many people of my generation and my parents' generation retain a sentimental attachment – in itself understandable enough – to a particular construction of the "popular" – a construction which was specific to the period from the inter-War to the immediate post-War years and which found its most profound, its most progressive and mature articulation in the films of Humphrey Jennings and on the pages of *The Picture Post*. We hardly need reminding that that moment has now passed.

The community addressed by and in part formed out of the national-popular discourses of the late 1930s and 1940s – discourses which were focused round notions of fair play, decency, egalitarianism and natural justice now no longer exists as an affective and effective social unit.

Forty years of relative affluence, and regional (if not global) peace; five years of Thatcherite New Realism and go-gettery, of enemies within and without, and of the dream of the property-owning democracy, have gradually worn down and depleted the actual and symbolic materials out of which that earlier construction was made.

At the same time, the popular can no longer be hived off from Higher Education as its absolute other ("innocent", "spontaneous", "untutored") because those same forty years have seen more and more ordinary people gaining some, admittedly restricted, (and increasingly endangered) access to secondary, further, higher and continuing

173

education. It is neither useful nor accurate to think about the "masses" as if they were wrapped in clingfilm against all but the most unsavoury of new ideas.

There have, of course, been positive material advances. To take the most important example, feminist concerns, idioms and issues have become lodged in the very fabric of popular culture even in those areas from television sit-com to working men's clubs where the implications of feminist critique have been most actively and hysterically resisted. It's also clear that the mass media – whatever other role(s) they may play in social reproduction – have served to democratise, at least to circulate on an unprecedented scale, forms and kinds of knowledge which had previously been the exclusive property of privileged elites.

The Face should be seen as functioning within this transfigured social and ideological field. Whilst I would not suggest that *The Face* is the *Picture Post* of the 1980s, I would go along with the claim asserted in the accompanying notes that *The Face* exhibition "is about looking at popular social history in the making". *The Face* has exerted an enormous influence on the look and flavour of many magazines available in newsagents up and down the country and has spawned countless imitations: *I-D*, *Blitz*, *Tomorrow*, *Etcetera*, etc. The repertoire and rhetoric of photographic mannerisms, devices, techniques and styles in the fashion and music press have been fruitfully expanded and the studio has been rediscovered, in a sense re-invented as a fabulous space – a space where every day the incredible becomes the possible. But *The Face*'s impact has gone far beyond the relatively narrow sphere of pop and fashion journalism dictating an approach to the visible world that has become synonymous with what it means for a magazine today to be – at least to look – contemporary. The gentrified cut-up has found its way into the inaptly named *Observer* "Living" supplement and the *Sunday Times* has followed *The Face* into the continental 30.1cm × 25.3cm format.

Amongst its other services, *The Face* provides a set of physical cultural resources that young people can use in order to make some sense and get some pleasure out of growing up in an increasingly daunting and complex environment. It has been instrumental in shaping an emergent structure of feeling, a 1980s sensibility as distinctive in its own way as that of the late 1960s (though how resilient that structure will prove remains to be seen). But in any case, it does no good to consider the readers of *The Face* as victims, culprits, dupes or dopes, as "kids" or *tabulae rasae* or potential converts. Their world is real already even when the sensibility which *The Face* supports and fosters seems to bear a much closer and more vital relationship to the anomic Picture of the Post that I outlined earlier than it does to the "social democratic eye" of Hulton's classic photojournal weekly.

174

The Face reflects, defines and focuses the concerns of a significant minority of style and image conscious people who are not, on the whole, much interested in party politics, authorised versions of the past and outmoded notions of community. The popular and the job of picturing the popular has changed irrevocably out of all recognition even since the 1950s.

It should also be borne in mind that Nick Logan is not Jean Baudrillard and that *The Face* is infinitely better, more popular, significant, influential and socially plugged in than *The Tatler* is or ever could be. It's also clear that the photography, design, and a lot of the writing are, by any standards, good and on occasion attain levels of excellence which are still rare in British pop journalism. And, finally, it is as well to remember that a text is, of course, *not* the world, that no one *has* to live there, that it is not a compulsory purchase, that no one has to pay, that no one has to even pay a visit.

I'm well aware that only a gossip columnist, a fool or an academic could find the time to undertake a close analysis of such self-confessed ephemera or would set aside sufficient energy to go chasing round those circles where, as George Eliot puts it, "the lack of grave emotion passes for wit".[20] Yet, despite such reservations, I cannot escape the conviction that something else, something deeper is at stake, not just here in this talk of signifiers, surfaces, post-modernism, but in the broader streams of social life and practice, and in all personal and political struggle, irrespective of where it takes place and irrespective, too, of how these terms and the relations between them get defined.

Something that really matters is at stake in this debate. At the risk of alienating the reader with an analogy already stretched to breaking point, one last battle in the War of the Worlds may help to clarify the issue . . .

. . . I was about to leave *The Face* exhibition feeling vaguely uneasy about the ambivalence of my response when – not for the first time – the beautiful, clear, soulful voice of Chrissie Hynde came drifting across from the video installation in the corner of the room. The promo tapes were on some kind of a loop so that I had heard her sing the same song at least three times as I meandered round the photographs, the layout and typography panels, the cases containing Crolla and Bodymap clothes. As I moved towards the door, that voice rose once more singing over and over the same agonised refrain:

"It's a bitter line between love and hate . . ."

And words like "love" and "hate" and "faith" and "history", "pain" and "joy", "passion" and "compassion" – the depth words drawn up

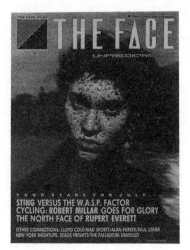

like ghosts from a different dimension will always come back in the eleventh hour to haunt the Second World and those who try to live there in the now. This is not just pious sentiment. It is, quite simply, in the very nature of the human project that those words and what they stand for will never go away. When they seem lost and forgotten, they can be found again even in – especially in – the most inhospitable, the flattest of environments. John Cowper Powys once wrote:

> "We can all love, we can all hate, we can all possess, we can all pity ourselves, we can all condemn ourselves, we can all admire ourselves, we can all be selfish, we can all be unselfish. But below all these things there is something else. There is a deep, strange, inaccountable response within us to the mystery of life and the mystery of death: and this response subsists below grief and pain and misery and disappointment, below all care and all futility."

That something else will still be there when all the noise and the chatter have died away. And it is perhaps significant that the quotation came to me courtesy of one of my students who included it in a deeply moving essay on how the experience of personal loss had transformed his response to photos of his family. He in his turn had found it in an advertisement for a group called The Art of Noise designed by Paul Morley, arch *bricoleur* and publicist, the mastermind at ZTT behind the Frankie Goes to Hollywood phenomenon last year.

Whatever Baudrillard or *The Tatler* or Saatchi and Saatchi, and Swatch have to say about it, I shall go on reminding myself that this earth is round not flat, that there will never be an end to judgement, that the ghosts will go on gathering at the bitter line which separates truth from lies, justice from injustice, Chile, Biafra and all the other avoidable disasters from all of us, whose order is built upon their chaos. And that, I suppose, is the bottom line on Planet One.

SECTION FOUR:

POSTMODERNISM AND "THE OTHER SIDE"

Angel of History
(*S. Masterson*)

Chapter 8

Staking out the Posts

Angelus Novus (*photomontage* – G. Budgett)

The success of the term postmodernism – its currency and varied use within a range of critical and descriptive discourses both within the academy and outside in the broader streams of "informed" cultural commentary – has generated its own problems. It becomes more and more difficult as the 1980s wear on to specify exactly what it is that "postmodernism" is supposed to refer to as the term gets stretched in all directions across different debates, different disciplinary and discursive boundaries, as different factions seek to make it their own, using it to designate a plethora of incommensurable objects, tendencies, emergencies. When it becomes possible for people to describe as "postmodern" the decor of a room, the design of a building, the diagesis of a

181

film, the construction of a record, or a "scratch" video, a television commercial, or an arts documentary, or the "intertextual" relations between them, the layout of a page in a fashion magazine or critical journal, an anti-teleological tendency within epistemology, the attack on the "metaphysics of presence", a general attenuation of feeling, the collective chagrin and morbid projections of a post-War generation of baby boomers confronting disillusioned middle age, the "predicament" of reflexivity, a group of rhetorical tropes, a proliferation of surfaces, a new phase in commodity fetishism, a fascination for images, codes and styles, a process of cultural, political, or existential fragmentation and/or crisis, the "de-centring" of the subject, an "incredulity towards metanarratives", the replacement of unitary power axes by a plurality of power/discourse formations, the "implosion of meaning", the collapse of cultural hierarchies, the dread engendered by the threat of nuclear self-destruction, the decline of the university, the functioning and effects of the new miniaturised technologies, broad societal and economic shifts into a "media", "consumer" or "multinational" phase, a sense (depending on who you read) of "placelessness" or the abandonment of placelessness ("critical regionalism") or (even) a generalised substitution of spatial for temporal co-ordinates[1] – when it becomes possible to describe all these things as "postmodern" (or more simply, using a current abbreviation, as "post" or "very post") then it's clear we are in the presence of a buzzword.

This is not to claim that because it is being used to designate so much, the term is meaningless – though there is a danger that the kind of blurring (of categories, objects, levels) which goes on within certain kinds of "postmodernist" writing will be used to license a lot of lazy thinking. Many of the (contentious) orientations and assertions of the Post are already becoming submerged as unexplicated, taken for granted truths in some branches of contemporary critique. Rather I would prefer to believe, as Raymond Williams indicates in *Keywords*, that the more complexly and contradictorily nuanced a word is, the more likely it is to have formed the focus for historically significant debates, to have occupied a semantic ground in which something precious and important was felt to be embedded. I take, then, as my (possibly ingenuous) starting point, that the degree of semantic complexity and overload surrounding the term "postmodernism" at the moment signals that a significant number of people with conflicting interests and opinions feel that there is something sufficiently important at stake here to be worth struggling and arguing over.

I want to use this opportunity to try to do two things here. First, I shall attempt to summarise in a quite schematic way some of the themes, questions and issues that gather round the term "postmodernism". This attempt at clarification will involve a trek across territory already

sketched out elsewhere in this book. It will also entail my going against the spirit of postmodernism which is founded in the renunciation of the claims to mastery and "dominant specularity" implied in a term like "overview". However, I think it's worth trying because it may help to ground what is, after all, a notoriously vertiginous concept, and to offer an opening onto the debates in Europe and the States between marxism and postmodernism – and more specifically, between postmodernism and what we might call the "neo Gramscian" line in British cultural studies represented most clearly in the work of Stuart Hall. I make no claims for the authority of what I have to say: the tone here will be credulous but critical. I shall merely be taking one man's route, as it were, through or round the Post. Second, resorting to what I hope is a more constructive or at least more positive register, I shall seek to specify exactly what it is that I feel is at stake in these debates and to offer a few suggestions about the lessons I've learned from living through them.

To say "post" is to say "past", hence questions of periodisation are inevitably raised whenever the term "postmodernism" is invoked. There is, however, little agreement as to what it is we are alleged to have surpassed, when that passage is supposed to have occurred, and what effects it is supposed to have had (see, for example, Perry Anderson's closely argued objections to Marshall Berman's periodisation of modernisation/ modernism in *All That is Solid Melts into Air*[2]). Michael Newman further problematises the apparently superseded term in postmodernism by pointing out that there are at least two artistic modernisms articulating different politico-aesthetic aspirations which remain broadly incompatible and non-synchronous. The first, which is ultimately derived from Kant, seeks to establish the absolute autonomy of art and finds its most extreme and dictatorial apologist in Clement Greenberg, the American critic who sought to purify art of all "non-essentials" by championing the cause of abstract expressionism – the style of painting most strictly confined to an exploration of the materials and two dimensionality of paint on canvas. The second modernist tradition, which Newman traces back to Hegel, aspires to the heteronomous dissolution of art into life/political practice and leads through the surrealists, the constructivists, the futurists, etc., to performance artists and the conceptualists of the 1970s.[3]

If the unity, the boundaries and the timing of modernism itself remain contentious issues, then postmodernism seems to defy any kind of critical consensus. Not only do different writers define it differently, but a single writer can talk at different times about different "posts". Thus Jean-François Lyotard has recently used the term postmodernism to refer to three separate tendencies: i) a trend within architecture away from the Modern Movement's project "of a last rebuilding of the whole space occupied by humanity"[4] (ii) a decay in confidence in the idea of

183

progress and modernisation ("there is a sort of sorrow in the Zeitgeist" [Lyotard]) and (iii) a recognition that it is no longer appropriate to employ the metaphor of the "avant garde" as if modern artists were soldiers fighting on the borders of knowledge and the visible, prefiguring in their art some kind of collective global future. J. C. Merquior (in a hostile critique of what he calls the "postmodern ideology") offers a different triptych: (i) a style of mood of exhaustion of/disaffection with modernism in art and literature, (ii) a trend in poststructuralist philosophy and (iii) a new cultural age in the West.[5]

Furthermore, the Post is differently inflected in different national contexts. It was, for instance, notable that *The Anti-Aesthetic* in the edition available in the United States arrived on the shelves beneath a suitably austere, baleful and more or less abstract (modernist?) lilac and black cover which echoed the Nietzschian tone of the title. However, when the same book was published in Britain it appeared as *Post Modern Culture* with a bright yellow cover consisting of a photograph of a postmodernist "installation" incorporating cameras, speakers, etc., complete with comic-book sound and light rays. The translation of postmodernism as a set of discourses addressed in America to a demographically dispersed, university and gallery centred constituency for a similar, though perhaps slightly more diverse, more geographically concentrated readership in Britain (where cultural pluralism, multi-culturalism, the appeal or otherwise of "Americana", the flattening out of aesthetic and moral standards, etc., are still "hot" issues and where there is still – despite all the factional disputes and fragmentations of the last twenty years – a sizeable, organised left) involved the negotiation of different cultural-semantic background expectancies.

National differences were further highlighted during the weekend symposium at the London I.C.A. in 1985 when native speakers giving papers which stressed the enabling potentialities of the new "user friendly" communication technologies and the gradual deregulation of the airwaves, and which celebrated popular culture-as-postmodern-bricolage-and-play were confronted with the Gallic antipopulism of Lyotard who declared a marked preference for the fine arts, idealist aesthetics and the European avant garde tradition, and demonstrated in comments made in response to the papers in the session on Popular Culture and Postmodernism a deep, abiding suspicion for the blandishments and commodified simplicities of "mass culture".

To introduce a further nexus of distinctions, Hal Foster in his Preface to *The Anti-Aesthetic* distinguishes between neo-conservative, anti-modernist and critical postmodernisms, and points out that whereas some critics and practitioners seek to extend and revitalise the modernist project(s), others condemn modernist objectives and set out to remedy the imputed effects of modernism on family life, moral values,

184

etc.; while still others, working in a spirit of ludic and/or critical pluralism, endeavour to open up new discursive spaces and subject positions outside the confines of established practices, the art market and the modernist orthodoxy. In this latter "critical" alternative (the one favoured by Foster) postmodernism is defined as a positive critical advance which fractures through negation (i) the petrified hegemony of an earlier corpus of "radical aesthetic" strategies and proscriptions, and/or (ii) the pre-Freudian unitary subject which formed the hub of the "progressive" wheel of modernisation and which functioned in the modern period as the regulated focus for a range of scientific, literary, legal, medical and bureaucratic discourses. In this positive "anti-aesthetic", the critical postmodernists are said to challenge the validity of the kind of global, unilinear version of artistic and economic-technological development which a term like modernism implies, and to concentrate instead on what gets left out, marginalised, repressed or buried underneath that term. The selective tradition is here seen in terms of exclusion and violence. As an initial counter-move, modernism is discarded by some critical postmodernists as a Eurocentric and phallocentric category which involves a systematic preference for certain forms and voices over others. What is recommended in its place is an inversion of the modernist hierarchy – a hierarchy which, since its inception in the eighteenth, nineteenth or early twentieth centuries (depending on your periodisation[6]) consistently places the metropolitan centre over the "underdeveloped" periphery, Western art forms over Third World ones, men's art over women's art or, alternatively, in less anatomical terms "masculine" or "masculinist" forms, institutions and practices over "feminine", "feminist" or "femineist" ones.[7] Here the word "postmodernism" is used to cover all those strategies which set out to dismantle the power of the white, male author as privileged source of meaning and value.

The three negations

I shall return later to some of the substantive issues addressed by "critical postmodernism" but for the moment I should like to dwell on the constitutive role played here, indeed throughout the Post, by negation. In fact, it is a crucial one for postmodernism as a discourse (or compound of discourses) is rather like Saussure's paradigm of language, in that it's a system with no positive terms. In fact, we could say it's a system predicated, as Saussure's was, on the categorical denial of the possibility of positive entities *per se*. (See, for instance, Lyotard's bracketing off, de-construction, de-molition of the concept of "matter"

in the catalogue notes for the *Les Immateriaux* exhibition at the Pompidou Centre in 1984. More recently, Lyotard has argued against the "vulgar materialist" line that matter can be grasped as substance. Instead he suggests that matter should be understood as a "series of ungraspable elements organised by abstract structures".[8]) However, a kind of rudimentary coherence begins to emerge around the question of what postmodernism negates. There are, I think, three closely linked negations which bind the compound of postmodernism together and thereby serve to distinguish it in an approximate sort of way from other adjacent "isms" (though the links between post-structuralism and postmodernism are in places so tight that absolute distinctions become difficult if not impossible). These founding negations, all of which involve – incidentally or otherwise – an attack on marxism as a total explanatory system, can be traced back to two sources: on the one hand, historically to the blocked hopes and frustrated rhetoric of the late 1960s and the student revolts (what a friend once described to me as the "repressed trauma of 1968") and, on the other, through the philosophical tradition to Nietzsche.

1) *Against totalisation*

An antagonism to the "generalising" aspirations of all those pre-Post-erous discourses which are associated with either the Enlightenment or the Western philosophical tradition – those discourses which set out to address a transcendental subject, to define an essential human nature, to prescribe a global human destiny or to proscribe collective human goals. This abandonment of the universalist claims underwriting all previous (legitimated) forms of authority in the West involves more specifically a rejection of Hegelianism, Marxism, any philosophy of history (more "developed" or "linear" than, say, Nietzsche's doctrine of the Eternal Recurrence) and tends (incidentally?) towards the abandonment of all "sociological" concepts, categories, modes of enquiry and methods, etc. Sociology is condemned either in its positivist guises (after Adorno, Marcuse, etc.) as a manifestation of instrumental-bureaucratic rational-ity or more totally (after Foucault) as a form of surveillance/control always-already complicit with existing power relations. In the latter case, no real distinctions are made between positivist/non-positivist; qualitative/quantitative; marxist/pluralist/interpretative/functional-ist, etc., sociolog*ies*: all are seen as strategies embedded in institutions themselves irrefragably implicated in and productive of particular configurations of power and knowledge. In place of the totalising intellectual, Foucault offers us the intellectual-as-partisan: producer of "socio-fictions" which despite their equivocal truth status may have

"reality-effects", and the intellectual-as-facilitator-and-self-conscious-strategist (Foucault's work with prisoners' rights' groups is often cited as exemplary here). All larger validity claims are regarded with suspicion. Beneath the euphemistic masks of, for instance, "disinterested Reason", "scientific Marxism", "objective" statistics, "neutral" description, "sympathetic" ethnography or "reflexive" ethnomethodology, the eye of the Post is likely to discern the same essential "Bestiary of Powers" (see, especially, Jean Baudrillard and Paul Virilio for explicit denunciations of "sociology"[9]). There is an especially marked antipathy to sociological abstractions like "society", "class", "mass", etc. The move against universalist or value-free knowledge claims gathers momentum in the 1960s with the growth of phenomenology but reaches its apogee in the late 1960s and 1970s under pressure from external demands mediated through social and political movements, rather than from epistemological debates narrowly defined within the academy – i.e., in the late 1960s, the challenge comes from the acid perspectivism of the drug culture, from the post 1968 politics of subjectivity and utterance (psychoanalysis, post structuralism) and from the fusion of the personal and the political in feminism, etc.

In Europe, the retreat from the first person plural "We" – the characteristic mode of address of the voice of liberation during the heroic age of the great bourgeois revolutions – can be associated historically with the fragmentation of the radical "centre" after 1968 (though the process of disenchantment begins in earnest after World War 2, with the revelations of the Moscow Trials, and after 1956 with the invasion of Hungary and the formation of the New Left). At the same time, during the 1950s attempts had been made, most notably by Sartre, to rescue a viable marxism and to rectify the over general conception of epochal change which marks the Hegelian philosophy of history. Sartre and Merleau-Ponty sought to relate dialectical materialism, as Peter Dews has recently put it, to "its smallest, most phenomenologically translucent component, the praxis of the human individual".[10] However, these anti-generalist tendencies are most clearly enunciated in the late 1960s with the widespread disaffection of the students from the French Communist Party and the odour of betrayal that hung over the Party after the events of 1968;[11] with the appearance of publications like Castoriadis's *History as Creation*, and with the fully fledged revival of interest – assuming the proportions of a cult in the 1970s and early 1980s – in the work of Nietzsche – a revival which can be traced back to the rediscovery of Nietzsche in the late 1950s by the generation of intellectuals which included Foucault and Deleuze[12] but which did not really take off until the post 1968 period of disenchantment. From 1968 we can date the widespread jettisoning of the belief amongst educated, "radical" factions not only in Marxist-

Leninism but in any kind of power structure administered from a bureaucratically organised centre, and the suspicion of any kind of political programme formulated by an elite and disseminated through a hierarchical chain of command. This process of fragmentation and growing sensitivity to the micro-relations of power both facilitated and was facilitated by the articulation of new radical or revolutionary demands, and the formation of new collectivities, new subjectivities which could not be contained within the old paradigms, and which could be neither addressed by nor "spoken" in the old critical, descriptive and expressive languages. Feminism, molecular and micro politics, the autonomy movement, the counterculture, the politics of sexuality, the politics of utterance (who says what how to whom on whose behalf: the issue of the politics of power and discourse, the issue of discursive "space") – all these "movements" and "tendencies" grew out of the cracks, the gaps and silences in the old radical articulations. Given their provenance on the "other side", as it were, of the *enoncé* it is hardly surprising that the new politics was more or less centrally concerned with the issue of subjectivity itself.

All these fractures and the new forms which grew inside them can be understood in this context as responses to the "crisis of representation" where the term "representation" – understood both in its everyday sense of "political representation" and in the structuralist sense of a distortive "ideological" representation of a pre-existent real – is regarded as problematic. From this point on, all forms and processes of "representation" are suspect. As the films of Jean-Luc Godard set out to demonstrate, no image or utterance from political speeches to narrative films to news broadcasts to advertisements and the inert, reified images of women in pornography was to be regarded as innocent ("In every image we must ask who speaks" [Godard]). All such representations were more or less complicit with, more or less oppositional to, the "dominant ideology". At the same time, the self-congratulatory rhetoric of political representation as a guarantor of individual and collective freedoms managed through the orderly routines and institutions of parliamentary democracy was rejected as a sham. This, of course, was nothing new: such an orientation forms the basis of a much older oppositional consensus. But more than that, for the disaffected factions who lived through the events of May, 1968, the idea of an individual or a political party representing, speaking for a social group, a class, a gender, a society, a collectivity, let alone for some general notion of history or progress, was untenable. (What "he" could ever speak adequately for "her", could recognise "her" needs, could represent "her" interests?) What tended to happen after 1968 is that these two senses of the term "representation" were run together around and through the notion of discourse and language as *in themselves*

productive of social relations, social and sexual inequalities, through the operations of identification, differentiation and subject positioning. In the closely related interrogation of and assault upon the idea of the (unitary) subject, a similar ambiguity was there to be exploited: subject as in classical rhetoric and grammar, the subject of the sentence, the "I" as in "I did it my way", "I changed the world", etc., the mythical "I" implying as it does the self conscious, self present Cartesian subject capable of intentional, transparent communication and unmediated action on the world. On the other hand, there is the "subjected subject": "subject" as in subject to the crown, subjugated, owned by some higher power. In the gap between these two meanings we became subjects of ideology, subject to the Law of the Father in the Althusserian and Lacanian senses respectively: apparently free agents and yet at the same time subject to an authority which was at once symbolic and imaginary – not "really" there but thoroughly real in its effects. The project of freeing the subject from subjection to the Subject was interpreted after 1968 by a growing and increasingly influential intellectual contingent as being most effectively accomplished through the deflection of critical and activist energies away from abstractions like the State-as-source-and-repository-of-all-oppressive-powers towards particular, localised struggles and by directing attention to the play of power on the ground in particular discursive formations.

But Paris represents just one 1968. There were others, the 1968, for instance, of Woodstock and the West Coast, of Haight-Ashbury, the Pranksters, the hippies, the yippies, the Weathermen, the Panthers and the opposition to the war in Vietnam. The lunar desertscapes and dune buggies of Manson and the Angels: the space of acid: the libertarian imaginary of unlimited social and sexual licence, of unlimited existential risking. Here, too, the rights of pleasure, the play of desire and the silent "discourse of the body" were being asserted against the puritanism and logocentricism of an earlier "straighter" set of "radical" demands and aspirations. In different ways, in Paris and in San Francisco in the wake of two quite different 1968s, the assertion of the claims of the particular against the general, the fragment against the (irrecoverable) whole was to lead to the apotheosis of the schizophrenic, as it did more or less contemporaneously in London in the work of R. D. Laing and David Cooper.[13] Whilst in Paris, Kristeva, Foucault, Deleuze and Guattari excavated and redeemed the buried, repressed and forbidden discourses of the mad and the marginal (Batâille, Artaud, Pierre Rivière), young men and women stalked around cities as far apart as Los Angeles and Liverpool wearing T-shirts decorated with a screen printed photograph of Charles Manson staring crazed and blazing eyed out into the world at chest level. The failed apocalyptic aspirations of 1968 and the cult of the psychotic are both deeply

registered in the rhetoric and style of postmodernist critique and leave as their legacy a set of priorities and interests which functions as a hidden agenda inside the Post (see 2 below).

To end this section on a footnote, it is perhaps surprising, given the anti-generalist bias which informs and directs the manifold vectors of the Post, that thinkers such as Jean Baudrillard and Jean-François Lyotard should retain such a panoptic focus in their work, writing often at an extremely high level of abstraction and generality of a "post modern condition", or "predicament", a "dominant cultural norm", etc.

(2) Against teleology

A scepticism regarding the idea of decidable origins/causes; this anti-teleological tendency is sometimes invoked explicitly against the precepts of historical materialism: "mode of production", "determination", etc. The doctrine of productive causality is here replaced by less mechanical, less unidirectional and expository accounts of process and transformation, such as those available within the epistemological framework provided by, for instance, "catastrophe theory" – to take one frequently cited example. In the same kind of knight's move which marked the growth of systems theory in the 1950s, arguments and paradigms from the "hard" sciences, from post-Newtonian physics, relativity, biochemistry, genetics, etc., are transposed to the broad fields of "communications" where they function as metaphors (principally, perhaps, they work – as such transpositions of scientific terms worked within modernism, for instance in futurism and cubism – as metaphors of modernity itself, as signs of the new). The anti-teleological tendency is potentially there in the Saussurean insistence on the arbitrary nature of the sign. It "comes out" explicitly in the post-structuralist elevation of the signifier/withering away of the signified, and is most pronounced in Baudrillard's order of the *simulacra* where in a parodic inversion of historical materialism the model precedes and generates the real-seeming (which in the age of miniaturised communications is all that's left of the "real"), where use value is completely absorbed into exchange value (in the form of sign-exchange value) where the old base-superstructure analogy is turned upside down so that value is seen to be generated in the production and exchange of insubstantials (information, image, "communications", in speculation on, for example, the currency and commodity future markets), rather than from the expropriation of "surplus value" through the direct exploitation of an industrial proletariat employed to produce three-dimensional goods in factories. (At this point Baudrillard's characterisation of a world given

190

over to the production of irreal or "hyperreal" *simulacra* derives a specious quasi-empirical grounding from the work of those "post-industrialists" (Alain Touraine, Daniel Bell, Andre Gorz, Alvin Toffler) who concentrate on the impact in the overdeveloped world of the new communications technologies on labour power, the relations between and composition of the classes, industrial patterns of work, consumption, culture, models of subjectivity, etc.).

The rhetorical tropes which form the literary-artistic-critical means for effacing the traces of teleology are parody, simulation, pastiche and allegory.[14] All these tropes tend to deny the primacy or originary power of the "author" as sole source of meaning, remove the injunction placed upon the (romantic) artist to create substance out of nothing (i.e., to "invent", be "original") and confine the critic/artist instead to an endless "reworking of the antecedent" in such a way that the purity of the text gives way to the promiscuity of the inter-text and the distinction between originals and copies, hosts and parasites, "creative" texts and "critical" ones is eroded (i.e., with the development of meta-fiction and paracriticism). In parody, pastiche, allegory and simulation what tends to get celebrated is the *accretion* of texts and meanings, the *proliferation* of sources and readings rather than the isolation, and deconstruction of the single text or utterance. None of these favoured tropes (parody, etc.) offers the artist a way of speaking from an "authentic" (that is [after Barthes, Derrida and Foucault[15]] imaginary) point of pure presence (romanticism). Nor do they offer the critic a way of uncovering the "real" or intended meaning or meanings buried in a text or a "phenomenon" (hermeneutics).

In Jameson's autopsia, the idea of depthlessness as a marker of postmodernism, accompanied as it is by a rejection of the vocabulary of intellectual "penetration" and the binary structures on which post Socratic thought is reckoned to be based, e.g., reality v appearance, real relations v phenomenal forms, science v false consciousness, consciousness v the unconscious, inside v outside, subject v object, etc., can be understood in this context as another step away from the old explanatory models and certainties. Derridean deconstruction and grammatology further destabilise such dualistic structures by disrupting the illusion of priority which tends to collect around one term in any binary opposition through the prepositional links which bind antinomies together (e.g., *behind* consciousness, the primary unconscious; *underneath* illusory phenomenal forms, the real relations; *beyond* subjective distortions, a world of stable objects, etc.). If the "depth model" disappears then so, too, does the intellectual as seer, the intellectual as informed but dispassionate observer/custodian of a "field of enquiry" armed with "penetrating insights" and "authoritative overviews", enemy of sophistry, artifice and superficial detail. Once

such oppositions dissolve, a lot of other things go too: there can be no more rectification of popular errors, no more trawling for hidden truths, no more going behind appearances or "against the grain" of the visible and the obvious. (The anti-positivist, anti-empiricist impetus that animated critical (rather than Greenbergian) modernism is, in other words, no longer available as a viable option.) In short, no more (Book of) Revelations. Instead what is left, to use another postmodernist key word, is a "fascination" with mirrors, icons, surfaces. In those accounts of postmodernism produced by writers who retain a problematic, residual commitment to marxian frames of reference, this ending of critical distance and the depth model is seen to be tied to (though not, presumably, determined by) a larger historical shift into a post-industrial, consumer, media, multi-national or monopoly phase in the development of capitalism. After the prohibitions, the instrumental rationality, and the purposiveness of a production economy (and the complementary oppositions and interruptions of modernism), we get – or so the argument goes – the licensed promiscuity, the unconstrained imaginaries, the merger of subjects and objects, mainstreams and margins, the drift and the dreamwork which characterise life in the consumption economy of the Post. In an economy geared towards the spinning of endlessly accelerating spirals of desire, consumption allegedly imposes its own ecstatic or pluralist (dis)order (Jameson's "heterogeneity without norms"). Idolatry, the worship of Baal (commodity fetishism) replaces positivism and its doppelganger, marxism, the dominant epistemic faiths of the modern period. Adorno and Horkheimer's *Dialectic of Enlightenment* collapses as the combative strategies of modernism – negation, estrangement, "non-identity thinking" – which were supposed to work to reveal the arbitrariness/mutability of symbolic-social orders and to form the last line of defence for the "authentic" and "autonomous" values of a kingdom yet to come – are either rendered invalid (obsolete: no longer offering a purchase on the contemporary condition) or are absorbed as just another set of options on a horizontal plane of meaning and value, where either everything means everything else (post-structuralist polysemy) or alternatively – what amounts to the same thing – everything means nothing whatsoever (Baudrillard's "implosion of meaning"). Ultimately these two options achieve the same effect: the evacuation of an axis of power external to discourse itself: end of "ideology", the cutting edge of marxist critical practice...

From such a set of premises it is no longer possible to speak of our collective "alienation" from some imagined (lost or ideal) "species being". Without the gaps between, say, perception, experience, articulation and the real opened up by the modernist master categories of ideology and alienation, there is no space left to struggle over, to

struggle from (or, as we shall see below, to struggle towards). Both the Cartesian subject capable of moral and aesthetic judgement and the routine discrimination of truth from lies, reality from fiction and the Enlightenment subject, child of the great modern abstractions: liberty, equality, progress, fraternity, etc.: these creatures disappear (their phantasmagoric essence finally exposed) in what Lyotard dubs the postmodern "sensorium": a new mode of being in the world, constituted in part directly through exposure to the new technologies which through the computational simulation of mental, linguistic and corporeal operations work to efface the line between mind and matter, subject and object (e.g., "cerebration" occurs at the "interface" between, say, two computational systems (one warmblooded, the other electronic) and is no longer adequately conceptualised as a purely internal process).

In a different, though related Lacanian declension of the Post, desire (which replaces reason or the class struggle as the historical constant, the motor of history) reinforces the Law, propelling the subject (which is constituted out of a series of partitions) on a doomed quest for completion and the final satisfaction of the very lack, the recognition of which, through the Oedipus complex, marked the "origin" of the subject *qua* subject in the first place (i.e., because the Oedipus complex marks the entry into language/the Symbolic, and the Symbolic already "owns" the discursive positions which the subject now exists to occupy). Within the Lacanian scenario, that quest for completion and satisfaction is doomed because desire is nothing more than the insatiable other side of lack, and lack itself is *recto* to the *verso* of the Law. It is doubly doomed because the questing subject is itself literally nothing if not incomplete ("I think where I am not and I am not where I think" [Lacan]). It is triply doomed because this fragmented subject is an ontological "fact" only in so far as it "finds" itself (i.e., gets positioned) in language and the Symbolic which is the domain of the Law which, to complete the circle, the movement of desire can only confirm and trace out rather than contradict or overthrow, etc. Once sutured in to the Jamesonian critique of consumer culture (where the "death of the subject" is seen as an historic "event" rather than (as from the post-structuralist perspective) as a philosophically demonstrable case valid at all times in all places), the Lacanian model of subjectivity and desire tends to consolidate the anti-utopianism which forms the last of the major postmodernist negations (see 3 below), though Lacanian feminists and critical postmodernists stress the extent to which a new political front is opened up within discourse (signifying practice) itself. At this point, through a series of poststructuralist slippages and puns, a kind of total "closure of discourse" (Marcuse) tends to occur, so that we are denied the prospect of any kind of "elsewhere", any kind of

"alternative", let alone transcendence through struggle, or any prospect – imminent or otherwise – of the removal of "scarcity" through the rational deployment of global resources. At one level, what are presented in the marxist discourse as "contradictions" which are historical (hence ultimately soluble) get transmuted in the discourse(s) of the Post into paradoxes which are eternal (hence insoluble). Thus "desire" supersedes "need", "lack" problematises the calculus of "scarcity", etc. The implication is that there is nowhere left outside the ceaseless (mindless) spirals of desire, no significant conflict beyond the tension (resorting here to the very different terms and emphases of Foucault) between bodies and those constraints which shape and cut against (de-fine) them as *social* bodies. Agon – the timeless (Hellenic) contest between evenly matched combatants where there can be no final victory, no irreversible outcome, here replaces history – the grand (Hebraic) narrative of the struggles of the righteous against the forces of evil – a narrative composed of a succession of unique, unrepeatable moments unfolding in a linear sequence towards the final day of judgement (Armageddon, the Apocalypse, Socialism: end of class struggle).

According to one strand within the postmodernist account, the implication here is that without meaningful duration and the subjective dispositions, expectancies and orientations, which such a "sense of an (imminent, just and proper) ending" surreptitiously imposes on us all, psychosis begins to replace neurosis as the dominant psychic norm under late capitalism. For Baudrillard there is the autistic "ecstasy of communication" where judgement, meaning, action are impossible, where the psychic "scene" (space of the subject/stage for psychic "dramas" complete with "characters" equipped with conscious and unconscious intentions, drives, motivations, "conflicts", etc.) is replaced by an "obscene" and arbitrary coupling of disparate "screens" and "termini" where bits of information, images, televisual close-ups of nothing in particular float about in the "hyperreal" space of the image-bloated *simulacrum*: a Leviathan-like lattice work of programmes, circuits, pulses, which functions merely to process and recycle the "events" produced (excreted) within itself.[16] For Jameson there is the schizophrenic consumer disintegrating into a succession of unassimilable instants, condemned through the ubiquity and instantaneousness of commodified images and information to live forever in *chronos* (this then this then this) without having access to the (centring) sanctuary of *kairos* (cyclical, mythical, meaningful time).[17] For Deleuze and Guattari there is the nomad drifting across *"milles plateaux"* drawn, to use their phrase, "like a schizophrenic taking a walk" from one arbitrary point of intensity to the next by the febrile and erratic rhythm of desire (conceived in this case against Lacan as the subversive Other to the

194

Law, not as its accomplice).[18] In each case, a particular (end of) subjectivity, a particular subjective modality, a distinct, universal structure of feeling is posited alongside the diagnostic critique of the contemporary condition.

Just as Marshall Berman proposes that modernisation (urbanisation, industrialisation, mechanisation) and modernism, the later answering wave of innovations in the arts together articulated a third term, the experience of modernity itself; so the prophets of the Post are suggesting that postmodernisation (automation, micro technologies, decline of manual labour and traditional work forms, consumerism, the rise of multinational media conglomerates, deregulation of the airwaves, etc.) together with postmodernism (bricolage, pastiche, allegory, the "hyperspace" of the new architecture) are serving to articulate the experience of the Post. Whereas the experience of modernity represented an undecidable mix of anticipated freedoms and lost certainties incorporating both the terror of disintegrating social and moral bonds, of spatial and temporal horizons and the prospect of an unprecedented mastery of nature, an emancipation from the very chains of natural scarcity – whereas, in other words, modernity was always a Janus-faced affair – the experience of *post* modernity is positively schizogenic: a grotesque attenuation – possibly monstrous, occasionally joyous – of our capacity to feel and to respond.

Postmodernity is modernity without the hopes and dreams which made modernity bearable. It is a hydra-headed, decentred condition in which we get dragged along from pillow to post across a succession of reflecting surfaces, drawn by the call of the wild signifier. The implication is that when time and progress stop, at the moment when the clocks wind down, we get wound up. In Nietzsche's dread eternal Now, as the world stops turning (stroke of noon, stroke of midnight), we start spinning round instead. This, at least, is the implication of the end of history argument: thus – Zarathustra-like – speak the prophets of the Post. In the dystopian extrapolation of schizophrenia as the emergent psychic norm of postmodernism we can hear perhaps, the bitter echo (back to front and upside down) of the two 1968s: San Francisco (Jameson) and Paris (Baudrillard). The schizophrenic is no longer presented as the wounded hero/heroic victim of the modernising process ("Who poses the greater threat to society: the fighter pilot who dropped the bomb on Hiroshima or the schizophrenic who believes the bomb is inside his body?" R. D. Laing.) The schizophrenic is no longer implicitly regarded as the suffering guarantor of threatened freedoms and of an imperilled ontic authenticity, but rather as the desperate witness/impotent victim of the failure not only of marxism but also of the inflated libertarian claims, dreams and millenarian aspirations of the two 1968s.

195

(3) Against Utopia

Running parallel to the anti-teleological impulse, and in many ways, as is indicated above, serving as the inevitable complement to it, there is a strongly marked vein of scepticism concerning any collective destination, global framework of prediction, any claims to envisage, for instance, the "ultimate mastery of nature", the "rational control of social forms", a "perfect state of being", "end of all (oppressive) powers". This anti-utopian theme is directed against all those programmes and solutions (most especially against marxism and fascism) which have recourse to a bogus scientificity, which place a high premium on centralised planning/social engineering, and which tend to rely heavily for their implementation on the maintenance of strict party discipline, a conviction of ideological certitude, etc. The barbaric excesses (e.g., Auschwitz, the Gulag) which are said to occur *automatically* when people attempt to put such solutions and programmes into action are seen to be licensed by reference to what Lyotard calls the *"grands récits"* of the West: by the blind faith in progress, evolution, race struggle, class struggle, etc., which is itself a product of the deep metaphysical residue which lies at the root of Western thought and culture. In other words (and here there is an explicit link with the *nouvelles philosophes* of the 1970s) all Holy Wars require casualties and infidels, all utopias come wrapped in barbed wire. Many commentators have remarked upon both the banality and the irrefutability of these conclusions.

The image which is often invoked as a metaphor for the decline of utopian aspirations, the refusal of "progress" and the "progressive" ideologies which underpin it – an image which in a sense encompasses all three of the founding negations of postmodern thought – is Walter Benjamin's allegorical interpretation of Paul Klee's painting the *Angelus Novus*. Benjamin suggests that in this painting, the angel of history is depicted staring in horror at the "single catastrophe" which hurls "wreckage upon wreckage" at his feet as the storm which is blowing from Paradise propels him irresistibly "into the future to which his back is turned".[19] "This storm," writes Benjamin, "is what we call progress." In a number of subtle and elaborately developed arguments evolved partly in the course of his protracted debate with Habermas over the nature of rationality and modernity, Lyotard has sought to clip the angel's wings by recommending that we abandon all those "modern" sciences which legitimate themselves by reference to a metadiscourse which makes an explicit appeal to "some grand narrative, such as the dialectics of the spirit, the hermeneutics of meaning, the emancipation of the rational or working subject, or the creation of wealth".[20]

In what becomes in effect an explicit renunciation of marxism (Lyotard was a founder member of the *Socialism or Barbarism* group in the

1950s), Lyotard returns to Kant – especially to the critique of judgement – to reflect upon the origins of modern social thought, aesthetics and the relationship between the two. He sets out to examine the philosophical underpinnings of the Enlightenment project which is defined as a twofold impetus towards universalisation (reason) and social engineering (revolution), both of which find support and legitimacy in the related doctrines of progress, social planning and historical "necessity". Much of Lyotard's argument turns on an involved discussion of the distinction in Kant (following Burke) between the two orders of aesthetic experience; the beautiful and the sublime. Whereas the beautiful in Kant consists in all those views, objects, sounds from which we derive aesthetic pleasure but which can be framed, contained, harmoniously assimilated, the sublime is reserved for all those phenomena which exceed logical containment and which elicit a mixture of both pleasure and terror in the viewer (Burke mentions, for instance, the spectacle of a stormy sea or a volcano).[21]

Lyotard argues that insofar as the various modernist literary and artistic avant gardes attempt to "present the unpresentable" (through abstraction, alienation, defamiliarisation, etc.) they remain firmly committed to an aesthetics of the sublime rather than the beautiful. For Lyotard, a properly avant garde poem or canvas takes us to this sublime point where consciousness and being bang up against their own limitations in the prospect of absolute Otherness – God or infinity – in the prospect, that is, of their disappearance in death and silence. That encounter compels the spectator's, the reader's and the artist's subjectivities to be predicated, for as long as it lasts, in an unlivable tense: the postmodern tense. Postmodernity is here defined as a condition that is also a contradiction in terms. Lyotard calls this timeless tense the future anterior: "post" meaning "after", "modo" meaning "now". (What Lyotard calls "postmodernity" is similar to Paul de Man's a(nti)historical definition of "modernity" as the perpetual present tense within which human beings have always lived at all times and in all places, pinioned forever between a disintegrating, irrecoverable, half remembered past and an always uncertain future.) Lyotard insists on the validity and the viability of this avant garde project of the sublime and seeks to promote those artistic practices which pose the issue of the unpresentable in a gesture which has to be incessantly forgotten and repeated. Using a term from psychoanalytic theory, Lyotard calls this process "anamnesis": the re-encounter with a trauma or former experience of intensity through a process of recollection, utterance and invocation, which involves not so much a recovery of the original experience as a recapitulation of it.

What might at first seem a quite arbitrary, unnecessarily abstruse and idiosyncratic detour through eighteenth-century German idealist

aesthetics actually provides Lyotard with an opportunity to flesh out his central objections to Habermas's attempts to defend and build on the Enlightenment inheritance, to revive what Habermas regards as the prematurely arrested project of modernity.

For Lyotard uses the notion of the sublime as a kind of metaphor for the *absolute* nature of those limitations placed on what can be said, seen, shown, presented, demonstrated, put into play, put into practice, and he implies that each encounter with the sublime in art provides us with the single salutary lesson that complexity, difficulty, opacity, are always there in the same place: *beyond our grasp*. The inference here, in the insistence on the palpability of human limitation, is politically nuanced at those points when Lyotard talks about the disastrous consequences which have flowed from all attempts to implement the perfect (rational) system or to create the perfect society during what he calls the "last two sanguinary centuries".[22]

Habermas, publicly aligned with the Frankfurt tradition which he is concerned both to revise and to revive, has emphasised the emancipatory and utopian dimensions of art, favouring an aesthetics of the beautiful. From this position, the fact that the harmonious integration of formal elements in an artwork gives us pleasure, indicates that we are all drawn ineluctably by some internal *logos* (reason reflexively unfolding/folding back upon itself through the dispassionate contemplation of form), that we are, in other words, drawn towards the ideal resolution of conflict in the perfection of good form. Here our capacity both to produce and to appreciate the beautiful stands as a kind of promissory note for the eventual emancipation of humanity. Lyotard, on the other hand, in a move which mirrors the deconstructive strategies exemplified by Derrida, takes the relatively subordinate, residual term, the "sublime" in the binary coupling upon which "modern" (i.e. Enlightenment) aesthetics is based (the beautiful – [the sublime] where the sublime functions as that-which-is-aesthetic-but-not-beautiful) and privileges it to such an extent that the whole edifice of Enlightenment thought and achievement is (supposedly) threatened. For whereas the idea of the beautiful contains within it the promise of an ideal, as yet unrealised community (to say "this is beautiful" is to assert the generalisability of aesthetic judgements and hence the possibility/ideal of consensus), the sublime, in contrast, atomises the community by confronting each individual with the prospect of his or her imminent and solitary demise. In Lyotard's words, with the sublime, "everyone is alone when it comes to judging".[23]

The sublime functions in Lyotard's work as a means of corroding the two "materialist" faiths (positivism and marxism) which characterise the superseded modern epoch. For example, responding recently to an attack on postmodernism by the British marxist, Terry Eagleton,[24]

Lyotard made the provocative (or facetious) claim that Marx "touches on the issue of the sublime" in the concept of the proletariat, in that the proletariat is, in Kantian terms, an Idea in Reason, that is, an idea which must be seen as such, not as an empirically verifiable existent (i.e. the working class). The "proletariat", in other words, according to Lyotard cannot be incarnated and specified as this or that group or class. It is not reducible to "experience" (Lyotard declines, of course, to specify how – given this distinction – marxism is to fulfil its claims to be a philosophy of praxis. . . .). Using Adorno's shorthand term to signal the litany of disasters which he sees underwriting the modern period, Lyotard asserts that "Auschwitz" happened because people made precisely that category error from the time of Robespierre's terror on, seeking to identify (more commonly to identify *themselves* with) such Ideas in Reason. A succession of revolutionary vanguards and tribunals have set themselves up as the subjects and agents of historical destiny: "'I am Justice, Truth, the revolution . . . We are the proletariat. We are the incarnation of free humanity' "[25] and have thereby sought to render themselves unaccountable to the normative framework provided by the web of "first order narratives" in which popular thought, morality and social life is properly grounded. Those moments when men and women believed themselves to *be* Benjamin's Angel of History who "would like to stay, awaken the dead, and make whole what has been smashed",[26] moments of illusory Faustian omnipotence, and certainty are the dangerous moments of supposedly full knowledge, when people feel fully present to themselves and to their "destiny" (the moment, say, when the class in itself becomes a class for itself). For Lyotard they are the moments of historical disaster: they inaugurate the time of revolutions, executions, concentration camps. In an ironic retention of Kant's separation of the spheres of morality, science and art (ironic in view of Lyotard's judgement of the Enlightenment legacy), he seeks to stake out the sublime as the legitimate province of (post)modern art and aesthetics whilst at the same time rigorously excluding as illegitimate and "paranoid" any aspiration to "present the unpresentable" through politics (i.e., to "change the world") or to constitute an *ontology* of the sublime (i.e., "permanent revolution", attempts to create a new moral or social order, etc.). The sublime remains *das Unform*,[27] that which is without form, hence that which is monstrous and unthinkable. Rather than seeking to embody universal values of Truth, Justice and Right, finding the licence for such pretensions in the great metanarratives ("the pursuit of freedom or happiness"[28]), Lyotard recommends that we should instead think of the human project in terms of "the infinite task of complexification".[29] ("Maybe our task is just that of complexifying the complexity we are in charge of". [Lyotard].) This "obscure desire towards extra sophistication"[30] effectively functions within Lyotard's

199

most recent work as a panglobal, transhistorical imperative assuming at times an almost metaphysical status (although he does make a concession to the persistence of scarcity in the Third World in the cryptic division of humanity into two (unequal) halves, one of which (i.e., ours?) is devoted to the task of complexification, the other (theirs?) to the "terrible, ancient task of survival"[!][31]). Lyotard may have jettisoned the socialism which formed his preferred option in the stark choice which he felt was facing the world in the 1950s (*S ou B*) but he remains alert to the threat of barbarism which he now associates with a refusal to acknowledge and/or contribute to this eternal complexifying mission ("The claim for simplicity, in general, appears today that of the barbarian" [Lyotard]).

Lyotard offers one of the most direct, most intricately argued critiques of the utopian impetus within modern, Enlightenment and post-Enlightenment thought, but there are, within the Gallic version of the Post, other variations on the (Nietzschian) theme of the end of the Western philosophical tradition (Lyotard ends by dissolving dialectics into paradoxology, and language games). In some ways, those discourses from Foucault to Derrida, from the Barthes of the *Tel Quel* phase to the Jacques Lacan of *L'Ecrits* might be said to be posited, following Nietzsche, on the no man's land (the gender here *is* marked!) staked out between the two meanings of the word "subject" mentioned earlier (see section 1) – a no man's land which is just that: a land owned by no body in the space between the *enoncé* and the *enonciation* where questions of agency, cause, intention, authorship, history, become irrelevant. All those questions dissolve into a sublime, asocial now which is differently dimensionalised in different accounts. For Derrida (in grammatology) that space is called *aporia* – the unpassable path – the moment when the self-contradictory nature of human discourse stands exposed. For Foucault, it is the endless recursive spirals of power and knowledge: the total, timeless space he creates around the hellish figure of the panopticon: the viewing tower at the centre of the prison yard – the *voir* in savoir/pouvoir, the looking in knowing. For *Tel Quel* it is the moment of what Julia Kristeva calls *signifiance*: the unravelling of the subject in the pleasure of the text, the point where the subject disintegrates, moved beyond words by the materiality, productivity and slippage of the signifier over the signified. And for Lacan, it is the Real – that which remains unsayable and hence unbearable – the (boundless, inconceivable) space outside language and the Law, beyond the binaries of the Imaginary register: the Real being the realm of the promise/threat of our eventual (unthinkable) disintegration, our absorption into flux. The sublime is here installed in each case as the place of epiphany and terror, the place of the ineffable which stands over and against all human endeavour, including the project of intellectual

totalisation itself. Lacan's Real, Foucault's power-knowledge spirals, Kristeva's *signifiance*, Derrida's *aporia*, Barthes' text of bliss: all are equivalent, in some sense reducible to Lyotard's category of the sublime. This elevation of the sublime (which has its more literal [or crass] quasi-empirical corollary in the cult of schizophrenia [see above] – the cult, that is, of dread, of the sublime mode of being in the world) could be interpreted as an extension of the aspiration towards the ineffable which has impelled the European avant garde at least since the Symbolists and Decadents and probably since the inception, in the 1840s, of metropolitan literary and artistic modernism with the "anti-bourgeois" refusals of Baudelaire. It implies a withdrawal from the immediately given ground of sociality by problematising language as tool and language as communicative medium, by substituting models of signification, discourse and decentred subjectivity for those older humanist paradigms and by emphasising the *im*possibility (of "communication", transcendence, dialectic, the determination of origins and outcomes, the fixing or stabilisation of values and meanings). The moment which is privileged is the solitary confrontation with the irreducible fact of limitation, otherness, difference, with the question variously of the loss of mastery, "death in life" (Lyotard), of the "frequent little deaths" or "picknoleptic interruptions" of consciousness by the unconscious (Virilio).

The conversion of asociality into an absolute value can accommodate a variety of more or less resigned postures: scepticism (Derrida), stoicism (Lyotard, Lacan, Foucault), libertarian anarchism/mysticism (Kristeva), hedonism (Barthes), cynicism/nihilism (Baudrillard). However, such a privileging of the sublime tends to militate against the identification of larger (collective) interests (the isms of the modern epoch, e.g., marxism, liberalism, etc.). It does this by undermining or dismissing as simplistic/"barbaric" what Richard Rorty has called "our untheoretical sense of social solidarity",[32] and by bankrupting the liberal investment in the belief in the capacity of human beings to empathise with each other, to reconcile opposing "viewpoints", to seek the fight-free integration of conflicting interest groups. There is no room, in the split opened up in the subject by the Post, for the cultivation of "consensus" or for the growth and maintenance of a "communicative community", no feasible ascent towards an "ideal speech situation" (Habermas). The stress on the asocial further erodes the sense of destination and purposive struggle supplied by the "optimistic will" (Gramsci), and the theoretical means to recover (i.e., emancipate) a "reality" obscured by "something called "ideology" (created by power) in the name of something called 'validity' (not created by power)"[33] (Habermas again). The stress on the impossible tends, in other words, seriously to limit the scope and definition of the political (where politics

is defined as the "art of the possible"). A series of elisions tend to prescribe a definite route here (though it is a route taken by more disciples than master-mistresses). First there is the absolute conflation of a number of relatively distinct structures, paradigms, tendencies: the emergence of industrial-military complexes, the Enlightenment aspiration to liberate humanity, the rise of the modern scientific episteme, the bourgeoisie, the bureaucratic nation-state and "Auschwitz". Next, these discrete and non-synchronous historical developments are traced back to the model of the subject secreted at the origins of Western thought and culture in transcendental philosophy. Finally, an ending is declared to the tradition thus established and the equation is made between this ending (the end of philosophy) and the ending of history itself.

As Rorty has pointed out – and these concluding remarks on anti-utopianism are a precis of Rorty's arguments – such a trajectory overestimates the wider historical importance of the philosophical tradition and especially overestimates the extent to which modern social, economic and political structures were underwritten by (i.e., required) models of subjectivity "originating" in the context of philosophical debates on the nature of consciousness, perception, alienation, freedom, language, etc. In this way, the Post tends to reproduce, back to front as it were, like a photographic negative, the mistake which Habermas himself makes of linking the story of modern post-Kantian philosophy and rationalism too closely to that other modern story: the rise of industrialised democratic societies. Rorty suggests that the second story has more to do with pressures and social movements external to the academy, that the idea(l) of the "communicative community" has been established through "things like the formation of trade unions, the meritocratisation of education, the expansion of the franchise, and cheap newspapers"[34] rather than through the abstract discussion of epistemology; that religion declines in influence not because of Nietzsche, Darwin, positivism or whatever, but because "one's sense of relation to a power beyond the community becomes less important as you see yourself as part of a body of public opinion, capable of making a difference to the public fate".[35] Viewed in this light, the history of philosophy from, say, Descartes to Nietzsche is seen as a "distraction from the history of concrete social engineering which made the contemporary North Atlantic culture what it is now (with all its glories and its dangers)" and Rorty concludes by sketching the outlines of an alternative philosophical canon in which the "greatness" of a "Great Mind" would be measured less by reference to her/his contribution to the dialectics of the "Great Debates", and by the epistemological complexity of the arguments put forward, than by his/her sensitivity to "new social and religious and institutional

possibilities" – a prescient and strategic orientation which renders questions of "grounding" and "legitimation" irrelevant . . . Within such a transformed knowledge-practice field, the function of analysis would be neither to unmask ideology, to assist the forward march of Reason, nor to trace out the eternal perimeters of sociality, knowledge and the sayable but, rather, following Foucault, to explain "who was currently getting and using power and for what purposes and then [unlike Foucault] to suggest how some other people might get it and use it for other purposes."[36]

Such an orientation would seem to require that same combination of qualities, that same mix of conjunctural analysis and strategic intervention which typifies the Gramscian approach (especially as developed by people like Stuart Hall, Ernesto Laclau and Chantal Mouffe – albeit, as Hall himself points out, along rather different lines (see the interview with Stuart Hall in the *Journal of Communications Inquiry*, University of Iowa, Summer, 1986), where a "war of position" is waged between conflicting alliances of "dominant" and "subaltern" class fractions over and within a heterogeneous range of sites, which are themselves shaped by a complex play of discursive and extra-discursive factors and forces. But what distinguishes the Gramscian approach is the way in which it requires us to negotiate and engage with the multiple axes of both power and the popular and to acknowledge the ways in which these two axes are "mutually articulated" through a range of popul*ist* discourses which centre by and large precisely on those pre-Post-erous modern categories: the "nation", "roots", the "national past", "heritage", "the rights of the individual" (variously) "to life and liberty", "to work", "to own property", "to expect a better future for his or her children", the right "to *be* an individual": the "right to choose". To engage with the popular as constructed and as lived – to negotiate this bumpy and intractable terrain – we are forced at once to desert the perfection of a purely theoretical analysis, of a "negative dialectic" (Adorno) in favour of a more "sensuous [and strategic] logic" (Gramsci) – a logic attuned to the living textures of popular culture, to the ebb and flow of popular debate.

In this shift in the critical focus, the meaning of the phrase "legitimation crisis" is inflected right away from problems of epistemology directly on to the political, as our attention is drawn to the *processes* whereby particular power blocs seek to impose their moral leadership on the masses and to legitimate their authority through the construction (rather than the realisation) of consensus. The Gramscian model demands that we grasp these processes not because we want to expose them or to understand them in the abstract but because we want

to *use* them effectively to contest that authority and leadership by offering arguments and alternatives that are not only "ideologically correct" ("right on") but convincing and convincingly presented, arguments that capture the popular imagination, that engage directly with the issues, problems, anxieties, dreams and hopes of real (i.e., actually existing) men and women; arguments, in other words, that take the popular (and hence the populace) seriously and that engage directly with it *on its own terms, and in its own language.*

At the same time, the Gramscian line is identified, at least in Britain, with a commitment to flexible strategies, to responsive, accountable power structures, with a commitment to decentralisation and local democracy. It is associated with a challenge to the workerism and the masculinism of the old Labour Left, a move away from the dogmatism which can still plague the fringe parties, with a sensitivity to local and regional issues, with an alertness too, to race and gender as well as class, as significant axes of power... It is associated with a commitment to "advance along multiple fronts", with the kind of policies implemented by progressive enclaves within the local state. The GLC's sponsorship of feminist, gay rights, ethnic minorities, citizens' rights and alternative health care groups is often cited as exemplary in this context, together with the initiatives it took under Ken Livingstone's leadership in setting up police monitoring committees, in lending support for small, alternative presses and in funding cheap public transport, minority arts programmes, popular arts festivals, expanded public information services and issue-orientated "consciousness raising" publicity campaigns. These policies so provoked the Thatcher administration that during the 1985/6 parliamentary session, the central government dismantled the system of municipal government in the big urban centres run throughout the 1980s by Labour administrations (leaving London as the only major Western European capital without its own elected council).

The commitment on the one hand to local radicalism, to a menu of bold, experimental policies for the inner city, and on the other the critique of Thatcherite "authoritarian populism"[37] and the resolve to engage, for instance, on the traditional rightist ground of "national-popular" discourses, represent perhaps the two dominant and potentially opposed tendencies which derive in part from debates amongst the British Left on the relatively recently translated work of Gramsci.[38] However, while the first tendency clearly resonates with many of the (more positive) themes of the Post (1968) debates, the stress on populism seems to run directly counter to the drift of the Post. For the popular exists solely in and through the problematic "we" – the denigrated mode of address, the obsolescent shifter. This "we" is the imaginary community which remains unspeakable within the Post –

literally unspeakable in Baudrillard, who presents the myth of the masses as a "black hole" drawing all meaning to its non-existent centre.[39] In Gramsci, of course the "we" is neither "fatal" in the Baudrillardian sense, nor given, pre-existent, "out there" in the pre-Post-erous sense. Instead it is itself the site of struggle. The "we" in Gramsci has to be *made* and re-made, actively articulated in the double sense, both spoken, uttered and linked with, combined. (It has to be at once positioned *and* brought into being.) The term articulation is thus a key bridging concept between two distinct paradigms or problematics. It bridges the structuralist and the culturalist paradigms which Stuart Hall has identified[40] and since the late 1960s sought to integrate in that it both acknowledges the constitutive role played by (ideological) discourses in the shaping of (historical) subjectivities and at the same time it insists that there is somewhere outside discourse (a world where groups and classes differentiated by conflicting interests, cultures, goals, aspirations; by the positions they occupy in various hierarchies are working in and on dynamic (i.e., changing) power structures) – a world which has in turn *to be linked with*, shaped, acted upon, struggled over, intervened in: changed. In other words, the concept of articulation itself articulates the two paradigms by linking together and expressing the double emphasis which characterises Gramscian cultural studies. It performs the same metonymic function, is as homologous to and as exemplary of Stuart Hall's project as *differance* is to Derrida's (where the term differance simultaneously connotes and itself *enacts* the double process of differing and deferring meaning which Derrida sees as language's essential operation). The reliance on the concept of articulation suggests that the "social" in Gramsci is neither a "beautiful" dream nor a dangerous abstraction, neither a contract made and re-made on the ground as it were, by the members of a "communicative community" in multiple face-to-face interactions which are "context-dependent" (Habermas) nor an empirically non-existent "Idea in Reason" which bears no relation whatsoever to experience (Lyotard). It is instead a continually shifting, mediated relation between groups and classes, a structured field and a set of lived relations in which complex ideological formations composed of elements derived from diverse sources have to be actively combined, dismantled, bricolaged, so that new politically effective alliances can be secured between different fractional groupings which can themselves no longer be returned to static, homogeneous classes. In other words, we can't collapse the social into speech act theory, or subsume its contradictory dynamics underneath the impossible quest for universal validity claims. At the same time, rather than dispensing with the "claim for simplicity" by equating it with barbarism, we might do better to begin by distinguishing a claim from a demand, and by acknowledging that a

demand for simplicity exists, that such a demand has to be negotiated, that it is neither essentially noble nor barbaric, that it is, however, *complexly articulated* with different ideological fragments and social forces in the form of a range of competing populisms.

It would be foolish to present a polar opposition between the Gramscian line(s) and the (heterogeneous) Posts. There is too much shared historical and intellectual ground for such a partition to serve any valid purpose. It was, after all, the generation of marxist intellectuals who lived through 1968 and who took the events in Paris and the West Coast seriously who turned in the 1970s to Gramsci. In addition, there are clear cross-Channel links between the two sets of concerns and emphases, for instance, in the work of Michel Pêcheux on "interdiscourse". The retention of the old marxist terms should not be allowed to obscure the extent to which many of these terms have been transformed – wrenched away from the "scientific" moorings constructed in the Althusserian phase. What looks at first glance a lot like the old "rationalist" dualism ("Left" v "Right", etc.); the old "modernising" teleology ("progressive", "reactionary", "emergent", "residual", etc.); a typically "modernist" penchant for military metaphors ("dominant" and "subaltern classes", etc.); an unreconstructed "modernist" epistemology ("ideology", for instance, rather than "discourse") looks different closer to. From the perspectives heavily influenced by the Gramscian approach, nothing is anchored to the *grands récits*, to master narratives, to stable (positive) identities, to fixed and certain meanings: all social and semantic relations are contestable, hence mutable; everything appears to be in flux: there are no predictable outcomes. Though classes still exist, there is no guaranteed dynamic to class struggle and no "class belonging"; there are no solid homes to return to, no places reserved in advance for the righteous. No one "owns" an "ideology" because ideologies are themselves in process: in a state of constant formation and reformation. In the same way, the concept of hegemony remains distinct from the Frankfurt model of a "total closure of discourse" (Marcuse) and from the ascription of class domination which is implied in the Althusserian model of a contradictory social formation held in check eternally (at least until "the last (ruptural) instance") by the work of the RSAs and the ISAs. Instead hegemony is a precarious, "moving equilibrium" (Gramsci) achieved through the orchestration of conflicting and competing forces by more or less unstable, more or less temporary alliances of class fractions.

Within this model, there is no "science" to be opposed to the monolith of ideology, only prescience: an alertness to possibility and emergence – that and the always imperfect, risky, undecidable "science" of strategy. There are only competing ideolog*ies*, themselves

206

unstable constellations, liable to collapse at any moment into their component parts. These parts in turn can be recombined with other elements from other ideological formations to form fragile unities which in turn act to interpellate and bond together new imaginary communities, to forge fresh alliances between disparate social groups (see, for instance, Hall and others on national popular discourse[41]).

But it would be equally foolish to deny that there are crucial differences between the two sets of orientations. A marxism of whatever kind could never move back from or go beyond "modernity" in the very general terms in which it is defined within the Post (which is not to say that marxism is necessarily bound to a dynamic and destructive model of technological "advance" (see Bahro on the possibility of eco-marxism: a union of "greens" and "reds"[42])). However, it should be said that the kind of marxism Stuart Hall proposes bears little or no relation to the caricatured, teleological *religion* of marxism which – legitimately in my view – is pilloried by the Post. A marxism without guarantees is a marxism which has suffered a sea change. It is a marxism which has "gone under" in a succession of tempests that include the smoke and the fire of 1968 and the shrinkage of imaginative horizons in the monetarist "New Realism" of the 1980s and yet it is a marxism that has survived, returning perhaps a little lighter on its feet (staggering at first), a marxism more prone perhaps to listen, learn, adapt and to appreciate, for instance, that words like "emergency" and "struggle" don't just mean fight, conflict, war and death but birthing, the prospect of new life emerging: a struggling to the light...

Post-script 1: Vital Strategies

Impose: lay on (in various uses); exert influence *upon*, as with
fraudulent intent or effect: Latin imponere: place on or into,
inflict, set over, lay as a burden, deceive, trick see POSE. Hence
IMPOSING, exacting, impressive. So IMPOSITION: laying-
on of hands (Wyclif Bible); impost [giving IMPOSTOR: one
who imposes on others]; exercise imposed as a punishment"
(The Oxford Dictionary of English Etymology)

Writing is a curious imposition: a burden and a trick, an exercise
imposed upon impostors as a punishment. It is a laying-on of hands, an
attempt to heal the breach, to close the wound, to exorcise and expiate.

And – *pace* Derrida – it never works; we never get it right. What we write defers and differs from our originary intentions. These post-scripts are a final imposition (on the reader, on the writer); an attempt at a writing out – an exscription – of the dichotomous either/or (*either* Gramsci *or* the Post) which in-forms ("imbues, inspires [Wycliff]; furnishes with knowledge"[1]) and dis-appoints ("frustrates the expectation or fulfilment of"[2]) the what-it-was that wanted-being-said.

In the extravagant, "science fictional" cosmology put forward by Jean Baudrillard – a system which builds on the eschatology of waste, crime and the gift deriving from the work of Georges Bataille there is nothing to look forward to because there is nowhere left (no "I"/eye) to look from (no subject) hence no outside, no far perimeter, no other place to go. In the death of reason, the neophilia of the modern age gives way to the necrophilia and necro-mancy of the Post. There is a figure in rhetoric which describes this passage and the system it produces: the *hyperbaton* (an inversion of logical or natural order from the Greek *hyperbatos* "overstepping" (used in Plato and Aristotle to refer to the, for them, inadmissible) transposition of words which was one of the preferred tactics of the Sophists). In Baudrillard's *hyberbaton*, there is *only* negation. Psychosis, waste and death are positively valued so that only "fatal strategies" can prevail. A "negative" cultural tendency is countered not in "resistance" or in "struggle" (the terms of dialectic) but in a doubling of the same: a "hyper-conformity" or hyper-compliance. The critic-as-surgeon cutting out and analysing diseased or damaged tissue is replaced by the critic-as-homeopath "shadowing" and paralleling the signs of sickness by prescribing natural poisons which produce in the patient's body a simulation of the original symptoms. Hence Baudrillard's fatal simulations and excesses – more negative than the negative – his celebration of the death drive which converts all creation into excreta. Baudrillard's excessive morbidity stands as one sign of the Post: a sign-post which despite all the polemical denunciations of the linear can point in only one direction down the long dark road to the end of the night.

To *accuse* Baudrillard of "decadence" is to miss the point (decadence becomes a positive term in Baudrillard's *hyperbaton* as it was for Maurice Barrès, as it was for Baudelaire whose "flowers of evil" were grown in a soil enriched even then, at the very inception of the modernist adventure by what the poet saw as the corpses of Western rationalism and morality). "Decadent" is simply what postmodernism *is* whether that decadence is presented in postmodernist criticism as a historical phase – associated as in Jameson with an empirically discernible "cultural condition" produced by the (eternally?) prolonged decline of "late" capitalism – or whether it is equated with an end of historical

development as in Lyotard (where through the anamnesic process we nod off intermittently only to wake up to find ourselves in exactly the same place) or whether this decadence is itself the yearned for end of everything as in Baudrillard. The discourse of postmodernism is fatal and fatalistic: at every turn the word "death" opens up to engulf us: "death of the subject", "death of the author", "death of art", "death of reason", "end of history". If signs are material (and they surely are), if they do "position" and "move" us irrespective of our conscious intentions and resistances, if we do get dragged and lashed and ridden by signifying chains then where can such a discourse lead us except to the very edges of despair, to the gates of the necropolis? And who on earth in their right mind would *want* to go *there*?

But, of course, we don't *have* to go there, and if for whatever reason, we do get dragged in that direction then we can always pass *through* the gates: there is another side, an after-life beyond the multiple fatalities announced within the Post. And in this other space a sense of possibility is being engendered as new and different voices emerge to articulate positive critical energies, energies which cannot be appropriated to the "fatal" systems favoured by some (predominantly? exclusively?) male intellectuals, and which are conveyed along networks and circuits within which the university, the academy and the gallery no longer function as significant termini or are bypassed altogether. This much is clear: in the last twenty years or so, there have been major shifts in consumption, in popular cultural forms, rituals, dispositions; in the degree of conglomeration within the communications industries; in general patterns of capital investment and technological development which have registered deeply in the textures of everyday life in the States and Western Europe. The varieties of postmodernism together offer some of the most suggestive accounts and analyses of these shifts at least as they affect the metropolitan culture(s) of the affluent West. Elements of these analyses can be prised away from their vertiginous "groundings" in the Post and reinflected, forming the basis for the development of a more enabling, *vital* set of strategies.

This post-script is one attempt to explore some of the possibilities secreted in the largely fatal discourse of postmodernism:

One of the most powerful arguments that Jameson makes for a supercession of modernist categories is that the "avantism" of the modernist avant gardes has been effaced as modernist literature and art become "normalised": taught in colleges as "set books", shown to students as examples of the "modern tradition", displayed in galleries, adapted for television, etc., and as the saturation of visual and verbal forms and genres – the sheer overload of broadcast imagery and sounds – confront the consumer with a total "collage" environment. Nowadays, Jameson implies, both modernity *and* modernism are lived, and the

decentred, floating, fragmentary subject becomes the ideal target for advertising conceived as a system which no longer offers a "magical" sanctuary from "real" cares and needs (as Williams, Packard or Berger might have put it)[3] but provides instead an endless succession of vacatable "positions" for the "desiring machines" which replace the sexually repressed and regulated workers of an earlier epoch. However, even if we take seriously this extrapolation of the "new consumer" from advertising-seen-as-an-intertextual-system (and there are serious problems with it), it doesn't follow that the pre-emption or dispersal of the avant garde, the merger of the "incorporated" mainstreams and the "critical" margins is all bad.

As semiotics gets increasingly annexed by the advertising and marketing industries, information and knowledge begin to circulate outside the old parameters on the other side of the established institutional circuits: in the fast forward, rewind and slow motion functions of domestic video machines, in the pause button on a walkman audio cassette. Once rescued from the aura of despair which surrounds them in the original passages, pastiche and collage in this context shed their entropic connotations and become the means through which ordinary consumers can not only appropriate new technologies, new media skills to themselves, but can learn a new principle of assemblage, can open up new meanings and affects. Pastiche and collage can be valorised as forms which enable consumers to become actual or potential producers, processors and subjects of meaning rather than the passive bearers of pregiven "messages". Here "consumption" with its connotations of passivity, of waste, digestion, disappearance, needs to be replaced by some other term capable of conveying the *multi-accentuality* and *duration* over time and in different cultural-geographical contexts of commodified objects and forms as they move from one dislocated point to the next, from design, through production, packaging, mediation, and distribution/retail into use where they are appropriated, transformed, adapted, treated differently by different individuals, classes, genders, ethnic groupings, invested with different degrees and types of intensity.[4]

A critical attention to terms like "consumption" and "mass" imposes a shift in the analysis towards particulars and details. Everywhere the tesselated surfaces and plural textures of contemporary popular culture require us to remain alert to possibility and contradiction. The domestication of the formal code and the popularity, for instance, of the new generation of cheap "user friendly" communication technologies (Britain has the highest *per capita* ownership of videocassette recorders in the world) has no doubt helped to facilitate a greater and more rapid turnover of more diverse "consumption" (sub)cultures as new cultural and aesthetic forms

211

emerge based on the raiding and pasting together of rhythms, images and sounds from multiple sources which often bear no apparent "natural", historical or geographical relation to each other (e.g., "scratch" videos and music, rap (based originally on a bricolage of talkover reggae, soul and white 1980s electro funk),[5] hip hop, "duck rock" (Zulu, Burundi, West African Hi-Life, Appalachian and hip hop), opera/beat-box cross-over (Malcom McLaren's *Fans* album), the new, fast British "M.C." style of reggae, etc.). It no longer appears adequate to confine the appeal of these forms – the multiple lines of effect/affect emanating from them – to the ghetto of discrete, numerically small subcultures. For they permeate and help to organise a much broader, less bounded territory where cultures, subjectivities, identities impinge upon each other. In the suggestive terms introduced by Larry Grossberg,[6] such musics (in fact, all popular musics) can serve to articulate new "structures of desire" through the consolidation of "affective alliances" between elements in a heterogeneous field organised around contradictory and conflicting social-sexual appetencies, aspirations, inclinations, dispositions, drives. Attempts are continually being made (from within the music industry) to stabilise this complex and volatile amalgam of forces through the fixing of more or less enabling, more or less proscriptive social-sexual "identities". What follows is an attempt to use some of these complexifying categories and to combine them with elements in the Gramscian approach in order to draw out tentatively in what I hope is a positive spirit, some of the "emergencies" revealed, as it were, within the popular beyond both "subcultural resistance" and the fatal terminology of the Post.

From *Anarchy in the UK* to *Save the World*

Punk is often used as a watershed – a terminus or starting point in chronological accounts of the relationship between British popular music and popular culture. It has often been remarked that punk's influence and effects extended far beyond the confines of a particular subculture. Punk had been presented to the British public in the mid-1970s as and through a series of spectacular negations of consensually defined musical, sartorial and sexual norms and was generally associated with a creative and/or troublesome minority of urban "deviants" or "innovators". (This approach was duplicated in my own work.[7]) But punk cannot be constrained or understood within such a narrow framework... The spectacular negations concealed contradictory impulses. The lyrics and the looks of punk music and fashions topicalised the themes of "youth unemployment" and "urban crisis" which were generalised as the recession deepened during the next

212

decade, as the deteriorating, under-funded inner cities erupted in the youth riots in 1981, as the government-backed Manpower Services Commission sought to regulate and manage the growing numbers of jobless school-leavers through a succession of Youth Training Schemes. On the other hand, punk's visual and musical hyperboles helped to boost the British fashion and design industries, led to a (temporary) boom in independent record production and marked the beginning of a long-term (re)visualisation of popular music which spread from poster and record sleeve design to the massive investment in video promotions which was to pave the way for the "second British invasion" of the US music charts after MTV was set up in the early 1980s.

But punk also inaugurated in earnest the long retreat from the phallocentric codes of "cock rock"[8] and the (re)discovery of other (more or less marginalised) musics – bebop, cool jazz, swing, r & b, salsa, reggae, funk – and the invention of new ones – electro-synth, MC reggae, rap, jazz funk, etc. These new or transfigured musical languages have been used by performers to contest the given constructions of masculinity and femininity available within the wider culture and to articulate less monotonously phallic, and/or heterosexual structures of desire (e.g., The Slits, the Au Pairs, Carmen, Sade, Alyson Moyet, Culture Club, Bronski Beat, The Communards, Frankie Goes to Hollywood, The Smiths).

A moratorium was also held in punk on questions of race, ethnicity, nation. Not only did this involve refusals of the concept of a "United Kingdom" in songs like *White Riot* (The Clash) and *Anarchy in the UK* (The Sex Pistols) and the negative "white noise" of hardcore and later Oi. There were also attempts actively to erode internal racial/ethnic divisions in Britain and within the punk movement itself, both through explicit interventions like Rock against Racism and Two Tone and through the creation of hybrid musics which integrated or spliced together black and white musical forms. Rock Against Racism and Two Tone were vital strategies aimed at working – albeit in rather different ways – in and on the popular. RAR – set up by music journalists, designers, performers, record business personnel – together with the Anti-Nazi League – a broad, non-aligned pressure group headed by political and showbusiness figures – was extraordinarily successful in mobilising a popular front to counter the threatened resurgence in the late 1970s of racist political parties (the British Movement, the National Front (NF)). Using popular idioms and the slogan NF = No Fun, through concerts, marches and the punk-style magazine *Temporary Hoarding*, RAR sought to articulate the emergent "structure of feeling" inscribed within punk away from the nihilism and/or racism of some elements in punk itself towards the left-libertarian multiculturalism which was being simultaneously promoted by *The New Musical Express* –

at that time Britain's leading music paper.

Whereas RAR was widely identified with the Socialist Workers' Party, and retained a residual commitment to the old political formations, to the old sense of political priorities and tactics (marching, changing minds to change the world, exposing and explaining the historical roots of racism in *Temporary Hoarding*, identifying the enemy, "raising consciousness"), Two Tone remained entirely outside the domain of formal party politics. Founded, co-ordinated and, in part, directed by Jerry Dammers of The Specials, Two Tone was a loose confederation of music groups (The Specials, The Beat, The Selecter, Madness) from diverse racial-ethnic backgrounds, who set out to produce a fusion of white (punk) and black (reggae) British musical traditions by developing a contemporary version of 1960s Jamaican ska.[9] This transmogrified ska – more congenial, accessible and easily danced to than punk, less exclusive, separatist and turned in upon itself than heavy roots reggae – provided a vehicle designed literally to "move" the audience through dance into a new kind of British territory, a new multicultural space, an organic bonding of signs and bodies... Eschewing the didactic or polemical tone of RAR and *Temporary Hoarding*, and the laboured "Anti-Establishment" aggressivity of punk, and retaining what was then, in the late 1970s and early 1980s, an unprecedented control over the "product" (over everything from the final record mix to the design of the Two Tone logo) – the Two Tone groups presented a total package of sound and image so thoroughly integrated that the multiracial "message" could be *inferred* – without being explicitly rendered – by a broadly sympathetic audience. Here through the forging of a series of formal aesthetic, ideological and experiential correspondences, an "affective alliance" was offered as the ground on which organic solidarity could develop between disaffected black and white youths – a solidarity the authenticity of which was guaranteed by the "rootedness" of the Two Tone musicians themselves in the "Ghost Town" of the inner city.

This forging of affective alliances through the invocation of a specific mix of signs and rhythms has always functioned as a vital strategy within black music creating, as Paul Gilroy has forcefully argued,[10] a "diasporan" identity amongst the black urban dispossessed, an identity which can be mobilised to abolish geographical distances, particularism, localism and the systematic mystification of a shared history and common interests.[11] The diaspora is reassembled and addressed as a "congregation" in gospel, soul, rap and reggae by voices which bond the *idren* (the "righteous" (rasta) *bredren* and *sistren*) together by bearing witness for the local struggles in which particular communities are immersed. At the same time, these voices employ common forms and familiar inflections which mean that this witness can be shared,

generalised from, appropriated to other struggles in other contexts. The international systems of communication now available have been used in recent years *explicitly* to articulate panglobal affinities within the black diaspora. Bob Marley's high profile promulgation of the rasta world view is a case in point. From the earlier subculturalist perspective the marketing by Island Records of Marley's dreadlocks-and-ganja image, the adoption of a high quality, packaged album sound and the inclusion of rock guitar riffs would have been regarded as a negative "dilution" of an original (angry) essence, a deflection of energies away from the master projects of "resistance" and "refusal". The more positive orientations required by a shift to an emphasis on vital strategies, however, stresses the extent to which Marley's address to panglobal "African" interests across the First and the Third Worlds, his historically significant appearance, for instance, at the celebrations to mark the independence of Zimbabwe would have been impossible without the "commercialisation" and "packaging" of Marley which made him an international figure in the first place and which prepared the way for his passage "back to Africa". Similarly, seen as a vital strategy the rastafarian substitution of the words "I and I" for the personal pronoun (the passive *mi* in Caribbean patois) indicates less a splitting than a doubling of personhood: a reaching out beyond the self to the Other (the divinity), to the community of idren. It is a centring strategy re-minding the speaker, as Paul Gilroy points out,[12] that sociality and meaning are built upon a ground which is intersubjective. Meanwhile, in both Jamaica and Britain, from the 1960s onwards, reggae music, transmitted through channels embedded deep in the black community, offered a powerful bassline against "Babylon pressure". The sound systems – the mobile reggae discos with their own d.j.s, their "specials" and "dub plates" (specially recorded rhythms owned by the system), their own local followings – are networks of live wires and speakers, sounds and affects. They simultaneously service and drum up particular "communities" wherever they are activated (assembled, plugged in, "manned").

More recently, Afrika Bambaata, the New York rap d.j. has established an international "Zulu Nation" amongst hip hop devotees around the "wild style" of popping, breaking, scratching, graffitti, dance teams, football whistles, Zululations and the Funk Sign[13] – a style which originally developed in the 1970s into a coherent subculture grounded in the discos of the South Bronx. The affective alliance created through what might sound on a first hearing like a typically postmodernist (schizophrenic/schizogenic) collage of broken, stuttering and fragmented sounds bind together black *and* white youths historically and geographically dispersed, dispossessed, divided against each other as the "modern" Western empires implode into their

metropolitan centres. The Zulu nation is rapped up in a tradition which valorises verbal and physical dexterity and which, according to Bambaata and James Brown[14] is overtly pledged to the sublimation of fight into dance, of conflict into contest, of desperation into style and a sense of self respect. A great deal of work lies behind the sheer technical complexity and brilliance of a typical dance team's moves. The degree of focus and effort required to achieve such a high degree of physical grace and bodily control indicate the extent to which dance can serve, as Paolo Friere puts it, as a strategy of self-empowerment; not only providing the dancer with a legitimate source of pride and self esteem but putting the person in touch – literally in this case – with his or her own vital powers.

Underneath the machinations of international finance capital, in the face of the global domination of markets by multinational conglomerates and cartels, networks of mutual affinity and attraction grounded paradoxically in the airwaves – in the most sophisticated communication technologies available, technologies developed more often than not to service the industrial-military complexes and to perpetuate their power – are working from "the other side" to abolish the boundaries of race and nation in the interests of a different kind of internationalism. The Band Aid phenomenon is, perhaps, the single most spectacular, most public (and for some commentators the most suspect) example of an attempt to set up such vital networks in order to mobilise material and "immaterial" resources (i.e., the means and the desire at once to "feed the world" and to transcend narrow (self and national) interests). Many of the issues I've attempted to raise in this post-script were implicated in the "Band Aid Debate", and some of the more dismissive and hostile critical responses to Bob Geldof's initiatives can be used to highlight what are, I think, some of the "fatal errors" which all too often flow from the forms of institutionalised critique to which we are – perhaps treacherously – habituated.

Were we to process the aid phenomenon through Baudrillard's *hyperbaton* (where aid and AIDS would no doubt be transposed) it might perhaps emerge as a "system" which seals the "whole world" in upon itself through the feedback produced by a series of meaningless spectacle-events (Band Aid, Live Aid, Sports Aid, Farm Aid, Fashion Aid). In this system, information (entertainment, news, press releases, biographies, images of "stars" and dying children) and other signs: cheques, cash and credit cards, hard currency: money – reinforce and generate each other as they circulate within their own recursive spirals. The system produces its own "events": a television documentary on the Ethiopian famine impels a rock celebrity (Bob Geldof) to gather other rock celebrities to make a record to raise cash "to save the world at Christmas-time". At the Live Aid concert in July, 1985, "the biggest

music concert in history", Phil Collins, another rock celebrity, is flown on Concorde from Britain to the States so that he can perform on the same day – once at Wembley, once at the J.F.K. stadium in Philadelphia – before an estimated audience of one billion viewers in 150 countries including the USSR and China. During the flight on Concorde, satellite contact is maintained with a presenter on the ground so that Collins can describe "live" on air the aerial view available through the plane window (cloud formations). In the campaign to "feed the world", the Third World gets eaten up by the First and Second Worlds in a process which both reverses and "ghosts" (i.e., renders negative and immaterial) the flow of exchange which links the three worlds together in relations of power and subordination: cheap food stuffs and raw materials flowing south to north in exchange for images and rock stars (e.g., Geldof) flying north to south.

Such a reading corresponds in large part to the analysis produced (in advance) by the popular music and cultural critics who gathered in Montreal for an international conference on popular music which took place just before the Live Aid concert in July. I single out the Montreal responses not because they are especially virulent or impulsive (they were in fact a great deal more carefully considered and more closely argued than much of what's been published since). Rather, I have used them because they were clear, concise, raised objections which subsequently became typical and, most importantly, because they were made *in advance before the Live Aid concert had taken place*. In the published record of the session on aid,[15] the "Band Aid Wagon" was denounced for producing bland music embellished with "sentimental" or "naive" self-congratulatory lyrics; for overlooking black musical talent; for exploiting and diluting Afro-American-Caribbean musical forms and traditions; for failing to "politicise" the audience ("aid is a safe political issue"... "Why not South Africa or Nicaragua?") by neglecting to explain the deep structural and historical reasons for Third World famine (i.e., for blaming it on the weather); for using the plight of the exploited half of the world to get "free publicity" for the overprivileged representatives of the other half in order to "revive the flagging careers of ageing rock stars" and for promoting an offensive and ineffective version of "donationalism" and nineteenth-century "philanthropy" thus reproducing the inadequate and duplicitous foreign aid policies indulged in by Western governments.

Such an analysis, the substance of which was echoed many times in Britain in the following months in the radical leftist and alternative press, is valid enough within its own terms. However, it fails to engage with the positive potentialities inscribed in the phenomenon. It fails to grasp the kernel of good sense and good will which Geldof and the rest of the Band Aid team located so effectively in the course of the campaign.

For neither the hypothetical postmodernist account of Band Aid as a hyperreal event nor the sceptical dismissals of donationalism can diminish the impact, the imaginative sweep, the sheer daring, the will to organise, to mobilise and intervene exhibited in the conceptualisation, planning and execution of the Band Aid project – a project which set out to redistribute global resources on what – if we indulge in the "long historical view" – may well appear to be an insignificant scale, to bring other people's distress and misery home to us in the West and to get ordinary people to do something – anything – to alleviate that distress and misery. The direct appeal to "ordinary people" is crucial if we are to get to grips with what is vital in the Band Aid campaign...

In this context it may be worth noting that what the British press refer to as "the Geldof phenomenon" has possibly been more crucial than is generally realised in what proved to be a temporary dip in Thatcher's popularity in late 1985 and early '86. The absence of Geldof's name from the 1986 New Year Honours list, the refusal of the Treasury to waive the Value Added Tax on the sale of Band Aid records, the intransigence with which the Foreign Secretary, Sir Geoffrey Howe refused (publicly in television interviews) to take seriously Geldof's "naive" request to "think again" about the foreign aid budget in the light of the unprecedented turn-out for the Sports Aid day, the resilience Geldof displayed in refusing to be budged off the issue by the Prime Minister during their one televised encounter at a presentation of Young Achiever Awards ("But Mrs Thatcher what are you going to *do* about the butter mountain?"): all these highly publicised events when laid against the massive public support for and participation in Band Aid, Live Aid, Sports Aid, must have told to some degree against the popularity of the Prime Minister and the policies to which she is so trenchantly committed.

For Thatcherism, as Stuart Hall and others have indicated,[16] has always claimed to "speak for" the "real" England, to "get straight to the heart of the matter", to have sole rights to the cultivation and enclosure of the ground of "common sense". In the process a series of oppositions have been established: Us v Them, the people v the power bloc, the "self-made man" v the state-employed pen pusher, We (the free but resolute British people) v them, the enemy without (Argentina, Libya, the USSR)/; we (the decent, law-abiding English people) v what Thatcher once referred to as "the enemy within" (the striking miners/printworkers/schoolteachers; the IRA; the rioters, the hippy convoy; the immigrants; the "unassimilable" (black and Asian) cultures; the subversives and fifth columnists; the "do-gooders"; the Campaign for Nuclear Disarmament; the Greenham Common women; the Greater London Council). Through these binary structures, Thatcherism sets out to define the limits and value of "nation" and

"Englishness" in ways designed to cut across traditional class-party loyalties. It has been argued that the success of Thatcherism as a populist discourse capable of speaking (for) one nation derives from its ability to interpellate the "common (family) man" and to exploit a backlog of grassroots dissatisfaction with the compromises and the unwieldy infrastructure of the post-1945 corporate State with its embattled welfare services, its "faceless" bureaucracies, its endless queues for benefits and operations on the National Health, its inefficient, overmanned nationalised industries. Thatcherism promised in 1979 and again in 1983 to "roll back the frontiers of the State", to cut unnecessary quangos and red tape, to open up the stuffy corridors of British industry to the brisk, invigorating winds of freely competing market forces. And these simple solutions were presented in the plain language of "the people". Drawing an analogy between a "housewife" (sic) budgeting the weekly housekeeping allowance and the Prime Minister and her Cabinet together juggling the balance of payments, keeping down inflation, etc., Mrs Thatcher "explained" that if "we" the nation didn't have the money to spend then the plain fact was we couldn't spend it. The plausibility of such simple "explanations" and the appeal of the whole Thatcherite formation were by 1985 faltering in the face of the widely felt alarm and sense of crisis produced by the steady rise in unemployment, by the return of the spectre of Disraeli's Two Nations: the prosperous South and the decimated North, by the accelerated decline in social services, education and the heavy industries, by the miners' strike – the longest and most bitterly divisive industrial dispute in British history.

Geldof's arrival, however, introduced a new and different kind of threat to Thatcherite populism: the articulation of a different version of "common sense" drawing on traditions of co-operation and mutual support, rooted in the human(e) values of good fellowship and good neighbourliness, the ability to feel affinities across national, ethnic and cultural divisions, to imagine a community beyond the boundaries of the known. These other traditions are as antique, as invented (i.e., re-made), as deeply embedded in everyday practice, as securely enshrined in the popular memory as those invoked within the "common sense" of Thatcherism. Attempts to insert Band Aid into some general and abiding "conservative" ideology of voluntarism, paternalism, colonial philanthropy (with Geldof cast as a literal "moral *entrepreneur*", the very type of Thatcherite true grit and enterprise) fail to acknowledge the extent to which Thatcherism breaks with the older conservatisms (the shabby genteel remnants of nineteenth-century paternalism represented by the Old Guard headed by Harold Macmillan, the managerialism/corporate-classless mentality of Heath and the Bow Group[17]). These older conservatisms had incorporated wider and more

catholic definitions of community and nation; attachments to a longer, broader view of "national heritage" and the inherited (natural *and* social) "landscape". These definitions and attachments were abruptly jettisoned with Thatcher's rise to power to be replaced by a "new realism" harshly lit by the monetarist and explicitly authoritarian solutions to the "national crisis" which Thatcherism offered. Band Aid threatened the legitimacy and the appeal of this new Thatcherite formation and the essentially Hobbesian view of a self-interested, and atomised society inscribed within it, by challenging the very roots of that appeal: its populist mode of address, its fabricated 'We' designed to weld the nation together (along with its natural NATO allies) against the rest of the world (those foreign enemies within and without). Whereas Thatcherism addresses the nuclear family as the fundamental corner-stone of all social, moral and legal order ("family values", the "small family business", the "property owning democracy" of private "family homes"), Band Aid invoked a much larger and more primitive kinship structure: the public "Family of Man". Whereas Thatcher addresses the Nation, Geldof interpellates the entire world "cutting through red tape" on television – speaking to the EEC Parliament, lobbying politicians, diplomats, UNESCO, "public personalities", industrialists, button-holing the "average man and woman in the street" with a hectoring address to camera: "Hey, you lot out there, put your hands in your pockets. Lives are at stake here" ... As Geldof squared up to Thatcher on the news in that brief encounter at the ceremony to honour youthful achievement, we were suddenly witness to a contest between two opposed populisms, two versions of what constitutes "common sense": the clash of two monumental simplicities: save the nation (Us against Them): save the world (Us *and* Them).

Band Aid revived "old fashioned" criteria, a "superseded" set of priorities (priorities and criteria which incidentally were resurrected too in the highly critical report of government inaction on the problems of the inner city produced in 1984 by the Anglican Church which, according to the folk lore of the Left is supposed to be eternally wedded to the Tory Party). Band Aid may have failed to "feed the world" but it succeeded in resuscitating traditions of co-operation, mutual assistance and that faith in human agency and collective action which had, for instance, animated the early trade unionists and the Labour Movement – exhuming them from the ground in which they lay buried beneath the rubble of the "new realism" and re-articulating them in a form which was viable in the 1980s (which is not to say that Band Aid was in any orthodox sense "socialist") ...

In this way we might say that the ultimate beneficiaries of Band Aid may well be us (not Them/as well as Them) in so far as a more enabling, and more open handed version of "the public" and the "public interest"

is once again available, circulating unconstrained (and uncontaminated) by party political affiliations and yet providing an alternative version of – a means of yearning beyond – the appetitive and paranoid versions of human motivation and human worth carried in the Thatcherite and Reaganite visions. Within the "new realisms" staked out by both monetarist ideology and the fatal de-scriptions of some strands in the Post there are no conceivable alternatives, no "other sides". In both cases the identical, banal implication of this shrinkage of horizons is that there is indeed nowhere else to go but to the shops. Band Aid revived the prospect of an elsewhere, another side.

For the success of the Aid phenomenon stems ultimately from what in a postmodernist analysis might appear as the superstitious or sentimental conviction on the part of "ordinary" people that there *is* some connection between an image of, say, starving Ethiopians and a reality "out there", that something real and something terrible – the two ideas are related – is happening *somewhere else* and that "we" – all the rest of us – are directly connected to and in some ways responsible for that terrible though physically remote reality. There seems little evidence here of what Jameson calls a general "waning of affect": an immunity from feeling caused by a surfeit of imagery including (and especially) the "hackneyed" iconography of suffering, the nightly newsreels of disasters threatening them – the wretched others – on the other side of the world.

Whatever else we may feel about the Band Aid phenomenon, about what occurs around its edges in the showbusiness arena, I doubt that anyone would want to deny the strength and the importance of that other conviction – in a sense I think that everything hangs upon it – upon the survival of the capacity of ordinary people to identify, to bond together, and to act constructively in concert to make things better; the capacity of ordinary people to discriminate when it really matters between what is real and what isn't, to decide what the real priorities are. I don't think anyone in their right mind would deny that real and vitally important moral resources were relocated and effectively deployed on a massive, international scale by Geldof and the people working with him. It may indeed be possible that what we are just glimpsing here in the Band Aid phenomenon is the formulation of a new set of moral imperatives, a new kind of eco-politics in which "resolve" and "conviction" – keywords in the Thatcherite discourse, terms which were given a definite authoritarian gloss as they were persistently invoked to counteract appeals from all sides for a U Turn away from monetarist policies – were themselves turned in a new and startlingly different way by "Saint Bob" and his colleagues. After Geldof – the dishevelled, sometimes less than civil Irish man who spoke up on behalf of conscience – the *real* "Enemy Within", *the* repressed term in the

221

monetarist discourse – Mrs Thatcher could no longer claim to have a monopoly on either resolve or conviction. The possibility of emerging eco-perspectives simultaneously developed through and bound into global communication networks is an important if problematic one. Such eco-perspectives will be articulated differently in different national-political contexts as they combine and are combined with, inform and are informed by, existing political-discursive formations. There are no guarantees here either, no *telos* impelling "humanity" towards greater co-operation and mutual understanding in McLuhan's "global village". But there are vital lessons to be learned from Band Aid and the Geldof intervention concerning the mobilisation of affect, the as yet barely explored potentialities for organising and redirecting material and "immaterial" resources through affective networks opened up within transnational communication forms and systems.

From the point of view of the analysis sketched out here, the collective response of the Montreal group may appear disappointing. The bitter denunciations of bad faith and naïveté, the relentless negativity, the commitment to the "depth model" of analysis (the *real reasons* for the famine) seem ungenerous and unappealing because they are essentially unconstructive. They prejudge the issue (issue: outflow, offspring, progeny; (from the verb public giving-out)). Such a response seems so fatally fixated on the rectitude and propriety of its own line that it can offer no realistic means for working with and on the resources of optimism, good faith and good will tapped to such effect by the campaign. It is unable to engage or to engage with the symbolic community – the transcendental "We" – the "better half" of all of us – which Geldof and the rest managed to relocate during the Aid campaign. The Band Aid team(s) managed to resurrect for many people a sense of possibility and common interest precisely through "exploitation" and "manipulation": through the *dedicated* exploitation of their own positions as public figures, through their *passionate, convinced* manipulation of hyper-promotional techniques and marketing strategies learned in the course of their careers in the media. The will to *act* – to intervene however clumsily or ineffectively to make the world a better place – is neither foolish nor malign. It must not be scoffed at. But it has to be articulated: brought to bear in and on concrete situations *as a transforming force*, and this articulating process requires imagination and a readiness to risk (Geldof risked ridicule, failure, the loss of "street credibility" which is the [bankable] cultural capital of the rock business).[18]

Left stranded on its own in the "Grand Hotel Abyss" (Lukács), the negative dialectic which underwrites many of our more entrenched "critical" positions threatens to produce nothing more "profound" than what Popper once described as a "prolonged wailing". A politics

based exclusively on the perfection of critique, on the identification of pain and exploitation, on the regular exposure of "hard", "unwelcome" truths which would otherwise remain concealed from less alert, less well informed or less "politically committed" individuals, a politics which offers only "dissent" and "resistance" as positive terms, is simply not enough. It will not work. An internally consistent critique – no matter how concerned, committed or purely deconstructive in intent – necessitates *by definition* a closure on the part of the critic to lived and living contradictions, a turning away from that "other side" which must be faced, imagined, yearned towards if all the conflicting forces at play in a conjuncture are to be pushed towards a fruitful outcome (i.e., if that other side is to be brought into being). To use Baudrillard's preferred terminology (death and vertigo) against Baudrillard's fatal drift, to resurrect history in all its secular senses, we could say that the situation is indeed "grave" – it always is but it is especially grave at this moment, it is especially so now. We need to develop vital strategies if we are to rise out of and move beyond a situation of such overwhelming gravity.

At a more practical level, this revision of priorities requires us to redefine the function(s) of critique. To concentrate on the problematic of affect involves a break with those forms of (interpretive, functionalist, (post)structuralist) cultural critique which are bound into the problematic of meaning. It involves a shift away from semiotics to pragmatics, from the analysis of the putative relations between cultural practices and social formations, between "texts" and "readers" towards a critical engagement with those processes through which libidinal and "information" flows are organised via networks in which "meanings" and "affects" circulate, form clusters, separate in a flux combining signifying and asignifying elements. It demands more varied, supple, "credulous" approaches, a less stringently convinced defence of the inherited critical ground (which doesn't mean we have to abandon the critical analysis of power relations, the contestation of particular ideological formations, etc.). The following post-script is an attempt to trace out a few possible lines of development here opened up in the Post.

Chapter 10

Post-script 2: After (the) Word

In this second post-script I want to return to the ground on which postmodernism has developed: the academy, the university, the gallery – in order to consider the ways in which it might be said to both symptomatise and articulate a malaise which is specific to those sites. For the decentring of knowledge and the loss of intellectual mastery it implies is as much about institutional crises as it is about a general crisis in subjectivity, or epistemology. State sponsored Higher Education – at least in Europe – is being forcibly redefined as government funding is suddenly withdrawn or made conditional upon the satisfaction of criteria very different from those traditionally favoured in the sector. The rôle of Higher Education becomes (once more) the focus for

agonised debate as a host of forces and factors: the "New Vocation-alism", the shift from pure to applied sciences, the rise of the new computational technologies, the growth of commercial research laboratories, and data banks attached to multi-national corporations and government agencies, the erosion of academic disciplinary boundaries, and the old humanist models of knowledge which were used to justify the academic's privileged position – converge to undermine inherited wisdoms about the value, purpose and rationale of university education.[1] All these pressures are registered in the textures and the tone of postmodernist criticism (though they are not necessarily explicitly acknowledged). As the survival of the university (especially of the liberally educated critical theorist) is thrown into question, a bunker mentality can evolve. The more "fatal" projections of the Post could be seen in this context as defensive or resigned responses to the threat of an imminent institutional collapse and/or reformation which may well serve further to marginalise the social theorist within (what remains of) the academy: *("Aprés moi, le deluge!")*

A more positive assessment of the potentialities opened up by the crisis in Higher Education might begin by stressing the extent to which vocational criteria can now be used to justify the expanded rôle of adult and continuing education, to modify and pluralise existing definitions of valid and useful knowledge, and to argue for the provision within the sector of Access and retraining courses for people without formal academic qualifications.

Within the terms and orientations of postmodernism itself, there are, as Hal Foster points out[2] positive dimensions to the crisis of confidence in the old authorities, in the old tone of authority. For there are many good things to be grown in the autumn of the patriarch, many good things to be found in the ruins, in the collapse of the older explanatory systems, in the splintering of the masterly overview and the totalising aspiration. The unfreezing of the rigid postures of the past – the postures of the hero, the critic, the spokes*man* – may merely signal the long awaited eclipse of many oppressive powers in our world. It may permit meaning to flow with less alarming gusto down more indirect and winding channels. In this context, it might be worth citing the renewal of interest in rhetoric within literary and communication studies.[3] The revival of rhetoric as a discipline designed to bracket off questions of content and truth – of meaning as substance – and to make a repertoire of discursive strategies available to people involved on a (potentially) professional basis in the production of meaning may be one sign of a loosening of the bonds that bind us to the single and the singular track, to a paranoid obsession with certitude and fixed and single destinations.

Similarly, the growth of paracriticism and allegory may signal the beginning of a more playful, less authoritative, less authority-bound

tone: a productive blurring of the line between fiction and critique, a blurring, too, of origins and rôles in such a way that no single author can lord it over the world of the text (or, it goes without saying, the text of the world). It may presage the emergence of a more protean conception of personal identity, public voice and the relationship which individuals and groups can contract between the two. Here we could cite the setting up amongst a group of Italian intellectuals[4] of a school of "weak thought" dedicated not to the pursuit of rigorously defined master projects (which may or may not have a totalitarian inscription) but rather to the tentative framing of hypotheses to be tested, revised, abandoned, returned to so that a random, aleatory element can be introduced into the production of knowledge. Viewed sympathetically, "weak thought" might be seen less as a capitulation to perspectivism and decadence (with or without its pejorative connotation) than as a genuine attempt creatively to think a way through the current epistemological impasse(s). In the same spirit, Lyotard's questioning of the distinction between scientific and narrative knowledge, his attempt to restore the legitimacy of first order narratives grounded in the everyday, and to replace the royal hunt of reason with language games, with gentle probings of "complexity" and (un)decidability seem, if nothing else, harmless enough (so long as philosophy renounces its master status as Lyotard recommends it to do). Whatever we may think of the adequacy of Lyotard's "postmodern condition" as a global description (and Lyotard insists that it applies only to the overdeveloped world[5]); however often we may feel inclined as we read him to yell out "Tell the A.N.C. and the 'comrades' in the townships in South Africa, tell the people struggling in Chile or El Salvador that they shouldn't trust the *grands rècits* of vengeance and emancipation", I for one still find it refreshing to hear a distinguished Parisian intellectual like Lyotard using words like "maybe", "perhaps", "what if?", instead of seeking to perfect a "line" defensible on all fronts or to lapse back into the assured, disembodied accents of the professional academic or (social) scientist.

If postmodernism means putting the Word in its place in this way, if it means the opening up to critical discourse of lines of enquiry which were formerly prohibited, of evidence which was previously inadmissible so that new and different questions can be asked and new and other voices can begin asking them; if it means the opening up of institutional and discursive spaces within which more fluid and plural social and sexual identities may develop; if it means the erosion of triangular formations of power and knowledge with the expert at the apex and the "masses" at the base, if, in a word, it enhances our collective (and democratic) sense of *possibility*, then I for one am a postmodernist.

Post-script 3: Space and Boundary

"By 5.50 it was really light outside. We had lost our lead ship, but Lieutenant Godfrey, our navigator, informs me that we had arranged for that contingency. We have an assembly point in the sky above the little island of Yakushima, southeast of Kyushu at 9.10. We are to circle there and wait for the rest of the formation.

Our genial bombardier, Lieutenant Levy, comes over to invite me to take his front-row seat in the transparent nose of the ship, and I accept eagerly. *From that vantage point in space,*

seventeen thousand feet above the Pacific, one gets a view of hundreds of miles on all sides, horizontally and vertically. At that height the vast ocean below and the sky above seem to merge into one great sphere.

I was on the inside of that firmament, riding above the giant mountains of white cumulus clouds, letting myself be suspended in infinite space. One hears the whirl of the motors behind one, but it soon becomes insignificant against the immensity all around and is before long swallowed by it. There comes a point where space also swallows time and one lives through eternal moments filled with an oppressive loneliness, as though all life had suddenly vanished from the earth and you are the only one left, a lone survivor travelling endlessly through interplanetary space.

My mind soon returns to the mission I am on. Somewhere beyond these vast mountains of white clouds ahead of me there lies Japan, the land of our enemy. . . . Captain Bock informs me that we are about to start our climb to bombing altitude . . . We shall soon meet our lead ship and proceed to the final stage of our journey. We reached Yakushima at 9.12 and there about four thousand feet ahead of us, was *The Great Artiste* with its precious load . . . I saw Lieutenant Godfrey and Sergeant Curry strap on their parachutes and I decided to do likewise. . . . We started circling . . . We kept on circling . . . It was 12.01 and the goal of our mission had arrived.

We heard the pre-arranged signal on our radio, put on our arc welder's glasses and watched tensely the manoeuvrings of the strike ship about half a mile in front of us.

"There she goes!" someone said.

Out of the belly of *The Great Artiste* what looked like a black object went downward.'" [my italics]
(William Lawrence, "Atomic Bombing of Nagasaki Told by Flight Member", New York Times, *9 September, 1945.)*

"A boundary is not that at which something stops, but, as the Greeks recognised, the boundary is that from which something begins its presencing."
(Martin Heidegger, "Building, Dwelling, Thinking", quoted in K. Frampton, "Towards a Critical Regionalism" in Postmodern Culture*)*

Marshall Berman ends his book, *All that's Solid Melts into Air* by stressing the constraints which frame the possibilities and options confronting us today. Berman acknowledges the validity of the critique of International Style architecture – a critique launched by those designers and urban planners who – favouring organic metaphors over the mechanical analogies of high modernism ("Buildings are machines for living" (le

Corbusier)) — propose that architects should work within communities rather than against them, should adopt a more modest, consultative role, should use local and regional materials and, where appropriate, traditional methods rather than "rational" or "modern" ones, and should seek to preserve and build upon ethnic neighbourhood traditions. Such a return to a pre-modernist concern for the maintenance of those temporal continuities necessary for the establishment of "community" requires also an acknowledgement of space as an essentially *inhabited* dimension (what, according to Kenneth Frampton, Heidegger called "Raum" as opposed to the abstract "spatium" - the building "from scratch" - implied by tower blocks and the new (modern) city). According to Berman, the challenge of modernity must be redefined within a context framed by a consciousness of the limits of modernism (though Berman resists the term "postmodernism", insisting that the modern adventure can be rescued along with history, progress, human possibility, as *general* propositions).

The figure who for Berman embodies most concisely and (melo)-dramatically, the ambivalent nature of the modern experience, is Goethe's Faust. Faust - unleashing the tremendous forces which the knowledge acquired through his pact with Mephistopheles makes available to him - is at the same time threatened, haunted, destroyed by the negative, nihilistic powers unleashed in the same process by the diabolical contract. Faust knows the world to death: his "unnatural" mastery of natural mysteries threatens to destroy both himself and the world. He eats it all up: lays waste the earth and thus consumes himself. Henceforward, in the archetypal urban space of modernity, we live in a world where sense, meaning, value - nothing - is given, where everything has to be worked for, where, under and against the superordinate sign of exchange value, properly *human* values have to be re-invented on a new terrain: reterritorialised, redimensionalised. For Berman, Faust represents the modern condition - a condition in which, following Marx's dictum in *The Communist Manifesto* "all that's solid melts into air" in a decisive rupture with the past which releases human beings from the obscurantist chains of religion, ignorance and fear, making it possible for the first time in history for men and women collectively to *make* their own history.

The implication here (though it's not one that Berman himself would necessarily endorse) is that the old teleological, modernising and dynamic paradigms of development based on a confidence in infinite, utilisably "material" resources, and in the guaranteed progression of a universal entity - mankind - towards the ultimate elimination of scarcity, superstition, ignorance and war will have to be replaced by more structural, ecological and holistic models based instead around a consciousness of limitation. A kind of liminal constraint is placed upon

the project of modernity – a bottom line or lines – a set of thresholds which we would be ill advised to cross. It may be possible to trace out some of these lines, to specify a few of the parameters which can be used to map out a more bounded, hence more habitable, version of post modern space:

1. The limits of the modernising aspiration

A recognition of the practical limits set on the ideology of "development" by the finite nature of the earth's resources; the recognition, too, of the potential for collective self-destruction inscribed within the shift into nuclear technologies; the limitations of predictive systems of global, economic, cultural and political development which posit a prescribed, unilinear sequence of necessary "stages" through which "backward" nations must pass in order to "evolve" or "progress" towards the "rationality", "modernity" or "efficiency" exhibited in the "developed First and Second Worlds".

2. The limits of totalisation/centralisation

It may be that we have to learn that, as Benjamin put it, "the fragment is the gateway to the whole" instead of seeking to refer each case up to some prefabricated explanatory meta-system. This move away from the "molar" towards the "molecular"[1] level, or from deductive to inductive reasoning requires a sensitivity in aesthetic critique and practice to the incandescence of the particular, in political critique and practice to local (or regional) conditions and demands, to the construction of more effective, responsive, accountable and genuinely democratic structures, etc.; to the dismantling/dispersal/delegation of authority "concentrates".

3. The limits of control/mastery

The loss of mastery entailed in an acknowledgement of the validity of *all* those decentring discourses – e.g., feminism, marxism, psychoanalysis, semiotics, the ecology movement, alternative medicine, the Post – which stress the limits of "man's" power, consciousness and knowledge. The need for caution, care and circumspection which these multiple decentrings compel upon us can be summed up in the remarks of an eco-activist opposed to the destruction by a multinational corporation of the rain forest (and the human and non-human life forms it supports):

230

"They don't know what they've lost, because they don't know what they're doing". The stress on the positive aspects of the "loss of mastery" entails a recognition of the dangers involved in "overstepping"; a recognition too (especially pertinent to people of my sex) that our speaking is done from a house that is gendered and built in time, a house which overlooks a horizon which is historically and experientially contingent.

Liminality cannot, however, be conceived exclusively in terms of constriction, stasis, prohibition. There are multiple enablements which are opened up by this marking out of a viable postmodern space. The boundary is, as Heidegger indicated, also a beginning, an opening out onto the world, a prerequisite for being, a condition for becoming. Within the three horizons traced above, there is room for limitless development. The room (the raum) may be "finished" – de-fined for us – but, as Deleuze and Guattari put it, "we never stop moving the furniture around".[2] For we are creatures of the line and we are living *"on the line"*:[3] on the moving lines dividing more or less "sedentary", more or less fluid categories: man/woman; masculine/feminine; black/white/brown; power/powerlessness; work/nonwork; consciousness/unconsciousness. This is where the other side – the positive side of contestation, change and growth: what Deleuze and Guattari call "reterritorialisation" – what we might call a postmodern "Theory of Development" – begins.

And the deepest line – the one that marks the very boundary of the possible – was opened up, as we all know, by the planes that set off in 1945 for Hiroshima and Nagasaki. For nuclear technologies are developed at the irradiating edges of the knowable-controllable and they impose a dread-ful kind of gravity upon our situation. After Chernobyl, this much is absolutely certain: there is no such thing as safe nuclear power. The very fabric of our world, the very germ and tissue of the species is endangered. The arms race between superpowers forms an arc across the earth – an "edge of darkness"[4] beyond which it seems impossible to move. We are doomed to stasis, immobilised: rooted to the spot.

In Baudrillard's hyperbaton, the arms race is (what else?) a kind of game without a goal or referent (there will be neither confrontation nor climb down, he asserts, just a pointless, fatal "doubling of the same"). The notion of the "critical mass" usually associated with the dynamics of nuclear *fission* is applied by Baudrillard to the fatal process of implosion – a process which through the repeated invocation of the (non-existent) "silent majorities" (the "neutral mass") draws everything into itself with a "violence which is only just beginning, an orbital

and nuclear violence of intake and fascination, a violence of the void".[5] For Baudrillard the fact that the world has *"failed"* to blow up only means that it has succeeded in collapsing utterly into itself in another kind of death. Paul Virilio, the eco-urbanist and theorist of war, offers a different scenario but one which has similar implications. With "deterrence", he argues, we have finally reached a state of pure war: with the world economy geared to the eternal preparation of the final (Holy) War that logistically "cannot happen" (but which nonetheless might at any moment). In Virilio's account, the "all points" and "all weapons" strategies that dominate the arms policies of the superpowers lead to de-urbanisation (internal fragmentation and demographic dispersals leading to the death of the (targeted) cities) and "endo-colonisation": "turning a state of war into a war against one's own population").[6] As more and more funds are channelled into the development of increasingly sophisticated (i.e., expensive) military equipment, we reach a state of "ecological zero growth" which entails the *systematic* underdevelopment/pacification of the civilian population. Meanwhile the British socialist historian and polemicist, E. P. Thompson, adopting a more traditional radical, activist stance, recommends (contrary to Home Office advice) that we "protest [to] survive".[7] Outside the American missile base at Greenham Common – the base from which the F111s flew out on their bombing mission against Libya in 1986 – the women have been gathering, settling in makeshift shelters pressed up tight against the wire of the perimeter fence which they have woven with wool, hung with flowers, dolls, slogans, photographs of loved ones: a wall of yearning, a vital fence, around the other fence around the edge of darkness.

The situation looks and sometimes feels desperate but we have to learn to live inside it (there is no going back). In the Post, within a world of fragments, small locations, microchips, salvation has perhaps been miniaturised, cut down to size. We can begin to draw small lessons from unsuspected sources. In this final digression, in what I hope is an appropriately playful-but-careful postmodern spirit, I want to use the Talking Heads' video *Road to Nowhere* to explore some of the habitable dimensions – some of the more fruitful lines of response – which may be opened up within the desperate situation in which we find ourselves today.

Post-script 4: Learning to Live on the Road to Nowhere

"We know where we're goin'
But we don't know where we've been
And we know what we're knowin'
But we can't say what we've seen.
And we're not little children
And we know what we want.
And the future is certain,
Give us time to work it out.

We're on the ride to nowhere
Come on inside
Taking that ride to nowhere
We'll take that ride
Feelin' O.K. this mornin'
And you know
We're on the road to paradise
Here we go, here we go."
 (Words and music by D. Byrne ©
 Bleu Disque Music/Index
 Music. British publisher:
 Warner Bros Music. By
 kind permission)

"Utopia" - No Place (from Greek ou = not + topos = place)
 (The Oxford Dictionary of English Etymology)

The American band, Talking Heads, have a reputation for being highly self-conscious, technically accomplished innovators within the popular music field. They draw eclectically on a wide range of visual and aural sources to create a distinctive pastiche or hybrid "house style" which they have used since their formation in the mid-1970s deliberately to stretch received (industrial) definitions of what rock/pop/video/Art/ performance/audience are. All these terms are bracketed off or twisted away from their conventional anchorages in the folk lore of high modernism and the common sense(s) of broadcasting/rock criticism where, as we have noted, in both cases a more or less clear demarcation between "popular" and "serious" cultural forms and critical issues tends to be maintained. Talking Heads set out to problematise (poke serious fun at) such category divisions and are thus a properly postmodernist band. David Byrne, the group's founder and focaliser, sets out to articulate a particular postmodern structure of feeling: to address Barthes' sensibility of "the second degree" - a sensibility fascinated by the pulse of signification, and the play of representational and generic codes. Typical themes raised and obsessively reiterated in Talking Heads' work include the mediated nature of "live" performance, simulation, "projected" imagery, psychosis, the mutability of self, the substitution of copies for originals, of impostors for real people.[1] In this way, using Talking Heads to provide the "original text" for this last post-script is not arbitrary. It is not an innocent choice: Byrne's work involves a high degree of more or less explicit meditation on the blurring of levels, categories, signs, identities, which, as we have seen, characterise the discourse of postmodernism. However, unlike many of those who describe the "post modern" from the (fatally removed)

vantage point of the critic, Byrne *inhabits the space of postmodernism* and offers the audience ways into that space which, whilst not being comfortable, are nonetheless viable and – ultimately if not immediately – pleasurable.

The most direct route into this space is provided by *The Road to Nowhere* (1984). The video for this song, which Byrne storyboarded and directed, is frequently cited as one of the most technically complex and original micro-narratives yet produced for promotional purposes. A brief synopsis of the video follows:

With the opening bars of the song the viewer is confronted with a long shot of the Hi Vista community hall in what looks like a small mid-Western town. This is followed by a tracking shot inside the hall where a group of women, men and children heavily marked as "ordinary" or "typical" (they look like non-professionals) stand in front of the small stage as others sit at tables talking, reading, etc. The central group are singing the opening lines of what sounds like a hymn (Byrne's voice leads them off but he is not visible in the group): "We know where we're goin'/But we don't know where we've been/And we know what we're knowin'/But we can't say what we've seen/And we're not little children/And we know what we want." This – the documentary moment – suddenly cuts to an open road stretching off into a desert horizon as Byrne's voice takes over to sing the rest of the song and the "community" disappears as we are taken on a ride down the road to nowhere on a beat which is based around a repetitive and strongly pronounced bass line.

The rest of the video consists of a series of rapid cuts between a number of recurrent images and image-sequences: David Byrne running on the spot in time to the "jogging" rhythm of the song, a man and woman running after each other up a ladder, two men wearing bondage masks and suits hitting each other with suitcases, Byrne's face "singing" (i.e., miming) in a cube, a series of revolving aerial shots – of a young woman in a ballroom gown arms outstretched like a doll in a music box, of an empty classical plinth, of a man with a naked torso posed like a classical statue, of a man in a tuxedo and a woman in an evening dress dancing close, etc. There are also discrete "sequences": a condensed "life" in which in a series of accelerating jump cuts a man and woman meet, embrace, produce a baby, grow middle-aged, as their daughter grows in leaps and bounds before our eyes only to leave (wearing a leather jacket and dark glasses) looking back disdainfully at her parents who become suddenly aged, kiss and flutter their arms (as apprentice angels?) to the lines "We're on the road to paradise/Here we go, here we go." Near the beginning of the road sequence, an old man, naked except for a loin cloth is shown getting into a box. ("And it's very far away/But it's growing day by day/And it's alright. Baby it's

alright".) Towards the end, the lid of the same box is pushed open from inside and a little laughing toddler in a nappy (diaper) gets out. A man is shown facing the camera as a large golden paper crown descends on his head. Later this is repeated though this time the crown hits the side of his head and falls off. Throughout the tape the picture space is interrupted and broken up by chromakeyed insertions: a cube in the bottom right-hand corner of the screen "tells its own story" in a series of images: Meyerbridge-style little cut-out men running on a loop, a close-up of Byrne's lips mouthing the words, etc., and there is an "impossible" sequence towards the end in which Byrne faces the camera sitting on a throne as (thanks to animation) his hair moves as if it has a life of its own, a pair of eyes drawn on the lapels of his jacket blink, the flowers in his lapels wither and grow, two apples become cores then apples again, and row upon row of doll-like figures and chromium hubcaps dance behind him in a vividly coloured, nightmarish parody of a fairground shooting gallery. This extract is immediately followed by a rapid succession of whirling circles: a birthday cake, an atlas globe dripping with blood, a smiling cartoon face, a vortex of water spiralling down a hole. The final sequence takes us back to the road to nowhere. We pass an assortment of incongruous figures (incongruous in a desertscape): Byrne dressed in an antiquated bathing suit with a rubber ring around his waist, a man in a baseball hat pushing a shopping trolley, the waltzing couple, etc. The journey, the song and the video stop as the original "community" of ordinary folks veers into view. The camera halts in front of them as they contemplate the viewer from the middle of the road and Byrne sings the closing line.

Recounted cold as a written summary, the Talking Heads' tape perhaps sounds banal and inflated: a collection of laboured clichés of the kind encountered every day in student projects in art schools or film schools. This is partly due to the leaden quality of all such "translations": the *Road to Nowhere* is a video production (it probably takes less time to watch the original than to read my summary). It was made to be watched (and listened to) and yet, as Byrne himself has said, to "stand up to repeated viewings". It can be understood, then, in terms of its function, its form, and the context of its uses. There are many ways in which such a product might be appropriated to a postmodernist reading. Video promos have been viewed negatively on the whole by professional rock critics – seen as part of a long-term decline in the "live" context which is considered to provide a minimum guarantee for the preservation of popular music's vitality, authenticity, its "rough edges" and its capacity to attract "raw talent" against the industrial and institutional pressures which tend towards the standardisation of product. From this perspective, rock videos concentrate yet more attention on the (incidental/suspect) visual dimension and distract

236

attention away from the place of pure presence: the flow of utterance in the speaking, singing, living human voice and in the unpredictable, unstable contexts of live musicianship. Promo videos are thus seen as a further congealment/commodification of "authentic" culture into "inauthentic" (packaged) product in a process which leads to the *primacy* of the televisual: the simulacrum. Pop promos are seen as monstrous hybrids – undecidable objects – neither "pure entertainment" nor "pure promotion" – in which the image and the sound, the video and the record chase after each other (i.e., sell each other) in a double helix which shortcircuits other possibilities (e.g., contact with the "real", the audience, the "street", etc.).

Certainly, a massive investment of capital lies behind the development of a genre or series of genres which lean less and less heavily on the televisual codes evolved in broadcast television in the 1960s and 1970s (e.g., in programmes like *The Old Grey Whistle Test*) to represent "live" performance. As pastiche and the deliberate orchestration of intertextual codes take over in video promos they contribute to that (postmodernist) process whereby television (in the age of what Eco calls "neo" rather than "paleo" television) is said to "cannibalise" itself. This seems borne out by what might be seen as the defining characteristic of pop promos – the substitution of *referential density* for *narrative coherence*.[2] As indexical signs – those motivated signs which move the narrative along – succumb to referential signs – those which evoke atmosphere, establish the *mise-en-scène*, give clues to "character" and "mood": clothing, postures, lighting, special effects, etc. – the pop promo video becomes a form designed to "tell an image" rather than to "tell a story" (i.e., the story of a particular performance). At the most "developed" end of this video aesthetic, a tape like *Road to Nowhere* establishes a narrative or rather non-narrative space – a space of sub-liminal narrative *suggestions* which is neither "realist" nor "modernist" (in its non Greenbergian sense) encouraging neither identification nor critical reflection. This is partly because of the reliance in the tape on post production effects achieved through technologies like Paintbox, which shape and frame the space of narration converting chronology and causality into flat-spatial terms (i.e. the dislocated simultaneities of the chromakeyed insertions in *Road to Nowhere*).[3]

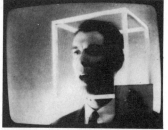

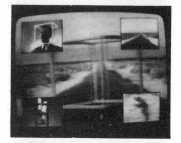

At another level, the *Road to Nowhere* could be used to exemplify Jameson's point about the diffusion (defusion) of modernist codes throughout "mass culture". The tape is strewn with self-conscious quotations from the text of modern art history. Going through the ones I spotted in random order there are the deconstructions of the myth of "live" performance. (At one point, a wedge is driven *à la* Godard or Bunel/Dali between the image and the soundtrack as, during an accordion solo, the "musician" is shown struggling up an incline

237

(actually a horizontal plane?) with an accordion strapped to his back.) There are references to Pop Art (Warhol: banal repetition; Rosenquist: a plate of spaghetti in close-up). The empty plinth and the cube recall the ironic gestures of Duchamp and Magritte. The gaudy animation sequence contains explicit references to Outsider Art traditions: the paintings of schizophrenics, the crowded fantasies of the Victorian patricide, Richard Dadd, (possibly) a reference in the figure of Byrne screaming/singing on a throne to Francis Bacon's *Screaming Pope*. There's even a section in which Byrne is shown underwater "miming" the lyrics of the song, in homage (perhaps) to the performance artist, Stuart Brisley.

The truncated paraphrase of married life could be read as a cheerful parody of the famous disenchantment scene in *Citizen Kane* where a twenty-year decline in marital relations is condensed under Welles's direction into a series of short vignettes of Mr and Mrs Kane at the breakfast table (beginning with a shot of the infatuated honeymooners and ending with Welles scowling at his wife from behind a newspaper). There's the metaphor of the "open road" itself which figures as a stock image in the iconography of the Great American Frontier (as a signifier of limitlessness: unbounded horizons) throughout American art and literature from Whitman to Hart Crane, from the novels of Jack Kerouac to the photographs of Robert Frank and endless eponymous road movies. And there is the flat, deadpan expressionless ("impersonal") modernist mode of delivery itself. Byrne's face here, as elsewhere, assumes the blank look of someone bringing news from nowhere. This anti-expressionism – a kind of simulated psychosis – has been the mode of address favoured by the modernist avant garde at least since Tristan Tzara and probably since the "Banquet Years", and Alfred Jarry's Ubu.[4]

Finally, during the animated passage, we encounter the pop video version of the sublime: an attempt (made possible through special effects peculiar to video) to "present the unpresentable". A closer "reading" – a reading from the Post – one which seeks less to "explicate" or "uncover" the meaning(s) of the "text", or to unravel its "textual processes" than to rewind and rerun it, to recapitulate its allegorical potentialities and effects might be useful here to demonstrate some of the arguments laid out in these post-scripts.

It is at the point in the narrative, just before we reach the end of the road, when Byrne's voice suddenly flies up into a higher and more desperate/ecstatic register, that we are confronted with the "schizophrenic" image of "Byrne" surrounded by the dolls and flowers – an image in which everything that moves is ("impossible") *animation within the frame* before we get swept along the stream of swirling-circle images

238

(the cake, the globe, etc.) to the end . . . Just before we are re-united once more in the last frame with the folks, from which we, the song and the story sprang at the beginning of the tape, just before we are folded back into the bosom of the family, there, for a time, we have the time to "realise" ourselves in the brief intermission between origins and destinations. There is a hiatus at this point – a pause in the pulse which drives the sounds and images along – and, as we stop at the dead centre of the road of life, the Talking Head takes us to the space of the sublime – the space of psychosis – where we fall through the cracks between what we see and say and think we're saying. We find somewhere to sit down. We reach the throne of fools ("There's a city in my mind/Come along and take that ride/And it's all right, baby it's all right") and we perch there windswept with the hubcaps forming a shifting arc behind us and the dolls dancing, courtesy of animation, on the table. And we sit there with the rosettes flowering and withering on our lapels and we look for a while into the face of things.

But the Talking Head tells us it's all right.

And at the moment when we stop we get bound into a writhing chain of signifiers, and dragged backwards into the here and now. We get stuck for the time being on the crazy ride, the fairground ride, the signifying whiplash where we slide along the signifiers from one circle to the next as we recapitulate our passage through the life-cycle from a birthday cake with candles on it and a smiling Mr Friendly face at one end, to a bleeding world and water going down the plug hole at the other end.

But it's alright, the Talking Head tells us. It's all right.
 And everything turns within the circle.[5] The circle is a metaphor which can contain everything and nothing. It can signify a black hole and the whole wide world. It can be the round nought of zero and the ovum awaiting impregnation: the very cell of life. And everything turns within the circle. Everything there is: joy and terror, tears of laughter, tears of pain.

But it's all right. Really, it's all right.

We're on the road to nowhere. All of us. There's nowhere else but here for us. No other time but now. This is all there is and it's enough to be getting on with. It's not so bad. In fact it can make us laugh.[6] The realisation can produce laughter – not the artful snigger, or the hollow, savage laughter licensed "beyond the fringe" or amongst the avant garde, but something closer to a belly laugh: a pregnant laugh that might help to usher in a new order.

For what marks the Talking Heads' tape off from modernism – what puts it firmly in the Post is that it has a light and laughing touch. The deconstructions and alienation effects are jokes rather than history lessons. The deadpan expression Byrne assumes owes at least as much to Buster Keaton as it does to Duchamp or Magritte. What makes it Post is that you can have fun with it: it is, as Byrne himself says, "multi-levelled": you can dance to it, enjoy the undemanding rhythm, think about its "message(s)", read it allegorically, use it as you like. You can watch it and forget it or steal it off the airwaves via video and play it back as often as you like. And what marks it off most clearly from most (all?) high modernist texts is that it seems to have been genuinely *popular*: it "got through" on whatever level. It caught the (British pop music) public's imagination, chimed in with its concerns. It was the single most requested music video on the BBC's 1985 *New Year's Eve Music Marathon*. The marathon was designed principally to showcase and recycle footage from the Live Aid concert. And despite the accusations of "nihilism" levelled against it, *Road to Nowhere* and the acknowledgement of liminality immanent within it is not *necessarily* incompatible with or corrosive of the Band Aid endeavour because its *tone* – which cannot be adequately conveyed on paper – was basically *affirmative*. Quite apart from the affirmation of ordinary people, of laughter over fear, of species being over individual existence, of life-as-running-on-the-spot over any kind of "fatal drift", the *Road to Nowhere* presents itself (amongst other things) as an affirmative allegory on the "loss of [masculine] mastery". It implies that dethronement is not to be resisted, or resented but accepted and welcomed. Instead of being offered the *death* of subjects and authors, *the end* of the Great Refusal, the *decline* of the old power of penetrating critique and totalisation, we are offered instead the *birth* of something new and something better – at least something brighter and fresher than ourselves (new life: the child in the box). We are offered something *lighter and more livable*: a world to grow up in and to be grown up in ("we're not little children") a world in which and for which men (once more the gender is marked) can at last begin to take responsibility without feeling responsible for the whole Symbolic Order. The moment when the paper crown comes crashing down on the man's head and falls to the floor is designed to provoke a smile not anguish, relief not despair. I smiled anyway. I felt relieved.

Because Byrne is right (and why not a pop star – an organic intellectual of the airwaves – instead of a professor?); the great meta-narratives can no longer be allowed to frame a sane assessment of our situation, can no longer be returned to as the ground upon which our explanations, accounts and actions can be legitimately posited. We must learn to live without the kinds of guarantee which have sometimes seemed to underwrite the human project. A consciousness of limitation

proscribes the space in which we live and work: a limitation on the aspirations of systematic critique, for instance, a recognition of the partiality and oppressive function of global accounts. To invoke what is, perhaps, a quite banal but nonetheless useful de-construction, dis-articulation of the word itself: his story – it is time for a dethronement of His Master's Voice, his masterful voice.

The collapse of the vertical (high rise) aesthetic in architecture and elsewhere, the collapse of the belief in authoritarian, centralised power structures – these are surely overdue. The idea of the intellectual artist, the critic or expert as a heroic "engineer of the soul" (Stalin) or as a surgeon cutting out the "problems" of the "masses" – whether they be "false consciousness" proper (i.e., "mystification" of the power/wealth axis) or the dogged persistence with which real people go on preferring, say, soap operas to opera proper, or Michael Jackson to Jackson Pollock – this idea has to be finally discarded, just as the transitive/transforma-tional paradigms of health care and science themselves – the actual practice of professional surgeons and engineers – are being questioned with the growth of alternative, holistic medicine, acupuncture, herbalism, etc., in the development of client organised self help and sickness support groups and in the gradual maturation of ecological perspectives.

And finally there is the deepest line: the one traced out by the holocaust, or rather by the two holocausts: the death camps and the prospect of nuclear catastrophe. In a sense we live between the two holocausts. In a world where global self-destruction is possible we have to think again and think again and learn to think again. We are – all of us – strung out on the road to nowhere and let's hope we can go on running on the spot forever strung out between those two unthinkable moments: strung out between then and the Day After. And if that is the real postmodern condition, then we must learn to lighten up; we must learn how to dance in the dark. We must learn to recognise that we can move along together not necessarily in time, certainly not marching to the drum of history, moving along, perhaps even having fun, getting some joy and pleasure and good cheer out of the whole exercise, moving along together though in different times to different rhythms. A gradual occupation of the space of the Post, a playful dance into the future – gradually learning how to accommodate, adapt, become more flexible, less driven to acquire, burn up, throw away, possess, becoming less tied into our bodies and our skins, less nailed into our genders; learning how to take it seriously yet lightly, how to take it seriously and yet not to take it personally.

A dance along the road to nowhere – one which requires in this loosening of the old rigid postures – a turning aside from the language of total transformation, a turning aside from the (impossible) requests, the

241

(irresponsible) yearnings of the two 1968s. We shall have to learn to start again not, as Godard might have said, "everywhere at once",[7] but here and now, perhaps in a calmer, more reflective and self-critical mood, learning how to question not only the structures and forms of domination out there but the forms of domination which are inscribed in our own lives, on our own bodies, which are registered in the grain of our own voices.

So eventually we have to learn (again) to give up certain things and to take up certain things in that dialectic, that alternation between loss, forgetting, disappearance and birth, recovery, appearance which finds its "other side" in the historical process.

There is always a fruitful exchange going on between knowing and realising how little we know, between re-membering and dreaming. So I come back in the end to those vital strategies: those strategies for life. Perhaps now it might be possible to specify a few: learning how to listen and to laugh as well as how to speak with "authority", to judge, to condemn; learning how to question our own practices, to watch what we say and do and how we say and do it without falling into stuttering self-cancellation, learning how to question not just for the sake of questioning, over-throwing, under-standing, but so as to produce a space around ourselves in which we can live and learn to find a voice, to find ourselves without damaging those who are around us and closest to us, without silencing *their* voices.

So you start – where else? (first lesson of feminism) – at home – in the place, in the palace where you live: as a living, gendered being. But this doesn't have to leave us stranded, pinioned forever on the irreducible facticity of difference – divided from each other and ourselves by the fraudulent (and fatal) power of the phallus. It doesn't have to leave us as just bodies – as if that were *all* there is on earth: bodies locked forever in pleasurable and painful contest, a mass of bodies bent on having a wild time until the lights go out, the body as the be-all and end-all of everything. Bodies, after all, are not just the mindless "subjects" and "objects" of "power" and "desire". They are – and we are what they are – yearning organisms. It may well be that we shall have to learn again what we knew before and have, perhaps, forgotten with modernity, that the seat of being is the belly not the eyes, the lips, the tongue, the ears, that the essential processes are visceral ones, that the processes essential for survival occur somewhere else – to one side as it were – of the flows, the "structures", the delusive "fixities" of language (delude: cheat into a false opinion, Latin *de-ludere*: play false, mock). We shall have to learn again that the belly is the vital organ: the mother of the world, the medieval seat of the humours, the organ of the appetites, digestion and laughter.

242

Mikhail Bakhtin once suggested that laughter has an all too often unacknowledged role to play in history.[8] It is the joker in the pack: the wild card. It stands on the other side of order "without rhyme or reason": the exception to the rule. Its appearance is always an interruption. It disrupts the players' concentration. It stops us taking it all too seriously. It makes the game a game again. Laughter is the joker in the pack of time. Bakhtin argued that laughter is a vital source of social renewal. It generates and regenerates the popular through carnival which inverts and relativises all hierarchies as it turns the "natural" social world upside down. It restores the community to itself in physical convulsions which revive our untheorised sense of solidarity in embodiment: the recognition that we are *just* bodies in the good sense: that we are bodies capable of being "just": even handed, reflexive and reflective, human(e) to each other, capable of reasoning with a small 'r', capable of laughing at ourselves. Bakhtin argued that laughter played an important part in the destruction of the feudal order. He demonstrates how Rabelais, living on the cusp of the Renaissance, took the ritualised inversions, the heresies and obscenities which were licensed in the medieval carnival and stretched them into the "grotesque realism" of the Gargantua and Pantagruel stories. In this way, Rabelais turned the therapeutic laughter of carnival into a weapon to attack the theocratic order. For Bakhtin, the modern age was laughed into being. The dust and the cobwebs, the angels and the devils, the necromancers and the priests, the barbaric inquisitions, the inflexible hierarchies, the sober, deadly serious *ignorance* of the medieval powers were blown away not by guns or great debates but by great gusts of belly laughter. It may well be this which needs to be re-remembered, re-turned to the moment – not Lyotard's sublime – if we are to find a way of moving forward in the Now. When we set up home on the road to nowhere we may have to learn to *laugh* our way around whatever sense of dread and crisis may afflict us, to laugh through the grave times we are living through, learning, this time, to laugh not in a carefree fashion (because *this* time, *everything's* at stake) but *really* (i.e., from the guts) – rather – care-fully, taking care as we circle and recircle and recircle . . .

> "We started circling . . . We kept on circling . . . It was 12.01 and the goal of our mission had arrived. We heard the prearranged signal on our radio . . .
>
> 'There she goes!' someone said.
>
> Out of the belly of *The Great Artiste* what looked like a black object went downward."[9]

There's no time left now and the laughter we are learning has got to be light and circumspect, chastened in the knowledge that living in the Now at noon plus one, there can be no final outcome, no margins left for

243

error, no more *Great Artist(e)s* floating in the air. It must be chastened in the knowledge that those first dark objects born(e) aloft and dropped in deadly earnest from the belly of the beast must also always be the last . . .

To close on an anti-climactic note (the only closure possible within the Post) – on a whisper not a bang – coming back to the what-it-was (I) wanted-being-said, coming back to base: to the dualism which seems inescapably, unavoidably there where we live if we live in the world and not over it or underneath it, entails a coming back to opposition: to the either/or which underlies (some versions of) postmodernism: the opposition between, on the one hand, the particular, the lived, the concrete and, on the other, the general, the abstract, the "unpresentable", the opposition between vertigo and ground which leaves us with that alternating sense of placelessness and rootedness which is the very rhythm of modernity. The dilemma opened up within modernity will never be resolved. The rhythm will not stop. But in the end we are – as Gramsci said – *all* of us philosophers, which means we are all homesick, yearning backwards to the source ("philosophy is homesickness" [Novalis][10]). We all come down to earth in time; we all come back "home": to that bounded space, that space which grounds us in relation to our own lives and to history. And to learn our place in time, to learn to live inside a situation requires us at once to "draw the line(s)", to acknowledge the need to live within our limits and yet, at the same time, to attend to what is gathering "beyond the boundaries", to respond as best we can to what is gathering, to yearn responsibly across it towards the other side

Notes and References

Introduction

1. In the Conclusion to *The Archaeology of Knowledge*, Foucault confronts his own ambivalence towards French structuralism by conducting a debate between two imaginary adversaries. The Conclusion takes the form of a kind of self-interrogation. (In this way, Foucault 'himself' escapes the finality of a conclusion; neither of the debating figures can be identified with their 'author'). At one point, the persona who has been given the job of defending Foucault's epistemology, says:

 > "But let us leave off our polemics about 'structuralism'; they hardly survive in areas now deserted by serious workers; this particular controversy, which might have been so fruitful, is now acted out only by mummers and tumblers."

 See Michel Foucault, *The Archaeology of Knowledge*, Tavistock, 1972. Later in the debate, this persona describes Foucault's project as an attempt "to deploy a dispersion that can never be reduced to a single system of differences...". Such an aspiration may be vain (in both senses of the word) but the peculiar itinerary undertaken in this book was dictated by a similar ambition.
2. See Roland Barthes, "The Rhetoric of the Image", in *Image-Music-Text*, Fontana, 1977; *Camera Lucida*, Hill & Wang, 1981; Andre Bazin, "The Ontology of the Photograph" in *What is Cinema?* Vol. 1, University of California Press, 1967.
3. Roland Barthes, op. cit., 1981.
4. Andre Bazin, op. cit., 1967.

Chapter 1: Hiding in the Light: Youth Surveillance and Display

1. S. Hall, C. Critcher, T. Jefferson, J. Clarke and B. Roberts, *Policing the Crisis: Mugging, the State and Law and Order*, Macmillan, 1978.
2. See "Imperialism, nationalism and organised youth" by M. Blanch, in J. Clarke, C. Critcher, R. Johnson (eds) *Working Class Culture: Studies in History and Theory*, Hutchinson, 1979, also Phil Cohen, "Policing the Working-Class City" and Ivy Pinchbeck and Margaret Hewitt, "Vagrancy and Delinquency in an urban setting", in *Crime and Society; Readings in History and Theory*, Mike Fitzgerald, Gregor McLennan and Jennie Pawson (eds), Routledge & Kegan Paul, 1981.
3. For the complicity between power/knowledge relations, the formation of modern State bureaucracies and the refinement of surveillance technologies see Michel Foucault, *Discipline and Punish; the Birth of the Prison*, trans. Alan Sheridan, Vintage, 1979; also "The Confession of the Flesh", in *Power/Knowledge: Selected Interviews and Writings 1972-1977* (ed.) Colin Gordon, trans. Colin Gordon, Leo Marshall, John Mepham and Kate Soper, Pantheon, 1980; and "The Subject and Power" in *Critical Inquiry* 8, 1982.

Baudelaire may have welcomed the opportunities for self-creation offered by metropolitan anonymity but 19th century commentators were on the whole more prone to deliver anxious condemnations of the chaotic urban scene or to rail against the supposed loss of *gemeinschaft*. For example, in 1844 Engels wrote:

> "The restless and noisy activity of the crowded streets is highly distasteful, and it is surely abhorrent to human nature itself. Hundreds of thousands of men and women drawn from all classes and ranks of society pack the streets of London ... they rush past each other as if they had nothing in common. They are tacitly agreed on one thing only – that everyone should keep to the right side of the pavement so as not to collide with the stream of people moving in the opposite direction ... this narrow-minded egotism – is everywhere the fundamental principle of modern society. But nowhere is this selfish egotism so blatantly evident as in the frantic bustle of the great city." (F. Engels, *The Condition of the Working Class in England*, 1844; Panther, 1969.)

Here the crowd functions as a metaphor for the law of private interest which Engels regards as the fundamental principle of capitalism. The crowd is seen as a symptom. It is the literal embodiment of Engels' thesis that the workers' alienation from the means of production is replicated elsewhere, everywhere; that it reverberates across every other category of social life producing other, parallel alienations.

4. See Henry Mayhew, *London Labour and the London Poor* Vol. 1, 1861; Dover, 1968, also Phil Cohen, op. cit., 1981.
5. John Tagg, "Power and Photography", in (eds) T. Bennett, G. Martin, C. Mercer, J. Wollacott, *Culture, Ideology and Social Process*, Open University, 1981.
6. See H. J. Dyos and Michael Wolff (eds), *The Victorian City: Images and Realities Vol. 1*, Routledge & Kegan Paul, 1978.
7. See Angela McRobbie, "Settling Accounts with Subculture", in T. Bennett et al. (eds) op. cit., 1981. Also Angela McRobbie, "Dance and Social Fantasy" and Erica Carter, "Alice in Consumer Wonderland" in A. McRobbie and Mica Naven (eds), *Gender and Generation*, Macmillan, 1984; Karen Benson, "Typical Girls" in *ZG* 1, 1981; the sado-masochism issue, *ZG* 2, 1981; Krystina Kitsis, "Simulated Sexuality; Androgynous Outcomes" in *ZG* The Body no. 10, Spring, 1984.
8. Quoted in Richard Barnes, *Mods!*, Eel Pie Publishing, 1980.
9. M. Venner, "From Deptford to Notting Hill: Summer 1981" in *New Community* Vol. IX, no. 2, Autumn, 1981.

Chapter 2: Mistaken Identities: Why John Paul Ritchie Didn't Do It His Way
1. This collage is taken from a number of different newspaper accounts. Some of them are inaccurate. For example. Spungen was not found "with a knife sticking in her stomach", *Evening News*, 13 October, 1978. In the context of this article, questions of verifiable fact are neither here nor there.
2. Angela Carter, *The Sadeian Woman. An Exercise in Cultural History*, Virago, 1981.
3. Robert Warshow, "The Gangster as Tragic Hero" in *The Immediate Experience*.
4. Angela Carter, op. cit.
5. *Evening News*, 13 October, 1978.

Chapter 3: Towards a Cartography of Taste 1935–1962
1. Evelyn Waugh, *Officers and Gentlemen*, Chapman & Hall, 1955.
2. Mary Douglas, *Purity and Danger*, Routledge & Kegan Paul, 1966.
3. David Cardiff, "The serious and the Popular: Aspects of the evolution of style in the radio talk 1928–39" in *Media, Culture and Society*, 1980, 2.
4. Nancy Mitford and Evelyn Waugh, *U & Non U*, Penguin, 1955.
5. Evelyn Waugh, *The Ordeal of Gilbert Pinfold*, Chapman & Hall, 1957.
6. Bevis Hillier, *The World of Art Deco*, Dutton, 1971.

7. George Orwell, "Pleasure Spots" in *Collected Essays – Journalism and Letters of George Orwell, Vol. 4, 1945–50*, S. Orwell and I. Angus (eds.), Penguin, 1979.

8. Richard Hoggart, *The Uses of Literacy*, Pelican, 1958.

9. Ibid.

10. Ibid.

11. Ibid.

12. Rev. Renwick C. Kennedy quoted in Eric Goldman, *The Crucial Decade and After: America 1945–60*, Vintage, 1956.

13. "An American Invasion" in *Picture Post*, 31 July, 1948.

14. Ibid.

15. D. Cardiff, P. Scannell, N. Garnham, Polytechnic of Central London, research into BBC Written Archives, 1928–1950 (to be published).

16. Iain Chambers, *Urban Rhythms*, Macmillan, 1984.

17. Quoted ibid.

18. This last comes from G. Orwell, "The Decline of the English Murder" in *The Decline of the English Murder and Other Essays*, Penguin, 1970. Orwell couples the decline of the English country house murder mystery with an apparent drop in the figures for passionate domestic homicides and attributes both to the pernicious influence of American culture. He sees one particular case – the Cleft Chin killings – in which an American army deserter and his "moll" murdered a number of people and robbed them "of a few shillings" during a drunken spree in 1944 – as symptomatic of this decline. The murderers reflected in their sordid crimes the "false values of Hollywood films" and pulp detective fiction. The essay is especially interesting as an early example of explicit anti-Americanisation. Orwell ends on this ominous note: "Perhaps it is significant that the most talked-of English murder of recent years should have been committed by an American and an English girl who had become partly Americanised."

19. Edward Hulton, "The Best and the Worst of Britain" (3) *Picture Post*, 19 December, 1953.

20. Ibid.

21. Ibid.

22. R. Hoggart, op. cit., 1958.

23. Ibid.

24. Ibid.

25. George Orwell, *Coming up for Air*, Penguin, 1962.

26. Reyner Banham, "Design in the First Machine Age" (1960), extracted in S. Bayley (ed.). *In Good Shape: Style in Industrial Products, 1900–1960*, Design Council, 1979.

27. Reyner Banham, "Detroit Tin Revisited", in *Design 1900–1960: Studies in Design and Popular Culture of the Twentieth Century*, (ed.) T. Faulkner, Newcastle upon Tyne Polytechnic, 1976.

28. Harold van Doren in Bayley, 1979.

29. See S. Bayley, "Industrial Design in the Twentieth Century", in S. Bayley (ed.), 1979.

30. See D. Cardiff, op. cit., 1980.

31. John Grierson, *Grierson on Documentary*, (ed.) F. Hardy, Faber, 1979.

32. John Heskett, "Archaism and Modernism in Design in the Third Reich", *Block 3*, 1980.

33. Nikolaus Pevsner, *An Enquiry into Industrial Art in England*, 1937, extracted in S. Bayley, op. cit., 1979.

34. Ibid.

35. Anthony Bertram, *Design*, 1938, in S. Bayley, 1979.

36. Ibid.

37. N. Pevsner, op. cit., 1979.

38. Harold van Doren, *Industrial Design – A Practical Guide*, 1954, extract in S. Bayley, 1979.

39. R. Banham, op. cit., 1979.

40. Raymond Loewy, "Industrial Design – the Aesthetics of Salesmanship – An American View", letter to the *Times*, 19 November, 1945, reprinted S. Bayley, 1979.
41. Robin Spencer, *Designs for Silent Rides over Rough Roads*, in Faulkner (ed.), 1976.
42. Ibid.
43. Ibid.
44. Stanley Mitchell, "Marinetti and Mayakovsky: futurism, fascism, communism", in *Screen Reader*, September, 1977.
45. Henry Dreyfuss, *Designing for People*, 1955, extracted in Bayley, 1979.
46. J. Heskett, op. cit., 1980.
47. Donald Bush, *The Streamlined Decade*, Braziller, 1975.
48. Edgar Kauffman, *Borax or the Chromium Plated Calf*, 1950, quoted in Banham, 1976.
49. Richard Hamilton, "Persuading Image", *Design*, no. 134, February, 1960, extracted in Bayley, op. cit., 1979.
50. R. Banham, 1976.
51. Ibid.
52. Ibid.
53. Ibid.
54. Ibid.
55. Herbert Marcuse, *One Dimensional Man*, Routledge & Kegan Paul, 1964.
56. Ibid.
57. Charles Walker, *Toward the Automatic Factory*, 1957, quoted ibid.
58. Serge Mallet, *Arguments no. 12–13*, 1958, quoted ibid.
59. H. Marcuse, op. cit., 1964.
60. Chas Critcher, "Sociology, Cultural Studies and the Post War Working Class", in *Working Class Culture* (eds.), J. Clarke, C. Crichter, R. Johnson, Hutchinson, 1979.
61. Ibid.
62. See Paul Wild, *Recreation in Rochdale*, in J. Clarke et al. (eds.), 1979.
63. Ibid.
64. Mike Brake, *The Sociology of Youth Culture and Youth Subculture*, Routledge & Kegan Paul, 1980.
65. Mark Abrams, *The Teenage Consumer*, London Press Exchange, 1959.
66. Ibid.
67. Ken Barnes, *Coronation Cups and Jam Jars*, Hackney Centreprise, 1979.
68. See T. Jefferson, "The Cultural Meaning of the Teds", in S. Hall, J. Carke, T. Jefferson, B. Roberts (eds.), *Resistance Through Rituals*, Hutchinson, 1976.
69. T. R. Fyvel, *The Insecure Offenders: Rebellious Youth in the Welfare State*, Pelican, 1963.
70. "The Truth about the Teddy Boys (and Teddy Girls)", *Picture Post*, 29 May, 1954.
71. George Melly, *Revolt into Style*, Penguin, 1972.
72. S. Hall, J. Clarke, T. Jefferson, B. Roberts, "Subculture, Culture and Class", in Hall et al., 1976.
73. R. Banham, op. cit., 1976.
74. Walter Benjamin, "The Work of Art in the Age of Mechanical Reproduction", in J. Curran et al. (eds.), *Mass Communication and Society*, Arnold, 1977.
75. Antonio Gramsci, "Americanism and Fordism", in *Selections from the Prison Notebooks*, Lawrence & Wishart, 1971.
76. Benjamin, op. cit., 1977. The wise young narrator of Colin MacInnes's cult novel *Absolute Beginners*, Allison & Busby, 1959, puts the same point rather more succinctly: "It's a sure sign of total defeat to be anti-Yank".
77. See, for instance, T. A. Gurback, "Film as International Business", in *Journal of Communication*, Winter, 1974, and C. W. E. Bigsby, "Europe, America and the Cultural Debate", in C. W. E. Bigsby (ed.), *Superculture: American Popular Culture and Europe*, Paul Elek, New York, 1975.
78. Hoggart, op. cit., 1958.
79. Tom Wolfe, "The Noonday Underground", in *The Pumphouse Gang*, Bantam, 1968.
80. Christopher Booker, *The Neophiliacs*, Collins, 1969.

81. Len Deighton, *The Ipcress File*, Hodder & Stoughton, 1962.
82. T. R. Fyvel, op. cit., 1963.

I would like to thank Barry Curtis, Tim Putnam and John Walker for the comments and corrections they made to the draft of this chapter.

Chapter 4: Object as Image: the Italian Scooter Cycle
1. Roland Barthes, "Introduction", *Mythologies*, Paladin, 1972(a).
2. Roland Barthes, quoted in J. Bird, *The Politics of Representation, Block 2*, 1980.
3. Roland Barthes, "Ecrivains et ecrivants", in *Critical Essays*, Evanston, 1972(b).
4. Roland Barthes, "The New Citroen", in Barthes, op. cit., 1972(a).
5. Roland Barthes, op. cit., 1972(b).
6. Roland Barthes, "The New Citroen": "The bodywork, the lines of union are touched, the upholstery palpated, the seats tried, the doors caressed, the cushions fondled; ... The object here is totally prostituted, appropriated: originating from the heaven of *Metropolis*, the Goddess is in a quarter of an hour mediatized, actualizing through this exorcism the very essence of petit-bourgeois advancement".
7. Lisa Tickner, "Women and Trousers: unisex clothing and sex-role changes in the 20th Century", in *Leisure in the 20th Century*, Design Council, 1977.
8. Paul Willis, "The Motor Cycle Within the Subcultural Group", in *Working Papers in Cultural Studies* (2), University of Birmingham.
9. Roland Barthes, op. cit., 1972(a).
10. Vance Packard, *The Wastemakers*, Penguin, 1963.
11. Ibid.
12. T. Adorno, quoted in Colin MacCabe, *Godard: Sound Image: politics*, BFI Publications, 1981.
13. Louis Althusser, "Contradiction and Overdetermination", in *For Marx*, Allen Lane, 1969.
14. Jan Stevens, *Scootering*, Penguin, 1966.
15. Mike Karslake, *Jet-Set*, Lambretta Club of Great Britain, December, 1974.
16. Paul Sweezey, "On the Theory of Monopoly Capitalism", in *Modern Capitalism and Other Essays*, Monthly Review Press, 1972. Peter Donaldson in *Economics of the Real World*, Penguin, 1973, provides some interesting statistics here on the transfer of capital in Britain during the post-war period. He writes: "Spending on take-overs during the first half of the 1960s was something like ten times that of the 1950s ... One estimate is that the mergers movement during the 1960s must have involved the transfer of some twenty per cent of the total net assets of manufacturing industry ..."
17. See Vance Packard, *The Status-Seekers*, Penguin, 1961.
18. Stuart Ewen, "Advertising as Social Production", in *Communication and Class Struggle*, Vol. 1, IG/IMMRC, 1979. Also Stuart Ewen, *Captains of Consciousness: Advertising and the Social Roots of the Consumer Culture*, McGraw-Hill, 1977.
19. Quoted ibid.
20. J. K. Galbraith, *The Affluent Society*, Penguin, 1970.
21. Richard Hamilton in S. Bayley (ed.), *In Good Shape: Style in Industrial Products 1900–1960*, Design Council, 1979.
22. Ann Ferebee, *A History of Design from the Victorian Era*, Van Nos. Reinhold, 1970.
23. "This exquisite social appliance", a line from *We Carry On*, Innocenti promotion film, 1966.
24. R. Barthes, 1972(a).
25. Henri Lefebvre, *Everyday Life in the Modern World*, Allen Lane, 1971.
26. Vance Packard, op. cit., 1963.
27. "A New Race of Girls", in *Picture Post*, 5 September, 1954.
28. From an advertising jingle used on Australian radio during 1962, sung by the Bee Gees.
29. S. Bayley, op. cit., 1979.

30. Jack Woods, "Is the Scooter Making a Comeback?", in *Motorcycle Sport*, November, 1979.
31. Ibid.
32. Reyner Banham, "Mediated Environments", in *Superculture: American Popular Culture and Europe*, Paul Elek, 1975, (ed.) C. W. E. Bigsby.
33. F. K. Henrion, "Italian Journey", in *Design*, January, 1949.
34. Ibid.
35. Ibid.
36. Ann Ferebee, op. cit., 1970.
37. John Heskett, *Industrial Design*, Thames & Hudson, 1980.
38. Mike Karslake, op. cit., 1974.
39. Ibid.
40. Personal recollection from Mike Karslake.
41. Jack Woods, op. cit., 1979.
42. From an article entitled "The Buzzing Wasp" which appeared in *On Two Wheels*. The series also carried an article on Lambrettas called "The Alternative Society".
43. Colin MacInnes, *Absolute Beginners*, re-issued by Allison & Busby, 1980.
44. Ibid.
45. See R. Barnes, *Mods!*, Eel Pie Publishing, 1980, on which I drew heavily for the mod sections in this paper; *Generation X* (eds.) Hamblett & Deverson, Tandem, 1964; Gary Herman, *The Who*, Studio Vista, 1971; S. Cohen, *Folk Devils and Moral Panics*, Paladin, 1972. See also D. Hebdige, "The Style of the Mods", in S. Hall et. al. (eds.), *Resistance Through Rituals*, Hutchinson, 1976.
46. Baron Isherwood and Mary Douglas, *The World of Goods: Towards an Anthropology of Consumption*, Penguin, 1980. Isherwood and Douglas define consumption as a "ritual process whose primary function is to make sense of the inchoate flux of events. . . . rituals are conventions that set up visible public definitions". Luxury goods are particularly useful as "weapons of exclusion". This idea compares interestingly with Bourdieu's definition of "taste": "Tastes (i.e., manifested preferences) are the practical affirmation of an inevitable difference . . . asserted purely negatively by the refusal of other tastes . . ."
47. R. Barnes, op. cit., 1980.
48. Ibid.
49. Ibid.
50. Ibid.
51. Ibid.
52. S. Cohen, op. cit., 1972.
53. See Fiona MacCarthy, *A History of British Design 1830-1970*, Allen & Unwin, 1979. The Design Centre opened in 1956. The Duke of Edinburgh's Prize for Elegant Design was first awarded three years later; also *The Practical Idealists*, J. & A. Blake, Lund Humphries, 1969.
54. Ibid.
55. Quoted in F. MacCarthy, *All Things Bright and Beautiful*, Allen & Unwin, 1972.
56. S. Cohen, op. cit., 1972.
57. P. Barker and A. Little, in T. Raison (ed.), *Youth in New Society*, Hart-Davis, 1966. Peter Willmott gives some interesting figures on patterns of scooter and motorcycle ownership in a working-class London borough in *Adolescent Boys in East London*, Penguin, 1966, during the mod-rocker period. Of his sample of 264 boys, one in ten over sixteen owned scooters (mainly in the sixteen- to seventeen-year range) whilst only one in twenty over sixteen owned a motor bike (they tended to be slightly older, seventeen to eighteen).
58. This comes from a review of the new Vespa P200 in 'The Buzzing Wasp", in *On Two Wheels*.

Thanks to Mary Rose Young and thanks especially to Mike Karslake, president of the Lambretta Preservation Society for giving me so much of his time and allowing me access to his collection of Innocenti publicity material and memorabilia.

250

Chapter 5: In Poor Taste: Notes on Pop
1. *Pop Art in England. Beginnings of a New Figuration, 1947–63*, York City Gallery, 1976.
2. Richard Smith, *Ark 32*, Journal of the Royal College of Art, Summer, 1962, in John Russell and Suzi Gablik, *Pop Art Redefined*, Thames & Hudson, 1969.
3. Jonathan Miller, *New Statesman*, 26 May, 1964.
4. Tom Wolfe, "Bob and Spike", in *The Pump House Gang*, Bantam, 1969.
5. Sidney Tillim, "Further Observations on the Pop Phenomenon", in *Art Forum*, 1965, in *Pop Art*, Michael Compton, Hamlyn, 1970.
6. Mark Twain, *Innocents Abroad or The New Pilgrim's Progress* Collins, 1986.
7. Leslie Fiedler, *Towards a Centennial: Notes on Innocents Abroad in Unfinished Business*, Stein and Day, 1972.
8. Lawrence Alloway, "The Long Front of Culture", 1959, in *Cambridge Opinion*, Cambridge University, 1959, reprinted in J. Russell and S. Gablik, op. cit., 1969. This phrase occurs in a comparison between Hitchcock's films before and after the war. It is presented as an allegory for a more general shift in cultural values from the pre-war fixation on "manly" action to the 1950s absorption in image: "In the pre-war *Thirty-Nine Steps*, the hero wore tweeds and got a little rumpled as the chase wore on, like a gentleman farmer after a day's shooting. In *North by North West* (1959), the hero is an advertising man... and though he is hunted from New York to South Dakota, his clothes stay neatly Brooks Brothers. That is to say, the dirt, sweat and damage of pursuit are less important than the package in which the hero comes – the tweedy British gentleman or the urbane Madison Avenue man... The point is that the drama of possessions (in this case, clothes) characterises the hero as much as (or more than) his motivations and actions... "
9. I. Karp, "Anti-Sensibility Painting" in *Art Forum*, 1963, reprinted in M. Compton, op. cit., 1970.
10. See Paul Barker, "Art nouveau riche", in Paul Barker (ed.), *Arts in Society*, Fontana, 1977.
11. John McHale, "The Fine Arts and the Mass Media", in *Cambridge Opinion*, 1959, reprinted in J. Russell and S. Gablik, op. cit., 1969.
12. Reyner Banham, "Representations in Protest", in P. Barker(ed.), op. cit., 1977.
13. Robert Indiana, "What is Pop Art? Interviews with eight painters", Gene Swanson, *Art News*, November, 1963, reprinted in J. Russell and S. Gablik, op. cit., 1969. The quote is taken from an interview with Indiana. The next sentence is worth quoting too: "[Pop] is basically a U turn back to representational visual communication, moving at a breakaway speed in several sharp late models... some young painters turn back to some less exalted things like coca cola, ice cream sodas, big hamburgers, supermarkets and *eat* signs. They are eye hungry, they pop... [They are] not intellectual, social and artistic malcontents with furrowed brows and fur-lined skulls..."
14. Uwe M. Schneede, *Paolozzi*, Thames & Hudson, 1971.
15. Lawrence Alloway, op. cit., 1959.
16. John Canaday, "Pop Art sells on and on. Why?", in *New York Times*, 1964, reprinted in M. Compton, op. cit., 1970.
17. Irving Sandler, review of New Realists exhibition, New York, 1962, in *New York Post*, 1962, reprinted in M. Compton, op. cit., 1970. The full quote is illuminating: "The coming together of fine and commercial art must have contributed to the wide recognition that New Realism has received. No other manifestation in recent years has been given as much attention so quickly in the slick magazines. Ad men (and others who share their approach) have probably promoted New Realism because it flatters their own 'art'. And they have also been able to apply it to their own work."
18. Peter Fuller, "The Crisis in British Art", in *Art Forum*, 1977.
19. Hugh Adams, *Art of the Sixties*, Phaidon, 1978.
20. Lynda Morris, "What made the Sixties' Art so Successful, so Shallow", in *Art Monthly*, 1976.
21. Schneede, op. cit., 1971.
22. Dick Hebdige, "Towards a Cartography of Taste, 1935–62", Chapter 3.

23. John Blake, "Space for Decoration", in *Design* no. 77, May, 1955.
24. Richard Hoggart, *The Uses of Literacy*, Penguin, 1958.
25. Ibid.
26. Lawrence Alloway, op. cit., 1959.
27. Richard Hoggart, op. cit., 1958.
28. Richard Hamilton, quoted in *Pop Art in England*, 1976. Of course, there was still an adherence to fine art values even amongst the original proponents of pop. In order to underline the fact that transformational work had indeed been performed upon the original subject matter, Hamilton (in marked contrast to Warhol) tended to stress just how elaborate the process of "cooking" had become, no matter how plain and simple the original ingredients: "One work began as an assemblage assisted with paint, was then photographed, the photograph modified and a final print made which was itself added to paint and collage." Hamilton quoted in Compton, op. cit., 1970.
29. Richard Hamilton, "An exposition of She" in *Architectural Design*, October, 1962.
30. Christopher Booker, *The Neophiliacs*, Collins, 1969.
31. David Bailey and Peter Evans, *Goodbye Baby and Amen*, Corgi, 1972.
32. Ibid.
33. Paul Barker, introduction to P. Barker (ed.), op. cit., 1977.
34. Ibid.
35. James Brown, *E.S.P.*
36. Paul Bergin.
37. Gerard Cordesse, "The Impact of American Science Fiction", in *Europe in Superculture: American Popular Culture and Europe*, (ed.) C. W. E. Bigsby, Paul Elek, 1975.
38. Paolozzi, quoted in Schneede, op. cit., 1971.
39. Pierre Bourdieu, "The Aristocracy of Culture", in *Media, Culture and Society*, Vol. 2., no. 3, 1980. Also in *Distinction: A Social Critique of Kant's Critique of Judgement*, Routledge & Kegan Paul, 1984.
40. Ibid.
41. Lawrence Alloway, op. cit., 1959.
42. *Science Fiction Quarterly*, reader quoted ibid.

Chapter 6: Making do with the "Nonetheless": In the Whacky World of Biff
1. See Kathy Myers, *Understains*, Comedia, 1986.
2. Lewis Mumford, *Art and Technics*, Columbia University Press, 1953.

Chapter 7: The Bottom Line on Planet One: Squaring Up to The Face
1. Northrop Frye, *The Great Code: The Bible and Literature*, HarBrace., 1981.
2. See, for instance, Paul Virilio and Sylvere Lotringer, *Pure War*, New York, Semiotext(e), Foreign Agents series, 1983; Félix Guattari, *Molecular Revolution, Psychiatry and Politics*, Penguin, 1984; Félix Guattari and Gilles Deleuze, *Anti-Oedipus: Capitalism and Schizophrenia*, University of Minnesota Press, 1983; Meaghan Morris, "Room 101 or a few worst things in the world", in André Frankovits (ed.), *Seduced and Abandoned: The Baudrillard Scene*, Stonemoss Services, 1984; Meaghan Morris, "des Epaves/Jetsam", in *On the Beach 1*, Autumn, 1983; André Gorz, *Farewell to the Working Class*, Pluto Press, 1983; André Gorz, *Paths to Paradise*, Pluto Press, 1985; Rudolf Bahro, *From Red to Green*, New Left Books, 1982.
3. See Roland Barthes, *The Pleasure of the Text*, Jonathan Cape, 1976. For a more condensed, programmatic manifesto of post-structuralist aims and objectives, see R. Barthes, "Change the Object Itself" in S. Heath (ed.), *Image-Music-Text*, Penguin, 1977.
4. The phrase the "impossible class" was originally coined by Nietszche in *The Dawn of the Day*, 1881; Gordon Press, 1974: "... the workers of Europe should declare that henceforth *as a class* they are a human impossibility and not only, as is customary, a

harsh and purposeless establishment... [They must] protest against the machine, against capital and against the choice with which they are now threatened, of becoming, *of necessity*, either slaves of the State or slaves of a revolutionary party..." The phrase has since been appropriated as a self-description by certain anarchist groups, by situationists, urban Red Indians, radical autonomists, etc. (see, for instance, the anarchist pamphlet *Riot not to Work* on the 1981 riots).

5. This is a mutated echo of the title of an article by Jean Baudrillard (see note 6 below): "The Precession of Simulacra" in which he postulates that the "social body" is being mutated by the "genetic code" of television in such a way that psychotic planar states of drift and fascination emerge to supplant social and psychic space (the space of the subject). In this way, reality is supposedly replaced by a "hyperreality" (an eventless imaginary). See "The precession of simulacra" in *Art & Text 11*, Spring, 1983.

6. For an excellent introduction, summary and critique of Baudrillard's work read André Frankovits (ed.), *Seduced and Abandoned: The Baudrillard Scene*, Stonemoss Services, 1984. To retrace Baudrillard's trajectory (for given his flatness it can hardly be a descent) from a semiotic analysis of consumption to flat earth science fiction, read *For a Critique of the Political Economy of the Sign*, Telos, 1981: *The Mirror of Production*, Telos, 1981; *In the Shadow of the Silent Majorities*, New York, Semiotext (e), Foreign Agents Series, 1984; "The Ecstasy of Communicaion", in Hal Foster (ed.), *Postmodern Culture*, Pluto Press, 1985. This is the kind of thing that "happens" in the Baudrillard scene: "... There's no longer any transcendence in the gaze. There's no longer any transcendence of judgement. There's a kind of participation, coagulation, proliferation of messages and signs, etc.... And one is no longer in a state to judge, one no longer has the potential to reflect... This is fascination. It is a form of ecstasy. Each event is immediately ecstatic and is pushed by the media to a degree of superlative existence. It invades everything" (Baudrillard quoted in Frankovits (ed.), op. cit., 1984).

 Confronted with the terminal condition of culture in the West, Baudrillard relinquishes the rôle of surgeon (radical, dissecting analyst) and tries homeopathy (paralogic) instead... more decadent than the decadent...

7. See Frankovits, op. cit., 1984.

8. See, for instance, Alain Touraine, *The Post-Industrial Society*, Wildwood House, 1974; A. Gorz, op. cit., 1983, 1985; Daniel Bell, *The Coming Post Industrial Society*, New York, Basic Books, 1973; Alvin Toffler, *The Third Wave*, Bantam, 1981; for postmodernism, see Hal Foster (ed.), op. cit., 1985; Jean-François Lyotard, "Answering the question: what is postmodernism?", in *The Postmodern Condition: A Report on Knowledge*, Manchester University Press, 1984; Fredric Jameson, "Post modernism or the Cultural Logic of late Capitalism", in *New Left Review*, 146, 1984. For New Left and neo-Marxist critiques of postmodernism, see Perry Anderson, *Considerations on Western Marxism*, New Left Books, 1976, and "Modernity and Revolution", in *New Left Review* 144, March to April, 1984; Dan Latimer, "Jameson and Post modernism", in *New Left Review*, November to December, 1984.

9. Jameson quoted in Latimer, op. cit., 1984.

10. This phrase from *The Communist Manifesto* is taken by Marshall Berman as the title of his book. *All that's solid melts into air*, Simon & Schuster, 1983. The book deals with the dialectics of modernisation – the process of social, demographic, economic and technological change associated with the rise of capitalism – and modernism – the answering innovations in the arts. For a discussion of Berman's account of the "experience of modernity", see P. Anderson, op. cit., 1984 and M. Berman, "The Signs in the Street: A response to Perry Anderson", in *New Left Review* 144, March to April, 1984.

11. This neologism is used by Jean-François Lyotard in "The Sublime and the Avant Garde" in *Art Forum*, April, 1984.

12. See Baudrillard, also Latimer, op. cit., 1984. Latimer suggests that Dick Hebdige adopts the celebratory stance in "In Poor Taste: Notes on Pop". He writes: "'We cannot afford,' says Jameson, 'the comfort of 'absolute moralizing judgements' about

post modernism. We are within it. We are part of it whether we like it or not. To repudiate it is to be reactionary. On the other hand, to celebrate it unequivocally, complacently, is to be Dick Hebdige..." Whilst agreeing with Jameson on the facticity of certain aspects of the post modern condition, the present author would distinguish himself from the "Dick Hebdige" referred to here.

13. See Jean-François Lyotard, *The Postmodern Condition: A Report on Knowledge*, Manchester University Press, 1984; Edward W. Said, "Opponents, Audiences, Constituencies and Community", in Foster (ed.) op. cit., 1985; Herbert Schiller, *Communication and Cultural Domination*, Pantheon, 1978, and *Who Knows: Information in the Age of the Fortune 400*, Ablex, 1981.

14. See, amongst many others, Herbert Marcuse, *One Dimensional Man*, Beacon Press, 1966; Jean-François Lyotard, "The Sublime and the Avant garde", in *Art Forum*, April, 1984.

15. The Italian school of "weak thought" was invoked by Umberto Eco in conversation with Stuart Hall in the opening programme in the current series of *Voices*, Channel Four, 1985. Weak thought refers to new, more tentative and flexible styles of reasoning and argumentation developed to avoid the authoritarian and terroristic tendencies within "classic" (social) scientific theorising.

16. Fredric Jameson, Foreword to Lyotard, 1984.

17. Alvin Toffler, op. cit., 1981. Toffler argues that information technology and home computing are rendering "second wave" (i.e., industrial) patterns of work, leisure, family structure, etc., obsolete. Commuting electronically from her/his "electronic cottage", the prosumer is the new (a) social subject, working, playing, and shopping by computer and thus synthesising in his/her person via her/his terminal the previously separate functions of production and consumption.

18. Lyotard, *Art Forum*, op. cit., 1984.

19. Charles Baudelaire, "The Painter of Modern Life" in *The Painter of Modern Life and other essays*, (ed.), J. Mayne, Phaidon Press, 1964.

20. George Eliot, *Daniel Deronda*, 1876, Penguin, 1967. This final note provides a late opportunity for me to point out that whilst this article is ostensibly about *The Face* and postmodernism, it is also in part an indirect critique of certain aspects of my own work. For instance, *Subculture: The Meaning of Style*, Methuen, 1979 – especially the insistence in that book on ambiguity and irony both as subcultural and as critical strategies. This is not a retraction but rather a modification of an earlier position. This note may also explain the subtitle of the present article: "Squaring up to *The Face*". By squaring the circular logic of those hermeneutic analyses which concentrate exclusively on the world of the (photographic/written/cultural) "text" I have sought to find a bottom line – a point of departure and return – from which it becomes possible to draw on some poststructuralist, postmodernist work without at the same time being drawn into the maelstrom (male strom?) of nihilism, epicureanism and Absurd Planer "logic" associated with some Post strands. After the ironic modes of "cool" and "hip", and studied self-effacement, a speaking from the heart: squarer than the square...

The student's essay referred to in the text is *Paper Ghosts – a phenomenology of photography* by Steve Evans.

Chapter 8: Staking out the Posts

1. See, for instance, Hal Foster (ed.), *Postmodern Culture*, Pluto, 1985, published originally in the USA as *The Anti-Aesthetic*, Bay Press, 1983; Lisa Appignanensi and Geoff Bennington (eds), *Postmodernism: ICA Documents 4*, Institute of Contemporary Arts, 1986; Jean-François Lyotard, *The Postmodern Condition. A Report on Knowledge*, University of Manchester Press, 1984; *New German Critique, Modernity and Postmodernism Debate*, No. 33, Fall, 1984; Fredric Jameson, "Postmodernism or the Cultural Logic of Late Capitalism", no. 146, July – August, 1984; Larry Grossberg, "Rocking with Reagan"; Hilary Lawson, *Reflexivity: The Post-Modern Predicament*, Hutchinson, 1985.

2. Perry Anderson, "Modernity and Revolution" and Marshall Berman's reply, "Signs in the Street", in *New Left Review*, 144, March – April, 1984.
3. Michael Newman, "Revising Modernism, Representing Postmodernism", in Appignanensi and Bennington (eds.), op. cit., 1986.
4. Jean-François Lyotard, "Defining the Postmodern", ibid.
5. J. G. Merquior, "Spider and the Bee", ibid.
6. For problems of periodisation, see Foster, op. cit., 1985, especially Foster, "Postmodernism: A Preface"; J. Habermas, "Modernity – An Incomplete Project"; F. Jameson, "Postmodernism and Consumer Society". Also, P. Anderson, op. cit., 1984 and M. Newman, op. cit., 1986.
7. For a discussion of these terms see, for instance, Annette Kuhn, *Women's Pictures: Feminism and Cinema*, Routledge & Kegan Paul, 1982. Also Shirley Ardener, *Perceiving Women*, Malabay Press, 1975.
8. Jean-Françopis Lyotard, "Complexity and the Sublime", in Appignanensi and Bennington (eds), op. cit., 1986. See, also, "Les Immateriaux" in *Art & Text: Expositionism*, 17, 1984.
9. See Jean Baudrillard, *In the Shadow of the Silent Majorities*, Semiotext(e), Foreign Agents Series, (eds), Jim Fleming and Sylvere Lotringer (trans.) Paul Foss, Paul Patton and John Johnston, New York, 1983. Although Baudrillard is Professor of Sociology at the University of Paris, the implication of his thesis in this book is that sociology is dead (along with meaning, art, politics, the social, etc., etc.). Paul Virilio and Sylvere Lotringer, *Pure War*, Semiotext(e), (trans.) Mark Polizotti, New York, 1983.
10. Peter Dews, "From Post-Structuralism to Postmodernity", in Appignanensi and Bennington (eds), op. cit., 1986.
11. The best account of the intellectual debates surrounding the events in Paris, 1968, available in English is still Sylvia Harvey's *May '68 and Film Culture*, British Film Institute, 1978.
12. See P. Dews, op. cit., 1986. Gilles Deleuze published *Nietzsche and Philosophy* in 1962.
13. See, for instance, R. D. Laing, *The Divided Self*, Quadrangle Books, 1960; *The Politics of Experience and The Bird of Paradise*, Pantheon, 1967; *Self and Others*, Tavistock, 1961; David Cooper, *Reason and Violence*, Tavistock, 1964; David Cooper, *Psychiatry and Anti-Psychiatry*, Paladin, 1967; *The Grammar of Living*, Penguin, 1976; *The Language of Madness*, Allen Lane, 1978. Norman O. Brown represents a similar visionary tendency in the States. See *Life against Death: The Psychoanalytical Meaning of History*, Vintage, 1964, and *Love's Body*, Vintage, 1966.
14. See M. Newman, op. cit, 1986, and Gregory L. Ulmer, "The Object of Post Criticism", in Foster (ed.), op. cit., 1985.
15. Roland Barthes, "The Death of the Author", in S. Heath (ed. and trans.), *Image, Music, Text*, Michel Foucault, "What is an author?" in *Language, Counter-Memory, Practice*, Ithaca, New York, Cornell University Press, 1977. (Both these articles are reprinted in John Caughie (ed.), *Theories of Authorship*, Routledge & Kegan Paul, 1981); Jacques Derrida, *Writing and Difference*, Routledge & Kegan Paul, and University of Chicago, 1978.
16. Jean Baudrillard, op. cit., 1983 and *Simulations*, Semiotext(e). "The Precession of Simulacra" is also available in *Art & Text 11*, Spring, 1983.
17. Fredric Jameson, op. cit., 1984, 1985. For a discussion of the distinction between *chronos* and *kairos*, see Frank Kermode, *Sense of an Ending*, Oxford University Press, 1969.
18. Gilles Deleuze and Félix Guattari, *Anti-Oedipus*, Viking Press, 1977.
19. Walter Benjamin, *Illuminations*, Fontana, 1973.
20. Jean-François Lyotard, *The Postmodern Condition. A Report on Knowledge*, University of Manchester Press, 1984.
21. I have tried to explore the problematic relationship between the category of the sublime, and more social/sociological definitions of the aesthetic experience in "The Impossible Object: Towards a Sociology of the Sublime" published in *New Formations 1* (Methuen, March, 1987). That article includes an abbreviated version

of the arguments put forward in the remainder of this section "Against Utopia".

22. Jean-François Lyotard, "Complexity and the Sublime", op. cit., 1986.
23. Ibid.
24. The substance of these objections was contained in Terry Eagleton, "Capitalism and Postmodernism", *New Left Review* 152, 1985.
25. Jean-François Lyotard, "Complexity and the Sublime", op. cit., 1986.
26. Walter Benjamin, op. cit., 1973.
27. Jean-François Lyotard, "Complexity and the Sublime", op. cit., 1986.
28. Ibid.
29. Ibid.
30. Ibid.
31. Ibid.
32. Richard Rorty, "Habermas and Lyotard on Postmodernity", in Richard J. Bernstein (ed.), *Habermas and Modernity*, Polity Press, Basil Blackwell, 1985.
33. Ibid.
34. Ibid.
35. Ibid.
36. Ibid.
37. Stuart Hall and Martin Jacques (ed.), *The Politics of Thatcherism*, Lawrence & Wishart with *Marxism Today*, 1983 and "Authoritarian Populism", S. Hall in *New Left Review* 153, 1985..
38. Antonio Gramsci, *Selections from the Prison Notebooks*, Lawrence & Wishart, 1971.
39. Jean Baudrillard, *In the Shadow of the Silent Majorities*, op. cit., 1983.
40. Stuart Hall, "Two Paradigms of Cultural Studies", in *Culture, Ideology and Social Process*, T. Bennet et al. (eds), Open University, 1981.
41. Stuart Hall, op. cit., 1983. See, especially, S. Hall, "The Great Moving Right Show"; M. Jacques, "Thatcherism – Breaking out of the impasse"; A. Gamble, "Thatcherism and Conservative Politics". Also T. Bennet et al. (eds), *Formations of Nation and People*, Routledge & Kegan Paul, 1984, especially Alan O'Shea's piece. For an analysis of how photography has been used in an attempt to serve the Thatcherite version of "Britishness" and national identity, see Colin Mercer, "Generating Consent", in the Consent and Control issue of *Ten.8*, no. 14, 1984.
42. Rudolf Bahro, *From Red to Green*, New Left Books, 1982.

Chapter 9: Post-script 1: Vital Strategies

1. *The Oxford Dictionary of English Etymology*
2. Ibid.
3. Raymond Williams, "Advertising: The Magic System", in *Problems in Materialism and Culture*, Verso and NLB, 1980; Vance Packard, *The Hidden Persuaders*, Pelican, 1962; John Berger, *Ways of Seeing*, BBC, 1974.
4. See Chapter 4, *Object as Image: The Italian Scooter Cycle*, for an attempt to reconstruct the variability in significance over time and in different cultural/national contexts of a single image-commodity.
5. See also *Cut 'n' Mix: Culture, Identity and Caribbean Music*, Comedia and Methuen, 1987.
6. Larry Grossberg, "The Politics of Youth Culture: some Observations on Rock and Roll in American Culture" in *Social Text* III, No. 2, 1983.
7. Dick Hebdige, *Subculture: The Meaning of Style*, Methuen, 1979.
8. Angela McRobbie and Simon Frith, "Rock and Sexuality" in *Screen Education* 29, Winter, 1978/9. McRobbie and Frith distinguish two opposed but complementary articulations of heterosexual desire within rock music in this article: (i) "cock rock" which is aggressively phallocentric promoting sadism, and the indiscriminate penetration/punishment of women and (ii) "teenybop" which aims to exploit the asexual, romantic fantasies of young teenage girls. See also the response by Jenny Taylor and Dave Laing, "Disco-Pleasure-Discourse: On Rock and Sexuality" in

Screen Education 31, Summer, 1979. These latter writers point out that McRobbie and Frith are virtually the first cultural theorists (in 1978/9) to topicalise the relations between sexuality, popular music and gendered identity but Taylor and Laing offer an approach more rooted in discourse theory insisting that "cock rock" and "teenybop" are not

> "two paradigmatic forms of music, but two different discourses of sexuality [in Foucault's sense of the term]. One [i.e., what Frith and McRobbie call "cock rock"] is defiantly 'speaking out': self-assertive, self-regarding, redefining or re-affirming the boundaries of 'normal' sexuality. The other [i.e., what they call "teenybop"] is confidential, private, 'confessional', setting up a relationship between singer and listener which implies a 'hidden truth' of sexuality to be revealed. But this is only one level of the play of discourses that constitute a musical product and this distinction can be found as much *within* the work of an artist or genre as between different performers ... "

9. For a fuller account of Two Tone, see D. Hebdige, "Ska Tissue: The Rise and Fall of Two Tone" in Stephen Davis and Peter Simon (eds) *Reggae International* (Rogner & Bernhard, U.S.A., 1982) reprinted in D. Hebdige, *Cut 'n' Mix: Culture, Identity and Caribbean Music*, Comedia and Methuen, 1987.

10. Paul Gilroy, *There ain't no Black in the Union Jack*, Hutchinson, 1987.

11. Ibid.

12. Ibid.

13. The Zulu Nation was formed in the Bronx by Afrika Bambaata, former member of The Black Spades, New York's largest black gang to promote "peace and survival". Bambaata took his name from a 19th century Zulu chief and the idea of the Nation from the early '60s British film *Zulu*:

> "When the British [at Rorke's Drift] thought they'd won the next thing you see is the whole mountain full with thousands of Zulus and the British knew they was gonna die then. But the Zulus chanted – praised them as warriors and let them live. So from there that's when I decided one of these days I hope to have a Zulu Nation too."

Bambaata quoted in David Toop, *The Rap Attack: African Jive to New York Hip Hop*, Pluto, 1984 – an informative introduction to rap and hip hop. The funk sign = two fingers (the shortest and longest digits) jabbed in the direction of the stage, the record decks, or the dance floor in time to the rhythm. Together with the "zulu chant" (zululations) it signals approval of a dance move or a rhythm. (According to one black London boy I talked to, the zululations originated at football matches in Tottenham in the late '70s when white racists in the crowd began making "monkey noises" whenever a black player took the ball. According to this version, the black funk crowd appropriated the taunt, drained it of its derisory or "primitive" connotations and turned it into a sign of commendation.)

14. James Brown is generally acknowledged to be the "founding father" of hip hop and hard funk, and has pledged his support for Bambaata's project. The theme of "hard work" and "good sense" as alternatives to crime and self destructive hard drug use for black youth in the ghettoes crops up frequently in Brown's paternalistic raps. Bambaata in turn acknowledges Brown's seminal influence and stresses the educative role of organisations like the Nation modelled loosely on the structure of the black street gangs (without the latter's emphasis on violence.

> "To me, the gangs was educational – it got me to learn about the streets, and the Black Spades they had a unity that I couldn't find elsewhere ... What got me excited first was when James Brown came out with 'Say it Loud, I'm Black and I'm proud'. That's when we transcend from negro to black. Negro to us was somebody who needed to grow into a knowledge of themself. There was no land called negroland."

Bambaata had been inspired by the example of black pride and self help provided by Malcom X and the Black Muslims:

> "The Nation of Islam was doing things that America had been trying to do for a while – taking people up from the streets like junkies and prostitutes and cleaning them up. Rehabilitating them like the jail system wasn't doing."

The Zulu Nation seeks through the promotion of rhythm, style and solidarity in dance to "rehabilitate" potential delinquents and to direct aggression and rage into self construction, a sense of community and the cultivation of a "positive attitude". See Toop, op. cit., 1984. Also D. Hebdige, *'Cut 'n' Mix: Culture, Identity and Caribbean Culture*, Comedia and Methuen, 1987.

15. *Rock for Ethiopia*, S. Rijven et al., International Association of Popular Music, University of Montreal, 1985.
16. Stuart Hall and Martin Jacques, *The Politics of Thatcherism*, Lawrence & Wishart with *Marxism Today*, 1983.
17. See Stuart Hall's chapter in J. Young (ed.), *Permissiveness and Control*, Routledge & Kegan Paul, 1980.
18. Coincidentally, Stuart Hall and Martin Jacques produced an analysis of the Aid phenomenon built around similar arguments and pursuing a line which runs very close to the one put forward here. (This is hardly surprising as my analysis is partly an attempt to follow through the implications of Stuart Hall's work on populism and articulation.) See Stuart Hall and Martin Jacques, "People Aid: A new politics sweeps the land", in *Marxism Today*, July, 1986.

Chapter 10: Post-Script 2: After (the) Word
1. For an analysis of the crisis of the University, see, for instance, Jean-François Lyotard, *The Postmodern Condition: A Report on Knowledge*, University of Manchester Press, 1984. This research was originally produced as a report commissioned by the University of Quebec. See also Edward Said, "Opponents, Audiences, Constituencies and Community" in Foster (ed.), *Postmodern Culture*, Pluto, 1985.
2. Hal Foster, "Postmodernism: A Preface", in Foster, op. cit., 1985.
3. One of the more surprising consequences of post-structuralism and grammatology within education (especially in the U.S.A.) appears to have been a revival of interest in classical rhetoric (see Christopher Norris, *Deconstruction*, Methuen, 1982). Terry Eagleton has recently presented rhetoric as a radical alternative to textual criticism. See, for instance, the concluding chapter of his *Literary Theory: An Introduction*, Basil Blackwell, 1983.
4. Mentioned by Umberto Eco in conversation with Stuart Hall on Channel 4's discussion programme, *Voices*, 1985. See note 15, chapter 7.
5. Jean-François Lyotard, "Complexity and the Sublime", in L. Appignanesi and G. Bennington, op. cit., 1986.

Chapter 11: Post-Script 3: Space and Boundary
1. For the distinction between the "molar" and "molecular" levels, see Félix Guattari, *Molecular Revolution: Psychiatry and Politics*, Penguin, 1984.
2. Gilles Deleuze and Félix Guattari, *On the Line*, Semiotext(e) (trans.) John Johnston, 1983.
3. Ibid.
4. *Edge of Darkness* was the title of a highly acclaimed six-part television series written by Troy Kennedy-Martin for BBC2. The series established a new television genre – the nuclear power thriller – and mixed together formal conventions and ideological themes from detective thriller and science fiction formats, combining these with overtly mythological, feminist and femineist elements to effect a startling departure from the realist norms of television drama (e.g., one of the main characters is the

ghost of the protagonist's daughter who is murdered in the first episode and who is a member of a mystical eco-feminist organisation called Gaia [Gaea: "the deep-breasted" was the ancient Greek earth goddess who created the universe, bore the first race of gods and the human race itself.]) So successful and so timely did this combination prove, that the BBC took the unprecedented decision to re-run the series on BBC1 on three consecutive nights within a fortnight of its original transmission in 1985.

5. Jean Baudrillard, *In the Shadow of the Silent Majorities*, Semiotext(e), 1983.
6. Paul Virilio, *Pure War*, Semiotext(e), 1983.
7. Edward Thompson, *Protest and Survive*, Spokesman Books, 1983.

Chapter 12: Learning to Live on the Road to Nowhere
1. See for instance, the films *Stop Making Sense*, 1984, and *True Stories*, 1986. In songs like *Once in a Lifetime, And She Was* and *Burning down the House* (and in the accompanying videos), Talking Heads use mediated imagery, animation and simulated psychosis to question notions of spontaneity, uniqueness and the "liveness" of live performance. The video for *Burning down the House*, for example, works explicitly within a Jungian framework. In a BBC television interview, Bryne explained:

> "... the symbolism of the song's title (*Burning down the House*) was about projection and projected imagery, it symbolised rebirth and destroying oneself or destroying some sort of transitory personality, and shedding a shell and coming out with a new one... So on one level, the video is about that and it's about one group of performers, us, being substituted by another, by a group of impostors. I get replaced by a little kid and the others get replaced by other people... the use of a lot of projection, a lot of projected images... is about one personality or one image being layered on top of another... That was meant to be the subliminal basis of that video..."

2. The idea of such a distinction was first suggested to me by Kieran Conlon, a former student of West Midlands College of Higher Education. Kieran invoked Barthes' indexical/referential distinction [from "The Structural Analysis of Narrative"] in the context of music videos in a highly stimulating essay entitled "Pop Promo Video: A Helical Scan".

3. David Marshall makes out a convincing case to the effect that video has massively intensified the tendencies towards centralised control of the rock industry, homogenisation of product and the commodification of the cultural forms of response to rock and pop. For heuristic purposes, in the context of the present discussion, these larger questions concerning the long-term implications of video for television and pop music production and consumption have been bracketed off. P. David Marshall, *Video Music as Promotional Form: The Incorporation of Popular Music into Television*, unpublished M.A. thesis for the Department of Communications, Simon Fraser University, Canada, August, 1985.

4. See Roger Shattuck, *The Banquet Years: Origins of the Avant Garde in France 1885–World War One*, Cape, 1969.

5. In a television interview transmitted during a videothon on BBC television in 1986, David Byrne was asked about the "nihilism" implicit in the song's title.

> *Q:* "The song, *Road to Nowhere* seems rather nihilistic. How did you think about illustrating that in the video?"
>
> *David Byrne:* "To keep the meaning of the song, in order not to trivialise it, you had to throw in all those... you had to say that this includes everything, that this is all-inclusive.... We're not talking about one depressed person on the Road to Nowhere or one group of people, or one group of musicians. We're talking about everything you can think of. And we tried to kind of imply that by putting in all those things."

6. "We try to slide the scarey stuff in with the funny stuff", David Byrne in the same television interview.

7. Towards the end of Jean-Luc Godard's film *Tout Va Bien*, 1972, which deals with the events in May, 1968, there is a famous tracking shot along the aisles of neatly stacked goods in a Parisian hypermarket. Jane Fonda, who plays a journalist who has been politicised by her observation of/involvement in a factory occupation, asks the question: "Where do we begin to struggle against the compartmentalisation of our lives?" The reply comes: "Everywhere at once". In an aside which is apposite in the context of the argument put forward here, Colin MacCabe remarks that this "solution" is "morally powerful but politically vacuous". See Colin MacCabe, *Godard: Images, Sounds, Politics*, BFI and Macmillan, 1980.

8. Mikhail Bakhtin, *Rabelais and his World*, MIT Press, 1968.

9. William Lawrence, "Atomic Bombing of Nagasaki Told by Flight Member", *New York Times*, 9 September, 1945.

10. For an elegant and intriguing meditation on the concept of home read Patrick Wright's introduction to his book *On Living in an Old Country*, Verso, 1985. The distinctive character of Wright's approach can be partly attributed to his resolve to open up the British Left (and British cultural studies) to a discussion of the work of Agnes Heller.

ACKNOWLEDGEMENTS AND PICTURE CREDITS

I would like to thank all those organisations and individuals who agreed to allow illustrations and extracts to be reproduced here. I am particularly grateful to Derek Ridgers, Nick Knight, Richard Hamilton and Dave Richardson of Shoot That Tiger all of whom were consistently helpful and generous in allowing me free access to their work. I would also like to thank Simon Greenleaf and Sarah Bruen for helping track down permissions and Bernard Gudynas for giving his time and lending his talents for the final stages of production. And thanks (once more) to Mike Karslake for allowing me to use imagery taken from back issues of *Lambretta Notizario* to illustrate the original version of Chapter 4.

The following copyright holders have given permission to reproduce the illustrations and extracts listed below. Numbers set in bold type indicate the pages on which the illustrations or extracts appear.

14 Tiger Richardson, JD 17, Screen Print no. 88, *Untitled* © 1987 The James Dean Foundation, TM, manufactured under licence by Curtis Licencing, © Shoot That Tiger, 33-41 Dallington St, London EC1

16 from *Picture Post* © BBC Hulton Picture Library

17 (margin top, centre, and bottom) Derek Ridgers

18 (margin top) Derek Ridgers

19 (margin bottom) Derek Ridgers

20 (margin top and bottom) reproduced courtesy of Manchester Public Libraries

21 (margin bottom) reproduced courtesy of the Metropolitan Borough of Stockport Central Library, Stockport, England

22 (top) Nick Knight
(bottom) Derek Ridgers

181 (centre) Graham Budgett, *The Angelus Novus*, print supplied by Camerawork

208 (centre) still from *Road to Nowhere* by Talking Heads, courtesy of Picture Music International

224 (centre) Anne McNeill

227 (centre) Victoria Annand

233 (centre) still taken from *Road to Nowhere* by Talking Heads, courtesy of Picture Music International

234-42 (margins) stills taken from *Road to Nowhere* by Talking Heads, courtesy of Picture Music International

234 *Road to Nowhere*: words and music by D. Byrne © Bleu Disque Music/Index Music. British publisher: Warner Bros Music. By kind permission.

243 (margin top and centre) designed by the author

244 (margins top and centre) stills from *Road to Nowhere* by Talking Heads, courtesy of Picture Music International (bottom) still from *Road to Nowhere* by Talking Heads, courtesy of Picture Music International

Although every effort has been made to trace copyright holders, I apologise in advance for any unintentional omission or neglect and shall be pleased to insert the appropriate acknowledgement to companies or individuals in any subsequent editions of this book.

INDEX